super serious

An Oral History of Los Angeles
Independent Stand-Up Comedy

super serious

An Oral History of Los Angeles Independent Stand-Up Comedy

MANDEE JOHNSON

Andrews McMeel Publishing

a division of Andrews McMeel Universal

1130 Walnut Street, Kansas City, Missouri 64106

www.andrewsmcmeel.com

20 21 22 23 24 TEN 10 9 8 7 6 5 4 3 2 1

ISBN: 978-1-5248-5505-5

Library of Congress Control Number: 2020930092

Editor: Allison Adler

Art Director: Sierra S. Stanton

Production Editor: Julie Railsback

Production Manager: Tamara Haus

ATTENTION: SCHOOLS AND BUSINESSES

Andrews McMeel books are available at quantity discounts with bulk purchase for educational, business, or sales promotional use. For information, please e-mail the Andrews McMeel Publishing Special Sales Department:

specialsales@amuniversal.com.

This book is dedicated to my partner
and the love of my life, Joel Mandelkorn.
I won't be who I am without you—you are my everything.
I love you.

This book is also dedicated to my amazing parents,
John and Eileen Johnson.

Thank you for allowing me to bully you into sending me to
photo school, where I met Joel.

Thank you for supporting us even when you didn't quite
understand what producing live comedy meant or how
exactly it was going to pay the bills—it kinda still doesn't.

Thank you for always believing in us; it means more than
words can express.

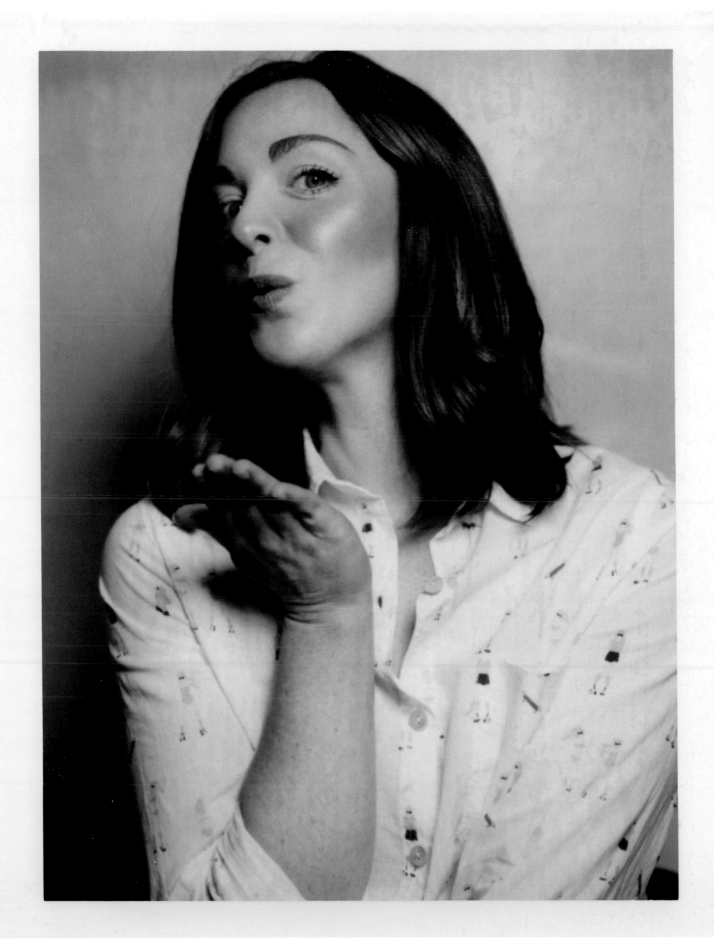

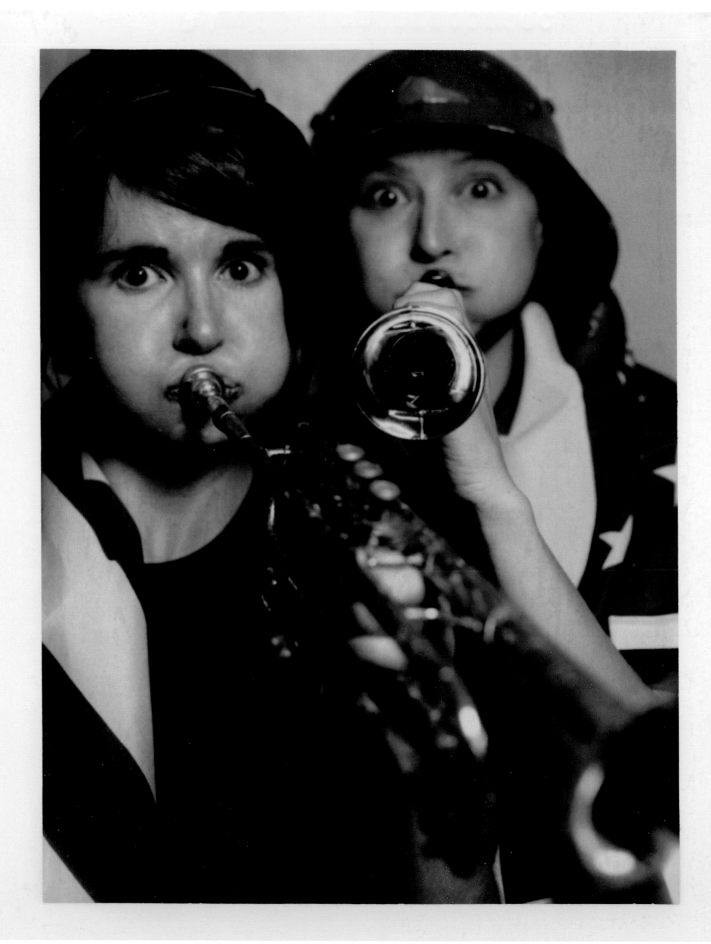

Hi. Welcome.

Mandee Johnson here, one of the producers and creators of *The Super Serious Show*. Joel Mandelkorn, my coproducer and partner, is here too.

We started *The Super Serious Show* in the summer of 2010. We are not comedians, but we set out to build a stand-up show that represented everything we loved: great music, cheap eats, free beer/wine, and a well-curated lineup. We didn't start this show with big plans. We just wanted to be part of the comedy community.

I took two 4x5 Polaroids of each comedian at *The Super Serious Show* over the past ten years. It became a deeply personal series to me—it documents not only our show and the comedians themselves, but a moment in time in our city's independent comedy scene.

This book, the portraits, and the interview selections contained within are a reflection of our shared history and community.

Thanks so much for stopping by. We appreciate it.

—Mandee (and Joel)

Hey! Thanks for coming out to *Super Serious.*

My name is Harris Mayersohn, and I'm
tonight's host-host.[1]

What a night!

Now, to introduce the book you're looking at right now, please
welcome the incomparable Demetri Martin!!!

[1] *What exactly is a host-host?*

Well, in live comedy it's gauche for the host to just come onstage, completely cold, without a proper, enthusiastic introduction to get the crowd all hot 'n' bothered. Usually, though, it's just some anonymous voice from the tech booth going, "Put your hands together for your host, Demetri Martin!" and that's it.

Not the case at *The Super Serious Show.*

Joel and Mandee, more so than anyone I know, are always thinking of how to make those little moments of a live show—even something as innocuous and generally unnoticed as the top-of-show intro—funnier and more vivacious. And that's how they came up with the role of host-host.

Crowds rarely remember their host-host, but host-hosts never forget their crowds. Host-hosting felt like my first "big break." The first chance for a young comedian (again, me) to perform a thirty-second bit and get a taste of the action in front of a sold-out crowd before a much better comedian (see Demetri Martin) makes the audience forget the host-host's name (Harris Mayersohn).

While there are tons of famous comedians featured in this here book, there are at least thrice as many unknown comedians who Joel and Mandee have given meaningful opportunities, like host-hosting, to grow and experiment. In an industry full of folks who don't care about anyone but themselves, they always seems to put their friends, audiences, and performers before themselves.

Anyway, that's what a host-host is. You can go back up.

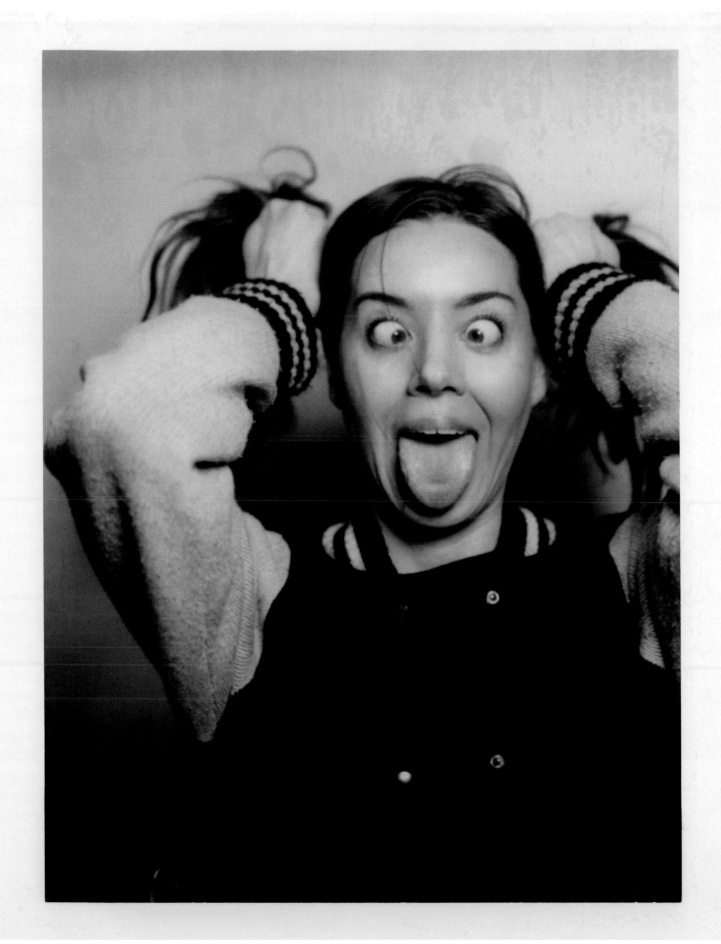

FORWARD

Thank you, Harris. And thank you, Mandee and Joel, for having me. This gig is a little different. I'm used to doing spots on stage, in front of live audiences. But this one is on page, for—well, sort of a "live" audience, I guess, with a bit of a time delay to get to each person, and the seats are way more spread out. But still, no drink minimum! Anyway, thanks for coming to the book. We've got a great lineup tonight (or whenever you're reading this). I don't want to waste any time, so let's keep the book moving and get right into the foreword.

Stand-up comedy is a unique job because comedians, more than any other creative workers, need live audiences in order to do their work. Lots of live audiences, every step of the way. You might say, "So do strippers and birthday clowns." And I might respond, "Yes, but let me finish, because it's not the same, which is exactly the point I'm making" or "Please don't heckle me while I'm writing a foreword. Okay?" Anyway, what I was trying to say before I was so rudely interrupted by myself is that we comedians actually need to be in front of live crowds not just for the making-a-living part of our job or for the tears-of-a-clown part of our personalities. For each of us, audiences are essential to the very process of creating comedy. You can write jokes at home, think of bits in your car, work out stories in your head, or compose funny songs on your toilet. But without a live audience, no comedian can ever really develop an act or figure out who they are as a performer. Live audiences are our creative partners, editors, focus groups, guinea pigs, and teachers. They sharpen our timing, guide our improvisations, and shape not only our material but our very comedic identities. And because of that, each of us who performs comedy, over the course of our careers, will do shows in thousands of different rooms of all sizes and several shapes (and sometimes with strippers and birthday clowns). Many of the rooms will be not good. Some will be rough. Even more will be horrendous. Others will smell. A few will be great. And a very small handful will be special.

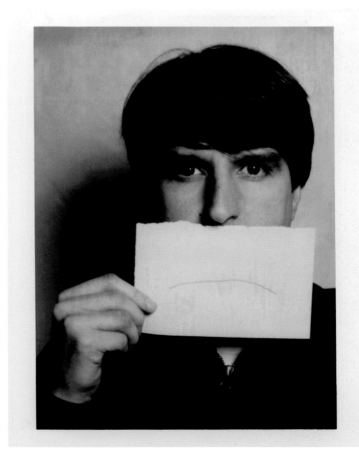

The Super Serious Show is special.

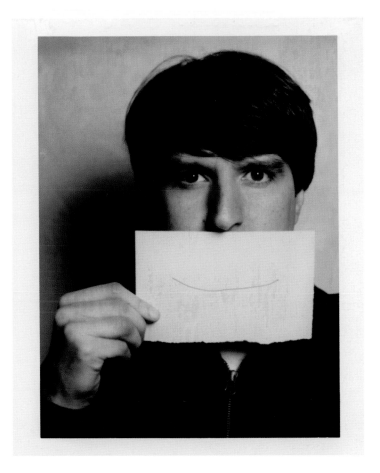

And it has been for a decade. The crowds are always warm and attentive. The lineups are consistently diverse and unique. And the atmosphere backstage has been supportive and positive since day one. Whenever I get to perform on *The Super Serious Show*, I know I'm going to have a good night, and I always leave feeling better than I did before I got there, even when my new material sucks or I've accidentally worn a shirt that's not that comfortable. So what makes *The Super Serious Show* so special? How does it have all of these great traits? And what is this third question doing here? The answer (to the first two questions) is simple: *The Super Serious Show* is exceptional because it's exactly like the people who created it. Mandee and Joel love comedy and comedians, and they produce every one of their shows with genuine enthusiasm and real love. They are supportive and attentive. They're enthusiastic and warm. And yes, I'm listing a lot of the words I just listed a few sentences ago, because they're worth repeating. Also, the answer to the third question above is that I wanted to have a third question to go with the other two, but I'm a procrastinator, so what was a placeholder is now a permanent part of this paragraph.

Like so many other comics who have had the privilege of performing on *The Super Serious Show*, I've been lucky to have a place where I can try out new material and catch up with friends backstage. Mandee and Joel haven't just made a show, they've created a community. And it's hard to overstate what that means to so many of us. The rooms where we spend most of our careers often disappear, even the special ones. It's just really hard to make a good show. So it's a lucky thing that *The Super Serious Show* existed and that Mandee used her camera along the way to capture it.

This book is a document of the comedy community Mandee and Joel have nurtured for so many years. In these pages you'll find those same adjectives I mentioned in that really good paragraph before the last one you just read. In Mandee's photos, you'll see her generous talent as a photographer and as a producer. And I believe you'll get a sense of just how special it has been.

Well, that's my time. Thanks again for coming out. I hope you enjoy the book.

OW

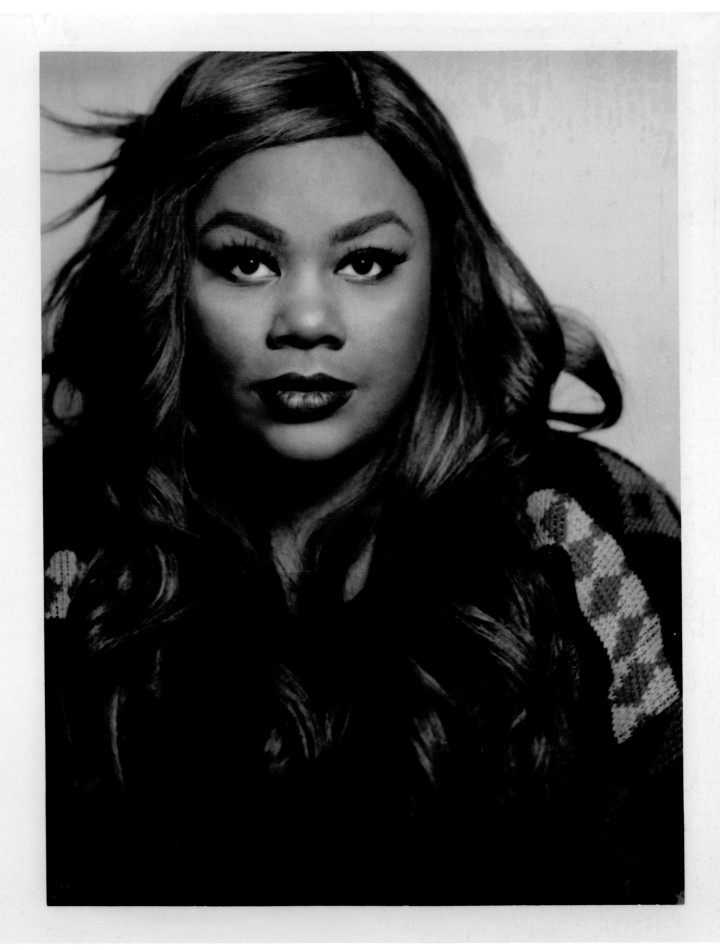

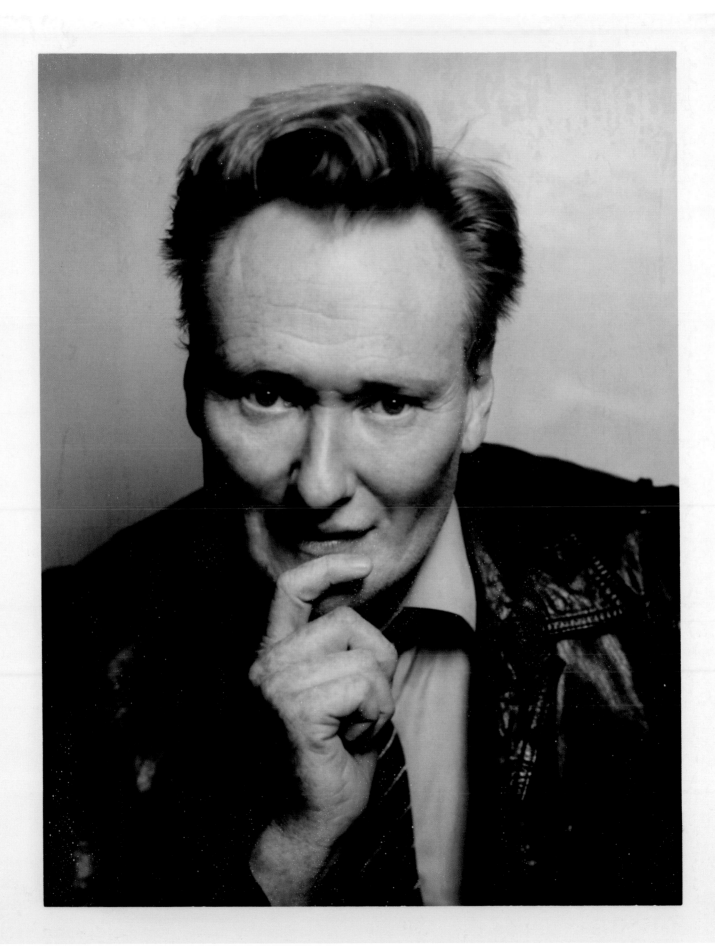

EDDIE PEPITONE: For me it was just completely the only thing that I ever wanted to do or was meant to do. I never had any thought of doing anything else.

MANDEE JOHNSON: How did you know that?

EP: Through television. I was born in 1958, so I am sixty. I grew up watching Jackie Gleason and *The Honeymooners*. I loved Gleason. That big, loud, bombastic guy with a really soft underside. Heart-of-gold type of guy. I love that. I loved Don Rickles when I was younger. When I was fourteen years old, I smoked my first joint, and I started listening to Carlin and Pryor.

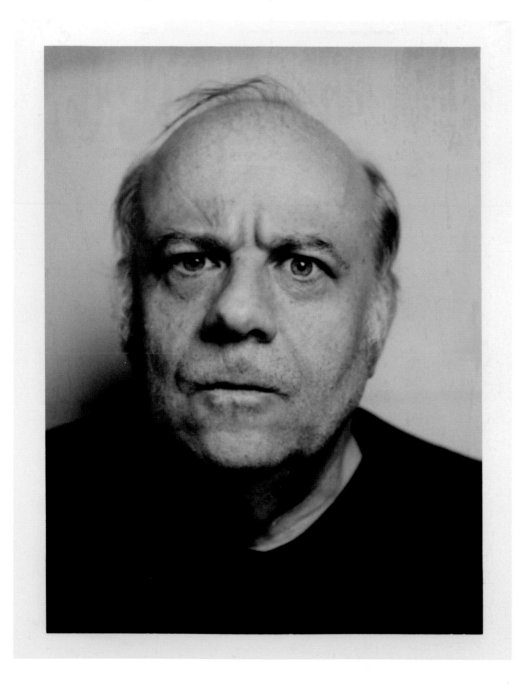

I had a fucked-up family life: my mom was diagnosed with bipolar disorder, and she was in and out of institutions, and my father was trying to hold the family together, and he didn't really do it. My salvation was comedy. It's cliché, but it's true. I never thought of doing anything else. I took acting classes, and every time I did a scene dramatically, like *Death of a Salesman* or whatever, people would laugh hysterically. I knew I was destined for comedy. I started doing open mics in New York City, and it was terrifying.

PEOPLE WOULD LAUGH HYSTERICALLY

-EDDIE PEPITONE

MJ: What year was that?

EP: Let's see, Kennedy got shot in 1963.

MJ: I love that that's a reference point for your stand-up career.

EP: I was five when he got shot. I was around . . . I was eighteen, nineteen.

MJ: So thirteen years after Kennedy was shot.

EP: We landed on the moon in '69.

MJ: So roughly seven years after that.

EP: It was around 1976, '77, something like that.

MJ: How was the open mic scene in New York?

EP: It was horrible. I just remember going to a place—it's not there anymore—called the Eagle Tavern. And everybody would go there, and I just was so terrified that I would throw up before shows. I would throw up backstage for shitty open mics. Then, I would go onstage and scream. It was crazy.

MJ: So nothing's changed.

EP: I knew you were going to say that. I wish I didn't know you were going to say it. But I knew you were.

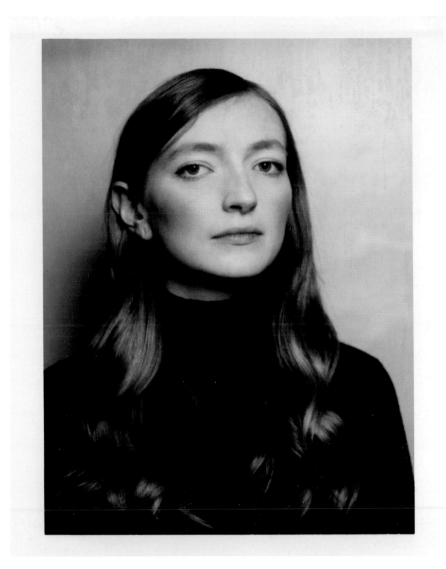

DANA GOULD: I was the fifth of six kids, and I was very much the runt of the litter. All my brothers are not only manlier, they're all physically a foot taller than I am—it's like my mother's body was out of testosterone. Just me and then I had a sister. That's true. And I was never an athlete. They always played sports, and they hunted, and I was just a TV kid. I gravitated toward horror movies and *Star Trek* but also comedy, and specifically as a kid, I was really into George Carlin, even though I was a kid. And then in the mid-seventies he was on TV a lot. Everyone in my family loved him. So it was one of those things where when he was on television, everybody shut up, and I was like, *Oh, this is good.* And being funny was a great way of getting attention.

MJ: Sure—big family, lotta kids.

DG: Yeah, big family, lotta kids. It was a great way of getting attention, and because I watched a lot of television, I ingested all of those rhythms and those patterns.

MJ: The timing.

DG: Yeah. And different algorithms for what's funny. I ingested them really early—ten, eleven, twelve years old.

 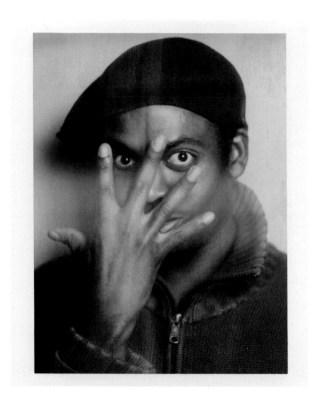

DAVE ANTHONY: Oh my god! I always wanted to do stand-up—since I was five.

MJ: What inspired you at the age of five?

DA: There was just never anything else I wanted to do. I would just watch comedians on TV and just became obsessed with them. I don't know why. Maybe my parents let me stay up late? Or maybe comedians used to be on earlier, but I would see them all the time. And then in my high school years I remember *An Evening at the Improv* came on after *SNL*, so I would sit there and watch it till I fell asleep.

My parents were divorced, so when I got to be like ten or eleven, my mom would go out on the town at night, and I would just sit there and watch TV. She would come home and try to get me off the couch to go to bed because I was on the couch watching stand-up until I fell asleep. I never really had any idea of doing anything else with my life. That was always what I wanted to do.

So it was always waiting, like it was a matter of time until I could start. In high school I would just write jokes. All of my binders would be full of me writing jokes. They were also *not* good jokes.

BARRY ROTHBART: I grew up in New York, and my dad would take me to the Comedy Cellar when I was really young, like when I was twelve.

MJ: They would let you go in?

BR: Yeah.

MJ: That's crazy.

BR: Isn't that weird? Yeah, we went every week, and I just thought it was magic. I wanted to try it one day. I secretly started keeping a notebook of jokes without telling anyone because I thought it was insane.

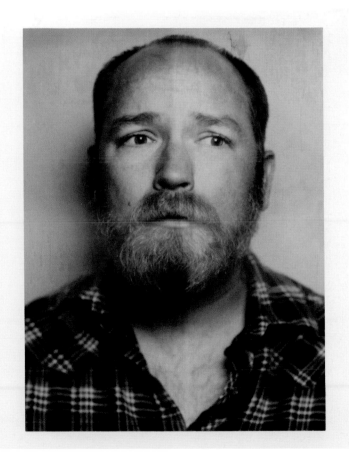 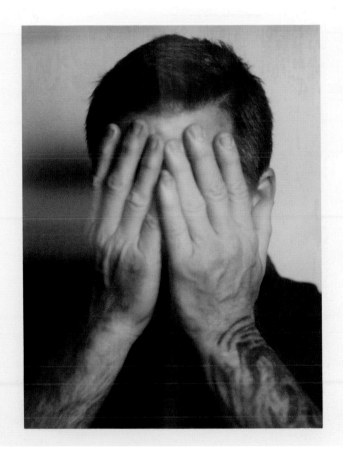

RANDY SKLAR: We were huge fans of comedy. When we were kids, our parents were funny. Our dad was funny.

JASON SKLAR: He always made people laugh! Right?

RS: Yeah. He wouldn't, like, write jokes or anything. But he'd take us with him on Saturday mornings when he'd go down to his office that he worked at, and then

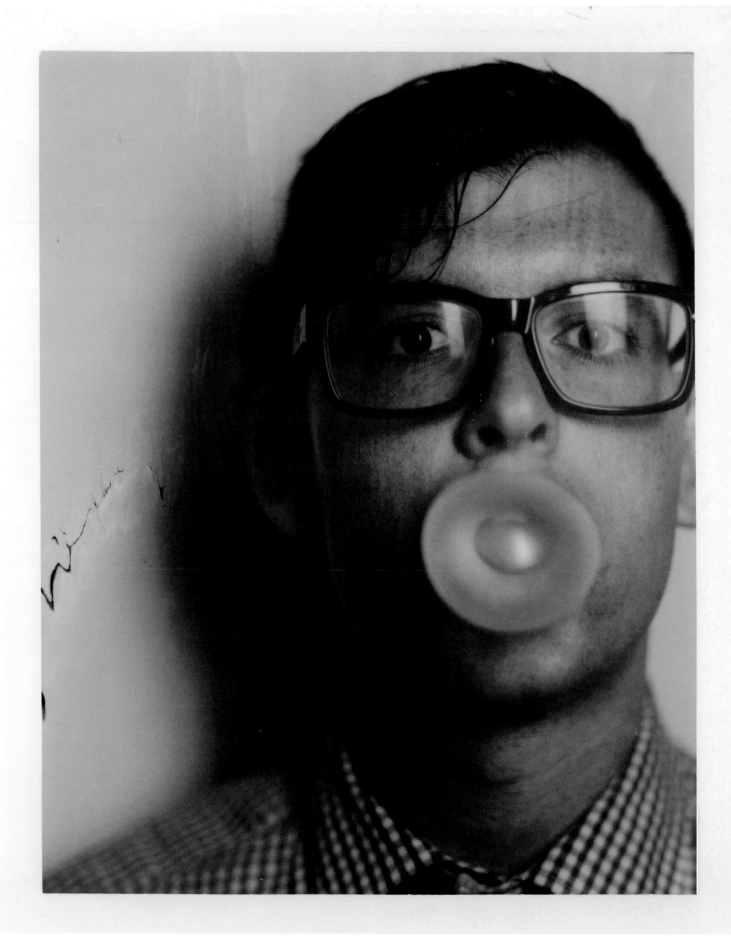

we'd run his errands with him and we would just sit in the car. He would go pick up his cleaning, and within thirty seconds of being with anybody, they would start smiling or laughing. So you see that over and over again, and you're like, "Oh, that's important. That's valuable." That's the way you're supposed to interact with people is to get them to laugh and smile.

JS: Or just it was a way of connecting with people.

RS: So we're like, "That's valuable." That just has an impact on you as a kid.

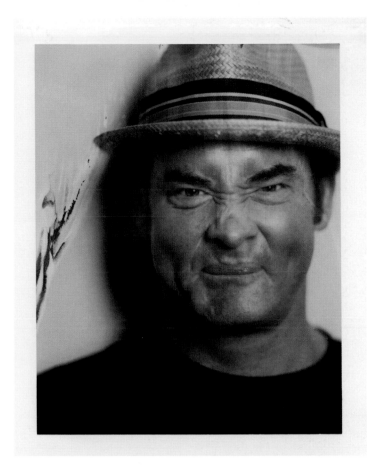

CHRIS GARCIA: Well, it was my childhood dream, so I always wanted to do it. I did it in little ways along the way. In elementary school, in Catholic school, the first time I guess I ever did it . . . I guess it was a forensics class or a speech class, and we're supposed to do a speech from the point of view of an Old Testament prophet. And I chose this person Habakkuk. I didn't know anything about him, but I had a friend who lived down the street who was Lebanese, and his family had the whole attire. I borrowed it, and they said, "OK, Chris, it's time for your report," and I had it all in a bag, and I went out in the hallway and came in with this costume on, like, "I am Habakkuk!"

I didn't know that I was wearing what this nun thought was anti-Christian attire. I was wearing traditional Muslim clothes.

MJ: What a closed-minded nun.

CG: I know.

MJ: You got in trouble?

CG: I got in trouble, but the kids loved it. It was so fun. It was really fun and creative, and I was like, *I think I can do this.*

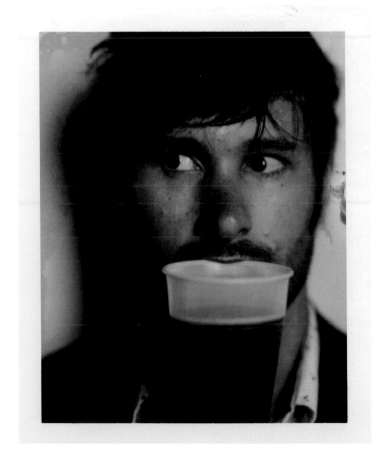

PAUL DANKE: I've been doing comedy stuff since I was a child. Forever. Doing voices and sketch stuff. My high school had an AV club, and they put on a weekly show, so we started writing sketches for it, and it was such a cool experience to get to do that. It aired closed-circuit for the school, and, you know, sometimes we'd do things that would offend some of the school, and we'd have to apologize for it. It was a truly incredible experience to write and act.

MJ: Really pushing the limits in the beginning, huh?

PD: Well, when you're a teenager, you can't help it. You're just being funny. They're like, "Have you thought of this?" And I'm like, "Oh my god, no. Literally never thought about it." But it really made for some of the more interesting content of having to apologize for bad behavior or addressing bad behavior. It was really cool. Just from that I've done [comedy] ever since, and then in college I started doing stand-up.

MJ: How did you get into stand-up?

PD: My college started a late-night show while I was going there.

MJ: You just really got blessed with all these schools.

PD: I did luck out going to very liberal-arts-geared schools. I started writing monologue: twenty jokes a week off of the news. I did that for a year and a half. It was awesome.

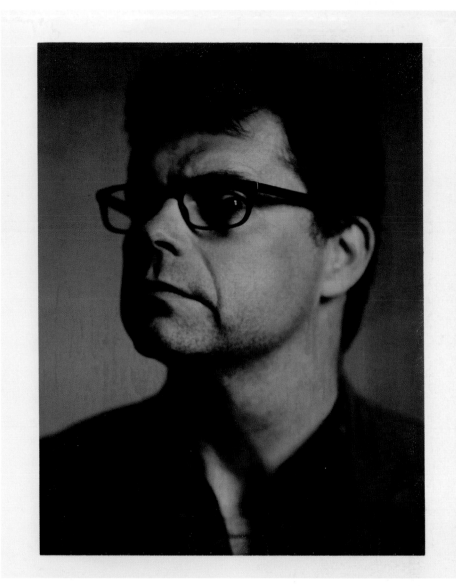

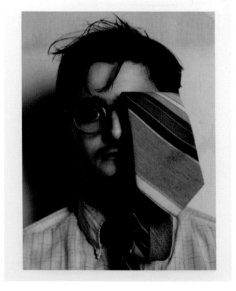

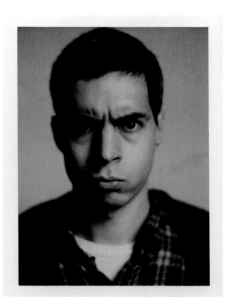

16

TOP: DANA GOULD, **BOTTOM: LEFT**-JOSH FADEM, **RIGHT**-BRENT WEINBACH

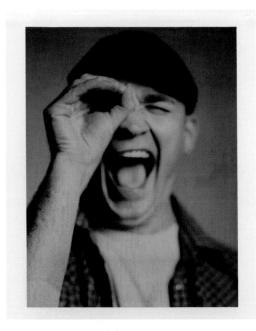

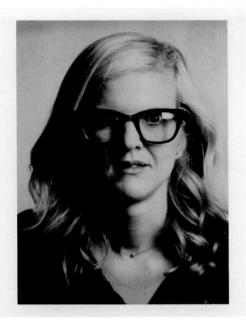

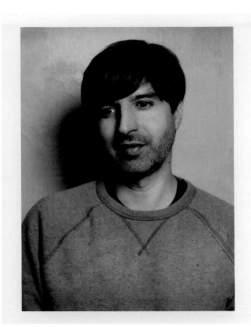

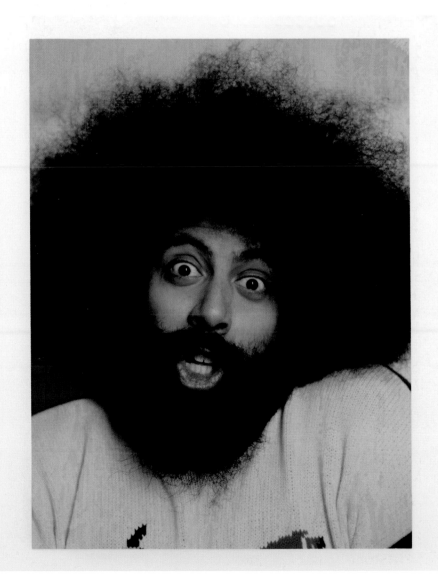

HASAN MINHAJ: I started in Davis, and I would drive up to Sacramento and do open mics, and that's when I met people like Brent Weinbach, Sheng Wang, Ali Wong, Arj Barker, Kevin Camia, W. Kamau Bell, Moshe Kasher, and Louis Katz. Those were the big comedians in San Francisco. They were starting to later become really big. And I remember just seeing the diversity. That was really inspiring to me to see the diversity of stand-up voices. Any given Sunday at the Punch Line in San Francisco—that's the showcase night I would see— those six or seven or eight. You know, Drennon Davis, Kevin Shea, Jasper Redd—it was so inspiring. That's what I thought comedy could really be. I think I got spoiled early on in life that a lineup would be that diverse— ethnically, style-wise, gender-wise. There were so many different types of voices. Then it was totally normal and not a thing that had to have a think piece written about it. It was just a reflection of who was a part of that community, which is really cool.

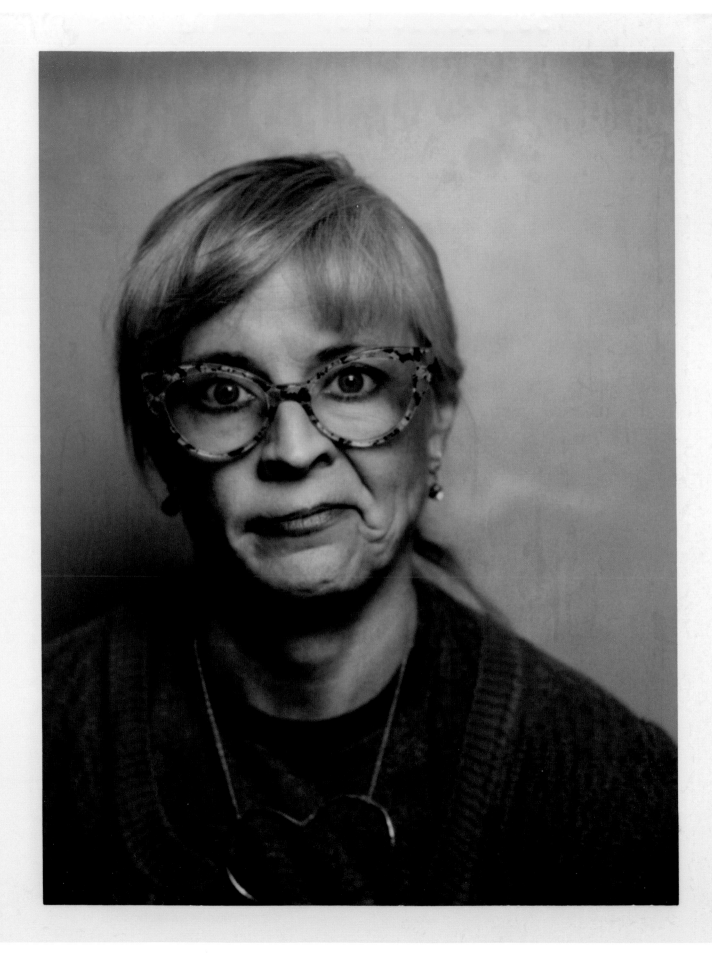

RORY SCOVEL: I think I stumbled into doing it. The reason is because it's a job that only requires my personality—the foundation of it is simply me being myself. It was a thing that totally blossomed completely naturally and organically throughout my entire childhood: loving being a class clown who would do idiotic stuff just to get people to laugh. To fill the need my attention craves. I realized I can get that filled by being good at sports.

JOEL MANDELKORN: You're good at sports?

RS: I come from a sports family and a family of smart-ass, asshole, class clown people. So everything about me is a direct product of my family. Now I'm passing it on to [my daughter]. Notice how she doesn't like that I'm getting your attention? It's in our DNA.

MJ: When you were in D.C. and New York, did you do mostly clubs?

RS: Not at all. I didn't come up in a scene where you went to the comedy club to perform. You got to perform there once in a blue moon. The only time we went to clubs was to stand in the back of the room if there was someone we wanted to watch. So for me, I'm used to performing in a scene where you go to the coffee shop, to the bookstore, to someone's house to do a show; you go to a random bar, mostly bars . . . in a back room.

DEMETRI MARTIN: I started in New York, and I was in law school, and I went to law school right out of college. I'd say a couple of months into the first year, I realized that I'd made a mistake. It wasn't going to be for me. But I'd only thought of being a lawyer since seventh grade

LEFT: CAITLIN GILL

or something. I had a crisis that second year of law school, which was my quarter-life crisis or midlife crisis, depending on when you die. I was like, "What do I like doing? If I didn't have to worry about money and woke up each day thinking about what I looked forward to doing? You know, I like joking around with my friends. I think the idea of doing comedy would be cool."

One day *The Daily Show* comes on—it was a new one with Craig Kilborn. They just started having a studio audience, and it said on the screen, *If you want tickets, call this number*. I called the number. I said, "Hi, yeah, I'd like tickets to the show," and also for some reason when I was on the phone, I said, "Hey, do you guys need any interns?" They said, "Yeah, we're hiring interns now; we're actually interviewing for the next semester. When can you come in?" I said, "I can come in tomorrow."

So I went in and I interviewed. I wore a suit (because for law school, for my scholarship interview, I had this suit). I got out of the elevator and I walked through the office, and there were all these people my age looking at me like, Who is this young Republican coming to *The Daily Show*? I was looking at them like, *Wow, I didn't even realize*. I had such blinders on from [going from] college straight into law school.

I interviewed, and they said, You need to get credit for school, because we can't pay you. I went back to school, and I thought, *Shit, there's no unpaid internships in law school; that's not how it works*. You take contracts.

I had a scholarship, and I go to the director, and I say, "Hey, I want to do this internship at this TV show; would you approve it?" He told me, "You know I can't approve it; you can't get any credit for it." But he said, "I'll tell you what: if you write

a letter, and it's not a lie, I'll sign it, and you can do your internship." So I wrote, "I, the director of this program, approve Demetri Martin's internship; upon the completion of his internship he will receive appropriate credit." Which is zero. And he signed it, which got me into *The Daily Show*.

MJ: It wasn't a lie.

DM: It wasn't a lie.

SARA SCHAEFER: I moved to New York, kind of straight out of college. I didn't know anything about comedy. I had done no research. I had never seen stand-up in person before; I'd only seen it on TV. I did not know what kind of comedy I wanted to do. I just wanted to be a funny person. I went to New York with all these big plans and then immediately didn't know what to do.

I tried to do little sketches at open mics, and it was a fucking disaster. My partner was this robot, and I was her creator . . . it was a mess. We did two shows with that robot sketch, and it was awful.

MJ: But think about how much you learn from that.

SS: I did. And I didn't do comedy again for like a year. But then about a year later, I got an idea for a bit. I wrote a song about my cubicle because I was working at a law firm during the day, and it was really dramatic. It was an angsty ballad about my cubicle. I wrote like a jazzy spoken-word piece about Excel spreadsheet programs. Very *Office*-y humor but that was my life. Write what you know, and I hated my job. I just thought, *How am I going to do this?*

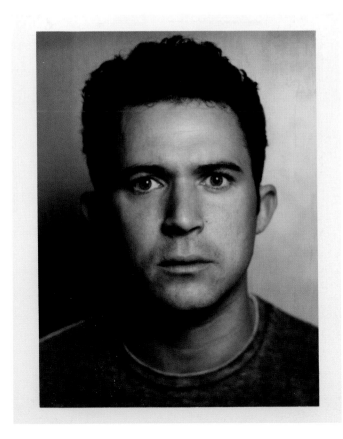

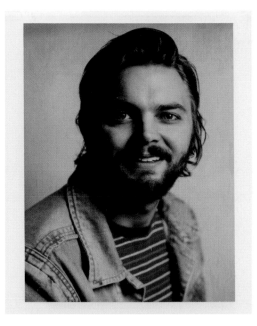

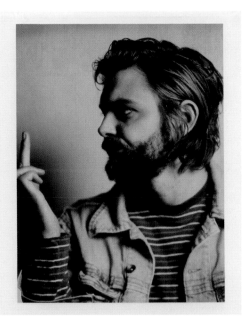

DEMETRI MARTIN: The summer of '97. I finally decided I'm going to drop out of school and just go for it. I dropped out before I ever got onstage, but I decided, I'm doing it whether I suck at it or not. I'm going for it. I did an open mic on Monday night at the Boston Comedy Club. It was a bringer show. I had to bring four people. I got six minutes, but I booked two nights in a row. I figured, I'm going to probably bomb my first night, so I'll do two nights in a row. So even if I eat shit, I'll have booked the second night, which will make me get up and do it again. So I go the first night, and I think I did twelve jokes, and I got decent laughs on half of them. I taped it. The next day I kept rewinding it and playing it; I couldn't believe it that I got laughs from all these strangers—that it really worked. Jokes that I sat down and wrote. Six out of the twelve worked. I was so psyched. I went back to my place; I remember I was so excited that I couldn't fall asleep. I'm a comedian!

Then the second night was at this place called Ye Olde Tripple Inn. It's a bar, not a comedy club, not a bringer show, not a new talent night, just a back room of a bar. I did the same set, but now with confidence, because half of these jokes are working. And I died. I just totally bombed. Nothing. There was one guy, who was kind of crazy or something, who cackled through a lot of people's sets. I taped that set too. When I listened to that, it's just me telling the jokes, the silence, and then this one guy, laughing at my failure. I got offstage, and that night I couldn't go to sleep either. I was confused and horrified. I couldn't believe it. I was like, I don't understand. I thought these were funny. That was just last night. The jokes worked. And then tonight, I died. They were definitely not funny jokes tonight. But last night, they were definitely funny. I felt it. I was like, *Oh god, this is going to be hard.*

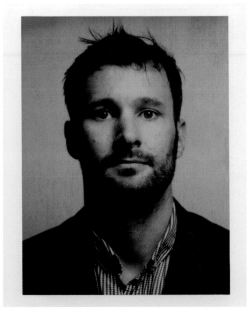

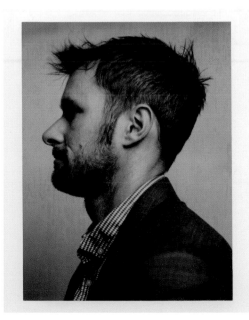

TOP: NICK THUNE, **BOTTOM:** NIGEL LAWRENCE

23

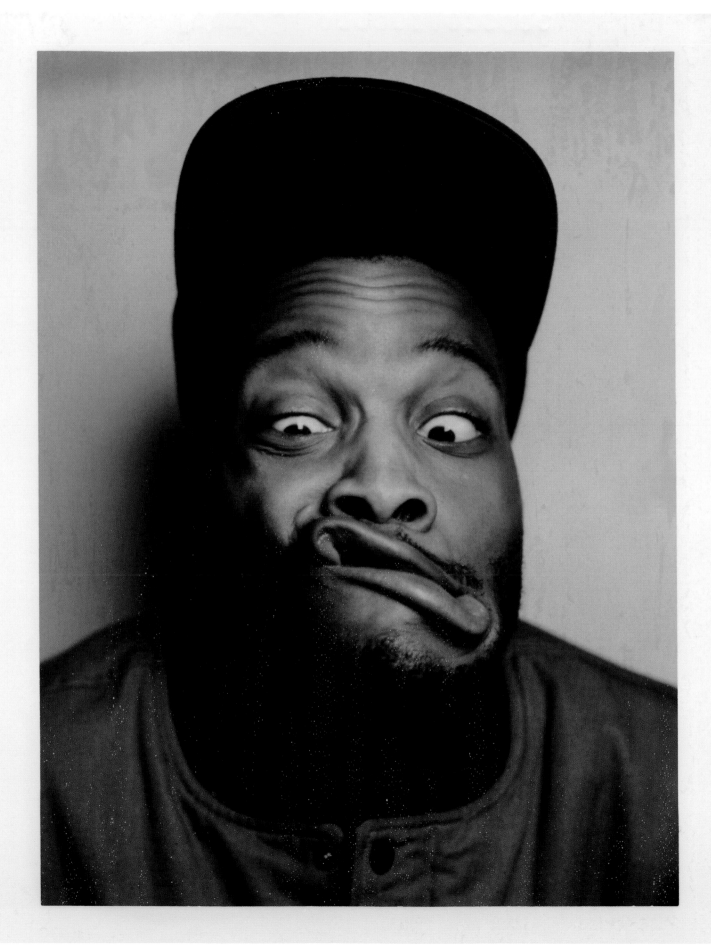

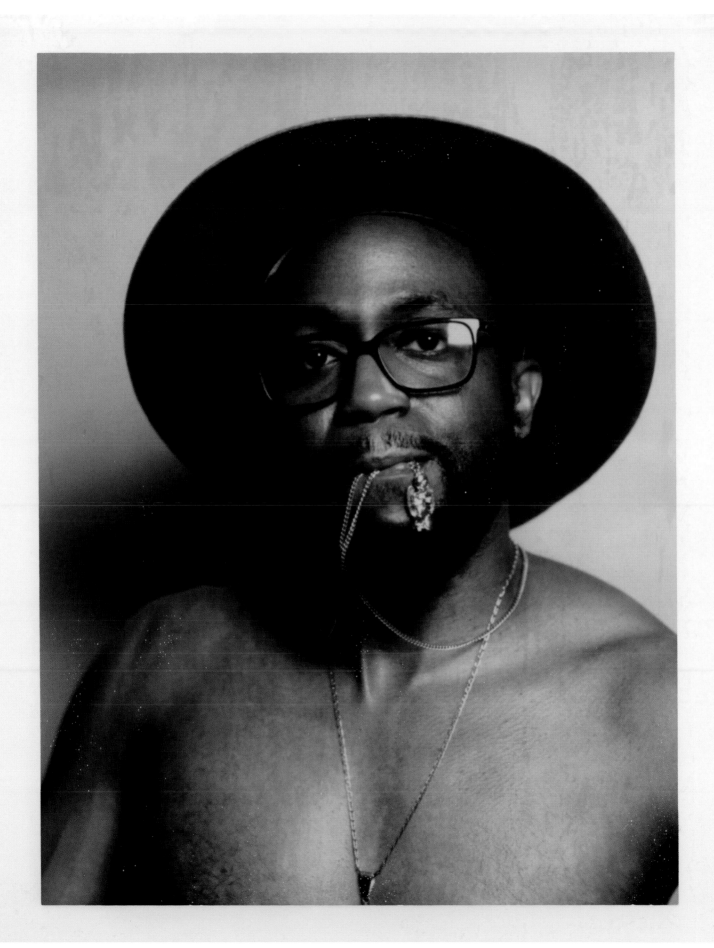

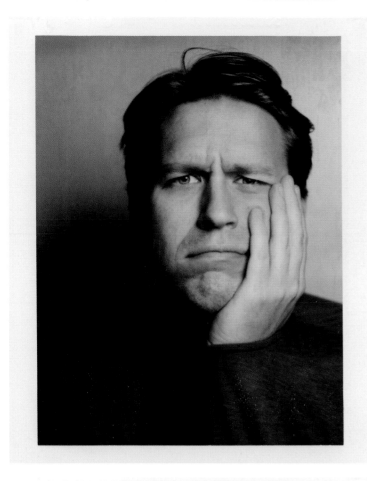

ANDY PETERS: I'm always envious of the comics that just did it: did the slow-burn start where they wrote first and tried open mics traditionally. Because the way I started was it was a contest. Three people showed up for this contest. We were the openers for Colin Quinn. Three scared college students doing stand-up for the first time ever in their lives. Long story short, I won. I think they just did it by audience applause.

It was not only my first time onstage; it was my first time meeting a stand-up comedian in person. I remember the producers were very casual about stuff, like, "You're doing five minutes; we're going to give you a two-minute light." I was like, What does that mean? What do I do? Where do I stand? What do I do with my hands? I didn't know how to interact with the audience; I didn't know any of the stuff that you learn slowly over years of open mic-ing. It was such a crash course. Colin Quinn offered me gum; I remember that happening backstage.

MJ: How many people do you think were there?

AP: Probably four hundred people.

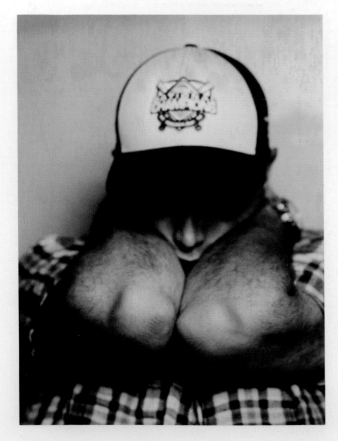

MOSES STORM: I'm legitimately not good at anything else. Which kind of feels like a cop-out. But I never went to school. In my life.

I moved constantly growing up. So we started in Kalamazoo, Michigan, and then we lived in an old Greyhound bus, so we would spend six months at a time in a place, but a lot of time in Florida. A lot of time. Right when I turned eighteen, I moved down to L.A. as quick as possible. I was doing improv so I would get confident enough to do stand-up.

MJ: You knew you wanted to do stand-up.

MS: Yeah. The first time I did stand-up was at Hollywood Improv. The main room. This woman running a showcase show, I'd met her at an audition, and she was like, "I do a showcase show."

MJ: You'd never done an open mic or anything?

MS: Never done an open mic or anything. This woman is a casting director that runs this showcase show? Sure, I'll do that. Put together a five-minute set. It was the main room, Tuesday; it was sold out. I was onstage—it went very well for the first time. It was a very warm crowd. Then I was like, This is all I want to do.

BYRON BOWERS: I started and quit the same day. It was Atlanta, Georgia, and it was amateur night at Uptown Comedy Corner. I'd never been in a club before, and me and a friend of mine went and signed up for amateur night just so we could get into the club for free. Mind you, I'd never written a joke before, so since I was lunchroom funny, I thought I could go up there and be funny. NOPE! I got booed by three hundred people. I quit that night for over a year and came back.

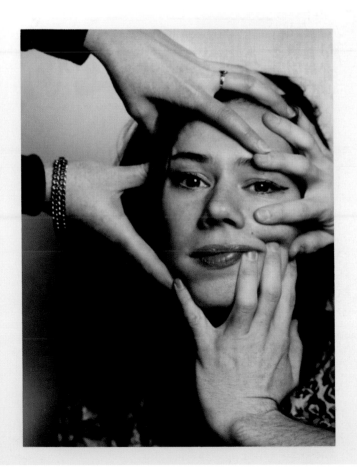

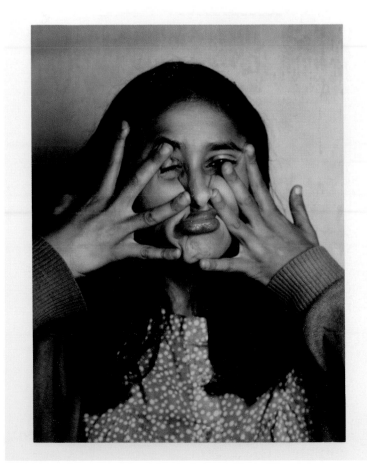

DAVE ROSS: I did stand-up maybe five times in 2006, and I would shake and cry.

MJ: In L.A.?

DR: In Fresno and then L.A. I have really bad stage fright.

(both laughing)

DR: Why are you laughing?

MJ: I just love that you have really bad stage fright. And you're like, "Wanna know what I want to do with my life? I want to be onstage."

DR: That's a comedian in a nutshell, right? Though I will say this: obviously, it's really, really sanded down, and I don't experience it so much anymore, but one of the reasons was the stage fright.

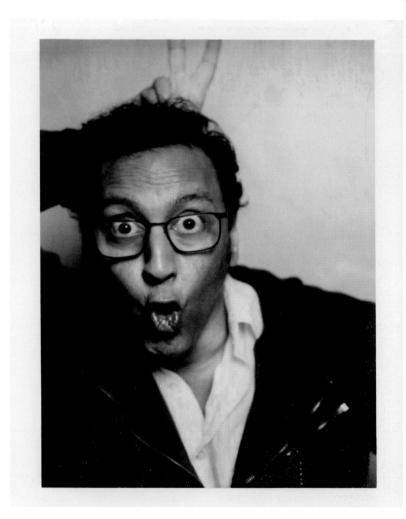

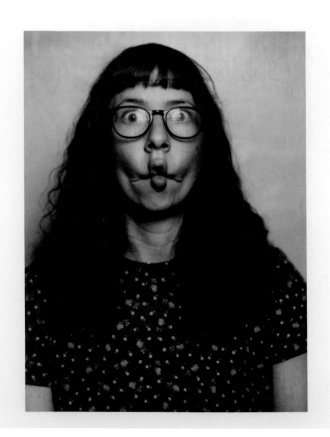

Because I'm also afraid of a lot of other things . . . I'm very open about it. And I wanted to conquer some fear, truly. In 2006 I was a radio DJ in Fresno. I don't know if you know this, but radio is not a stable career path.

MJ: So you were like, you know what's a better stable career?

Both: Stand-up!

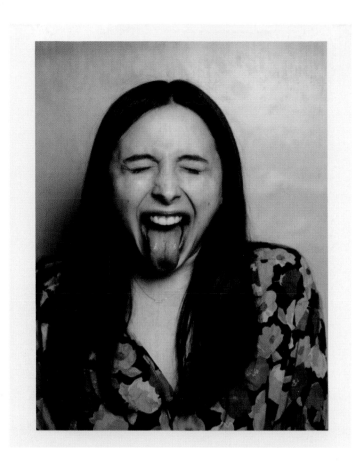
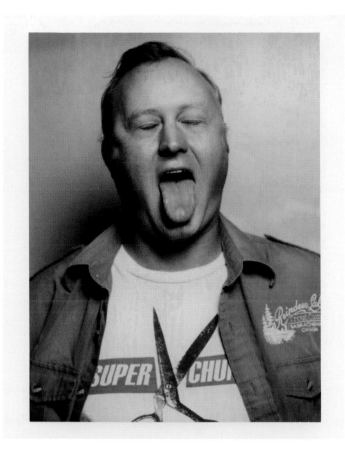
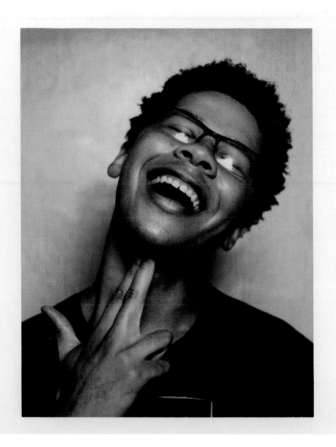
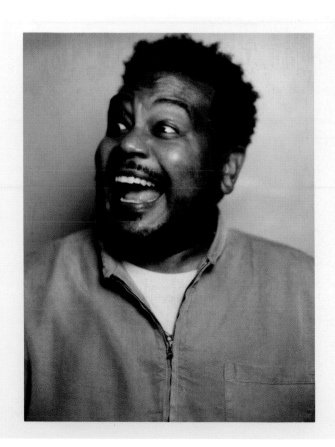

TOP: LEFT-ESTHER POVITSKY, **RIGHT**-JAMES FRITZ, **BOTTOM: LEFT**-AARON KEE, **RIGHT**-WILL MILES

JACKIE KASHIAN: My name is Jackie Kashian, and I got into comedy by accident because that's how you do it. In 1984, I believe. So Bill Kinison starts this club. It's in the basement, it's underneath this stupid pool hall bar, and I go and see stand-up comedy one night when I'm nineteen. The show was OK. I don't remember the show. I remember Sam Kinison, because he was having a hard set, and he said something, and I was sitting right next to the stage. I just made some crack at him, because his timing was slightly off. I was so drunk it was ridiculous.

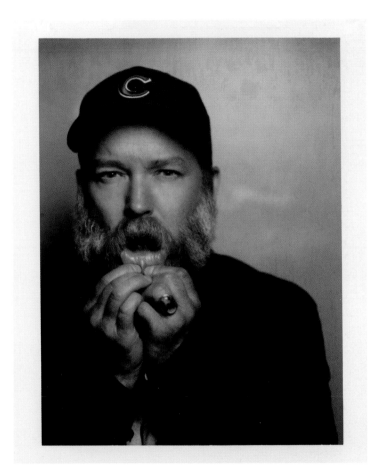

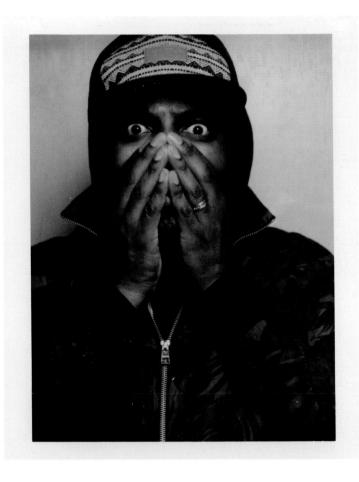

I didn't understand . . . the drinking age was eighteen; I was nineteen. I didn't know how to drink. I was hammered, and I heckled Sam. He mopped up the floor with me, but I was so drunk I didn't stop. Because there's nothing worse than a woman heckler. Whenever I'm being heckled now, I think of it as an indictment against my bad beginnings. I also

think of it as proof positive that a woman heckler, even if you're a woman comic, doesn't matter; the audience for some reason is still on the side of the woman heckler. And they were completely on my side, and Sam couldn't get out of it, and, finally, the manager [Bill] came over and told me to shut the fuck up: "You have to shut up. Open mic is on Sunday. If

you want to talk anymore, you either have to leave or come back to open mic on Sunday."

So three weeks later I came back to open mic. Sam Kinison was no longer there. Bill was still there.

LEFT: KYLE KINANE, **RIGHT:** BARON VAUGHN

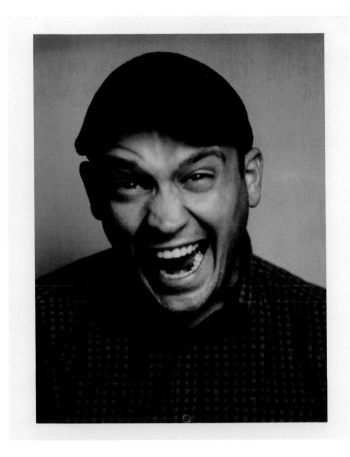

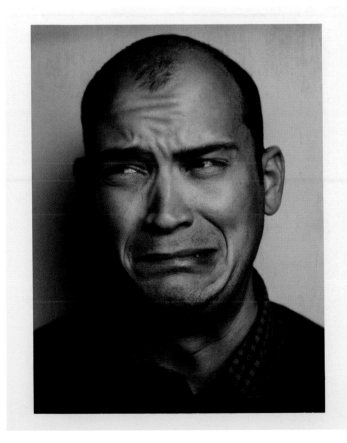

KATHERINE LEON (PRODUCER): I kinda fell into it. I didn't realize what I had gotten in to, to be honest. It was never really a thing that I saw as a job. I initially wanted to just [photograph] shows, but I was around enough that I started meeting performers and producers. I started shooting a few shows and would help out when I could, and, eventually, I tricked enough people into letting me try it out. I also maybe met everyone at the right time.

I've been a fan of comedy forever, but it really kicked in when I went to college and my best friend and I would just stay up talking about growing up watching *SNL*. I just knew things were funny—I didn't really clock it as comedy. We would drive an hour almost every weekend and wait forever for UCB shows, and we felt like we were on some wait-list to be a part of a clubhouse. I just saw so many great things there, and I think I figured at that point that funny was maybe the only thing. If something was sad, it could also be funny. People playing to the height of their intelligence could be funny. Dumb and simple could also be really funny.

ANTHONY JESELNIK: I always loved comedy, but it didn't seem like something you could really do. I'd had an internship in L.A. where I worked for a production company. I read scripts and answered phones. I was so dumb that I thought I knew L.A. I was like, *I'm wired. I have this internship; I'll come out here and get a job.* I did not. I didn't get a job at the place I interned at; I was just bumming around. After a year I was like, What do I want to do with my life? Stripping everything down, I thought, I loved comedy. Wouldn't it be fun to be a joke writer? Write jokes on a late-night show, you're writing every day with a bunch of other funny people. And one of my dad's friends from college was the head writer for Jay Leno, so I met with him, and he told me, "Do stand-up, because that will help you get your voice out there, instead of writing jokes and sending them in, which people do, but it's impossible. Do stand-up—it gets you out there more."

At the time I was working at a Borders Books and Music. It was my first job out here. They had a bunch of books on how to do stand-up comedy. I bought the thinnest one. I still have it. It was by Greg Dean. I read the book, and I was like, OK, I kind of get it. I didn't feel like I could just go to an open mic. Open mics seemed scary to me. So I took a class. At the back of the book, it says this guy teaches a class. I went, and it's me and a bunch of hopeless older people who were like, *Yeah, I'll do stand-up?* It's the last thing they're trying. This is the first thing I'm trying. At the end of the class you do a set. You do seven minutes.

MJ: Just in front of the class?

AJ: No, you go to the Comedy Store Belly Room and do a set. I had all my friends come. I thought I killed. I did compared to the other people.

MJ: Did you kill because you had all your friends?

AJ: No—I mean, that helped—it was because everyone was so bad. So nervous. In their forties. A twenty-two-year-old who was kind of funny . . . I went back and watched it.

MJ: Do you have the tape?

AJ: I have it somewhere. It's VHS. It's impossible to see. One of the jokes I used in my first set I ended up using in the Donald Trump roast. It was actually a good joke.

I went to the Ice House open mic like two weeks later. I was hungover. It was during the day. I just thought I'd repeat what I said at the Belly Room. And I bombed so hard that I had a panic attack. I remember going in the bathroom covered in sweat, like, *What happened to me? What just happened?* Then for months after that I would go to open mics and just sit in my car. I couldn't get out of the car.

A few months after that, the movie *Comedian* with Jerry Seinfeld came out. He'd just done the one-hour for his whole life. That was his whole hour. So it was him going from scratch. It was so inspiring. Just keep performing and keep failing and eventually you'll get something and keep writing. It clicked for me, and I started attacking open mics every night. The worse open mic, the better, for me. Just keep going, just keep writing . . . I eventually got away from anything the class taught me and just started writing jokes. I kept doing open mics, stayed away from the club scene entirely [because] you had to wait. I didn't want to wait. I wanted to get onstage. Either to succeed or to fail.

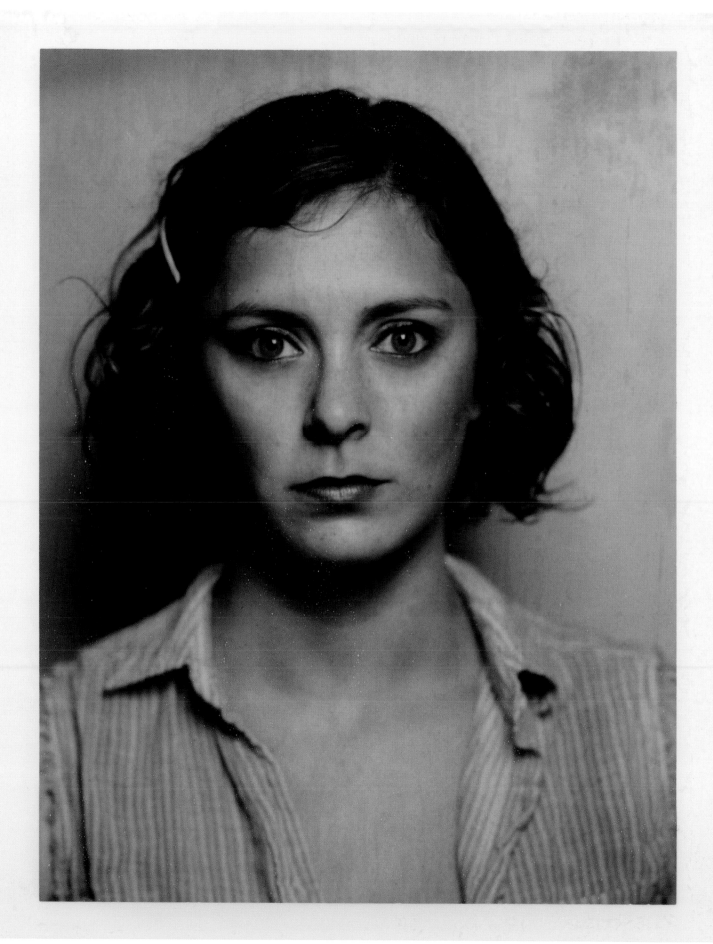

PAYMAN BENZ (DIRECTOR): My path to being a filmmaker was through a love of comedy. As a kid, I loved movies, but I was madly in love with comedy. Executing comedy visually is what got me interested in being a filmmaker. Growing up, I wanted to be a performer, and slowly I realized that overseeing the comedy was more exciting to me than being the person who was getting the laughs. My voice was built through the thousands of hours of stand-up, sketch, TV, and movies that I've watched since being a kid.

ANDY KINDLER: I was a musician before I was a comedian, and I came up in Los Angeles to make a career—what I thought was going to be a career in music. I tried music for a few years. It was a rough period in my life; the early twenties are not as much fun as they say. Then I got into the mid-eighties, and a friend of mine, he was very funny . . . he said, "Hey, have you ever done comedy?" And then he said, "Oh, I'll do it with you." So I was in a duo for a couple of years, a regular, straight-up stand-up duo. It was really great because it's very frightening to do stand-up as you know, so it made the start a little bit . . . We could both cry together. It made it easier to get into it.

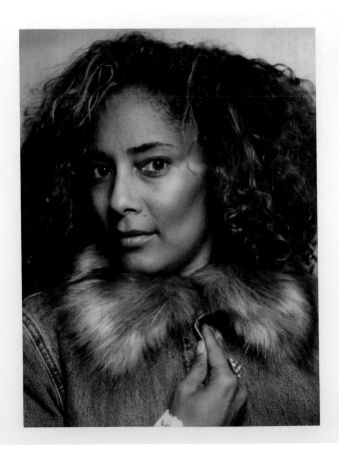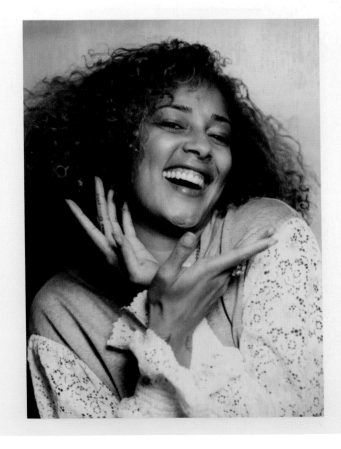

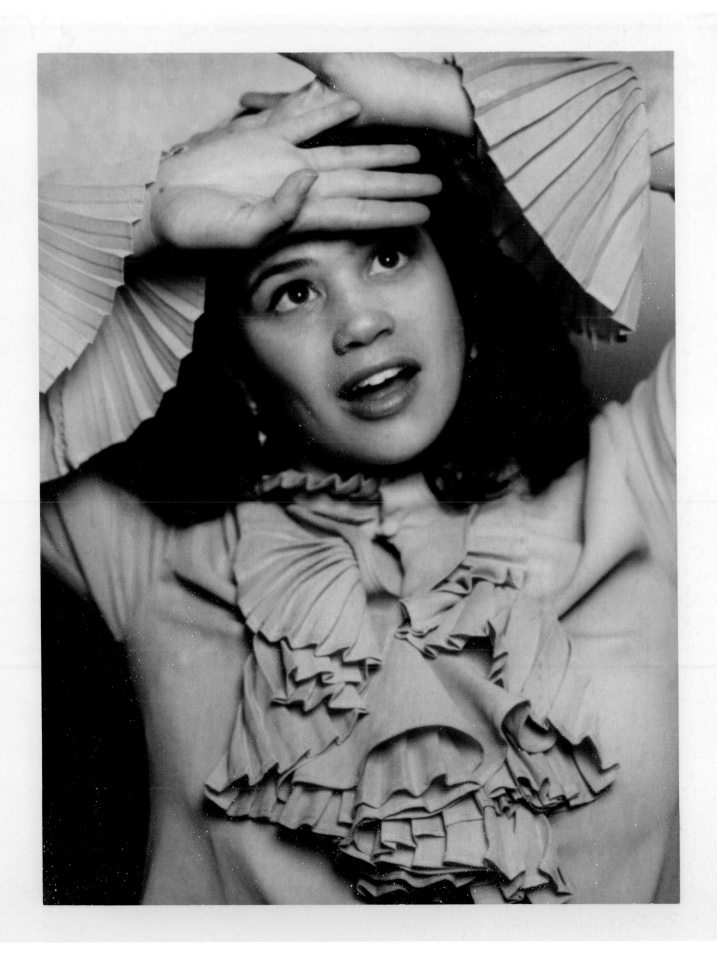

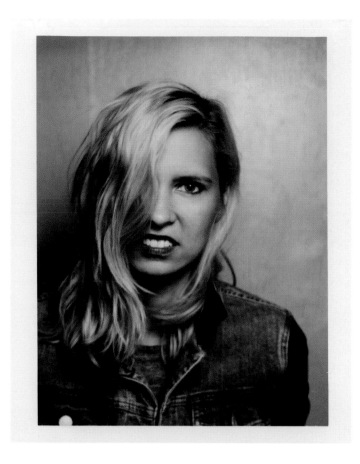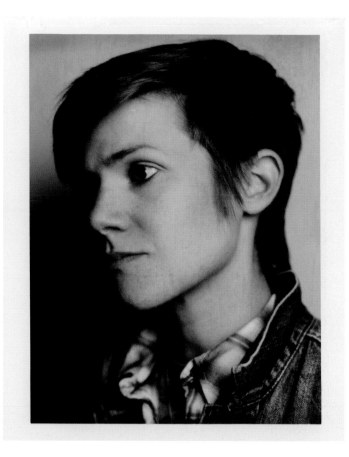

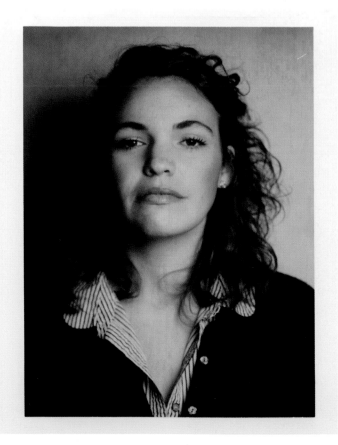

TOP: **LEFT-**MO WELCH, **RIGHT-**CAMERON ESPOSITO, **BOTTOM: LEFT-**BETH STELLING, **RIGHT-**EVER MAINARD

BARON VAUGHN: It literally was always something I wanted to do. I didn't understand that at the top of my consciousness, but deep down there was a part of me that felt I was a comedian.

People like Pryor or Eddie Murphy, Robin Williams, Steve Martin, people who are some of my favorite actors, were stand-up comics. I didn't know that, and then I found it out, and it was like, They're doing the thing I want to do. And so it wasn't until I was in college that I was afforded the opportunity to actually go to an open mic. It was a two-person bringer . . . it was a five-minute set. The Boston comedy scene is so strange. There's such a huge, strong, working-class group of people who are stand-ups, and then there are these heady, esoteric Emerson, Harvard, MIT students who want to do experimental stuff. You had Dan Mintz, Eugene Mirman who came out of Boston—these very heady comedians—but then it's the same place that created Denis Leary and Marc Maron.

MJ: Dana came up on Boston too.

BV: Exactly. Dana Gould is the bridge in sort of a weird way. He's got a working-class thing, but he's also got this heady, esoteric, experimental thing at the exact same time. Some people consider him one of the fathers of quote-unquote "alternative comedy." Boston is also the kind of place that creates Patrice O'Neal and Sam Jay. They're from the same neighborhood. Boston has all those different kinds of people, if you will, in the same room. The variety of a show in Boston was always insane. Very interesting. The other thing that Boston puts into you is that you don't really have the right to call yourself a stand-up—until you have been paid to do stand-up. Until then, you're an open mic-er.

MJ: Interesting. Until someone gives you money to do stand-up.

BV: Until someone gives you money to do stand-up.

MJ: It doesn't have to be a lot of money, just any money?

BV: Just any money. Now, to be fair, the fifth time I did stand-up, it was paid on the spot.

MJ: It sounds like you were a stand-up after your fifth time, then.

BV: I bombed.

MJ: Did they say it had to be a successful paid show?

BV: They didn't.

DANA GOULD: I came up in Boston in the mid-1980s at the peak of that comedy boom. And I was making, you know—I was a young guy, I was nineteen and twenty, and I had a driver's license and a car, and I didn't drink or do cocaine.

MJ: Congratulations.

DG: But I was one of the few people in Boston that didn't, and I worked all the time because I could drive comics to gigs and they did not have to worry about me getting drunk and not being able to drive home or having to socially offer me blow. Which meant more for them. Because of that, I worked constantly.

MJ: That's hilarious.

DG: I made a ton of cash because it was a cash business minus the cocaine. I was twenty years old living in a little neighborhood of Boston called the Student Ghetto. Janeane Garofalo lived across the street, and Tom Kenny, who is now the voice of SpongeBob, lived in my building. I moved to L.A. in '89, and then right around 1991, Janeane Garofalo moved out, and that was right around the time that we started what became the alternative scene in L.A.

MJ: Truly the grandfather and grandmother—you and Janeane—of the independent comedy scene.

DG: It used to be mother and father.

My heart is for LA comedians.

–Steve Hernandez

SEAN PATTON: I told my dad I wanted to do comedy maybe a year before during the holidays while him and I were drunk at a Christmas party. I was like, "I think I want to try that," and he was like, "Give it a go but it's a"—he said something I still think about, like, you know—"That's nothing but a lifetime of long shots."

MJ: That's such a deep, insightful quote.

SP: I remember him saying that and being like, "Nah, I don't know. Whatever." Now, eighteen years later, it's like, Yeah, he's right: it is a lifetime of long shots, but you just get better at aiming; you get better at taking the shot.

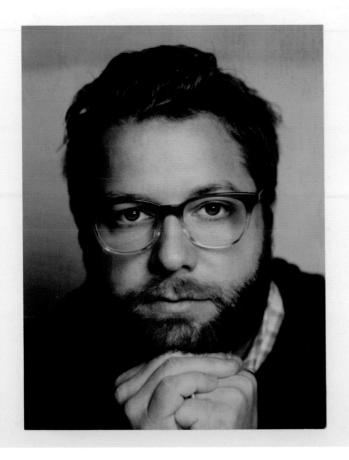
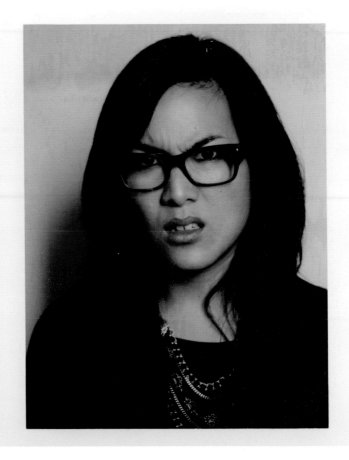

LOS AN
1989.

IGELES
-2019

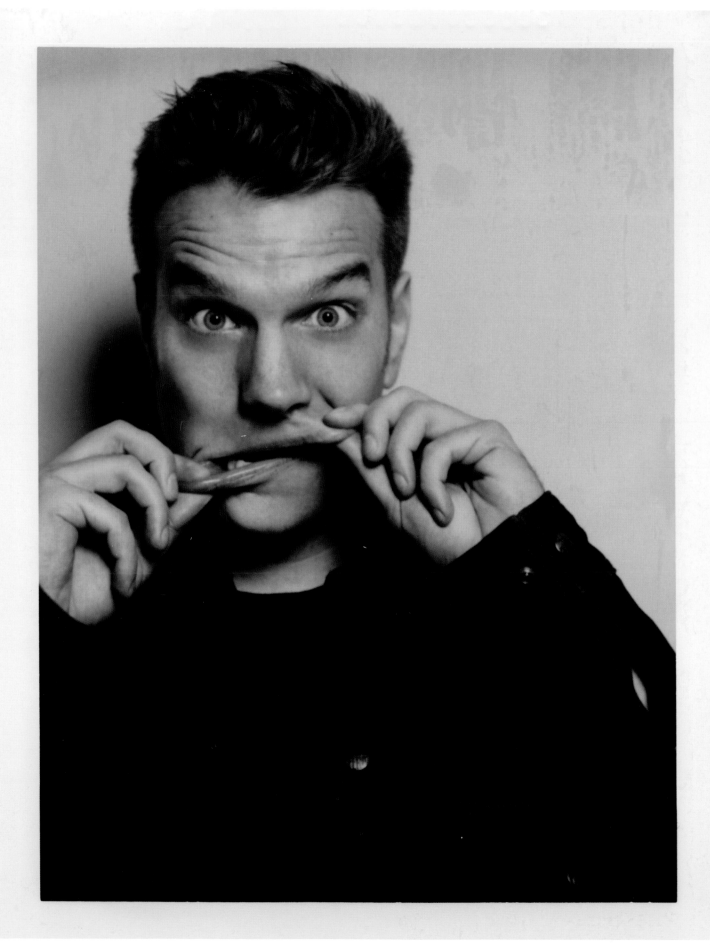

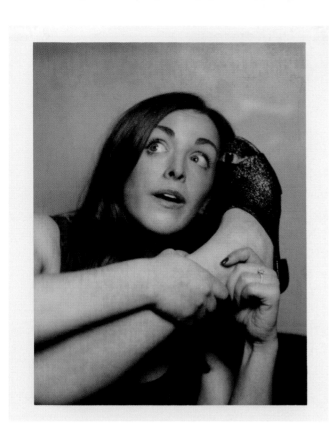

JAMES ADOMIAN: I grew up here. I moved here in 1989, when the smog was really bad. I was a kid; we moved from Georgia. I was very homesick and depressed and did not like Los Angeles. I moved here with my family. We had to figure out how to enjoy L.A.

MJ: It is a special talent.

JA: I didn't like the way the water tasted.

MJ: That's fair. You probably had wells in Georgia.

JA: The smog was scary.

ANDY KINDLER: There was always an alternative scene. Comics went down to a club called the Varsity Arts Center, which was downtown, and it was really, really fun. But very quickly when the boom got so popular, then that scene kind of went away, and everything got subsumed by the big-comedy movement.

In the mid-nineties, when I started going to the Just for Laughs festival, I started to book the alternative shows. Back then, alternative comedy really did define—it wasn't a style of comedy, but it was more like the comics who weren't just doing the same act over and over again.

The alternative scene that I was part of was started by necessity because we just couldn't get any work at other clubs. I wasn't getting work on the road because the clubs got so bad. We formed our own little—that was the *UnCabaret*, and Janeane Garofalo and Dana Gould had a room at the Big and Tall Bookstore, and Kathy Griffin had *Hot Cup of Talk*, so that's the real alternative movement.

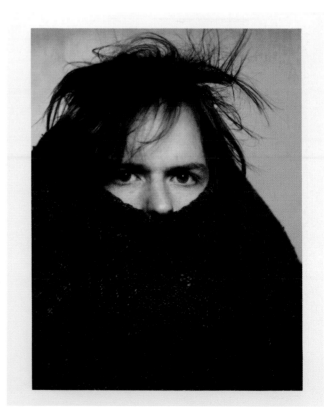

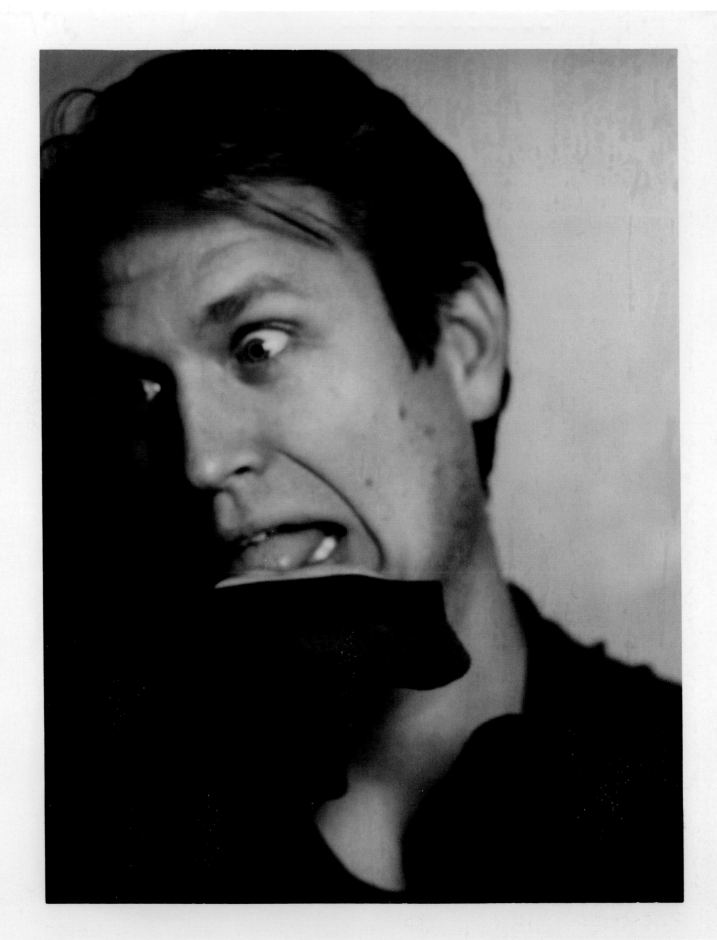

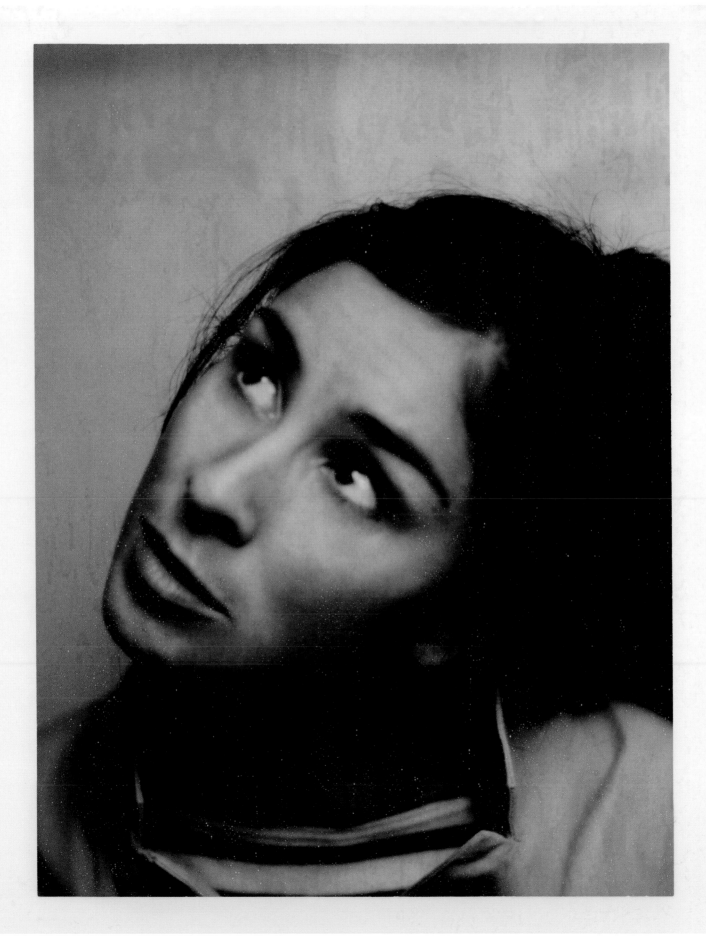

DANA GOULD: It was Janeane [Garofalo] who said, like, "I want a place where I can bomb if I have to." And there was no place.

I also remember very, very, very specifically going to see Elvis Costello . . . to support the album at the Universal Amphitheatre with Janeane and looking around at all of those people and going, "Where are these people? Why don't these people come to our shows? These are our peers; these are our friends." But the comedy boom had become so corporate by that point that they had been driven out of comedy clubs. The tourist bus would meet people at the airport, take them to Magic Mountain, and then drop them off at the Improv. We were the first people that day to try to entertain them that [weren't] wearing an oversized papier-mâché head. So we went out to look for our audience in the way that folk musicians in New York in the Sixties went out to look. The performer went looking for the audience instead of vice versa.

There were several things going on at once, and the one that we really hit on was this place called Big and Tall Books on Beverly Boulevard, and upstairs there was a tiny loft. It was the personification of the nineties; if the 1990s was a building, that was it. The building should have been wearing a suede coat. And we started to do shows there, and the premise of that show was you couldn't do material that you've done before.

MJ: An all-new-material show.

DG: And you had to write it, and everybody put it up, so you'd write it that day, which is the origin of bring[ing] your notebook onstage with you.

MJ: Were there other workout spaces prior to that in Los Angeles?

DG: No, no, no, there weren't. I remember I was at a comedy club in San Francisco and I did a chunk of new material, and a lot of it didn't work, and the club owners said, "You know these people didn't pay to be a part of your experiment."

MJ: That's crazy.

DG: And I remember going, "The whole point is an experiment!" That is supposed to be an experiment.

MJ: You don't get material without at least saying it first in front of a live audience.

DG: And, you know, the great thing is—the beautiful thing about stand-up is—I still don't know if stuff's going to work until I try it. You never, ever, ever know.

MJ: Demetri Martin had a great line onstage once at a *Hot Tub*: "All of these are equally funny to me before I say them in front of you."

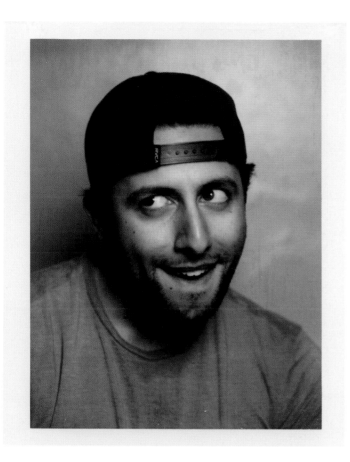

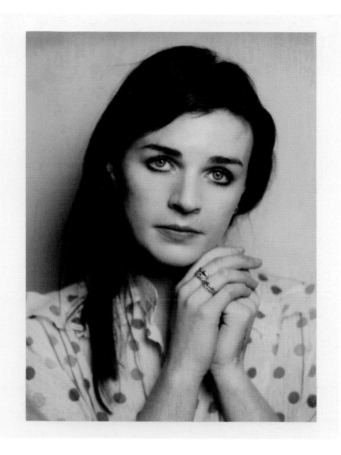

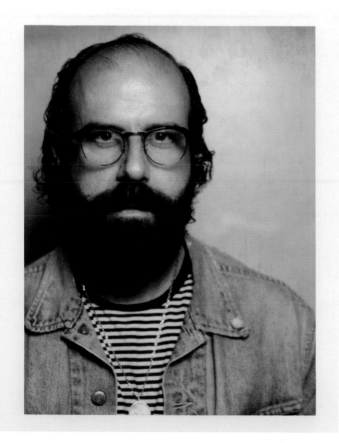

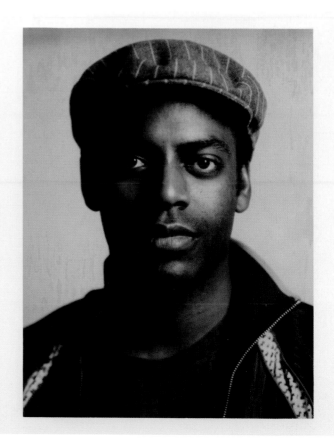

TOP: LEFT-FAHIM ANWAR, **RIGHT**-AISLING BEA, **BOTTOM: LEFT**-BRETT GELMAN, **RIGHT**-BARON VAUGHN

DG: Yeah, he's right. He's absolutely right.

MJ: So it was your show at the Big and Tall Bookstore, *UnCabaret*, and the original Largo. Was that the main independent comedy scene?

DG: Yeah, Largo came a little bit later. But Largo was always the cool kids' club. I was so excited when I finally got into Largo. There weren't a ton, but *UnCabaret* was at a club called Luna Park, and it became huge. Every Sunday night downstairs from like '94 to '97. That was the real ripened fruit of the first alternative scene.

I remember one year, I guess it was '95, it was me—Kathy Griffin, Andy Kindler, David Cross, Janeane Garofalo, Bob Odenkirk, Jack Black, and Will Ferrell were around. All of those people, we did shows somewhere every night, and we would do stuff every day. Paul F. Tompkins had just come down. It was a real scene at that point. It was social and professional. I remember saying to Andy Kindler at Luna Park one night, "This ain't gonna last." Like you could feel like it was a moment, and you knew it was gonna pass. But I remember very specifically in the moment going, "Yeah, this is a thing." What I should've said, what I didn't know to say: "This will grow and change." Which it did.

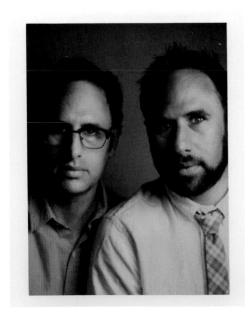

JACKIE KASHIAN: I moved in '97. I moved here because a friend of mine in Minneapolis was like, "You don't have any kids. Would you please try? I have kids. Get out." And so I moved here. People were like, Why'd you come to L.A. instead of New York? It was because I had someone to stay with here. Literally, I have fallen into absolutely everything.

I did all the open mics, like you do, and when I moved here, it was when the alt-comedy thing was starting. And I didn't even know what that meant. All I knew was that it turns out I have always been doing alternative comedy. I am not a setup, punch person. I am not a one-liner guy. I am a storyteller. I started doing all the alt rooms. I couldn't get into the clubs to save my life. I finally got into the Improv after a couple of years, which just meant that I could send in avails and they could ignore me, which was *exciting*. But the alt rooms started booking me.

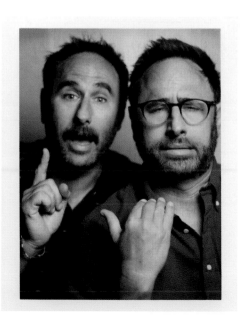

RIGHT: THE SKLAR BROTHERS

RANDY SKLAR: We started coming out to L.A. in '98 and '99, one week out of every month, and every Monday night we'd go to Largo, and we started to hang with Jack Black and Kyle Gass and—

JASON SKLAR: Karen Kilgariff.

RS: Karen Kilgariff—

JS: Mary Lynn [Rajskub].

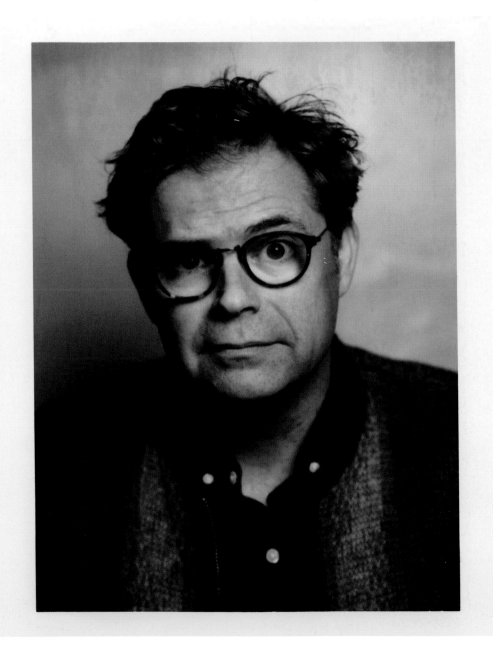

RS: All these people now. We were like, holy shit, we knew the scene in New York, so then we come to Largo and we would do it—

JS: Lisa Leingang . . . was booking the Largo show. She was like, "I'll put you guys up at the Largo show." We were like, "We've already done Luna Lounge, we've done the top of the heap in New York, and we were in the clubs in New York," so we were performing, we had material and bits, so we hit the stage at Largo way further along.

MJ: Did you guys do Luna Park?

JS: Oh, the Luna Park, yeah, we did; we tried. And we tried to get on UnCabaret, but at the time she wouldn't have us, but later we did it. Sam Brown's?

RS: Sam Brown show. Remember the show where Seth Rogan was there? What was the show we did out by Mrs. Field's in Westwood? What was that little—

JS: Gypsy Cafe.

RS: We came out here; it was crazy. We also had to do some open mics when we were here. There was that open mic—

JS: At the Roosevelt—

RS: At the Roosevelt Hotel, it was us and Maria Bamford. I remember we were like, "You're so funny."

JS: In the lobby with like a fountain between you and the audience, a water fountain. What is this thing? The Ramada Inn. I remember doing Josh Fadem's show in the basement of the Ramada Inn for like two people. It was me and Randy and Brody Stevens and Josh Fadem, who . . . Josh Fadem

who is going one hundred percent full bore into his characters in front of an older couple who are staying at the Ramada Inn who came down to the bar to get away from their room, and now they're watching Josh, who's doing a methed-out Harry Potter character.

RS: So we hit all that stuff. But Largo was the granddaddy. If you did the Monday night Largo show, that was it.

I'm not doing stand-up to get something else. I'm doing it because I like it. I like it the way it is.

—James Adomian

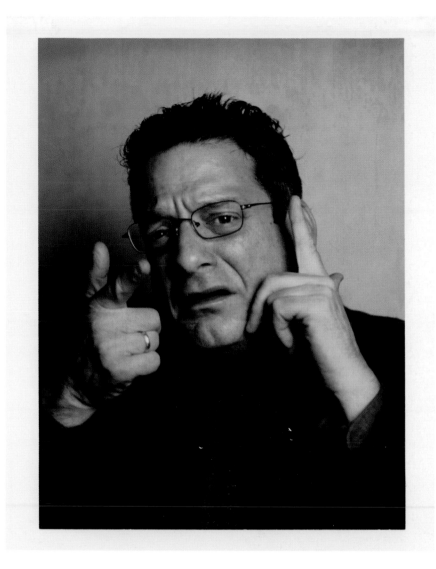

EDDIE PEPITONE: You know what was interesting— I started going to an open mic out here because I didn't know anybody. And I started going to this open mic, famous out here, run by Vance Sanders at the Westwood Brew Co., and I met everybody. Sarah Silverman before she was famous, Maria Bamford before she was famous. They were all doing this open mic. [Zach] Galifianakis would do it! It was fucking great. There were all kinds of levels—super funny people, middle of the road, and open mic-ers who were just there for therapy and whatever. It was cool—it's how I met so many people in L.A. I always gravitated toward the indie stuff.

Any show that takes chances and is willing to let people do something different—fail and foster an experimental environment—is going to be valuable in terms of discovering funny, talented people and showcasing new ideas.

—Jason Woliner (Director)

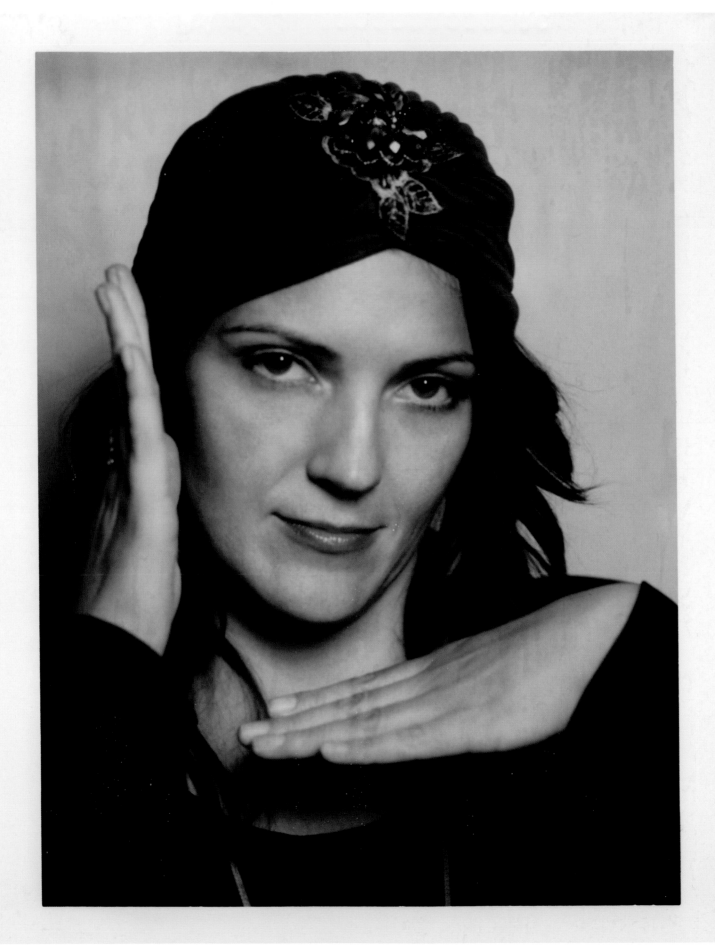

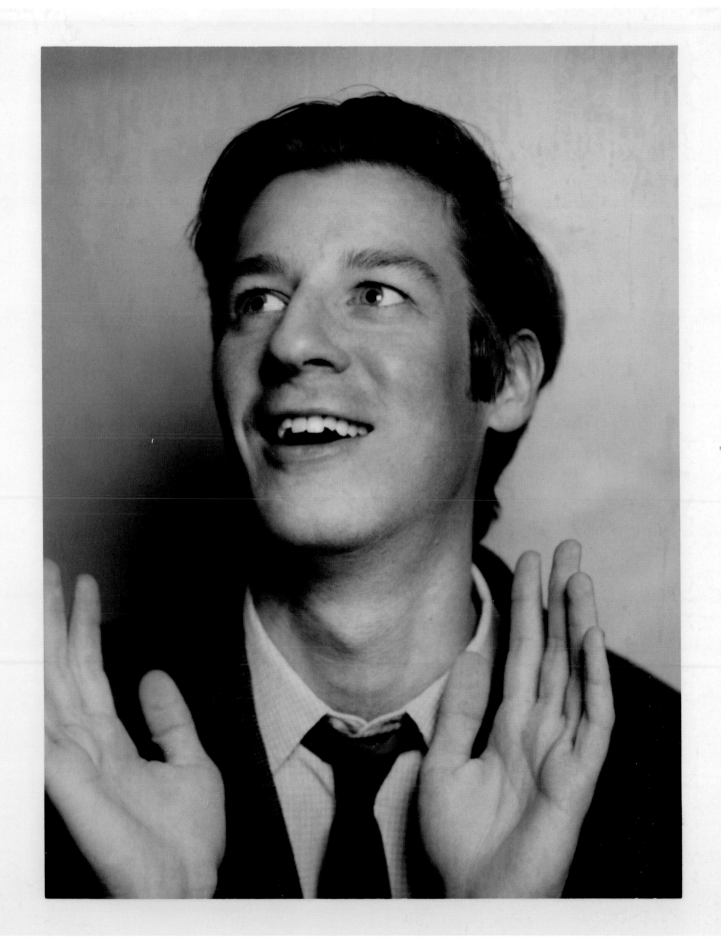

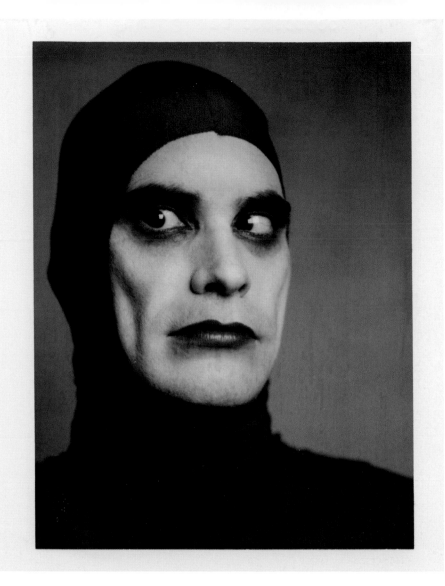

DA: Nope. Never done the Store. I don't like the vibe. Back then it had a vibe of more dirty comedy, and it was also hard to get in and had a weird owner. There was just a line. And I had an in at the Improv so—

MJ: If you did the Improv, you weren't, like, welcome at the Store?

DA: It wasn't, like, "welcome;" it was more like self-segregation, almost. People didn't really do both.

MJ: That's interesting. You're really limiting your stage time.

DA: Yeah, I mean, at the Store there was much more of an anti-alternative comic vibe. I always did the Improv. I was friends with Drew Carey, and he'd go do stand-up and then go to *Whose Line Is It Anyway?* I would get to do fifteen minutes up front, and it was the best audience

MJ: Everyone talks about the late '90s and early 2000s. The Westwood Brew Co. open mic was one main mic?

DAVE ANTHONY: Oh, yeah, definitely. That was around when I came here, and it was a really good room. It was, like, fun and anybody could pop in, and it was definitely the precursor to what everything is like now.

MJ: When you came out here, did you focus more on the independent scene versus the clubs?

DA: I've never done the Store, so—

MJ: Still?

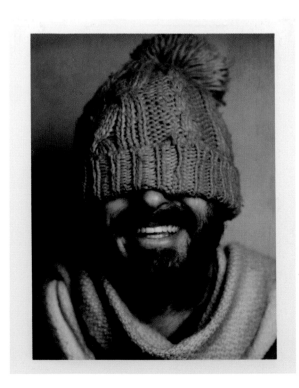

in the world. So I was kinda in at the Improv, and I got to do weekends. I just didn't have any desire or reason to go over to the Store. It has that weird vibe, like anytime I do a set there for a showcase or whatever, it just doesn't feel fun. It's just never been my scene. I did [the Improv], and I did the little places around town. I did Largo. I never felt completely comfortable in the scene there . . .

MJ: Cool kids' room?

DA: Yeah, it was the cool kids' room, and I was like cool kid adjacent? And they were also always having fights between themselves.

MJ: I've always heard Largo was super competitive inside of that sphere.

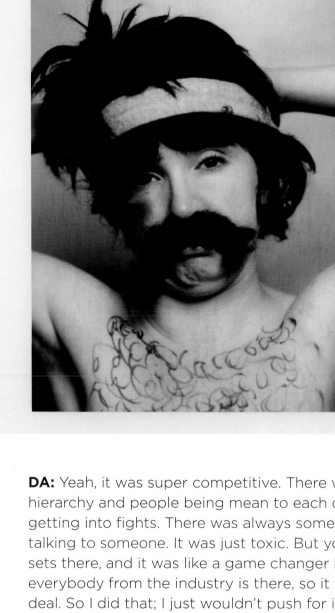

DA: Yeah, it was super competitive. There was a hierarchy and people being mean to each other and getting into fights. There was always someone not talking to someone. It was just toxic. But you do sets there, and it was like a game changer because everybody from the industry is there, so it was a big deal. So I did that; I just wouldn't push for it.

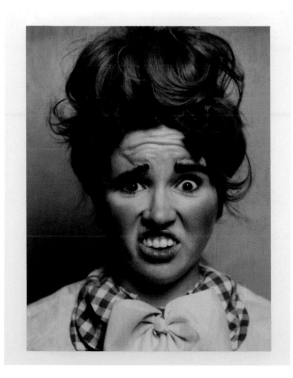

MJ: You did Largo, right? Lisa [Leingang]— she kind of booked it like a club? You could do five, and then you would come back, and it would have the same repetitional pattern as the Improv?

KAREN KILGARIFF: Totally. It was a club. Essentially. It was a music club every other night of the week. So it ran basically exactly like the Improv did or whatever. There were usually seven people on the show, the headliner was huge and awesome, and people would drop in and people coming through town, and it was like . . . a reliably great show, a sometimes unbelievable show. One time, my favorite thing I think that I've ever seen happen, is in the middle of a set, Zach Galifianakis walked offstage, out onto the sidewalk, because the stage door was right next to the front door, which was right on Fairfax. And he walked outside and started talking to people on the street, so it became like a radio show inside the club. And he starts to talk to this couple, and they say that they work for Halliburton, and he fucking starts to go off on them. He brings them inside, brings them onstage, and begins to scream at them about how fucking dark—

MJ: Early 2000s?

KK: It was Iraq War time. It was unbelievable.

MJ: How was that for the couple? How did they handle it?

KK: They seemed like they were in a sketch . . . on a separate show. They were both very perfect looking, and they were both very apathetic seeming. They did not give a shit. They were just kind of like . . . smirking and sneering, but they didn't fight him in any way; they didn't do anything. And then they just left. It was . . . no one knew if it was real or not. Because it would be so like Zach to do that. But I knew it was real because I knew him.

MJ: What other shows were around at that time?

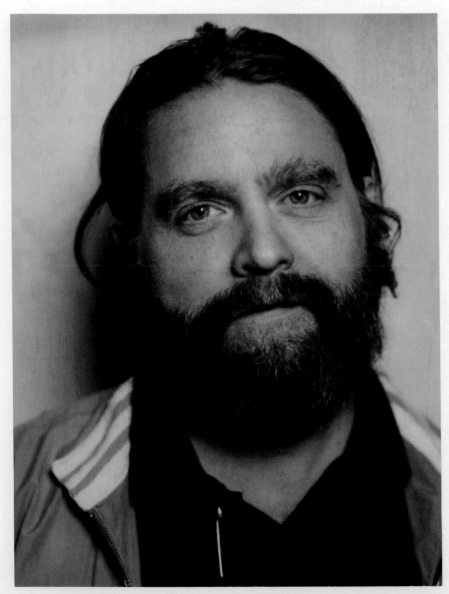

KK: There was this very defining show. It was a show that was very under the radar because it happened . . . I was not in Los Angeles for the bookstore show that Dana and Janeane did; that was before my time. When I moved to L.A., the show that everybody wanted to be on was this show, Laura Milligan hosted it, and it was called *Tantrum*. It was at that weird dance club; it was called the Diamond Club at the time, in 1995 or whatever. It was right on the corner of La Brea and Hollywood, where the silver women are holding up the thing. It was basically diagonally over from the silver women. You walk through a full-on dance club into the back room, and that's where the comedy show was. The stage was really high, and Laura hosted the whole show as "Tawny," who was an ex–child actor on drugs who started writing poetry and was now doing spoken word.

MJ: I love that whole complicated character; it's perfect.

KK: Basically every week, you could do whatever. You could do anything you wanted on this show: a self-contained sketch, you could do stand-up, a character, you had a notebook, you had some ideas . . . We started doing things that normally I would have never have done. In San Francisco, there was nowhere to do stuff like that. There were no sketch shows; there was nothing even along those lines. And this was this kind of whole new . . . Do you have an idea? Who cares? Whatever you want to do, you do it.

Molly Shannon did sketches there before she went to *SNL*; Will Ferrell would do this thing with his two other friends. They would come on as a Canadian performance art group called Simpatico. They would wear speed-skating unitards with the hoods up. They would pass a ball really fast between the three of them and yell "Simpatico!" while this weird music played. And it was one of the funniest things! It was legendary.

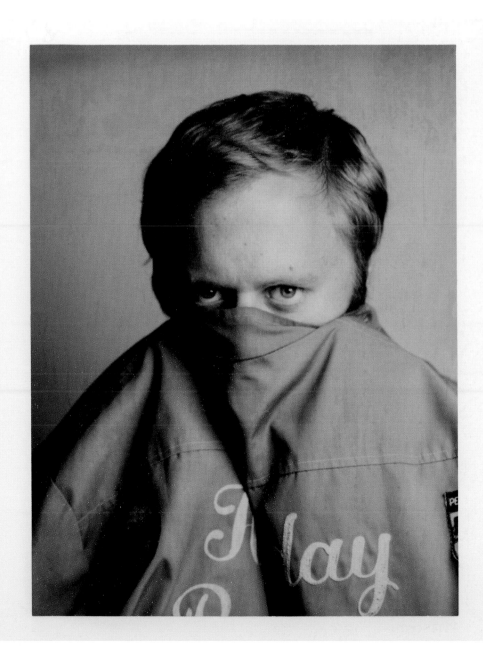

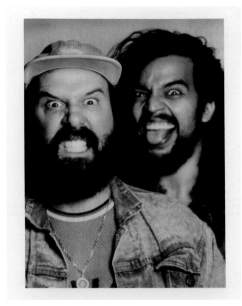 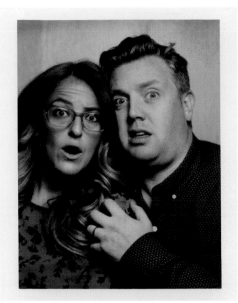 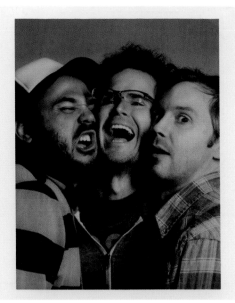

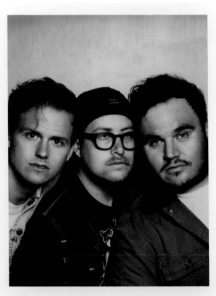 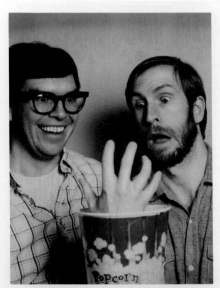 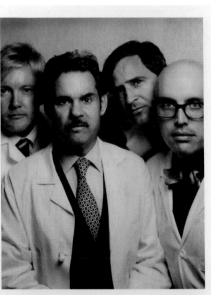

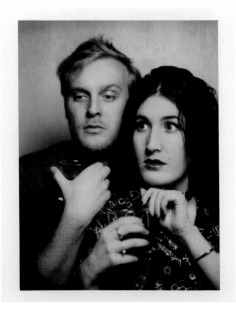 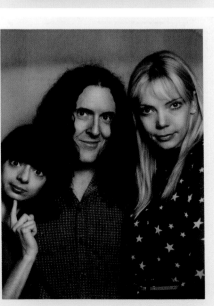

62 **TOP: LEFT**-GELMANIA, **MIDDLE**-KARA KLENK & JARED LOGAN, **RIGHT**-MATT + OZ WITH DAVID NEHER, **MIDDLE: LEFT**-POWER VIOLENCE, **MIDDLE**-THE WALSH BROTHERS,

Laura also did a show there called *Hacks Hacks Hacks* where everybody did a set of the typical certain type of hack. It was one of the most insane things. It was people getting up . . . this guy Jeff Haas, who was a legendary stand-up comic from San Francisco, did a character named Gary Monitor [who] instead of saying the jokes, he told you what he was going to do. He'd be like, "Casual hello, make a reference to the man's shirt in the front row, have a joke ready, surprise everyone even though you've done it forty-three times. Reference your mother, then tell everyone she's dead. When people seem sad, turn it around to say . . ."

That show basically took everything—these comics had to watch and observe—that other people regarded as good and finally get to comment on it. That show was very groundbreaking. The second time Tenacious D ever performed was at that show. First at Actors' Gang, that was their home place, but then . . . Jack Black, the second I saw him, I couldn't breathe. I was like, *He is a star*. He is just a star.

MJ: It is crazy when you watch someone and you know that. They're going to be insanely famous. You can just tell.

KK: It's like . . . something coming off of them. Same thing happened when Bob and David started doing *Mr. Show* sketches there. Paul Tompkins and Jay Johnston had a sketch group called Skates—basically when *Mr. Show* started, that's how those guys got hired. It was that whole scene from the Diamond Club.

MJ: Is that how you got hired on that show too? Because you were around then?

KK: Basically, because between the Diamond Club shows and *UnCabaret*, that's how we all got in front of each other.

JIMMY PARDO: The scene in '95—and maybe I'm overusing the word—but it was intimidating. It was all the people I had seen on TV, all the people that had HBO *One Night Stands*. I thought they were famous because I saw them on television. So that was bizarre.

Then Largo happened. The alt scene kicked in. I remember being jealous of the alt scene because I wasn't a part of it. Eventually Bruce, my manager, got me a spot on Largo, and Lisa Leingang, who was booking it at the time, was like, "It's your first time, so you can only do five minutes, and if it goes well, you'll get to come back and be a regular." So on and so forth. All right. It was a big deal. Doing Largo and being part of that scene with Janeane, Odenkirk, David Cross, Patton [Oswalt], and Paul F. and Greg Behrendt. I didn't know any of them, and they were the funniest people on the planet. They didn't know me; it was almost like showing up to an open mic again, where you're the brand-new guy and, "Who's this guy? Why's he here? I've never heard of Jimmy Pardo."

I went up, and I think whatever my opening bit was . . . there was a music stand on the stage, and I went, "If I played music, I'd put the sheet music right there." And the place erupted. I rode that wave for the next three and a half minutes. I came off, and Patton and them were all, "Who the F are you?" That was unbelievable.

Lisa was like, "When do you want to come back? Let's get you back up here. I don't like to do people more than every six weeks, but let's get you back in a month. Then we'll get you on a rotation." Then I ended up hosting a bunch for them. It was me and Todd Glass and a third that I cannot remember who it is now, but we were able to have our feet in both camps. We would do spots at the Improv and Largo.

That's how it was when I first moved here.

GREG BEHRENDT: Everybody kind of moved around the same time. We hooked up with the likes of Janeane Garofalo, David Cross, and all the *Mr. Show* people were here, Paul Tompkins, you know, all the people we'd refer to as the alternative comedy scene.

MJ: That fantastic label that we've all been stuck with for forever.

GB: It doesn't mean anything now; it's so funny. Now people just call it comedy—it's just straight-up comedy. Anybody doing comedy's just doing comedy; it doesn't matter what they're doing.

MJ: I always refer to things outside of clubs as independent comedy since it's not at a club. But it's more of a definition term. It's an independent show because it's being run by these random people who only do this one thing at this one venue.

GB: Right, and "alternative" always referred to the venue too. That was always meant to refer to, we were unable to get work in comedy clubs, so we did laundromats and Mexican restaurants and wherever anybody would let us put a microphone in there. There were just so many of us at the time that it sort of became a scene.

MJ: When you came to L.A., did you try to get passed at the clubs? How was that process?

GB: I remember I think I got in with the Improv, and I don't think I ever went to the Comedy Store. I did a handful of sets at the Laugh Factory, but there were really big alternative rooms at that time. *UnCabaret* and eventually Largo. So those were the things that we were trying to do.

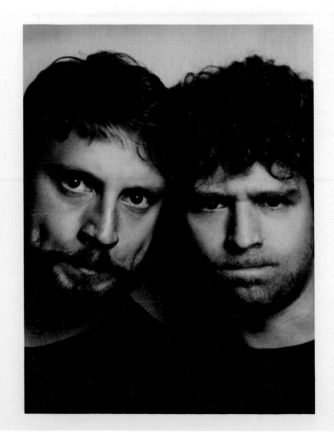

TOP: LEFT-THE SPRANGLERS, **RIGHT-**LEAH & KATIE HENOCH, **BOTTOM: LEFT-**MIMI CAVE & PARKER SEAMAN, **RIGHT-**DRENNON DAVIS & NICK STARGU

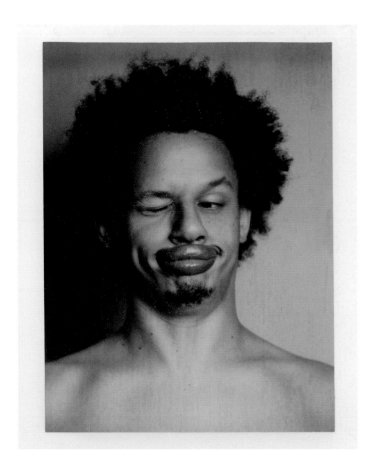

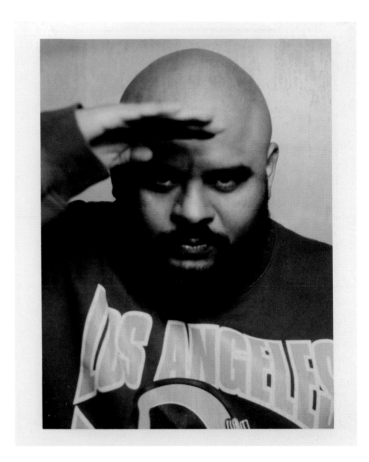

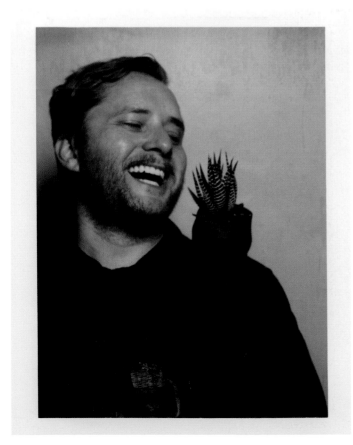

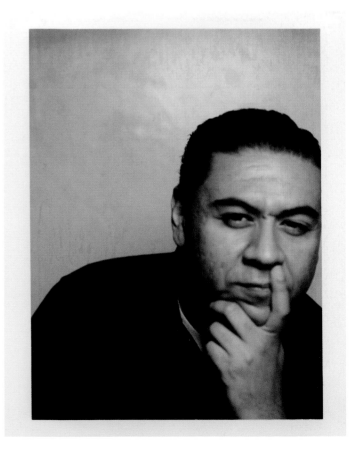

TOP: **LEFT-**ERIC ANDRE, **RIGHT-**STEVEN HERNANDEZ, **BOTTOM: LEFT-**PAUL DANKE, **RIGHT-**CHRIS ESTRADA

MJ: When you came down, were there already some established shows, or did you guys kind of build the scene when you guys moved?

GB: We helped build the scene when we moved, everybody . . . it all sort of coalesced. There was definitely *UnCabaret* and Janeane Garofalo and Dana Gould's show plus others. Luna Lounge on Sunday nights became the place to see comedy.

MJ: How would you say the independent scene evolved?

GB: People started to get famous, and, suddenly, we were where the action was. Janeane was making movies, Margaret [Cho] blew up, Kathy Griffin became a big deal, *Mr. Show* happened, and then the scene got bigger. Other people jumped on board like Zach Galifianakis and Sarah Silverman; all those people were at Largo as that became the next big room.

MJ: The rooms, they kind of ebbed and flowed, right? *UnCabaret* at the Luna Lounge, then Largo, etc. Did you ever feel like there was a time where there weren't independent rooms in Los Angeles?

GB: Not necessarily for me . . . There was *Comedy Bang Bang!* [*Comedy Death-Ray*], and there were always new things starting, but they all work in concert. *UnCabaret* hung in there for years, and Largo still is a force for alternative-minded comedians. Obviously, young kids start their own thing. You have a graduating class of people, and then another new class of people comes along, starts something different.

. . . there's always been that spark of the original.

—Andy Kindler

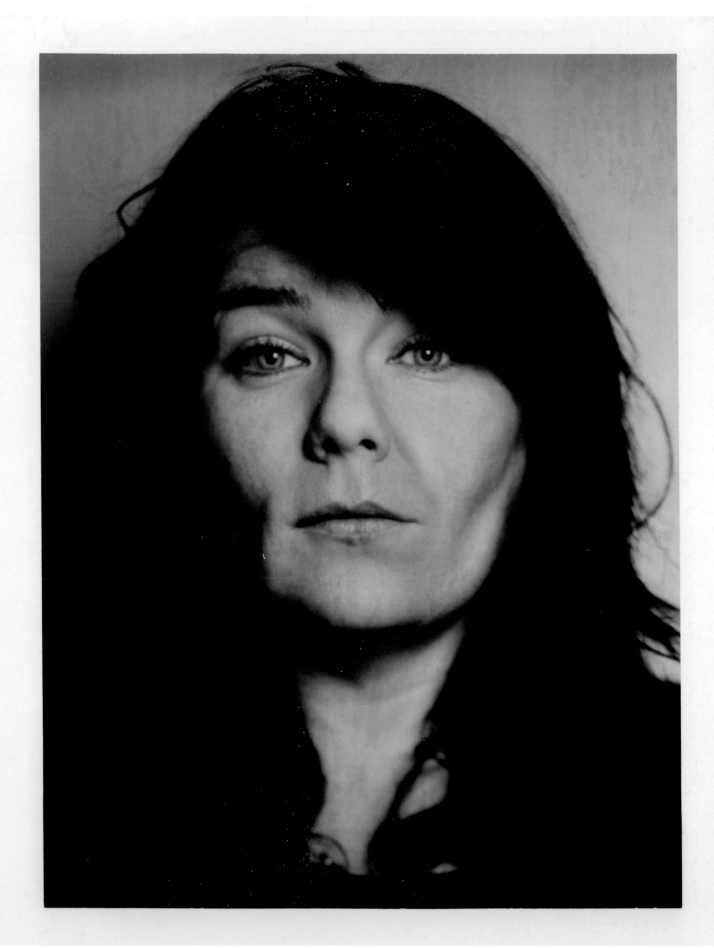

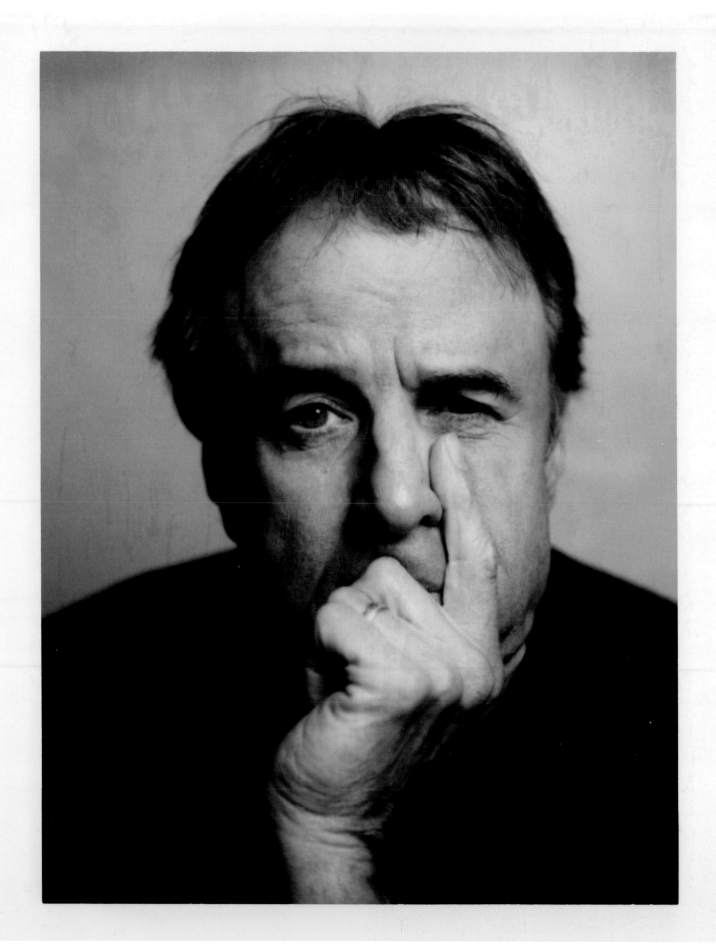

RON LYNCH: When I moved to L.A., the original Largo club was my home base. A dark, well-attended comedy and music club with a small stage in the corner where I felt comfortable to do new things and got to perform with lots of great people. I wasn't crazy about performing in the comedy clubs, though the comedy profession dictates that that should be what you should do. For example, I passed at the Laugh Factory but never went back.

———————

MJ: Do you ever feel like there was a dip in the independent scene in the 2000s?

ANDY KINDLER: There was. There were [fewer] shows, but now that I'm saying it, I guess I could make the argument that there's always been that spark of the original. I say that myself, "Oh, I started in the alternative comedy scene," but I think that's actually generational, because I hear comics today talk about when their alternative comedy scene starts . . . It was revolutionary at the time that this thing happened in the nineties, but I think it's probably always happened in one form or another. Where people break down the normal thing.

MJ: I mean, it does seem like the scene that you guys created in the nineties was really formative. I think the biggest thing that came out of that scene in the nineties—

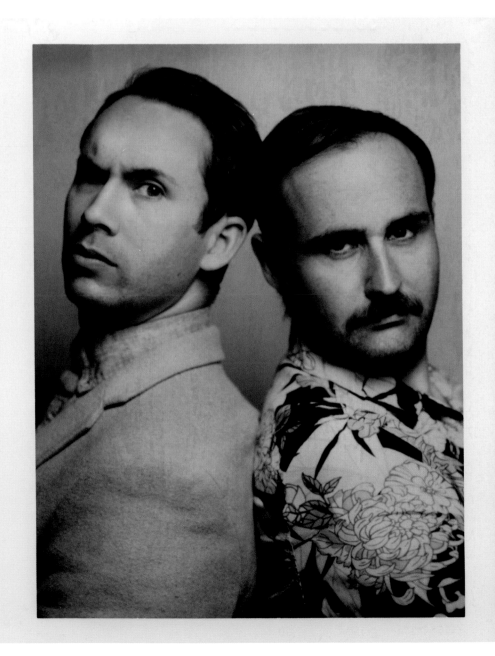

it brought us people like David Cross, Janeane Garofalo, Bob Odenkirk. It justified those spaces as homes where people could curate their careers and their comedy. It gave those rooms and spaces a reason to be there and proved that they were worthwhile and that you could develop outside of a club.

AK: Absolutely. The thing that the alternative scene did—and that, thank god, happened—was that it really did massacre the whole eighties style of comedy, which was just oppressively bad after a while. I used to make a joke in the nineties that the comedy boom made people hate comedy. I would say to my manager, You want to book me at a comedy club? That sounds a little dicey.

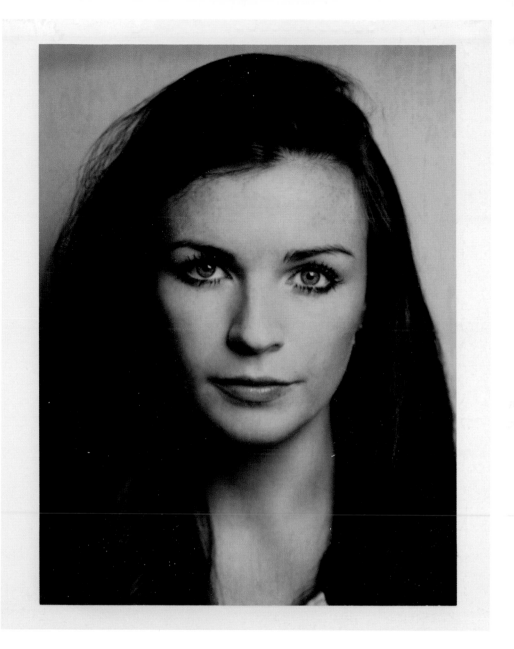

RYAN SICKLER: Christina Pazsitzky had a great [show] at Tangiers back in the day. She also ran one right on that Sunset Strip next to the Whiskey, used to be the Black Cat. I'm pretty sure the drummer from the Stray Cats owned it. That was a great one. A lot of these were restaurants . . . You know the deal with L.A.: you'll have a really nice restaurant, but there'll be a stage with some lights over in the corner that you don't see in Maryland, you know. So a lot of people had already jumped the gun and had their shows going there. But my favorite one was Tangiers, and the other one was World Cafe, which Jay Larson ran and then handed over to Carl De Gregorio, and that was one of the hottest spots in L.A. on a Wednesday night. And this was also [when] Dublin's was popping off at the time, upstairs.

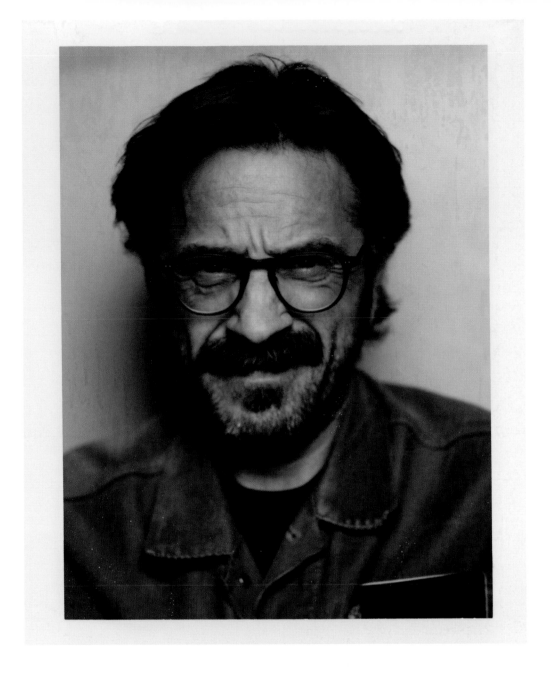

MJ: What was the scene like in 2002?

JONAH RAY: Largo was still going on, but there was no chance of getting in there. It was just one halfway-decent open mic a night in a different part of the city. Tuesday night was the best one: the Westwood Brew Co. run by Vance Sanders. It was great. It was the one that you wanted to go to. Maria Bamford would show up, Zach Galifianakis, a lot of people.

MJ: It's crazy, though, that there weren't a lot of independent shows, just open mics.

JR: Yeah, it was the only place to get stage time. It was really desolate. Shortly after, within a year or so, B.J. Porter and Scott Aukerman started *Comedy Death-Ray* Tuesday nights at M Bar. All of a sudden there was another show in a week that you could go and hang out at and see bigger comics and maybe perform.

When *Comedy Death-Ray* started at the M Bar show, it was on Tuesday nights. That was the night of the best open mic in town. The Westwood Brew Co. people would just go do the open mic and hang out. It was a bar. It was a nice place and fun. But when *Death-Ray* started, it was almost better to find some shittier open mic in the Hollywood area as opposed to driving all the way to Westwood and then going to hang out at the M Bar show. That hobbled the Brew Co. mic—even though it was an open mic, it was a good show. It took out everyone that had a name, and it really kind of took it out at the knees. That was that time in L.A. comedy—one show could fuck over another show.

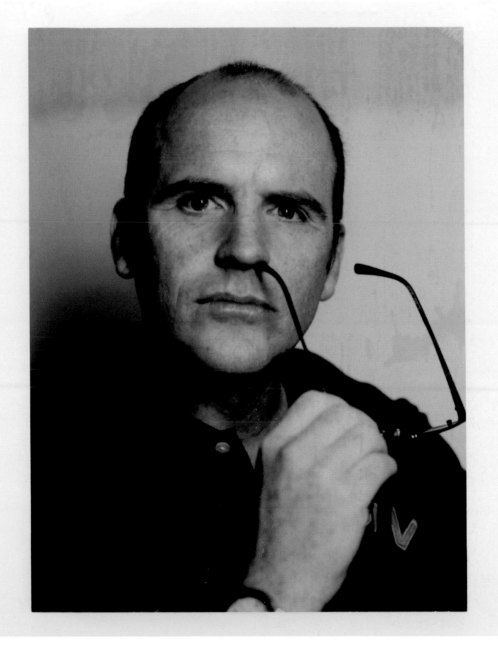

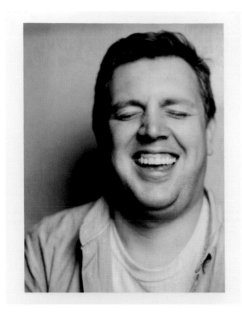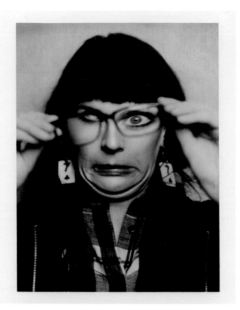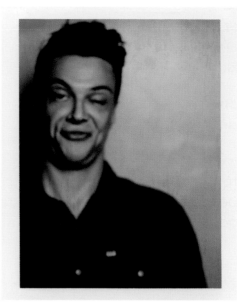
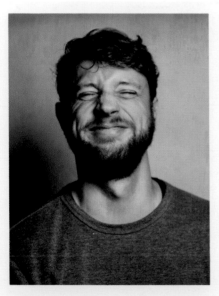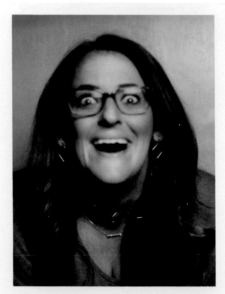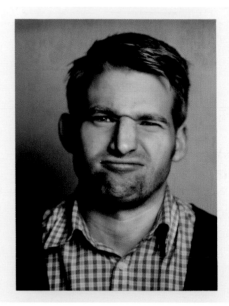
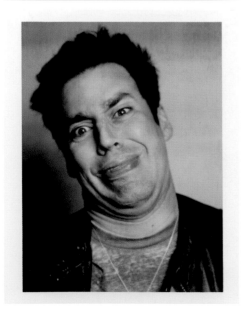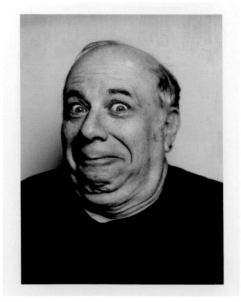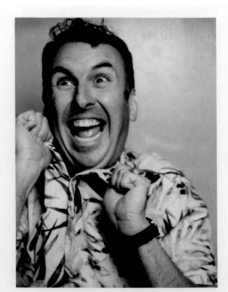

TOP: LEFT-JARED LOGAN, **MIDDLE**-AISLING BEA, **RIGHT**-HAMPTON YOUNT, **MIDDLE: LEFT**-DRENNON DAVIS, **MIDDLE**-KARA KLENK, **RIGHT**-WILL WELDON

MJ: Jonah was saying that . . . when *Comedy Death-Ray* started, it effectively crippled the Brew Co. night.

JIMMY PARDO: It destroyed it, because it was on Tuesday.

It was the hot place to be. It was the shiny new toy. And famous people were coming. If famous people are on the show, it means audiences are going to be there. Boy, it sure did ruin Brew Co.

There is a tradition in independent comedy of blazing your own trail.

— Andy Kindler

MJ: How was coming to the L.A. scene in 2003?

KYLE KINANE: I mean, it took awhile to get on track. Our buddy Matt Dwyer was out here first. I didn't know too, too many people. We would do shows at the Parlor. It's where Bar Lubitsch is now. It was a dumpy goth bar, and Katie Massa Kennedy and CeCe Pleasants ran that show. That's where I first saw Eddie Pepitone, Duncan Trussel, and all these people. Nobody would ever come to it, but it was a fun show.

It turned into go-go boy night afterward. All the comics would stay there because it was the cheapest place to drink. It was the only place with what I'd consider reasonably priced beer: $3.50 for a beer. I got here, and everything was like $5 for a beer, and I was like, "What? How dare you?" It was a real shithole, and I loved it. Bar 107 did shows too. Those were the first shows I remember doing.

MJ: Did you try to get passed or do the clubs when you moved out?

KK: No, I remember getting here and somebody being like, "OK, yeah, the Laugh Factory: you've got to wait three hours to do an open mic, and then you get rescheduled six months later, come back"—I was like, "Fuck you." I know I moved to L.A. to make it, but that's just stupid. That's just some bullshit power move. There's shows going on; I'll get on shows. That's stupid. I'm not going to play that dumb shit. So I never hustled to get into any clubs. The Improv was the place that would put me up, but at that time, Comedy Store was still kind of . . . a cave. A frat cave. I wasn't hanging out there much.

Another big show was *See You Next Tuesday* at UCB. They opened up UCB Franklin in 2005, I think. It was kind of like the incubator for [*Comedy*] *Death-Ray*. That was when the ASpecialThing message board was going, and people would write recaps of all the shows. It was right before this new comedy boom. This is band stuff; this was like music. People would recap the shows, they'd mention everybody that was on it, they'd do reviews. There were little fan clubs—all the people that were in the know

about comedy. It was right at the time when the Bridgetown Festival was starting, and it was all comedy nerds, if you will. It was a good time to do comedy. I'm glad I was around. You'd see your name pop up, like, "So-and-so did great." Oh yeah, that's me! All right! Strangers like what I'm doing! All right. It only took ten years. So that did a lot; people started paying attention to that message board. That was when you could get plucked off to do *Death-Ray*. That was the Double A team.

PAUL DANKE: In 2004, there were . . . clubs, and there was stuff at the M Bar. *Comedy Death-Ray* was happening there, and—

MJ: '04 is right before UCB opened.

PD: Yeah. I remember when UCB opened. It was like . . . it was fantastic, but . . .

the M Bar already did that. It was a great showroom with booths, and I loved the M Bar. I loved that the venue. I thought it was great. When UCB opened, it was like, Wow, there's this whole other thing. But it felt immediately full to me. It never felt like somewhere that was super accessible even though I'd performed there a

bunch of times. It was—god, it was mostly comedy clubs. And then there was stuff at the El Cid, there was *Garage Comedy*, and then soon after that the *Tomorrow!* show started, and we started doing our show, *The Comedy Garage*. We literally performed in the garage, and we thought that was very cool at the time.

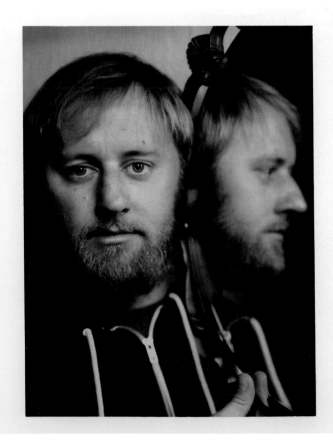

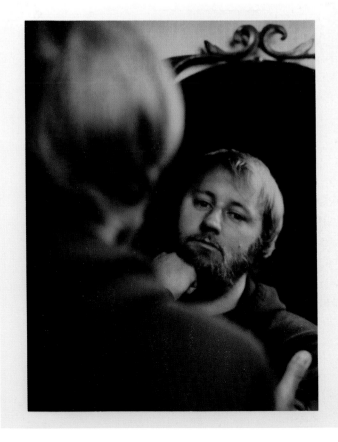

MJ: I mean, it's a smart way to make a venue.

PD: It was a great venue; it was a good size for it.

MJ: And the driveway was the audience, right?

PD: Yep. There were couches and stuff in the garage, there was a small pallet stage, and then there was . . . people stood outside and watched it, and it was more like a house party with a comedy show.

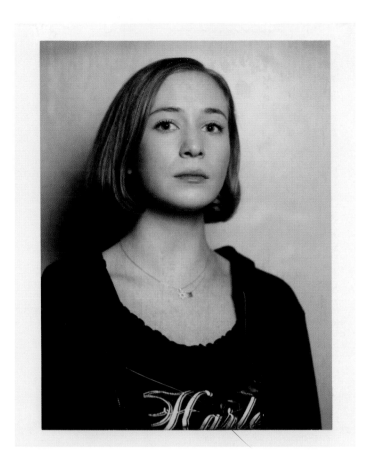

When producers started coming in and running shows [in 2010], that's when shows got better.

—Jonah Ray

RON LYNCH: In the early days of the Steve Allen Theater in 2004, Craig Anton and I were doing a show called *The Idiots* about the sons of Crick and Watson, and when the run ended, Amit Itelman [the theater's creative director] asked if we wanted to do another show. Craig suggested we do a midnight show, and we decided it would be as weird as possible, with a great variety of acts.

It was the only show of its kind at the time, and the *Tomorrow!* show continues to this day.

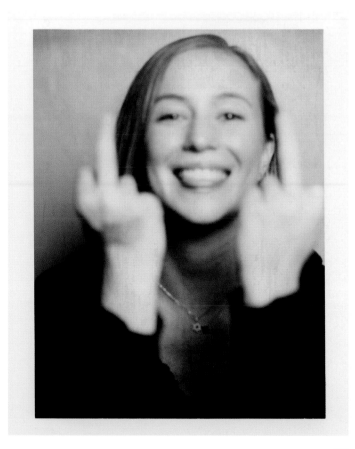

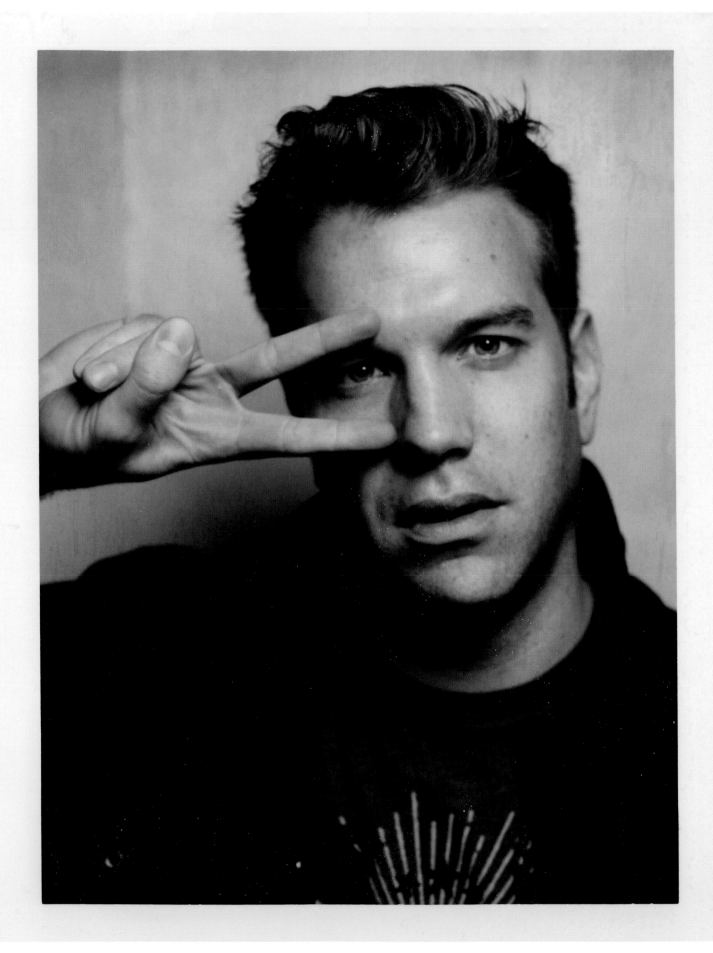

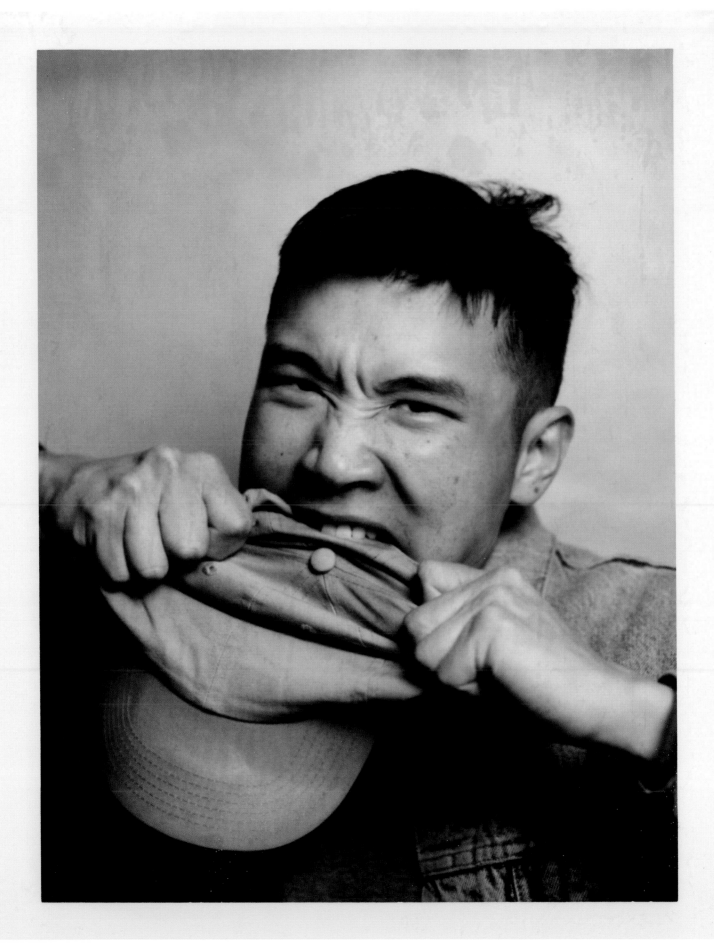

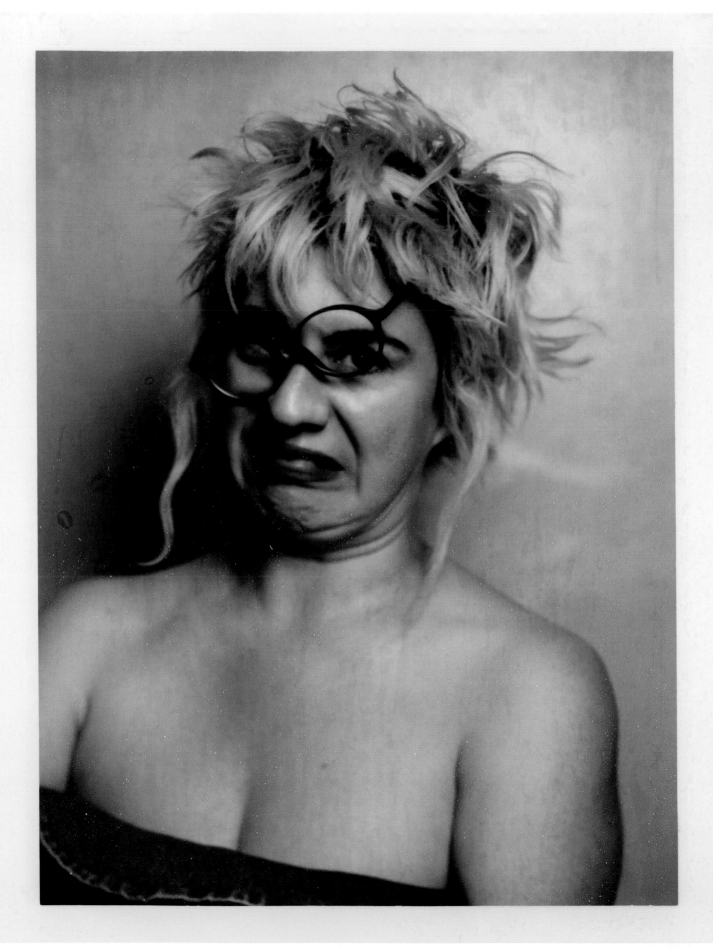

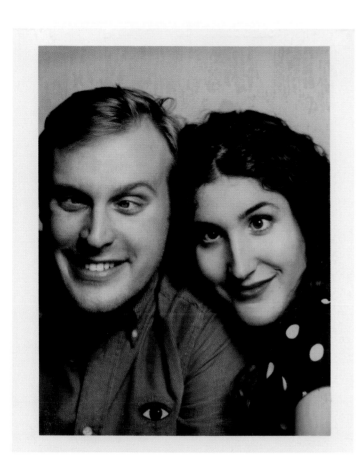

JOSH FADEM: It started out as a show in 2004 called *The Pretty Okay Ho-hum Spectacular on Ice!* It was me, Pat Healy, Danforth France, Chad Fogland, and a lot of people of note who would come and go. It was a semi-sketch [show] that we would thread between live stand-ups. There wasn't much like that at the time. We'd blow all our money on costumes and props. After a year, the group didn't want to do it anymore, but I wanted to keep running and booking a show, so it became *Josh Fadem's Acid Reflux Hour*. I hosted and booked a show every Sunday until the end of 2008. I'd had a real young punk's chip on my shoulder about exclusive picky booking, so I purposely tried to book anyone who asked me, even if they were green. Both shows were always a mix of that, peers, and bigger local names. I hosted as a character or did bits or just chatted and interrupted comics every week.

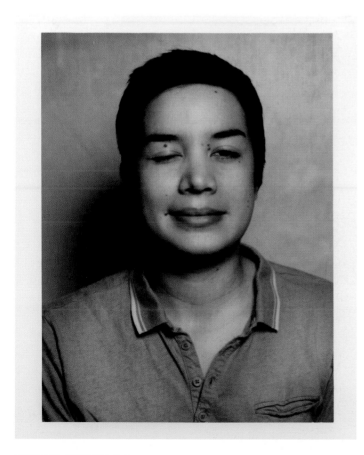

GREG BARRIS: There's gotta be some kind of correlation with the new crop of comics where they're post-alt wave . . . post-post-alt wave comics meets a new very new crop of venues. I've been thinking about this too. In L.A. when I first started coming here in 2005, there weren't these . . . There were cool neighborhoods, but it wasn't like it is now. It wasn't like Silver Lake is the cool neighborhood. Echo Park is cool, go to Echo Park, go to Silver Lake . . . It felt like L.A. was—

MJ: Hollywood.

GB: Just Hollywood. I think that had a lot to do with people moving into certain zones and being like, "Oh, this zone is cool; these comics are all moving and cool . . . the venues are in the zones that are cool, there's a couple of those." There's some kind of something that happened. A few things that lined up to begin this spark.

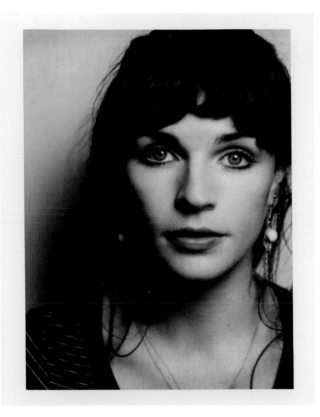 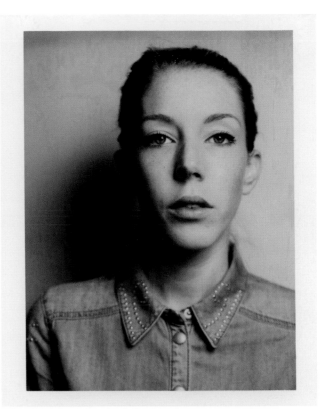

MJ: I think it all matters. I think that that time period also saw the beginning and the rise of podcasts, and L.A. started to see better restaurants and more artists moving here, not just comedians, but all artists. I think that as a whole, the city got more interesting. I think that it's definitely created a better home for independent comedy by far.

GB: Totally, the scene is cohesive. There's a lot of people educated on what a comedy show feels like and what their expectations are because they've seen it or done it, been to one. And I think that has a lot to do with—I think you're right— that period of time.

SEAN PATTON: When I came here, it was during the height of stand-up at UCB, here. It felt like that was the nucleus of Los Angeles comedy in 2006. And then everything else was just feeder fish around it. You had a couple of other shows at UCB that were all kind of like orbiting around *Death-Ray*, and then you had the El Cid, there was a lot of stuff going on there, Room 5 at Amalfi on La Brea . . . Comedy was not nearly as big as it is now, and that's crazy to say because that was only a dozen or so years ago, but it felt like comedy back then was a way smaller community.

MJ: One hundred percent. Producing comedy for the last ten years, not only the amount of shows but the amount of comedians alone is significantly—

SP: Quadruple, I'd say.

I feel like '06 to probably around 2013 was this time . . . on both coasts, where it was very do-it-yourself, if you want to make it happen, make it happen. You can do that.

LEFT: AISLING BEA, **RIGHT:** KATHERINE RYAN

MJ: What was the scene like, the independent comedy scene, when you started in '09?

JAKE WEISMAN: You know, when you look back on it, you feel differently about what it was. But at the time, how it felt was very exciting and energetic. There were a lot of people, totally outside the club scene, not that I have any problem with the club scene, but everyone just was outside the club scene at that point.

What I remember feeling was an incredible surge of energy. Dave [Ross] was part of that; he's so good at throwing events and coagulating people for events. There [were] all these shows. Let's put a show up in the basement! Let's put it in the living room! Let's put it in this coffee shop! And it just felt . . . there was a purity to the feeling. There were all these really funny people who just really came together to try—and there was probably a lot of psychological exorcism going on—but also trying to find careers and not being able to go the club route or even knowing about it. It was incredibly supportive, especially at first. So much energy and excitement. It was a crazy fun. It was almost like when you grow up, you hear about these scenes, usually in music, where it's like, Oh, in Columbus, Ohio, there was this incredible scene . . . it felt kind of like that. Let's just put up shows everywhere, and it became a lot bigger than I think we really thought it would go.

Especially because when we started, I was like, "I'm only going to do this for a few months. Just to kickstart my writing career." And then it becomes so intoxicating. It becomes like everything you know and everything you think about.

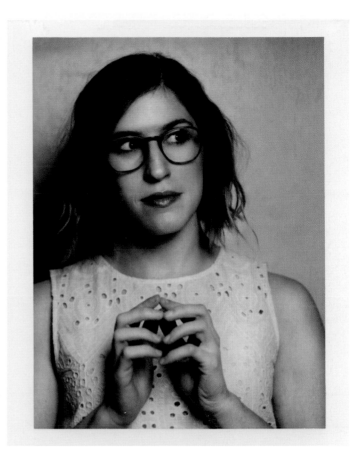

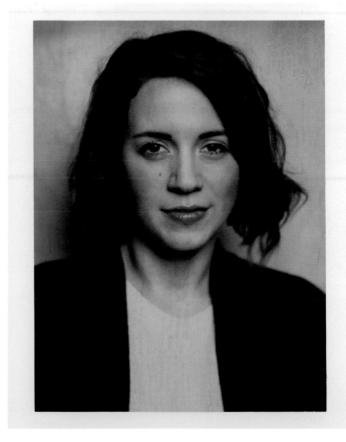

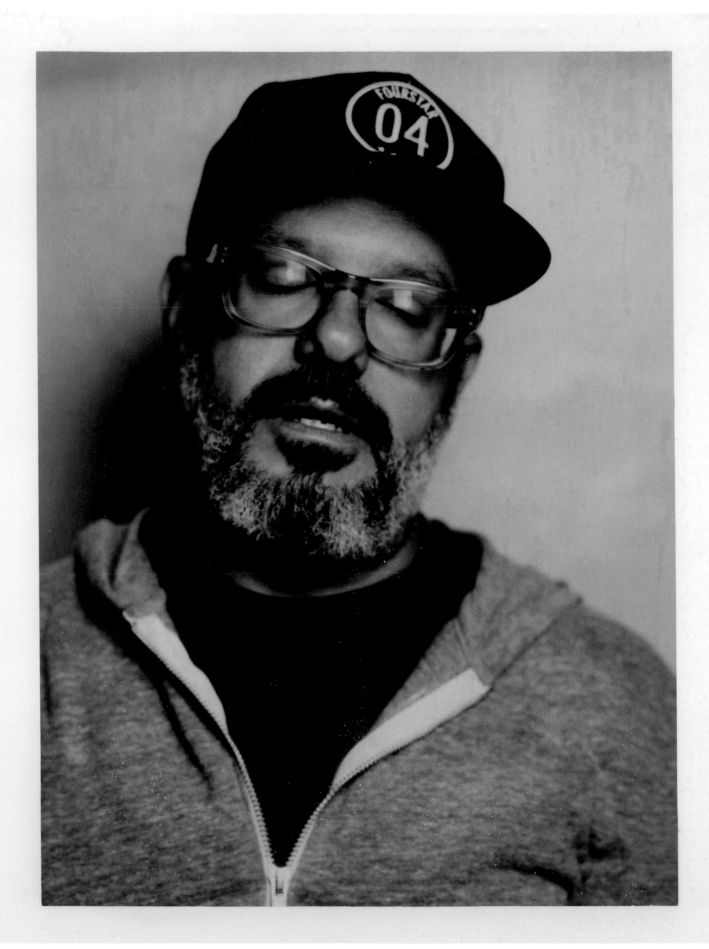

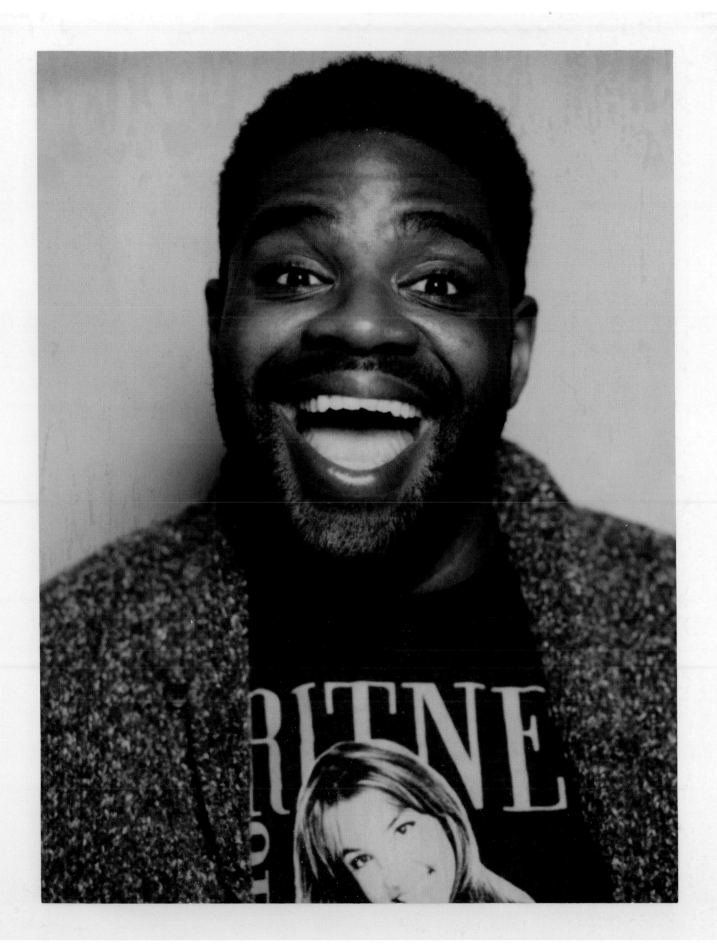

DAVE ROSS: There was an electricity to stand-up in L.A. [in 2009] that we all shared, that myself and my class were accidentally a part of just by nature of starting when we did and really, really loving comedy. And it's funny, having been around for a minute, I now know that everything comes and goes in waves.

And then it becomes so intoxicating.

—Jake Weisman

MATT INGEBRETSON: When I moved here, I stayed in the independent scene. The big shows I went to every week just to watch were *Comedy Death-Ray* and *Tiger Lily*. *The Comedy Garage* felt like the underground show of the underground shows. Dave Ross started running *Holy Fuck* at the Downtown Independent shortly after I moved here, and I could sense that was where I needed to be. That show ended up feeling pivotal for me. Once I started getting booked on that show regularly, which wasn't until about eight months into living in L.A. and doing open mics every night of the week, I felt like I was starting to get a foothold in the L.A. comedy scene.

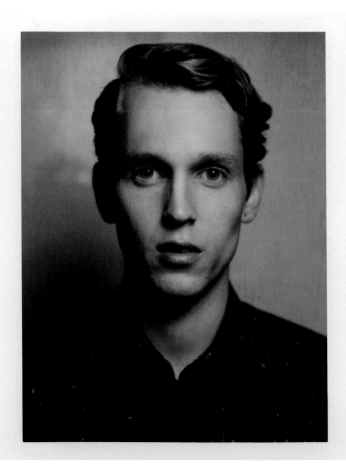

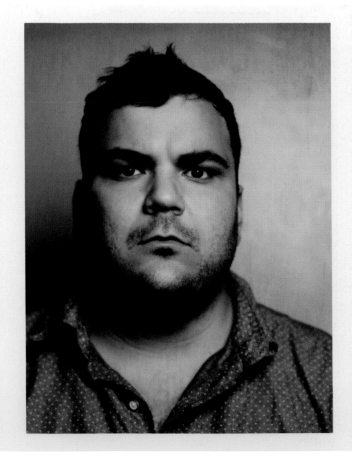

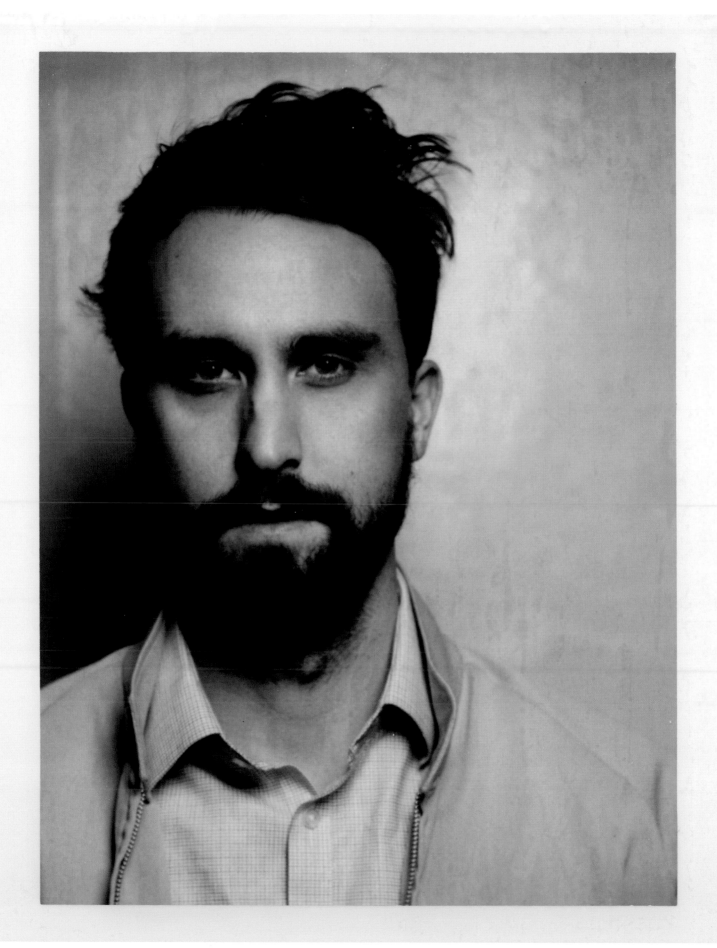

MJ: So when you came down to L.A. in 2009, did you do more of the club circuit, or did you focus more on independent stuff?

HASAN MINHAJ: I was in a tough spot in L.A., unfortunately. I was going through some personal stuff, and then I didn't know anybody. I was trying to find a fit, and I would hang out with the San Francisco guys like Moshe [Kasher] and Brent [Weinbach] and some other friends from San Francisco who had moved down. I was living in a dude's attic in Pasadena. I didn't know—he told me it was an apartment, but it was just an attic above his apartment. You had to pull down a thing and go upstairs.

I was in a tough spot personally, and then, you know, there's just a few clubs. The Improv, the Comedy Store, the Laugh Factory, the Ice House. There just felt like there was a massive bottleneck and a limited amount of spots. I'm getting passed at the Laugh Factory, getting passed at the Ice House and at the Improv, but you're just sending in avails but not getting spots. You're new; you don't hold any weight. I felt like I was really in this really tough holding pattern.

Then guys like Dave Ross and Jake Weisman—I was sort of meeting them, like my class of comedians. I had moved there around the same time they started stand-up. They started telling me about these other shows starting to pop up in downtown and other areas. That's when I found out about *The Super Serious Show*, about *Holy Fuck*, stuff like that, which changed my life—completely changed my life and comedy career. That energy, the independent energy, stuff like what I did in Davis.

It was cool to see Riot festival become a thing and see you guys take your show [*The Super Serious Show*] on the road. That was really, really cool.

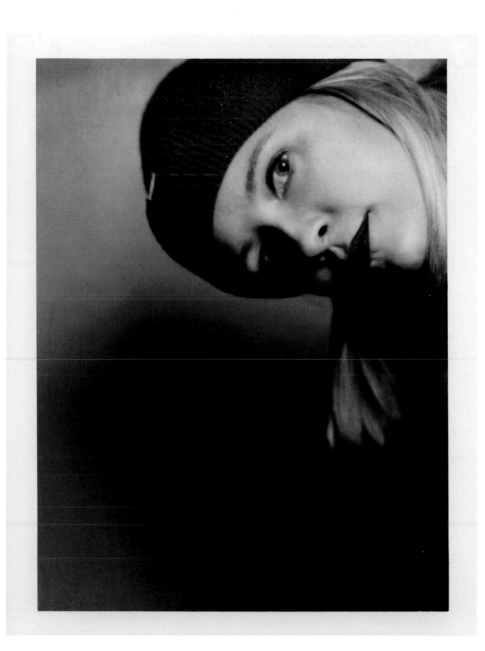

MJ: How was the transition to L.A. for you in 2009? Had you been coming out in spurts, or did you just decide to move?

BARRY ROTHBART: I never decided to move. I'd been coming out to visit every once in a while, and I was like, I'm going to spend three months out here. Just to see what it's like, to spend a little bit more time. And I ended up just liking it. I went back to New York, and I didn't want to be back in New York because I liked the L.A. scene so much.

MJ: What about the L.A. scene?

BR: It was sillier than the New York scene. New York was very, at the time, kind of . . . I don't know the right way to put it. Ball-busty, I guess. That's never been my style. I've never been a "tell it like it is" guy. It was getting a little mean. It was very competitive. When I was in New York, I just became stagnant because it was the same shows, the same people, and it was so competitive. People were so mean to each other. It was a very mean time to be in New York.

I came out here, and people were more supportive and willing to do weird bits. My dream was to get on *Comedy Death-Ray*, and I would go every week, and you would see Paul F. Tompkins come in and do a weird character instead of stand-up, which was unheard of in New York.

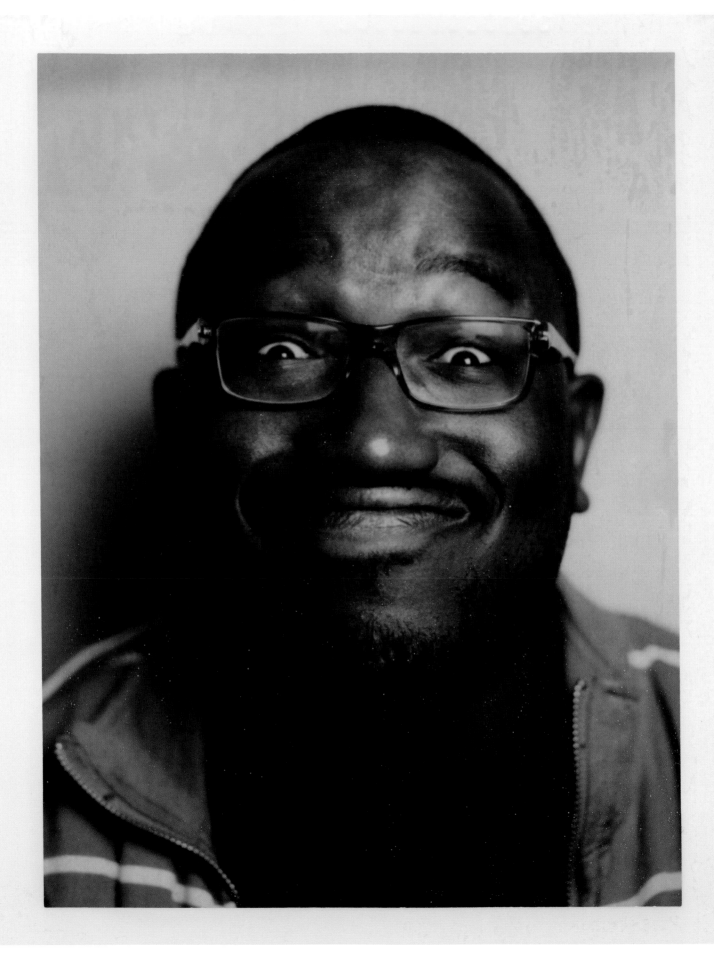

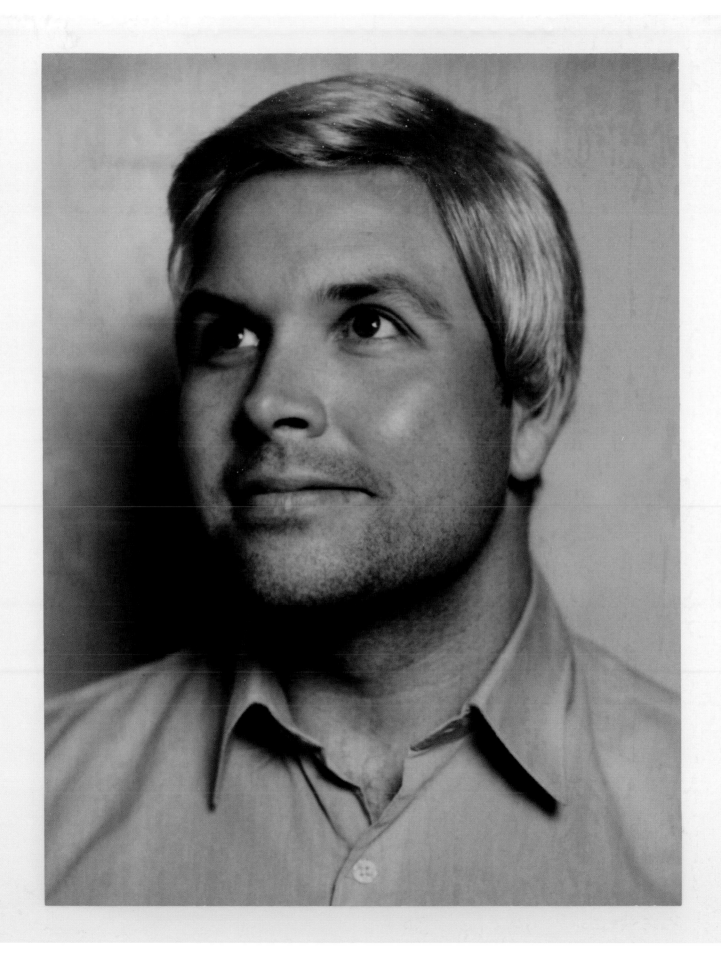

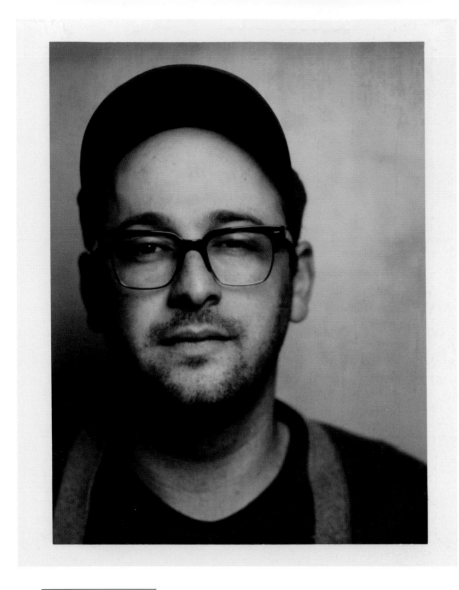

STEVE HERNANDEZ: I have the poster [Rusty Jordan] made for me . . . A blown-up poster of that first one [*Chatterbox*], August 1, 2010. So, yeah, we just started throwing them, and it's funny: even asking Dave [Ross], we had seen him at the open mic, it was like, "Oh my god, he ran *Holy Fuck* and stuff." I was like, "Man, it would be so amazing if this guy did our show," and he did it, and now I'm like, Of course he'd fucking do the show. Comics will go anywhere to do a fucking show. We're all dumb.

MJ: What was the scene like when you came out here in 2010? How was the transition from NYC?

DEMETRI MARTIN: I always found it probably like a lot of comics, harder to get a lot of stage time here, because number one, there are more big-name comics in the clubs, and they bump people and take stage time; number two, there are fewer rooms; number three, you've got to drive to them. I feel like there's more inertia.

MJ: Did you get passed at the clubs here in L.A. when you moved out?

DM: No, I never tried. I've only done, I think, two sets at the Comedy Store ever, five or six at the Improv, maybe more. I've never been a big comedy club guy. I still feel like it's such a shitty model. As long as I've been in the business, before and long after I'm out of it, the comedy clubs—the model—is designed to exploit comedians. I know it helps comedians come up when they need the stage time, but you start doing the math and you realize they're making a lot of money.

Sometimes I think I'll quit comedy tomorrow and other times I think I'll be 85 in a leopard dress yelling at people to shut the fuck up! The latter feels more likely.

—Megan Gailey

MJ: They're definitely making money.

DM: And they're paying comics garbage. It's supply and demand; there's nothing we can do about it. But the rooms like the Virgil and Largo and Luna Lounge at the time—so many of those rooms—I've always liked those, because it is more independent. It doesn't feel like you're getting exploited.

MJ: Did you notice around 2010, when the independent scene started to change in Los Angeles?

PAUL DANKE: Yeah, definitely. Because there became easily ten times more people pursuing comedy and producing comedy. We're in Echo Park now, I live over here, I moved here ten years ago, and there were zero shows in Echo Park. I didn't even know anyone who lived over here, except for my writing partner at the time. And I was like, This is a cool neighborhood; there should be comedy shows here. This seems like a lot of places. And now there's at least—

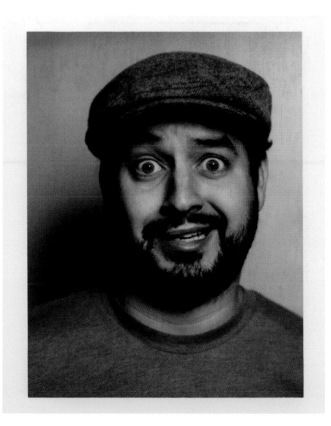

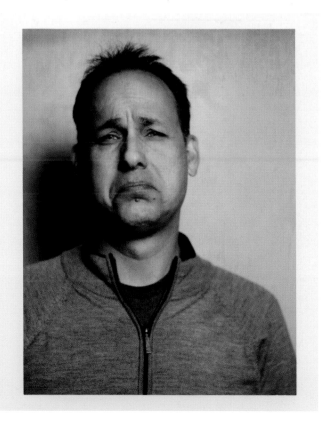

MJ: I mean, we're sitting in one place [Stories Books & Cafe] that has a show weekly [*Good Heroin*].

PD: This place has got one. There's easily ten different venues within a half mile of this place, which is rad. But it's one of those things: when there's so many people and so many shows, and you look at the list of how many shows there are a night, and it's like, Well . . . did the people interested in going out to live comedy . . . did that grow by ten? I don't think so. That's not been my experience. So some shows are popular, some can get some pals out, but then after a while . . . there's so much competition to get people out of their house.

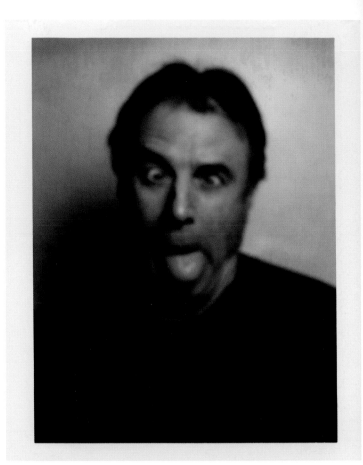

PETE HOLMES: I moved here in 2010. L.A. was sort of starting over but L.A. was different. I didn't have to open mic, because there were enough rooms. I immediately think of *Tiger Lily*: it was the best hang. That was the place that I would go just to watch and just to hang in that stupid kitchen.

It was sort of post-alt. Not that [alternative comedy] was over, but everybody knew that that was a viable thing and things were popping up; UCB is here and alt didn't have any stink on it. I felt like, in New York, people were kind of putting down the alt scene, and out here, everybody was like, *It just is the scene*. People don't know this, but L.A. is where I did some of the weirder shows. I did a show in a Thai restaurant or a Persian nightclub. It's as weird as New York, but then people—

MJ: It seems like that time frame was truly independent: people going, "I just want to produce a show to produce a show."

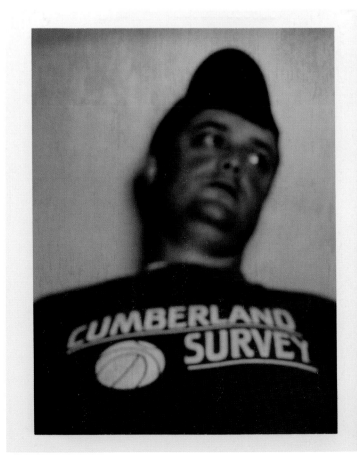

TOP: KEVIN NEALON, **BOTTOM:** NATE BARGATZE

PH: You put it perfectly. That is true. There were lots of places to go up. There didn't seem to be any need to get in with the clubs.

MJ: Did you get up at the clubs? Did you have to go through a whole thing to get passed again?

PH: Getting passed implies that there's one person booking every night. And the truth is—I feel like this is the clubs modeling the alternative model—they would just start giving nights to comedians. Like, well, they can do it. They'll promote it. They'll book it. Let them do it. When I was coming up in New York, it was all about getting passed at a club, and now I don't know if I've ever met the current booker for some of the clubs. In my calendar it'll say like, "8 p.m. Comedy Store," and I'll put the name of who booked me just in case I have to cancel or something. It's never the same person. This one's Mark, this one's Skyler, this one's Esther. That feels very alt-y to me.

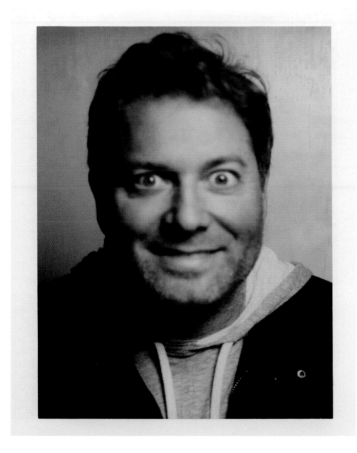

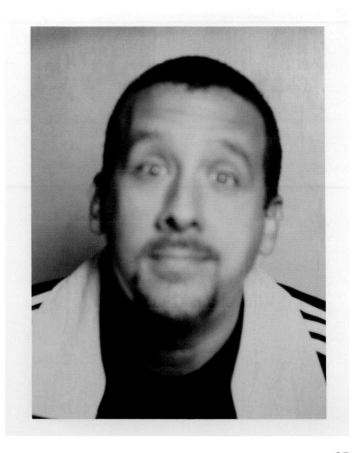

LEFT: JAY LARSON, **RIGHT:** RYAN SICKLER

MJ: I think [your show] *Power Violence* really embodied a lot of that punk spirit that comes with independent comedy, especially early in 2010, '11, '12, '13. A lot of it was very in that spirit of *I'll just fucking do it myself. I know better than all of you.*

WHITMER THOMAS: It's cool. I think we got very lucky. We truly had no idea what we were doing, and the fact that anybody would ever show up was insane. And also I'm sure so many people watched us and were like, "Fuck these little dumbasses." And I think we got lucky, that it was all an accident. If we had planned to do *Power Violence* and knew what we were doing, it probably would have been a massive failure, but because we had absolutely no idea how to do anything, I think it ended up working out for a little while. And, yeah, I think that was what was really special about that time period. There's probably . . . I have so many memories of things just killing at these comedy shows, these stupid bits, shit at *Holy Fuck*, and other things. But, honestly, I wonder if I went back in time, if they weren't killing and I just thought it was really funny because I was so excited to be a part of something.

MJ: Maybe it's a little bit of both. You never know.

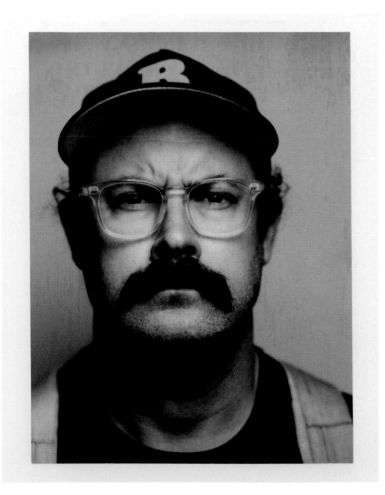

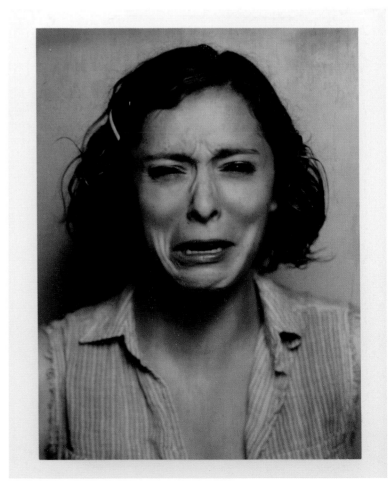

LEFT: SAM SIMMONS, **RIGHT:** RACHEL BLOOM

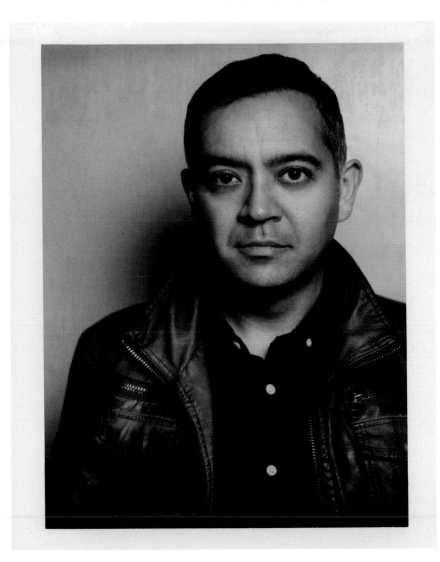

MJ: I don't think you know this, and this is just a fun fact from *The Super Serious Show* history, but the first time you did the show was in January of 2011. It was our seventh show. We were doing them at Smashbox. We would spend all day rigging and setting up the show. When I was rigging that November and December show, we had two or three presold tickets at both those shows, and we were are like, "What are we doing? Is this dumb. Is this a waste of time? Are we wasting our money?"—

DEMETRI MARTIN: It's really hard to start a show.

MJ: And then the January show, you were on it, and it was the first show we sold out.

DM: I'm so happy to hear that. That's nice. That's amazing. And you guys survived. It's so hard. And nobody knows—nobody knows that. Not just that show, but we all show up. And most comics have never produced a show. They don't know how hard it is. I never did it, because I knew that. I'd see my friends do that, and I'd be like, This is a nightmare. That makes me feel good.

MJ: It's a very pivotal moment in our history.

DM: That makes me feel really good. I would never know that, or even imagine that. I'm not a big draw. I'm not a lot of things. But there's a symbiosis there. It's the kind of room that I love. The two rooms I really love here are Largo and the shows you guys do . . . Wow, that's really nice. I didn't know. Yeah, I didn't know that. So glad it worked out.

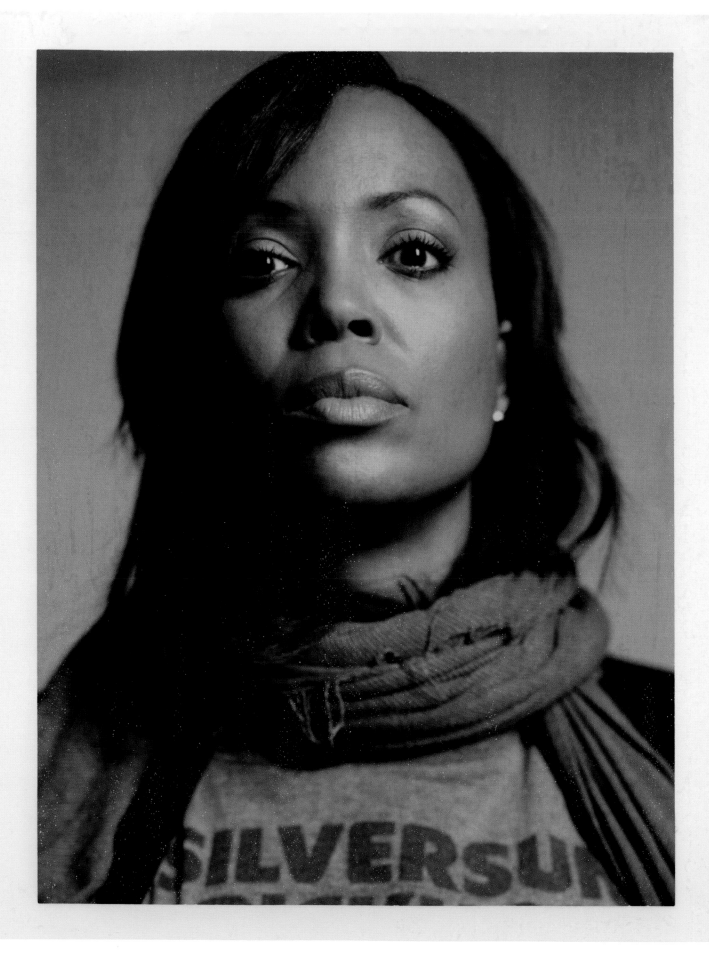

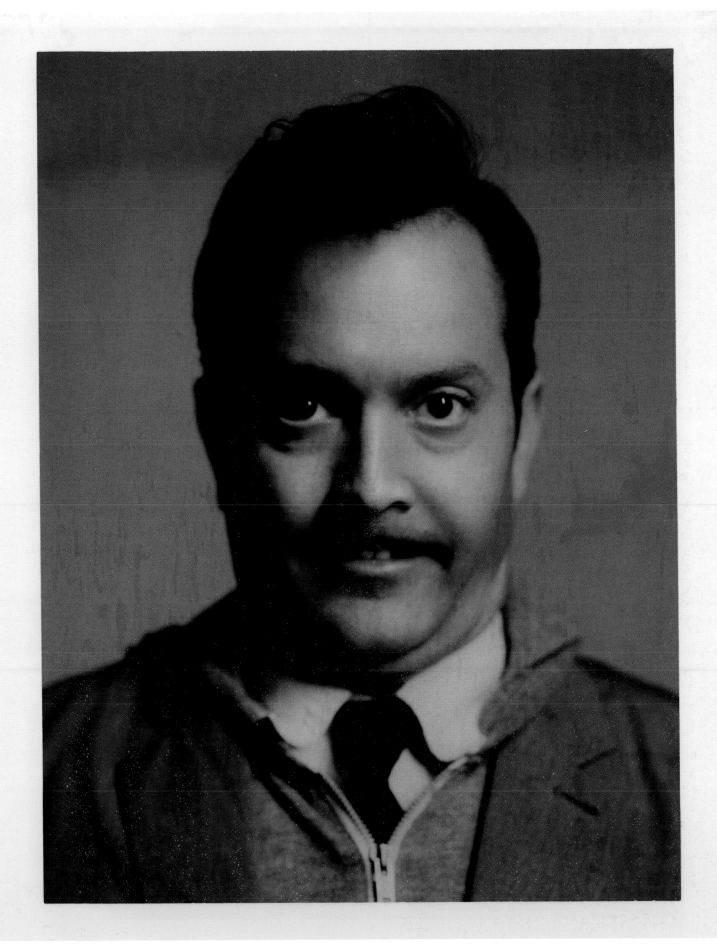

ANTHONY JESELNIK: When I came back from New York in 2012, I was still doing the indie shows. Improv sometimes, never Laugh Factory, Comedy Store was garbage. Now Comedy Store is the best club. I still loved the independent shows. I don't know how much they loved me as much. Before, it was like, "We get what he's doing." And now I think they're like, "Why is this jock up here telling us . . . ?" They don't get the nuance of the act anymore. I think I'm too established. Now I'm the man. So people treat it differently.

MJ: I love the idea of you being the establishment. It's very funny.

AJ: I think it's whilarious. I loved when I was a surprise. That was the independent

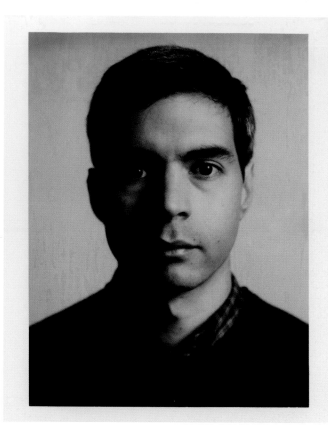

scene coming to New York or coming to different shows in L.A. They were just like, "Whoa. What did he just say? Is he . . . he's getting laughs, but he's still yelling at the audience? We've never seen that kind of thing. He's playing a villain." It was so over the top, they got it. I've made it more grounded.

MJ: Do you think it's because people believe that that's who you are as a person?

AJ: Yes. Yes, I think they must. Young kids are like, "You're being an asshole," and it's like, "I'm here to make you laugh. What do you mean? How could I possibly be an asshole and do this?"

MJ: Has that always haunted you, the way that you look more like a preppy jock?

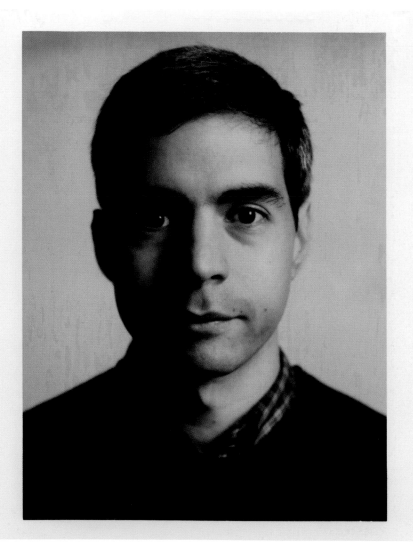

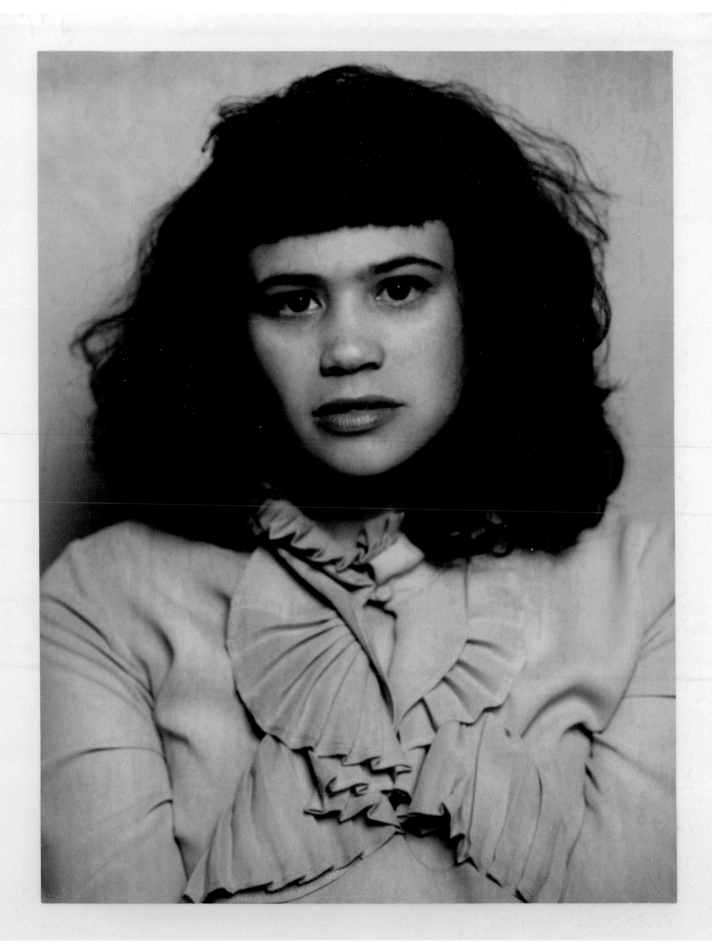

RON FUNCHES: I just had my six-year anniversary, so Fourth of July 2013. Things were just good timing for me because when I was coming, it was kind of this new golden era of shows going on. That was when the *Meltdown* was really popular, and to me that was kind of my oasis, where I was like, Oh, this feels like when I was doing really good Portland shows: they're nerdy, they're young, they understand the references. To me it was like going from high school to college, where you're just like, Oh, wow, this is fun and harder, and a lot more people are good; there's so much more, *Oh, I've got to really work hard if I'm going to stand out.*

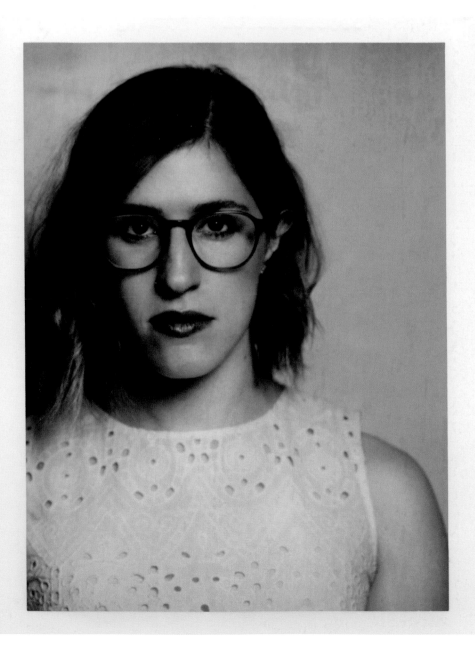

MJ: When you moved to L.A., did you try to get passed at the clubs in addition to performing on the independent shows?

BLAIR SOCCI: I never touched the Store for years—until last year, actually [2018]. It was never my scene.

MJ: Do you feel the independent scene helped give you the time and space to find your voice?

BS: Very much. Also, it was a big deal to do your shows [*The Super Serious Show* and *Hot Tub with Kurt and Kristen*]. You made it so special. You got paid, there was a poster, it was well run—the little sheet where you know where you are. That's not an L.A. thing, or at least it hasn't been. I think some people are getting on board with that now, but it wasn't organized, it didn't feel like. We were all showing up hoping for stage time, and stage time was the payment. And you guys made it feel special; you wanted to do really well. I think it's endemic to L.A., to get up onstage and mess around: "I don't know, what's next? What else? What do you guys want to talk about?"

AJ: It didn't haunt me; it informed me. Oh, these people hate me the second I take the stage. Let's lean into that. Let's become the villain. I didn't start like this. I understand why you don't like me; I wouldn't like me either. If I was watching your show and a twenty-four-year-old who looked like me walked onstage, I'd be like, What are you going to tell me?

What if I'd just been doing this forever? And I was a comedy savant? And you just hadn't heard of me yet but I'm amazing? That's where the ego came from. I'm the best. I've been doing this for six months, but I'm going to try and convince you. Because the other way is so painful. I hated being new. If I got in a time machine and went three years in the future, I would have done that. So I was like, Let's just pretend. And the audience kind of went with it.

MJ: Did that help with your pacing and your swagger onstage, to give you that character ego?

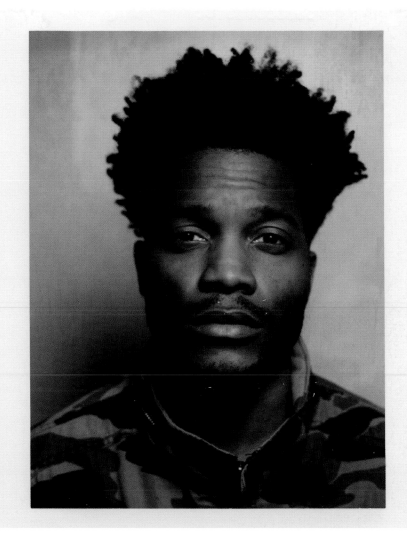

Right now [2019], comedy's better than it's ever been, in my opinion.

—Andy Kindler

AJ: That helped a little bit, but most of it was nervousness. I'm deadpan because I'm fucking terrified. I can hide it with being deadpan and being slow. I like the idea if the jokes are good enough that I can just stand here and say them and you're going to laugh, I don't need to sell it. I can just tell these jokes. They're that good. That was how I started out. I didn't take the mic out of the stand for ten years.

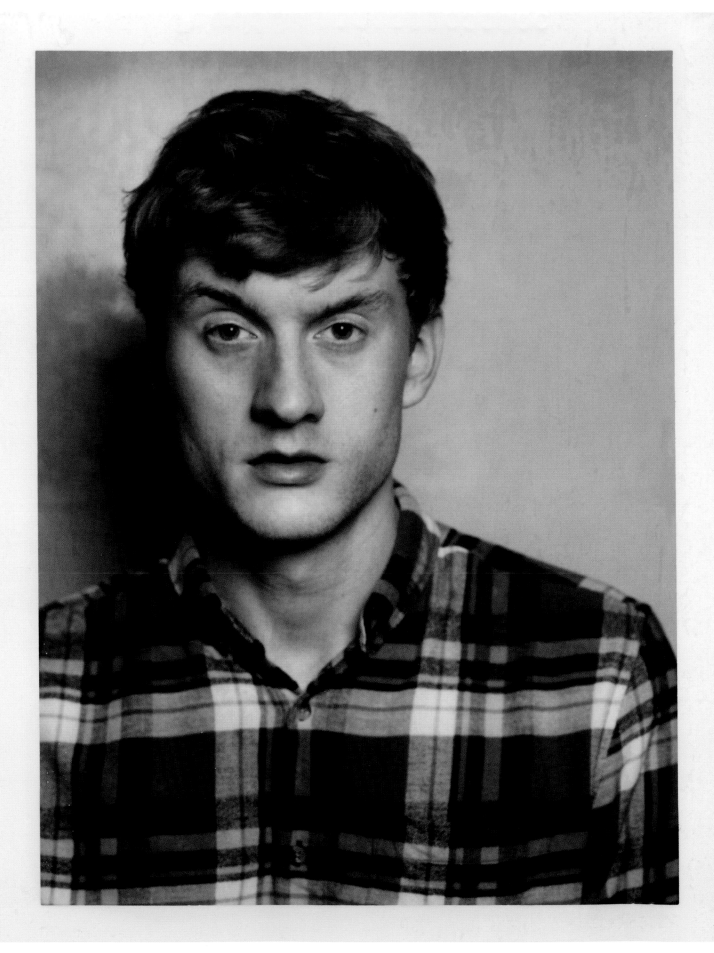

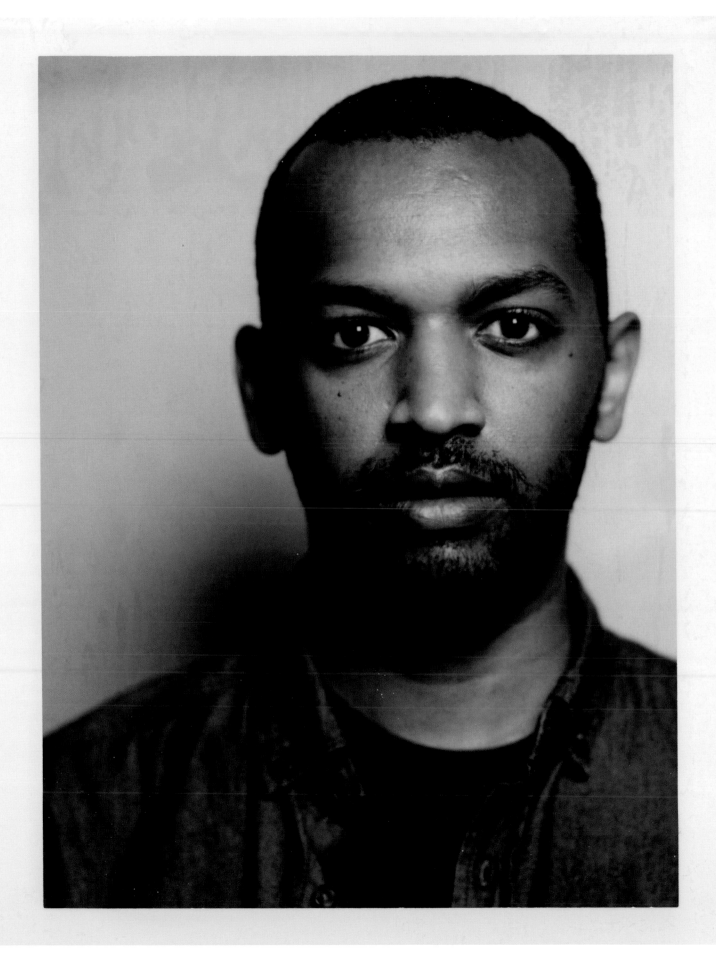

INDEPE

NDENT

TOP: **LEFT-**SEAN O'CONNOR, **RIGHT-**PETER ATENCIO, **BOTTOM: LEFT-**KURT BRAUNOHLER, **RIGHT-**JAKE WEISMAN

MANDEE JOHNSON: "Punk rock" is a term people keep using to describe independent comedy.

DAVE ANTHONY: It's interesting, you know. It's do-it-yourself, and that's what punk rock was. Do your own shows; do them in living rooms and all over the place. It's because all these comedians were carved out and left out of the mainstream and all of that bullshit, and they didn't have a place to go, so they started doing it. And then guys like you saw that, and you were like, "Oh! I can help out with this!"

MJ: We just wanted to be a part of this community, and we wanted to put together a show that we thought was cool, put on comedians that we'd like, and share with other people. It was that simple.

DA: In the beginning of alternative shows, that's just not what it was like at all. In the beginning of alternative rooms, it started with people who were not alternative booking it. It started with people from the business, from networks, booking alternative comedy rooms. So while the comedy was alternative, you'd normally see the politics were almost worse than comedy clubs. It's gotten away from that.

The clubs are always going to be good for whoever they're good for, and I'm glad they exist for a larger structural reason. Comedy needs both to thrive. It needs the formal system to be taken seriously, and it needs the punky energy of independently produced comedy to keep being pushed forward and to evolve.

—Monika Scott (comedian + producer)

MJ: At our shows, you've always taken a moment to thank the audience for coming out and acknowledged that it's an important place for people who create art.

REGGIE WATTS: It is. It is because it's unlike the club scene. It's not really . . . it runs more on the basis of "We all love comedy." The lineup loves comedy; the promoters love comedy. It's a tool for promotion, and you can use it to gain experience, community. If you're running a show, you can make money off of it, you can sustain yourself, you can put it back into the show. But, mostly, the sentiment of it is just purely for the love of comedy and performance, as opposed to a more traditional comedy club, which, certainly, of course, they don't exist without the love of comedy, but it's a little bit more tied directly into the industry.

MJ: Yeah, I think that's an interesting part about the independent scene. It's more creative in that way, more supportive, more community based in so many aspects.

RW: Yeah, of course it is. It's an opportunity to see things that you wouldn't normally. Weird shit that you're not going to see anywhere else. It's also a place where it's a blurry point between performance art, experimental theater, and comedy. That's what I like about it.

110

RYAN SICKLER: I think it's funny it's got this name "independent comedy," which I feel like almost does it a disservice in a way because it's . . . I feel like independent comedy is more mainstream than a lot of the clubs. I know it means independently run, but also that, to me, just in my mind, sounds small, and it's not.

I feel like most of the independent shows is where you're finding the real talent for these TV shows, the diverse comedians. They're getting their starts and thriving in these independent scenes. Some of them don't even get up onstage at these clubs. You'll see them in sitcoms, you'll see them in movies, you'll see them everywhere. I think it's important; it's imperative.

ASIF ALI: The independent scene has been so good and nice to me. For example, Dave Ross. The best. The nicest guy in the world. I would do his open mic, and then he was so nice. Every once in a while, he would put me on his show. And he probably doesn't think that's a big deal. But it was a huge deal. Huge deal for me, right? I'd put so much thought into my set and making sure that I crushed all the time and making sure that even when I did his open mic, I would always be writing new shit. I just wanted to have that muscle to be able to do that all the time.

MJ: It's funny: Hasan specifically said that Dave Ross was a huge deal in his—

AA: He doesn't realize it. He's an anchor in the same way you and Joel are . . . Shows are host based. He kept it so fun. Your guys' shows, it all felt kind of punk in a way. We're doing weird, interesting shit. I've always loved that whole DIY.

MJ: What do you think the importance of independent comedy is?

AA: As a comedy fan, you don't realize. If you're just watching shows, you don't realize how important it is, because especially in places like L.A., if you go off the number of clubs in L.A., there's three . . . on a given night, that's maybe ten shows happening. The number of comedians that are here and the amount of time and development it takes to become good and fully figure out what the fuck you're doing—which, by the way, takes forever; you never really figure that out—for that to be enough time for people to grow and get good, there would only have to be a couple hundred comedians. And, so, the importance of the indie scene is it gives them the ability to do shows and figure out what they're doing and build a community and not feel like they're constantly on the outside looking in.

It gives comedians all these really fun shows that people you know are running. You can do those shows and build on that. It's really important to have this thing you're working toward. Then you do it, and there's actually a great audience, and you feel valued. But, more importantly, it gives you a sense of community. And it gives you something. Not everybody is perfect for everything. Not everybody is that club comedian. Not everybody is a full alt comedian. It's good to know that there's somewhere for you to be.

MJ: I think in a healthy live comedy ecosystem, you—

It's huge, man. It's so big. It's so undervalued.
—Asif Ali

AA: You do both. It's really important to have that healthy ecosystem of everything. It's incredibly important. It also keeps comedy alive. It's nice to have a way for comedy to survive long-term. I feel like when it ebbs and flows, the thing that stays constant is these DIY places. DIY places stay constant because their overhead is much lower.

MJ: True. And it's not about making money.

AA: It's not about making money. They're just doing it for the love of the game.

BARRY ROTHBART: I think it's important to have parts of the comedy scene that aren't completely financially driven. I think that's the importance. I think once you involve a lot of money—which, clubs are a lot of money and big business; people are making a ton of money—I think it'll always breed some sort of limitations. I think there will always be a little more freedom with less money. I think that's most art. I think that as long as we make sure that we don't ostracize people like that from the indie scene, I think it'll serve its purpose. You're allowed to bomb trying out some weird shit. Where you might not be allowed to bomb as much at a club . . . I think when you involve money, failure has more risk. I think that's the basic need for a healthy independent scene in any art.

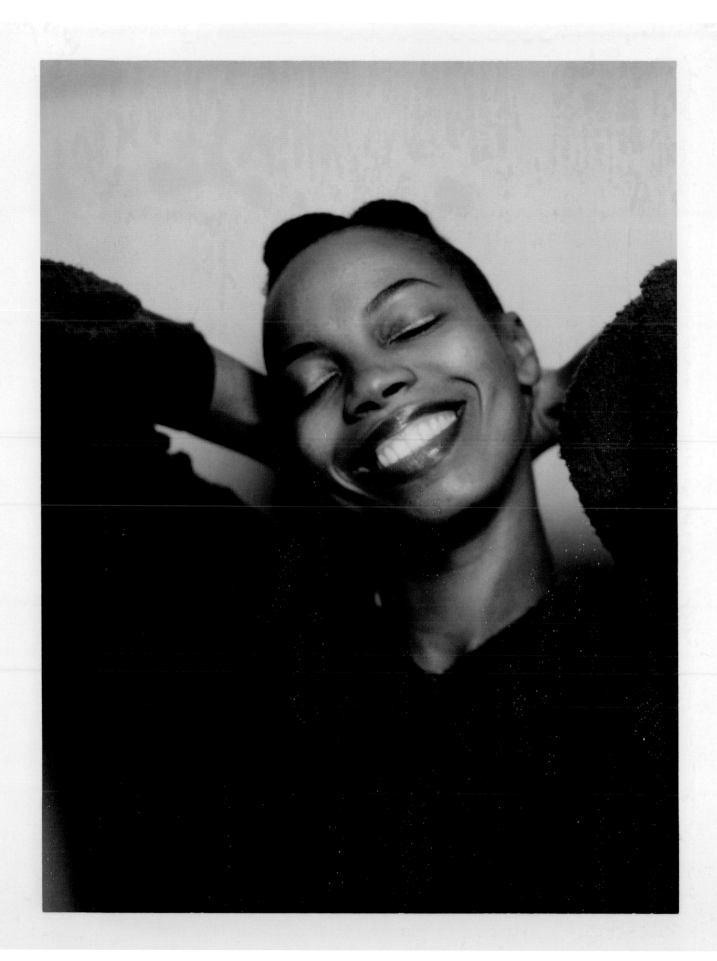

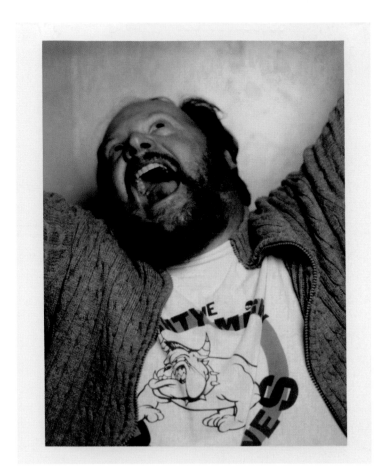

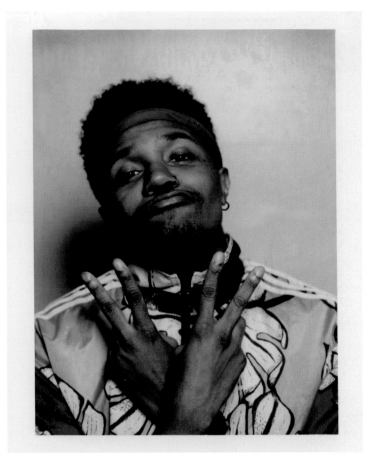

You're allowed to bomb trying out some weird shit.

—Barry Rothbart

ANDY PETERS: I think independent comedy cultivates comedy as an art form. Comedy right now is more of a legitimate art form than it's ever been. That's because it's treated as a community and less as a company or entity. Indie scenes and the independent do-it-yourself spirit have created so many styles, comedy-wise. Long ago it was considered art, but I think now because of the independence of it and that there's no rules to it, there's no one saying you have to do setup–punch line or you're not a comedian; that's the old-school mentality. You go to your shows at the Virgil, and you see people doing character stuff, riding bicycles onstage, throwing toast at the goddamn audience. It's free.

KURT BRAUNOHLER: New things can come out of [the independent comedy scene]. Clubs are very important, because they make money and they make comics money, but they are a business model that's primarily based on needing the audience to sit there for an hour and a half so people can eat food and drink beer. Whereas independent comedy is . . . nobody's getting paid, everybody is doing it because they love the art, and I think that's why . . . more unique shit comes out of independent stuff. I like that you're calling it independent. It used to be called alt comedy.

MJ: I know. Joel and I are real sticklers about it.

KB: I like "independent comedy."

It's not alt anymore. People who are just doing independent shows are doing stand-up that can go into clubs.

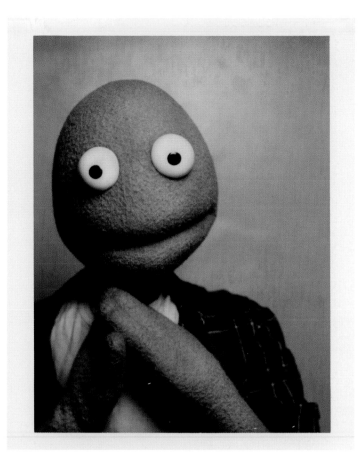

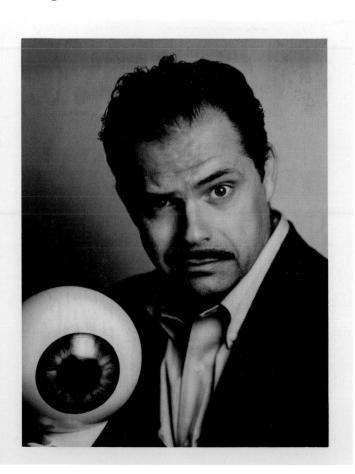

JUSTIN WILLMAN: Once I found the independent pocket in L.A., I really felt like I found my core group. It's about finding that safe place. If you're doing a show at a club or whatever, sometimes you feel like, *I've just got to go out and do what is my best fifteen*. But I feel like there's less learning and growth in that versus a place where you can go and do something for the first time or go and do something that really is fresh and you can learn where the beats are. I feel like there's a safe space in that and only a few rooms where I feel comfortable enough to do something that could fail. I think that's when the best stuff happens. You're doing something that could completely just be a bomb. If it turns out being great, you wouldn't know otherwise if you didn't have a room where you felt like you could have a safe space.

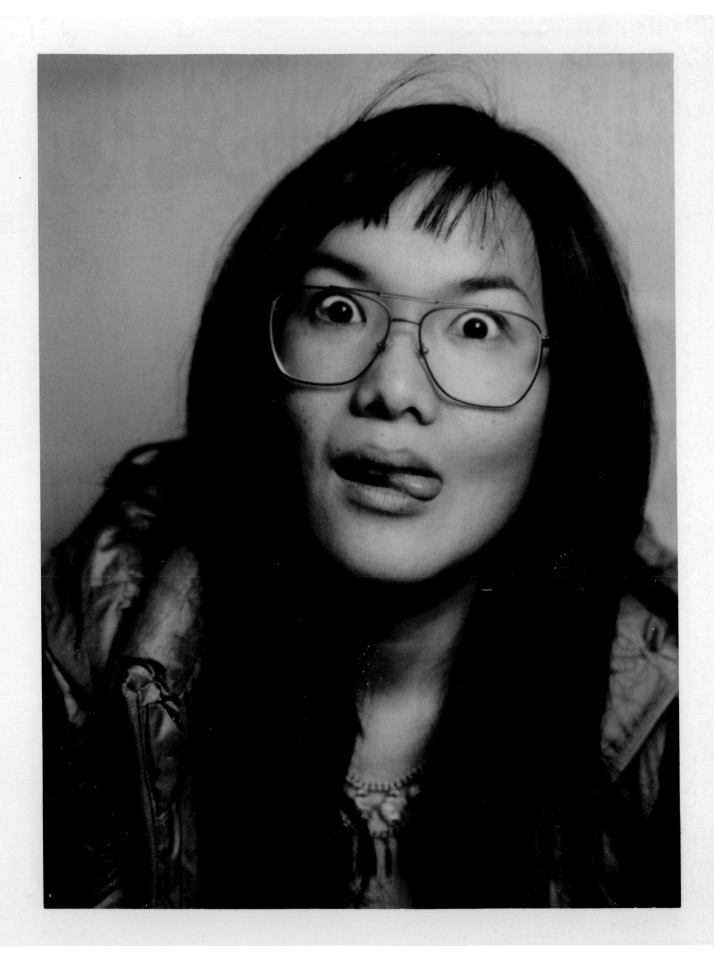

NATALIE PALAMIDES: People were really welcoming in the stand-up scene, which I was surprised by because of so many stories I'd heard of bad open mics where no one laughs at each other. I was a little bit nervous to delve into the stand-up scene. Everyone's so cool and chill and supportive. I think they welcome something a little bit odd on their lineups too. Even Kurt Braunohler, he just did a show on a [gondola]. They're all doing weird shit.

That's how I came up with a new bit where I'm a mermaid, and I made it originally for the gondola show because Kurt told us we could swim. I was like, *Well, there's no way I'm going to do a show where we can swim up to a boat and not be a mermaid.*

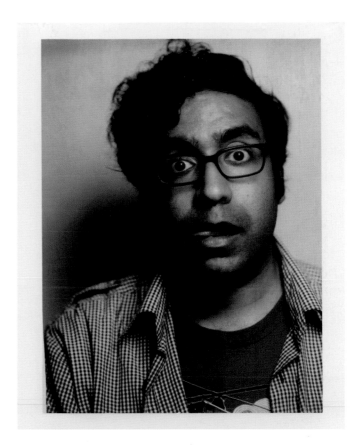

MJ: How do you do it when you do it onstage?

NP: I have them pull me out in a baby pool. I'm pouring a jug of water on me to keep moist. But, Mandee, you've always been really supportive, I have to say, of my weird comedy endeavors. I know if I come do *The Super Serious Show*, I will always be supported by you and Joel.

MJ: Always. Your crazy characters are always the best. Always finding ways to have water onstage—

NP: I know. I don't know why it attracts me so much. I was actually recently looking up ways to bring a fish tank onstage.

MJ: Do you think that you would have found your way to where you are now if you hadn't been able to go and do ten-minute spots on these independent shows?

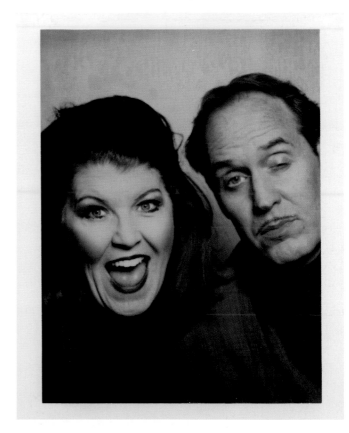

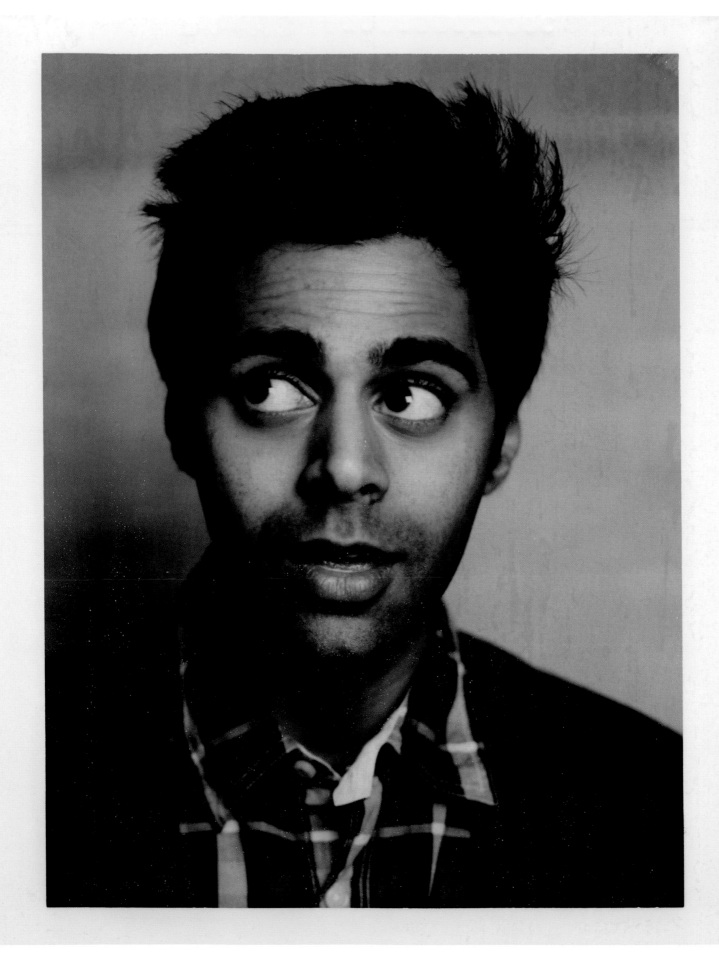

NP: I don't think so. If I couldn't have just gone up and thrown shit at the wall, with open arms—people welcoming me onto their stage with open arms—I don't think I would have been able to develop stuff. So much of what I do is developed through a relationship to the audience. So having the audience there is a really big part of it.

MJ: It sounds like you still use that as a way to develop new things. Who knows, this mermaid thing could be a whole one-woman show at some point.

NP: Once I get the tank made . . .

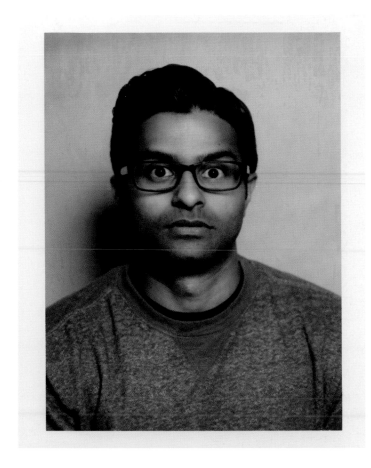 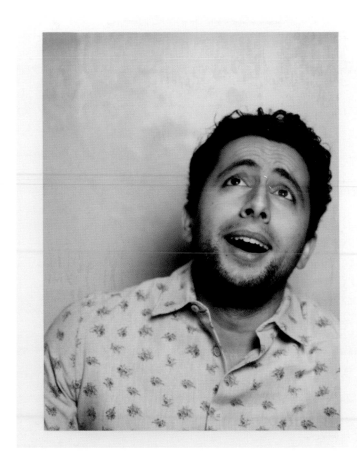

RON LYNCH: There are so many venues that support a greater variety of comedy. And the number of people that now have more places giving them the freedom to do whatever they want onstage has increased greatly. The name "alternative comedy," which has always been a silly name to me—which, I suppose, is now "independent comedy"—simply means not mainstream comedy club stand-up. The dividing line is fading, and the audience is changing constantly. When I used to see someone on a primarily stand-up show do something weird or different, I used to think, "Where else can they do that?" Now there's tons of places where anything goes.

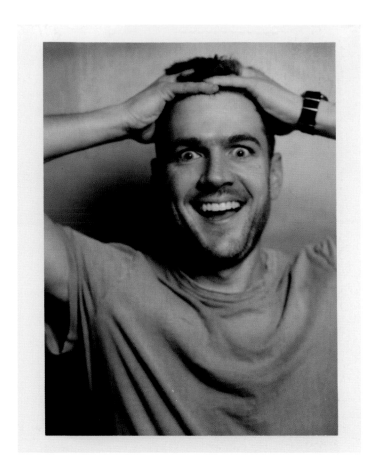
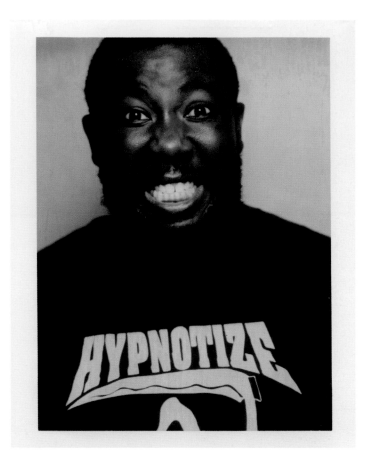

When you really break it down, independent comedy is the kitchen, clubs are the dining room. Independent comedy's a little bit more about what's the process, and if you're fed a delicious meal in a kitchen you're not going to complain. But clubs are like . . . we don't need to know how you make it, just serve it.

—Sean Patton

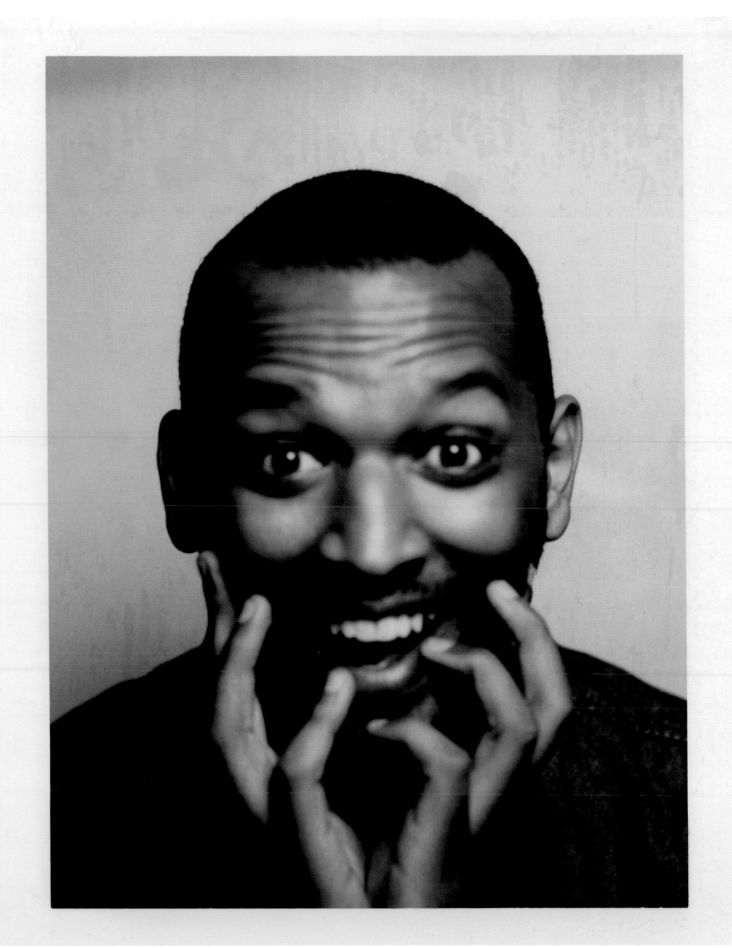

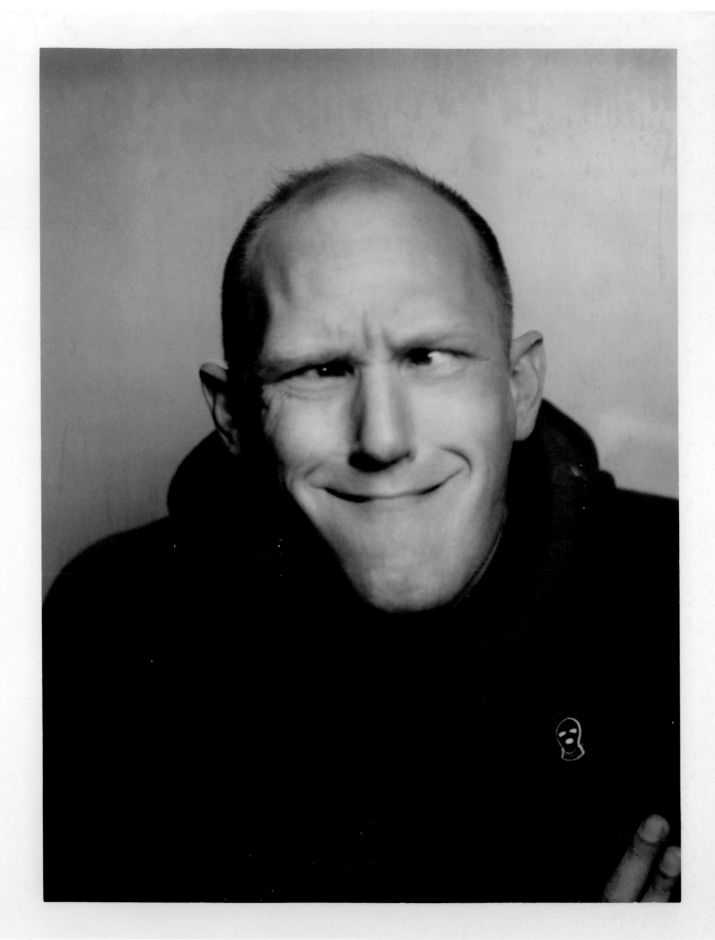

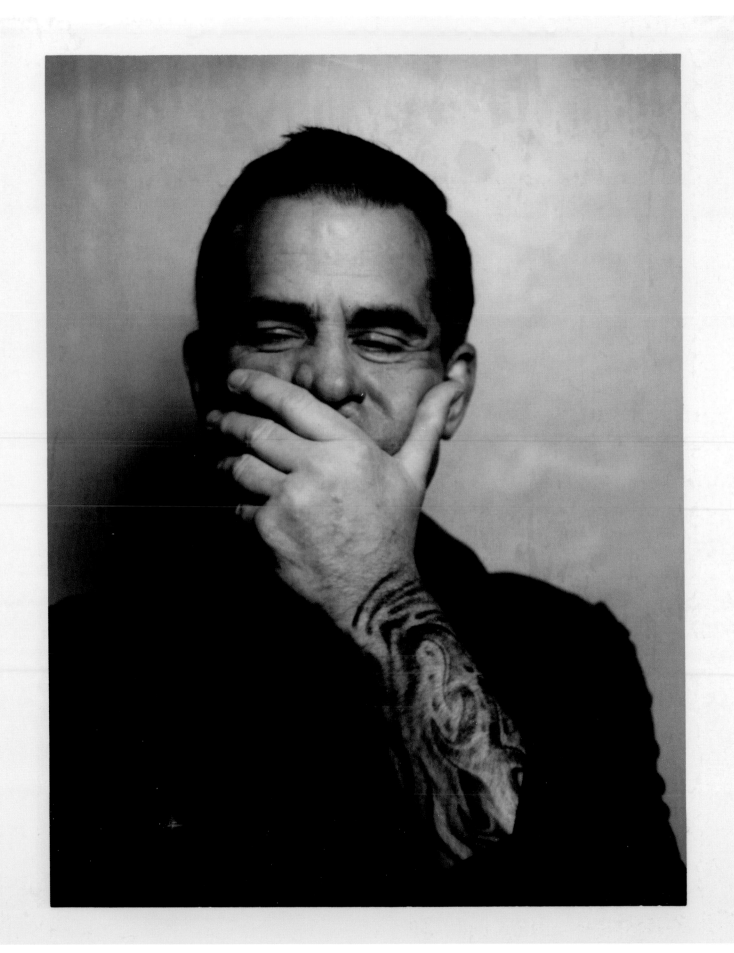

ANDY KINDLER: I think independent comedy reinvigorates Los Angeles . . . Look at Flappers: they opened up a club in the middle of all these strip malls or whatever, and to me, that club could be in any small town anywhere outside of L.A. We've got to appeal to this, we've got to appeal to that, we want to run a broad comedy club. It gets very hard. When you have an independent show, you just don't have to pay attention to those "market-driven" things which really aren't even market-driven things because I don't think people really want to see that . . . It's cheesy.

MJ: Yeah, the only point of producing independent shows as a producer (who doesn't perform) is if you get joy out of it . . . You're just curating the show to what you like, what you find interesting, what compels you. Versus what compels a bottom line.

AK: Right, and the thing is there's also a spirit to it because comedy is supposed to be aimed at taking a piss out of the big guy. It's supposed to be fighting for what's right.

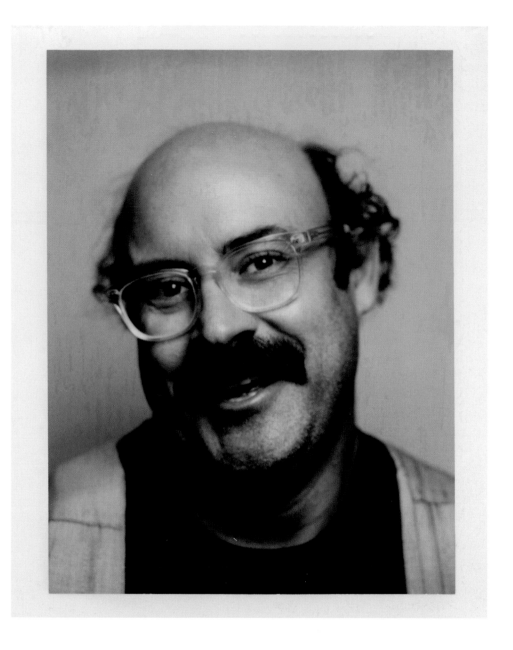

Live comedy is really honest. You can see in real time what people's response is to what you're saying.

—Parker Seaman (director)

JAKE WEISMAN: Oh, the independent scene is vital . . . It allows you to think differently. It allows you to fail differently which is sometimes the best way to learn. I think the independent scene is remarkable simply because if you just think about it on a purity level, what's so beautiful about comedy is you just need a fucking mic. The fact that people can have careers and do amazing things just by showing up to these weird little fucking rooms in the corners of coffee shops . . . that's the beautiful part of it. Just the fact that people started open mics. That to me is the most independent thing ever. It's a very almost entrepreneurial sort of American Dream kind of thing. If you don't have independent comedy, you essentially don't have comedy.

The independent comedy scene of L.A. is directly responsible for essentially why I have a career and why I'm still alive. It allowed me to work out a lot of different things and find out who I was. Any scene that is not regulated is always going to have its issues. Freedom comes at a price. But, oh my god, the beauty that it's created is stunning. The creativity that it pushes forward and forces you to come up with is the best. If it were only clubs, that would just be terrible, because then you're just at a place that is trying to sell dinner and drinks to you.

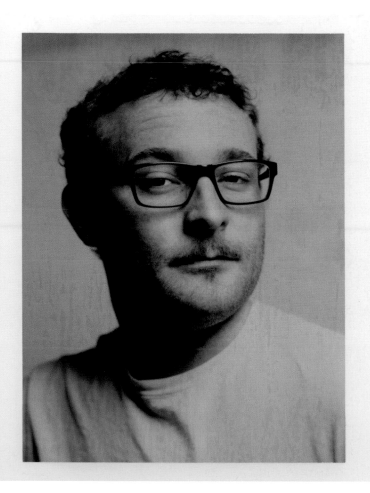

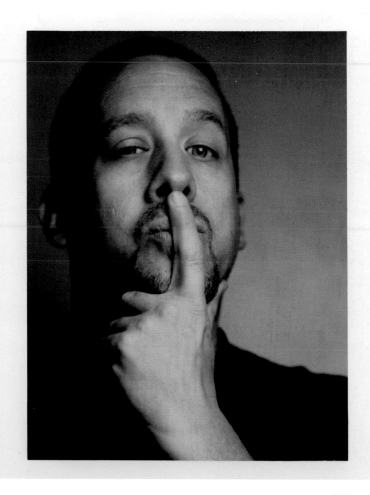

LEFT: JAMES ADOMIAN, **RIGHT:** RYAN SICKLER

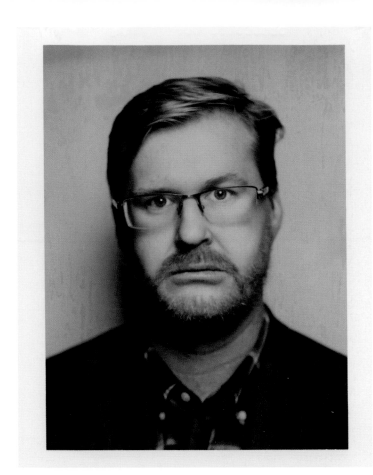 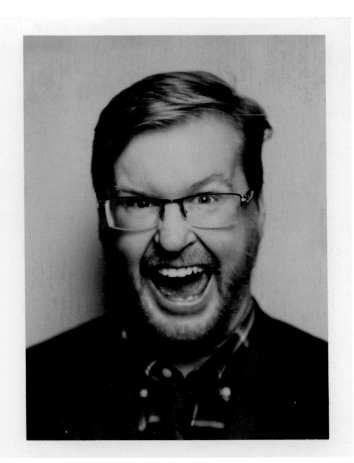

With clubs, you already have a system in place. You don't have to set up the mic or chairs. Independent stuff . . . it teaches you how to build things from the ground up, how much work you need to put in, how much attention to detail you need to give in order to create something great.

You're doing little stuff where it's like, Why are you doing that? Because you care. In order to make something awesome . . . you have to work when people are not working. You have to put in more energy to it than other people will. The best things in life come from putting everything into it.

You guys, I'm sure you make a little money, but you really are just doing some sort of charity. And it's because you love the thing. And it's because you work your fucking ass off. If you didn't, it wouldn't be that great a show.

I think since the nineties, there's been no break from alternative comedy, and it's just become more mainstream now.

—Andy Kindler

LEFT PAGE: KURT BRAUNOHLER, RIGHT PAGE: KRISTEN SCHAAL

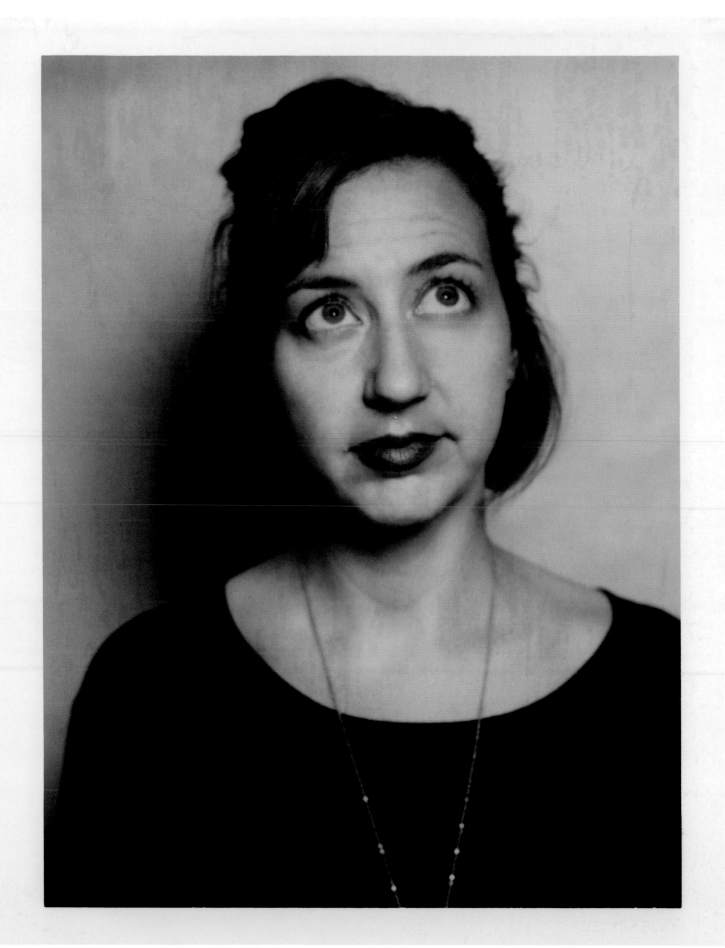

KATHERINE LEON (PRODUCER): I want people to make stuff. I want people to be able to make things that they want to make in the way they want to make it. A lot of the live comedy that I'm around is being used to test or work out ideas that can become something else that doesn't need to live on as a live show. Live shows can hone in a character or idea or an hour in such a unique way because of the immediate feedback from the audience.

Independent comedy is a bunch of weirdos putting their heart into something. It allows comedians to try out what they want, and it gives them an opportunity to shape it into exactly what they want. And things can just live as a live show if they want it to be. It almost makes it more special because you can experience this fever dream of a show with those people in that room watching something together.

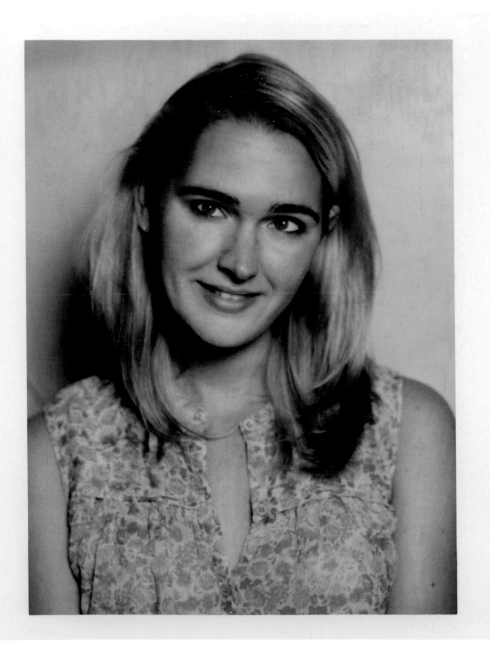

CHRIS GARCIA: I'm not one of those people that's like, "I take hard political stances," or "I'm not a concept person." I'm just always processing what's going on in my life. Whether it's my dad getting sick or me getting married. There's all these little things. I think that comes from having independent spaces. To feel comfortable being like, "Right now I'm thinking about being a dad, but I'm scared because of this." Those are the types of things that you reveal in those types of cool places.

MJ: I think that's super important because it demystifies life and personalizes it. I remember the first time when one of my nieces came to visit me for a month—she was young and wanted come see *The Super Serious Show*, when it

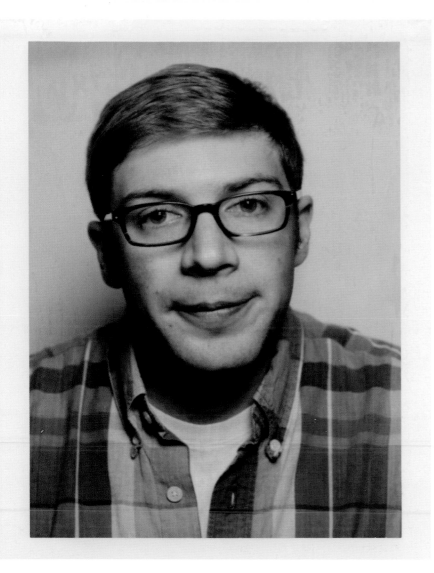

was still at Smashbox. We wouldn't let her watch the video, because the video was super dirty. We were like, This is obvious; she can't watch the video. She was so annoyed with us. The rest of the show was surprisingly fine. And then a comedian did a bit about masturbation.

When we were driving home after we had wrapped, I was thinking . . . I don't know? Is there a better way to hear about masturbation? In this moment a comedian is onstage sharing what could be perceived as something embarrassing, but they're sharing it openly in front of two hundred people, making them all laugh. Versus learning about it in the bathroom, where it could be seen as dirty, wrong, or a mystery. Maybe that's a moment someone would be ashamed about, but a comedian finds humor in it; they share it, and that it normalizes other people's experiences.

CG: Yeah, you feel less alone; you feel accepted and seen. That's important.

MJ: I think that that's what your style of comedy does for people.

CG: It normalizes it for me too. I don't know who it's for, but a lot of it's for me. It closes the circle to be able to articulate it and connect with people.

MJ: It's so impactful. I'm sure that you feel that when you talk about your stuff with your dad, the way the audience treasures or responds to those moments.

CG: It's really scary to put yourself out there. It's humiliating to do stand-up. It's stupid and embarrassing. It really is. And so to put yourself out there and for people not to like it, when it's so personal to you, is a nightmare. But if it connects, then it's the opposite of a nightmare. It's so satisfying. Reaffirming. It's a lovely thing.

Even though we're narcissistic egomaniacs, there's a lot of humility required to be a comedian.

—Pete Holmes

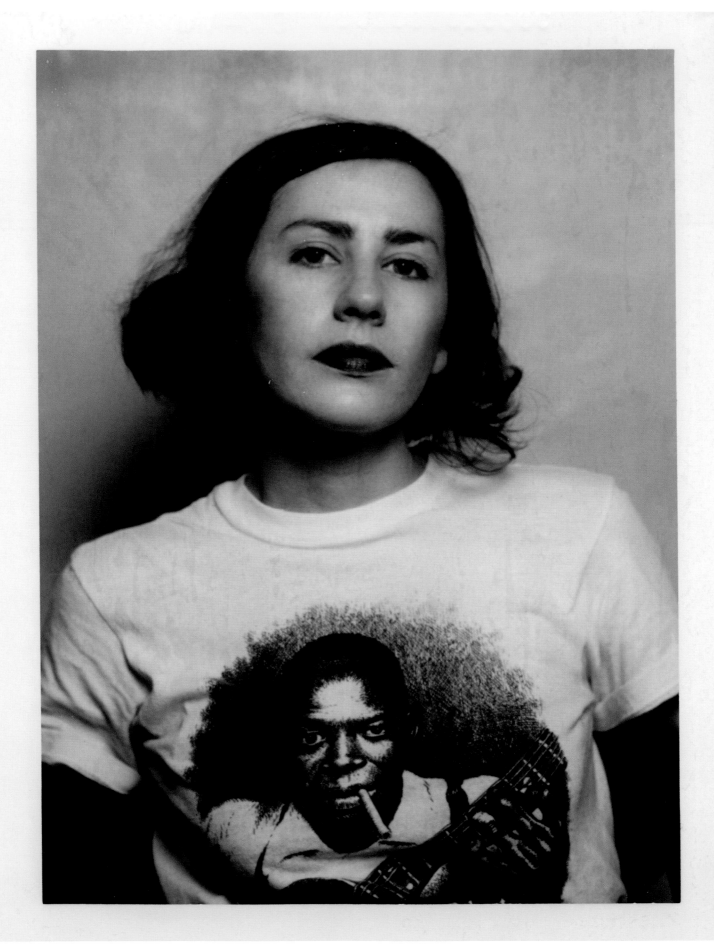

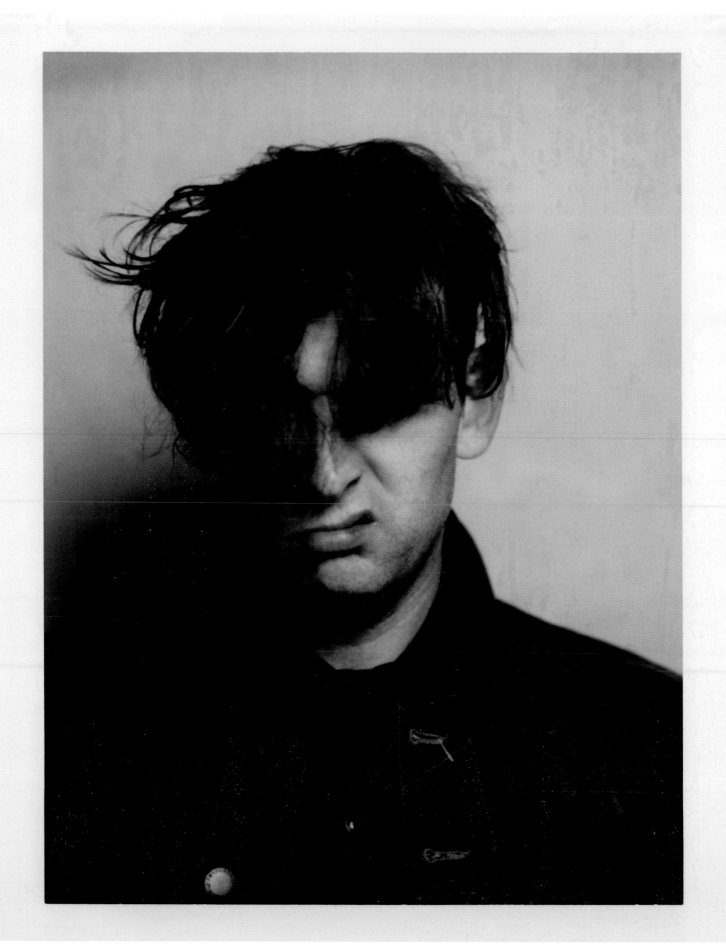

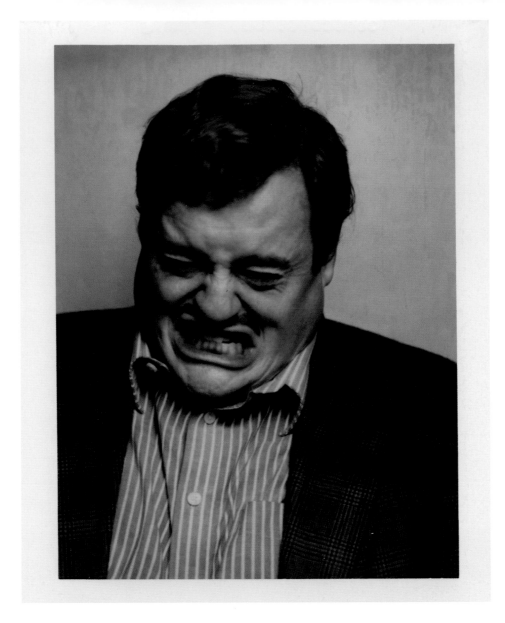

PETE HOLMES: Independent Comey is a space [where] nothing was happening so you can do anything with it, as opposed to clubs [which] always suffer [because] there's an expectation. Any sort of expectation. Exceptional comedy that just happened to be happening in a church is incredible. And magic. There's more ownership of it for everybody involved. More ownership for the audience. Do you ever consider that they feel good? They made the show good. They showed up.

MJ: They're part of the show. They're part of what makes the show great.

PH: Of course. And if it's not just this "Of course it's good! We pack 'em in, we chill 'em out, we get 'em drunk, we blast the music; it's like a TV taping"—if you can bring good energy to a church in Los Angeles on a Tuesday, the audience has more ownership, the acts have more ownership. It's not a foregone conclusion, but it's [not] like, "Yeah, comedy happens here; it's a comedy club." It's like, "No, we *made* comedy here." It's like seeing an alien abduction; it's more exciting.

MJ: It allows for it to be truly yours.

PH: It has a magical feeling.

DANA GOULD: That's when a scene happens is when a performer or a group of performers mirror where their audience is in their life. I think that's really valuable. That's what I think the difference is between regular stand-up and alternative stand-up. It started when we weren't just performing and talking at people—

MJ: But started talking to them.

DG: And I think that was reflected back, and I think that's what made it different. A lot of that is just the communication with the audience, and that was what made alternative comedy different: the performer's relationship to the audience.

MJ: It does feel like running a weekly show, you notice: not only do comedians come out for the sense of community, but you definitely feel the audience is there for a sense of community.

DG: I think that's the difference between alternative comedy and regular comedy. I also think that's what all alternative music does. In early rap and hip-hop certainly—for instance, NWA—they spoke to a specific audience. "I'm not trying to take you out of your life for a moment; I'm trying to legitimize your life."

MJ: Bring everyone together.

DG: And it's not escapism; it's actually the reverse. They're going to embrace who you are and validate your personal experience. The interesting thing about comedians is when you do have a relationship with your audience, you grow with them.

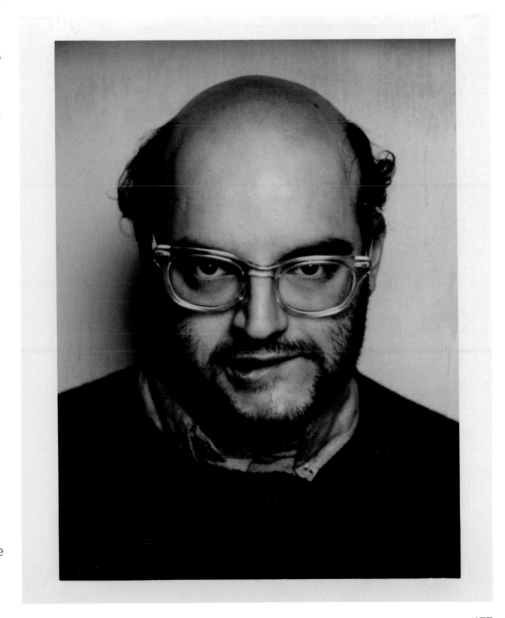

KRISTEN SCHAAL: I think that independent comedy is about grinding your way on your own and hoping an audience will come to you. And also for me, I just really like having a space . . .

When I was coming up, my favorite thing—I was in New York for like a week, and I was like, "What am I doing here?" and it was so overwhelming, and I stumbled into *Eating It*, which was created by Marc Maron and Janeane Garofalo, and Jeff Singer produced it. And it's where I saw Eugene Mirman and Jon Glaser and Todd Barry. And I saw all of these comedians that ended up becoming my friends eventually. Like Jon Benjamin performing with Jon Glaser. And it was $7, which I could afford because I had *no* money at all. I was royally struggling. And it was $7 to get in, and you got a free drink to go with it.

MJ: Wow, that *is* a good deal. An alcoholic drink?

KS: Yeah! It was a great deal. And those two things combined, it was something I could do every Monday night. I could go to the show, and I could watch. And I did it for two years before I even asked to perform there because I didn't think I was ready. That's what I like, and that's what comedy needs too, a place where other comedians or comedy lovers who don't have any money can go see shows . . . A night out is great, and if you want to spend a lot of money on a night out, you totally should. But comedy can exist every single night, and everyone [should] be able to enjoy it.

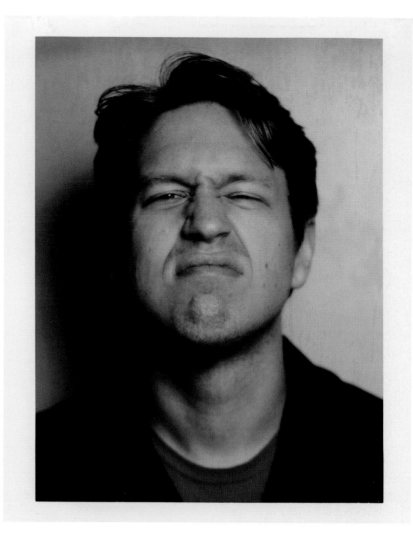

BARON VAUGHN: The thing about independent comedy is it is rarely motivated by the bottom line. Because of that, because people usually create shows because of their love and respect for comics and comedy. There's just a different . . . it creates an environment where comics can thrive, as opposed to getting eaten up by the competition that people can get wrapped up in. That way, there's always this breeding ground, if you will, of interesting shit happening. And the clubs are less interested in that. The indie scene is always evolving. It's always in front of the wave of what's happening with stand-up. The indie scene also is . . . what's the word I'm looking for . . . I want to say . . . accepting. Open to new people.

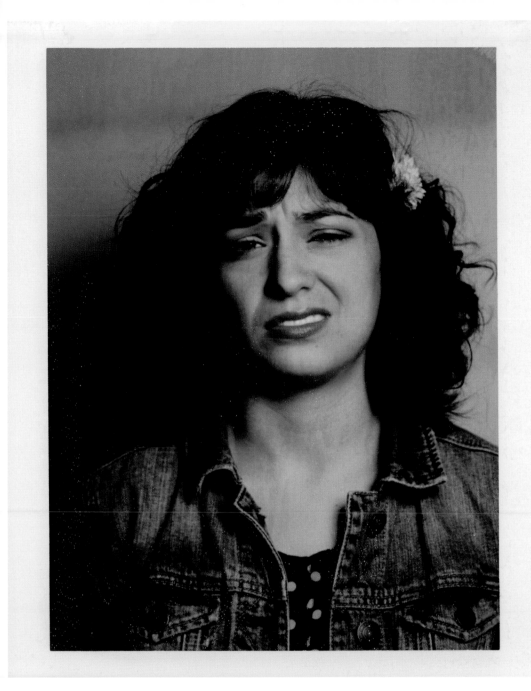

In those independent spaces . . . that's where you really throw the clay. And you mold it and maybe take it to the club. But you need that; you need that space.

—Chris Garcia

HASAN MINHAJ: The difficulty is how do you cultivate young voices? Because I understand that if it's a big show, you want to have premier talent on the show, but where is that grooming process happening? There needs to be a space for it, and that was what the independent shows allowed for. I got to see people like Allen Strickland Williams, Ahmed Bharoocha, Beth Stelling—like, these guys develop and cultivate. I got to see them become really, really great comedians, and it filled that which I thought was missing in those places: cultivate a talent and become the place to host premiere talent.

JOEL MANDELKORN: When money's not involved, you're free to go maybe a little looser with your goals on booking . . .

MJ: I think that producing an independent show, especially when it's your money that you put into it, you can do whatever you want. It's ultimately your show. No one's telling me who needs to be on my show. It's up to us, and we will either suffer

or be rewarded from them. An early thing people would say about *The Super Serious Show* that it was well curated and there was a distinct thought process toward it.

HM: To me, the show felt like eating at a great restaurant. Everything was cultivated or curated. It felt like it was an informed choice: the location, the lighting design, the feel of the show, the actual content, the meal of the show itself. That all felt like it came together and was a really amazing experience. For a once-a-month show, if you're a fan of comedy, that's a thing to go do. And getting to do your show, looking back on it, felt like, "Oh, I'm getting to do this really, really great show." And to say that I got to do that show that year is a big deal. Because all of those things were singing together.

You really have the freedom to explore an idea and fail [in independent rooms]. At a club there's a lot more pressure to kill because people are paying to be there.

—ALI WONG

RON FUNCHES: Independent comedy shows are on the ground floor of finding good comedians and developing them, giving them a chance to learn. People forget about things, like knowing how much is a six-minute set or a ten-minute set, not burning the light; these are all skills you have to learn so when you're on a TV show and there's real money involved, you're a professional. That starts on a base level. Knowing from the beginning that you're growing and you're building relationships. I think that starts with these independent shows because, like anything, if you're playing basketball or football, you don't normally start in any league; you start playing with your friends, and that's what these shows are.

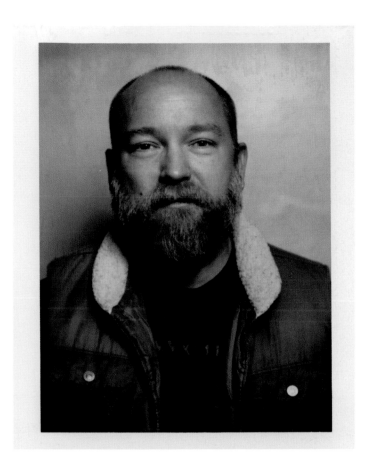
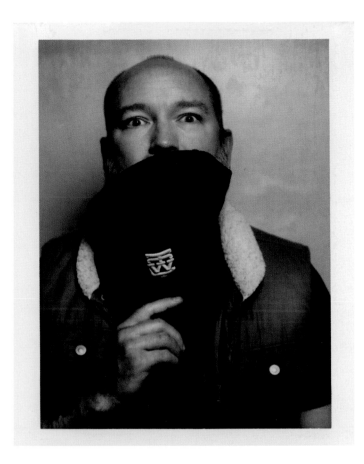
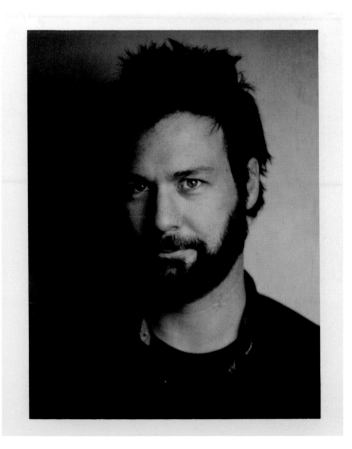
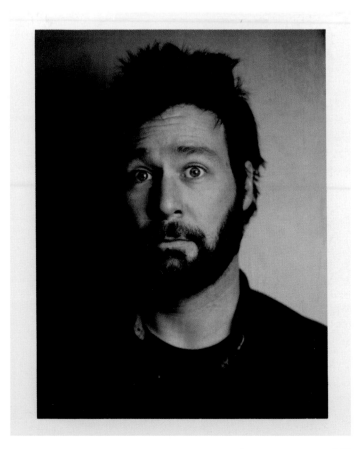

TOP: KYLE KINANE, **BOTTOM:** JON DORE

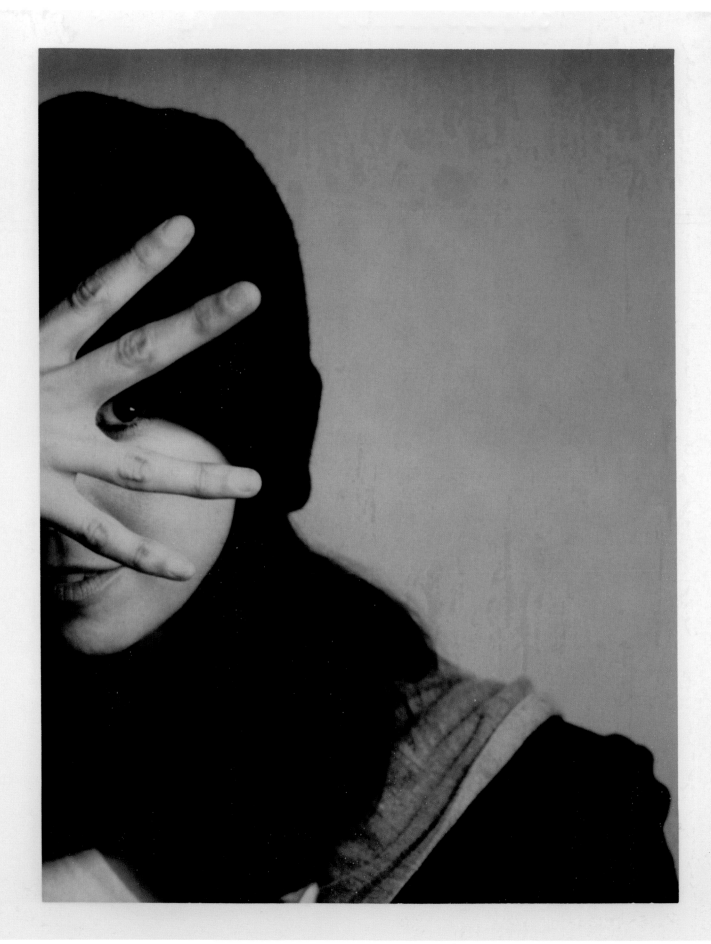

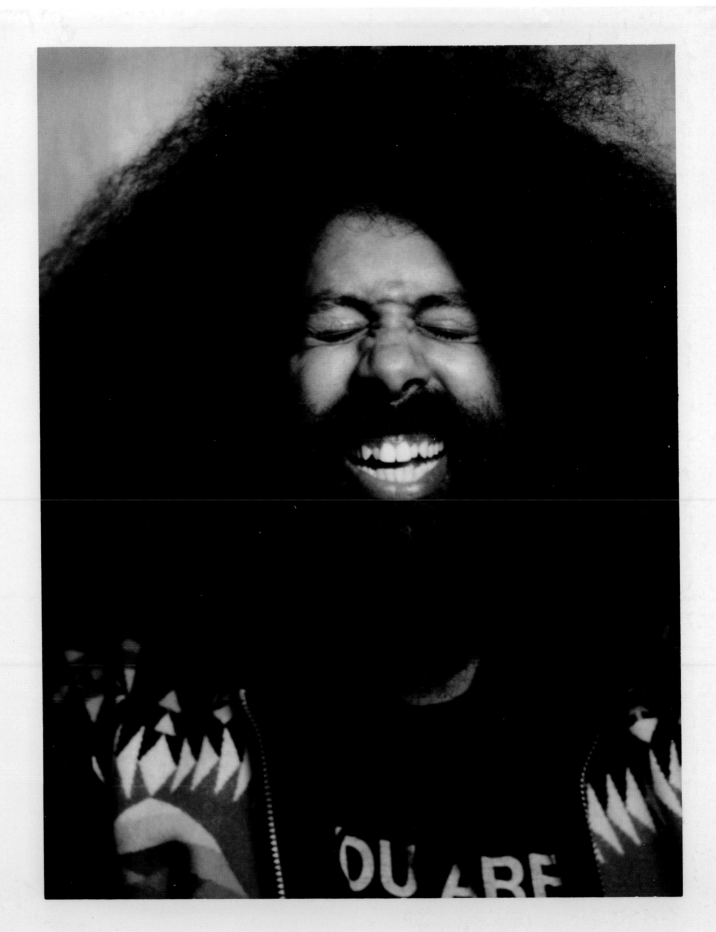

ADAM CAYTON-HOLLAND: Independent comedy is so important to me I can't even put it into words because I feel it should just be assumed. That's like asking, Why is independent music important to live music? Because it allows for voices to be heard that would otherwise never be heard. Interesting, intelligent, thought-provoking voices that may not rise to the top of your traditional club comedy chain of command, because odds are a corporate party who bought out ten tables on a Saturday night aren't going to respond to what they're doing. Indie comedy allows for those voices to learn and grow until they're so strong that you know what—they *will* crush with that corporate party on a Saturday night at a comedy club. Because they're that much of a pro they can even go into horrible comedy landscapes and do well. They just needed to hone their voices in a smarter environment first.

RACHEL BLOOM: It's getting rid of the idea of the gatekeeper—which relates to putting your comedy shorts on the internet. You can directly reach the audience. You don't have to wait for the powers that be. That's a very Western thing.

That's what doing live comedy does. The audience doesn't lie. Laughs don't lie. Lack of a laugh doesn't lie . . . When you're dealing with live theater or live comedy, it's right there. It gives you the urge to be current. Your audience is going to tell you if something you're saying isn't striking a chord with them.

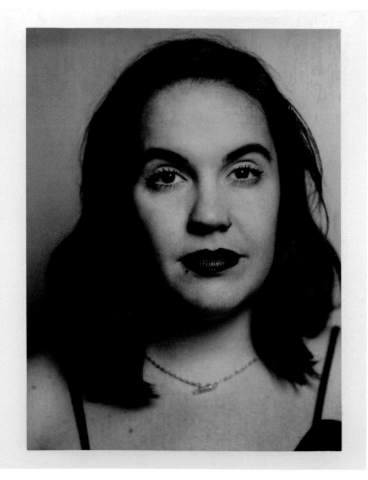

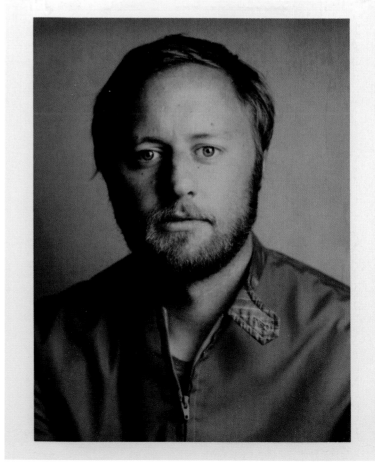

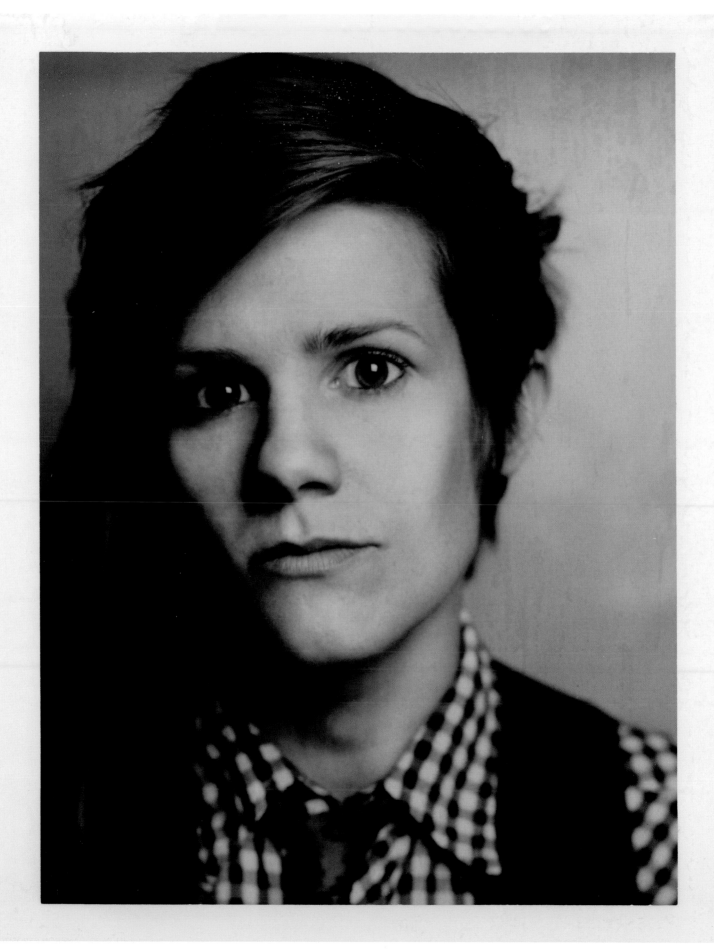

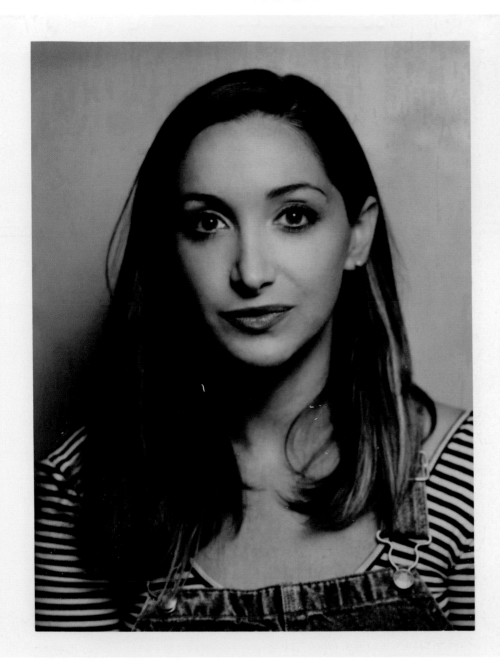

PAYMAN BENZ (DIRECTOR): I think independent shows are the key to innovation and originality. I'd much rather watch an independent comedy show because it's about quality and not about selling tickets because the star of a movie is performing that night. The audiences at independent venues know what they want to see, so it's a great vibe. I'd rather watch comedy in that environment than surrounded by drunk tourists at a comedy club on Sunset Boulevard.

MJ: What are your overall thoughts on that experience and the community that you built through your independent show and its contribution to the community?

CAMERON ESPOSITO: First of all, I will say that I think that show [*Put Your Hands Together*] had a lasting impact on the L.A. independent scene. When I got here, a lot of comics used the gay slurs, and I sort of had a policy that folks just wouldn't be readily rebooked if they used those at my show. I don't like to hear those words; I don't think it's interesting. When they did use it, I would talk about it afterward. When I go to indie shows today, I don't hear people saying them as much. So does it matter when one of the big indie shows in town has two queer people who will always call you out if you say a dumb homophobic joke? I think that stuff can sort of make little ripples that then eventually end up affecting a whole scene.

MJ: Definitely, I think that even on a larger perspective, the independent scene in Los Angeles over the past ten years has become incredibly more diverse in all walks of life and ways, which I think is very exciting. I think that shows, when they start to have an obvious eye toward wanting diversity because it's what they find more interesting, it adds some more interesting styles, points of view, and more interesting comedy. That it has a tidal wave through other shows.

CE: At the time when *Meltdown* was the biggest Wednesday show, *Put Your Hands Together* was the biggest Tuesday show, and *Hot Tub* was the biggest Monday show, all of those, three nights in a row, I think all of those shows were run by producers who were trying to have a really balanced lineup, and that, I think, had a huge effect.

Also, all of those shows have women, queer people, people of color, in power, and that also matters: when you see that the folks who are running the thing are from a marginalized demographic.

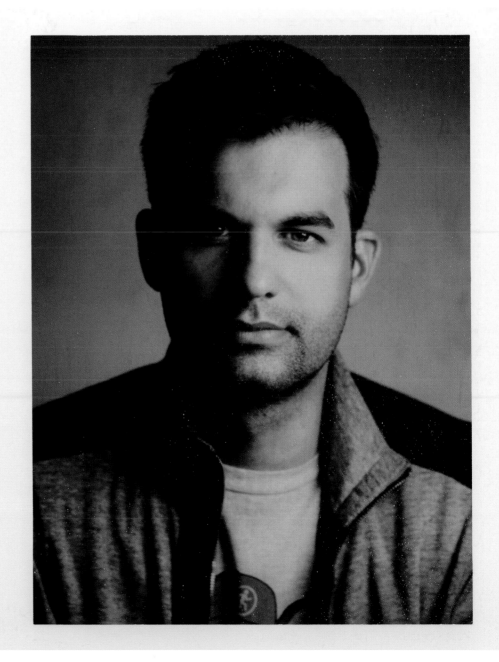

KYLE MIZONO: The scene is way more diverse from when I started. I literally remember going places and being, like, the only woman, maybe the only minority on a show. Some of the smaller shows that I do now, I'm just blown away because everyone is so unique and they seem to be going down their own path. It's cool to see people really just following who they are and doing stuff that no one else could do.

MJ: How did running your own shows impact the way you thought about live comedy?

BRENT WEINBACH: Running my own shows, it made me kind of . . . it made me interested in diversity, and I don't mean that racially or gender-wise—I mean comedically. If I ran my own show today, I would want to try to get different kinds . . . I would like to see a bill that had . . . I don't know, just somebody like Chris D'Elia and Reggie Watts on the same show. Or something like that. Get people who people think of as more club comedians with people who [they] think of as more alternative comedians. But I guess running my own show, I think I just don't really see any difference between alternative and club or whatever. I think it's all comedy, and, I don't know, I guess it's all about just funny. There's no difference really to me . . . There doesn't need to be any separation.

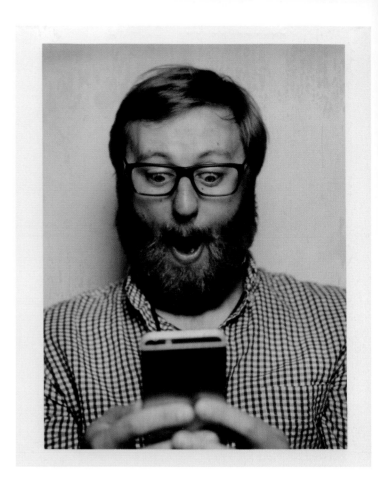

Any show that takes chances and is willing to let people do something different—fail and foster an experimental environment—is goiang to be valuable in terms of discovering funny, talented people and showcasing new ideas.

—Jason Woliner (director)

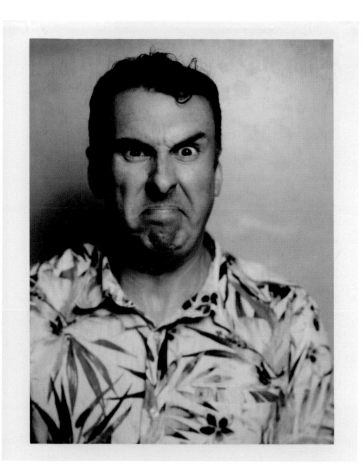

MOSES STORM: Independent comedy taught me how to be nice to people. A lot of the clubs have a tendency to reward people with big egos. The alt scene is very saturated because it's so small. No one's making money. It's not a business. Everyone's doing it to essentially perform or . . . no one's doing an alt show to get rich. It taught me you can just be nice to people and really respect everyone because these are the same people you're coming up with. The alt scene is very incestuous. The clubs can feel very separate. You're a Laugh Factory guy. You're an Improv. You're a Comedy Store guy. They have their own little camps. The alt scene is mixed.

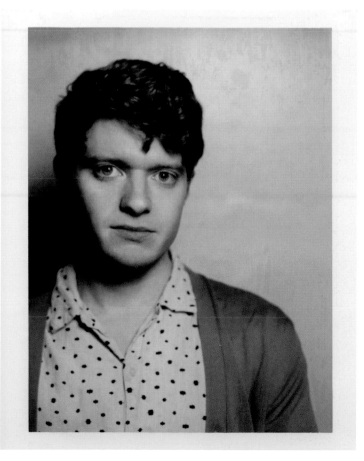

SEAN PATTON: I'm doing two spots in a night, and one of them is at a bar show, and one of them is at a club spot. I know that if I'm doing the same bit at both . . . I'm going to take the bit off its leash, and just let it run, at the independent show. Let's see what you can do. You know this works; let it breathe a little bit more. Let it take a second; let it take an extra syllable. Throw in a line that you thought of on the way there that might help it or might hurt it, but see. Either way you're able to rebound. Whereas I know when I go back to the club scene, I'm going to put the leash back on. Now I'm still going to let it roam, I'm going to maybe even let go of the leash at times, and that's kind of how it's always been. The independent club world, there is room for mistakes, which makes the shows so much more beautiful.

The independent rooms make you better at being in the moment, right? And the clubs make you better at fucking executing in that moment.

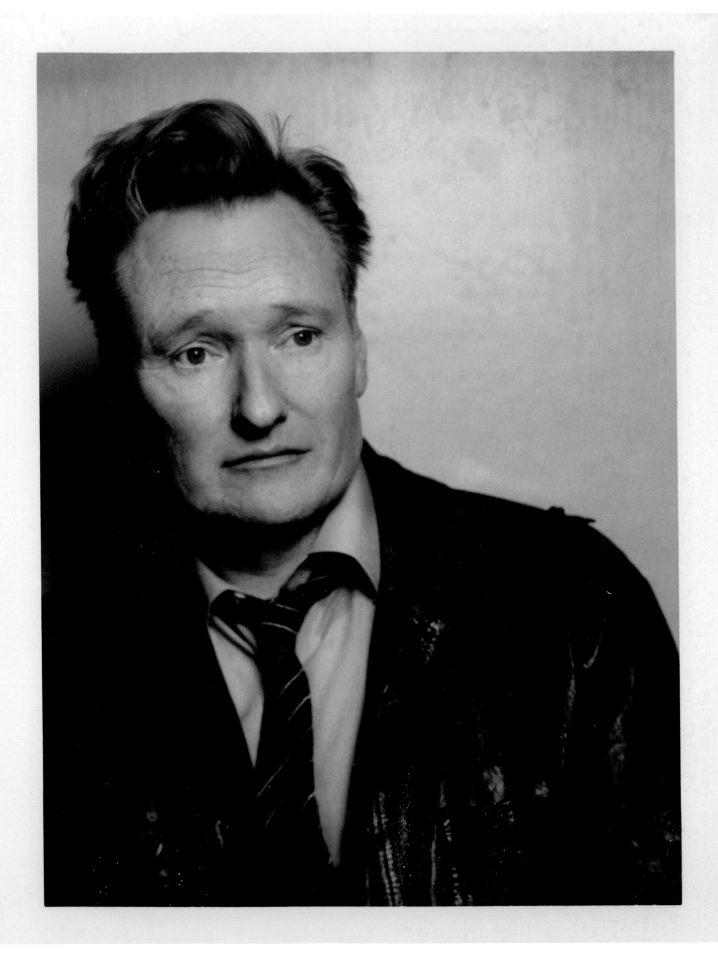

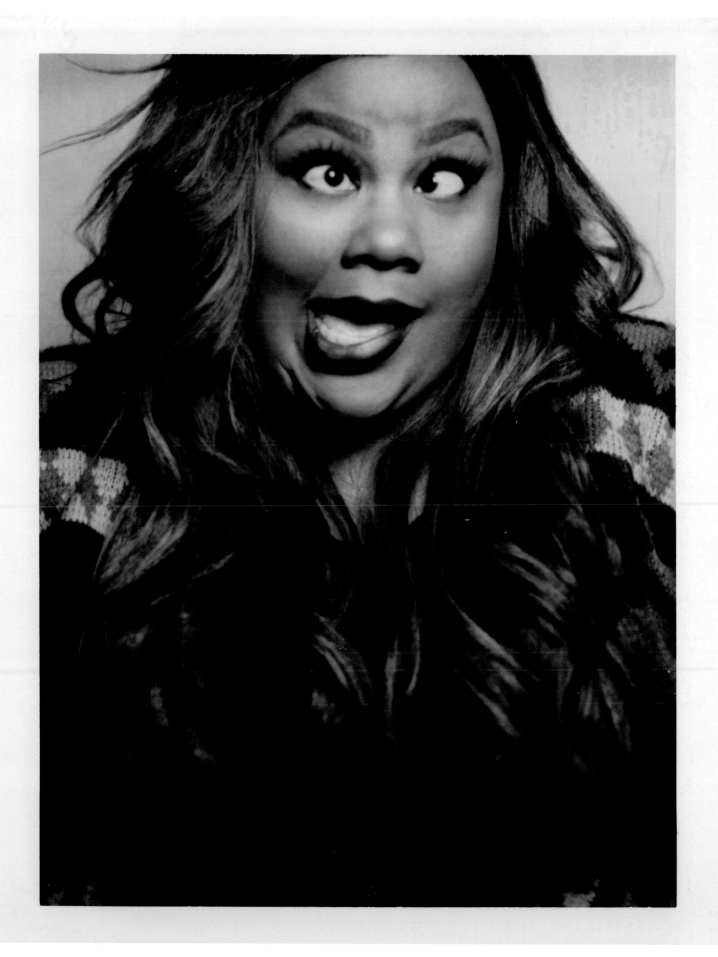

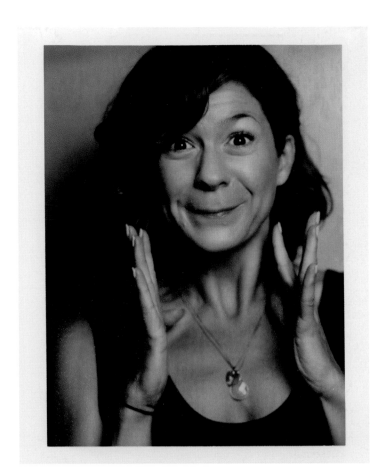 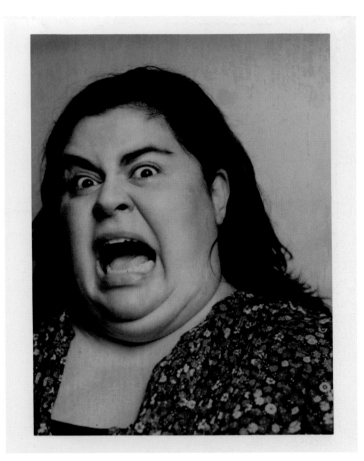

DAVE ANTHONY: I think that when people go to a comedy club, they go to see comedy, and sometimes they go to see a comedian, but usually that comedian is big, right? People who go to alternative rooms get into the actual comics' personas, like Eddie Pepitone or Maria Bamford. It's just a totally different feel. They sort of get into the person's personality more as opposed to just the jokes.

For me the ultimate example is Tig [Notaro] dragging the stool across *Conan*. That doesn't come from a comedy club. That is one of the funniest things, and that's just a person who did a lot of stuff and took a lot of chances and just comes up with that. And then there's Jon Dore doing the dueling set with Rory [Scovel]; that stuff is never gonna happen in a regular comedy club. There's this attitude of *Let's take a chance and do the craziest, weirdest thing and see if this will work*, and you'd just never do that anywhere else. You couldn't.

RORY SCOVEL: I really enjoy taking big risks and messing around, and I don't feel as guilty doing that in front of a crowd that didn't pay a lot or anything to get into the show. A lot of people were paying five bucks; it's like, C'mon, you probably want to see experiments happen, you know? But if you were paying $15 or more, maybe a date night, knowing how hard it is to get a babysitter and what that cost you . . . When you start to factor those things, I don't feel as free to just wing a set and try to find it. I'm still very loose, but it's stuff that I'm like, All right, this isn't brand new, and I have an alternate I can go to if this bombs.

The audience that you guys have cultivated is almost perfect because it's people that are willing to pay, but they also know exactly what they're getting.

MJ: Having that freedom to like really be like, Fuck it, I'm just gonna bomb. This is for me and not for them. Has that helped you craft and form and find that voice more?

RS: One hundred percent. Yeah, because throughout any performance, every second you're making a decision. And the more experimental or the more absurd a decision is, then you're going to end up in a place you haven't been before, and then that's going to teach you something.

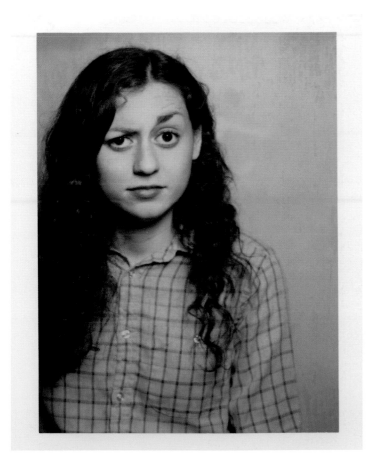

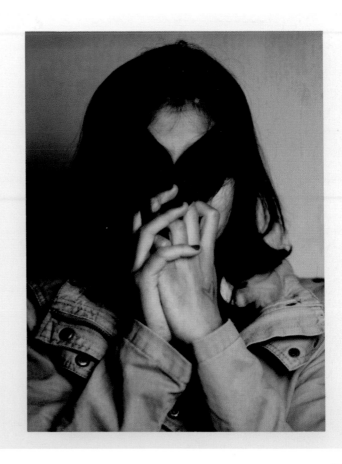

LEFT: ZANE RUBIN, RIGHT: APARNA NANCHERLA

DEMETRI MARTIN: For me . . . personally, and I think for a lot of comedians, and probably for the state of comedy, without being too monumental about it all—I think like anything, stand-up comedy can get pretty homogenous. It seems like there are people who make money off it even as we are unknown comedians, and the best model for them is for the comedians to be . . . to fit into a very specific box. The brick wall/microphone comedy shows in that sense, once you have the room, aren't that hard to produce.

Can I do a slideshow? No. Don't do a slideshow. *Can I play a piano?* No, we don't have a piano; you're not playing piano. So, in that sense, I think independent comedy is really important. It encourages people who are less typical to develop their voice.

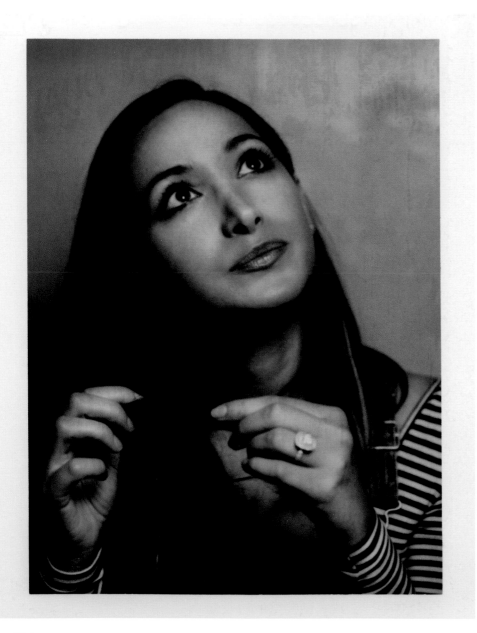

PAUL DANKE: I think independent stuff is the most important because it removes a layer of professional gatekeepers deciding what is and isn't allowed to be performed, which is inherently pro structure, pro status quo. I think comedy is inherently subversive, and so it really thrives independently . . . It grows up quickly in places you're not expecting it because there's so many people . . . that are not getting what they need from corporate-style comedy, preapproved, packaged, slick, smooth, noted, capital *C* comedy. To me, that's not what I needed. There was some of it I really liked when I was younger, but when I came and really found the alternative comedy scene, it was like, *Oh, this is so much more interesting. You can go so many different places with this.*

LEFT PAGE: JAMIE LEE, RIGHT PAGE: JANEANE GAROFALO

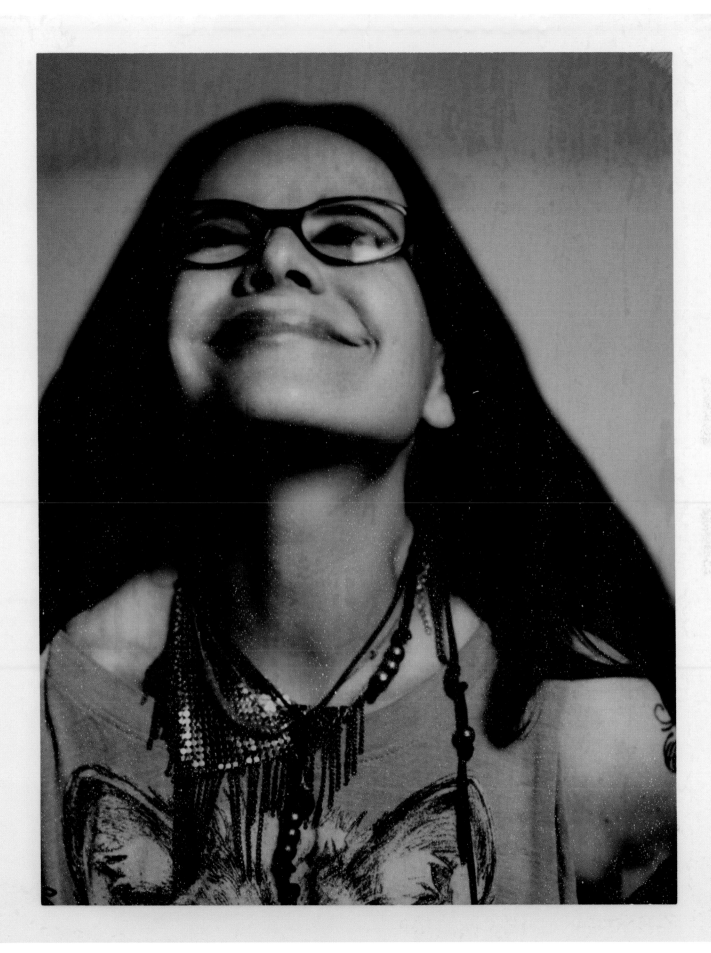

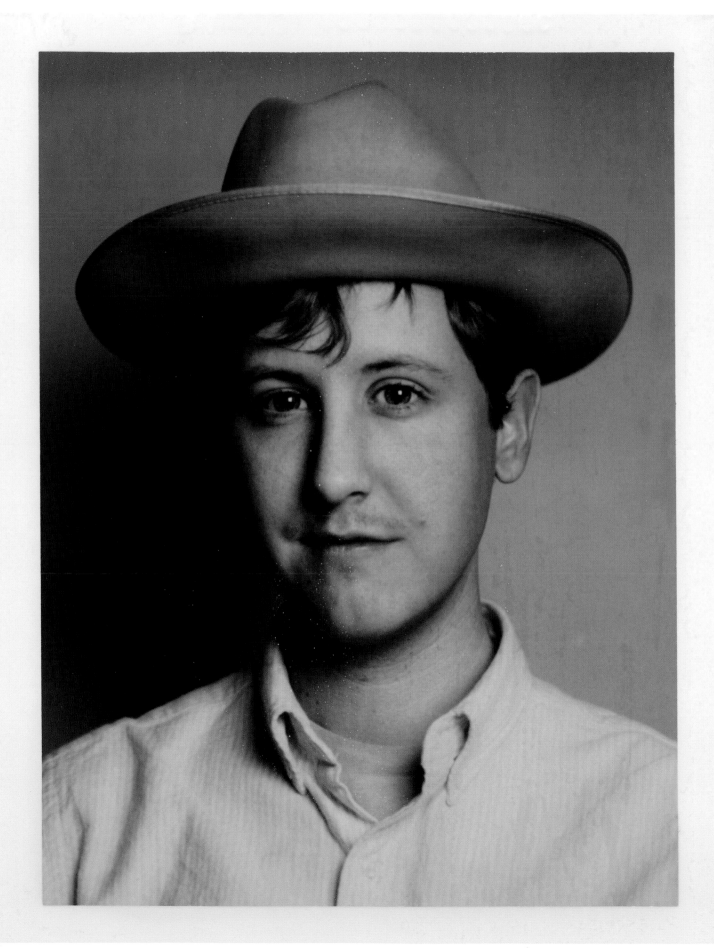

PETER ATENCIO (DIRECTOR): Independent shows are hugely important because they create a safe space for comedy to be experimental. A lot of people take that to mean material that is too offensive or vulgar, but that's not really it. It's more about trying things that you don't even know whether they're funny or not and discovering new observations about our society and culture by way of new methods of commentary. Independent shows keep comedy refreshing and interesting, and they're crucial to the survival of live comedy.

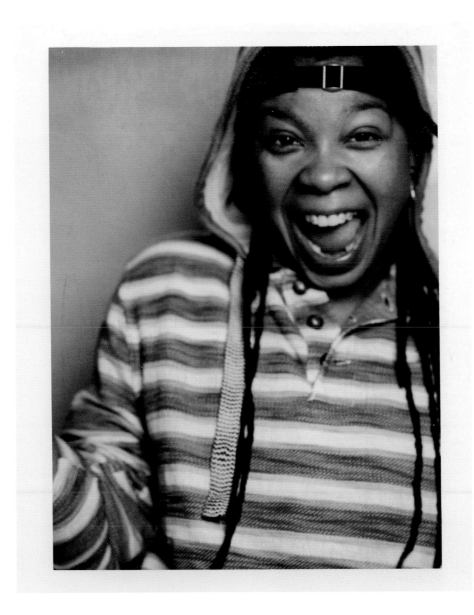

JOE MANDE: I think that a comedy scene really thrives when people take it upon themselves to produce shows. It's what incubates and develops a dynamic and organic comedy scene. Not just in L.A. or New York—I mean, any city. It's almost never a money-making enterprise, but it's vital in terms of bringing people together and creating stage time for people seeking it out.

ANNA SEREGINA: I honestly associate the independent comedy scene with you guys. To me it was a very . . . it was so cool to see . . . I remember my first time at *Hot Tub*—the audience is way more playful. They're knowledgeable about comedy; it's not like comedy is just bestowed upon them. It's their will.

Alternative doesn't mean bar show with one audience member. Alternative as successful had never really presented itself to me . . .

Hot Tub and *The Super Serious Show* definitely were very eye opening.

When I went to *Hot Tub*, that's the first time I saw Dr. Brown and Sam Simmons. I didn't even know comedy could do that . . . I saw *Ceremony*, and it was fucking great; it felt crazy. I don't want to be the kind of person who's like, "Yeah, and that's when comedy was punk," but it felt really . . . so exciting. It was unpredictable. It was the first time I felt as an audience [member] that my

enjoyment directly influenced what was happening onstage and dictated where the show goes, and it felt crazy. I didn't know that was an option. I thought comedy was done at you. I'd never seen comedy that considers you as an audience member, and that felt really cool. You're in the room, your laughter is guiding where the performance is going, you know it can't really be repeated. That stays with you . . . That feeling: it's physical.

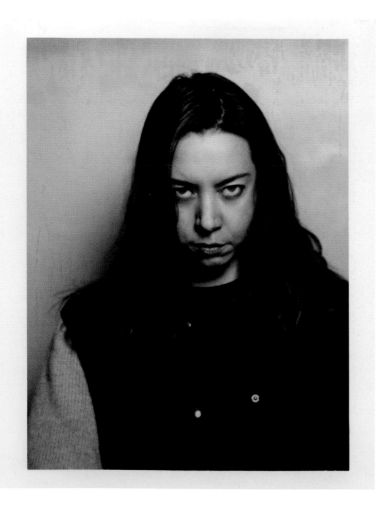

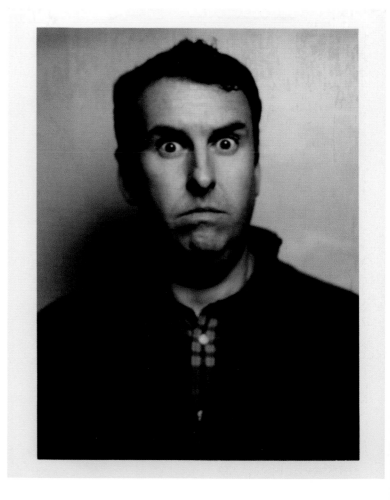

LEFT: AUBREY PLAZA, **RIGHT:** MATT BRAUNGER

ANTHONY JESELNIK: I think you just have to have something that's a little more avant-garde than the club scene. The club scene, you know what you're getting. It's a lot of tourists. I like the alt scene. The alt scene is always changing and evolving. It's much different than the alt scene that I came up in, which is different than the scene that I romanticized when I got here. I think it's a place where people can go and try different things, and they get a little more grace from the audience. They want something a little weirder. The difference between a Marvel movie and independent film. You want both. You like seeing both movies, but you'd be really bummed if independent film went away. I loved that you can try anything. You got really great people, major stars or legends doing some weird little thing onstage, that I love. You couldn't ever get away with that at a club. I think that independent comedy is much more important to me than the club scene. Even though I wanted to be able to do both.

MJ: There's value in both. You get better if you can do both. You play to different audiences and different strengths.

AJ: I think there's more patience in the independent scene. They'll let your character develop. They'll watch you go through this. You don't have to be funny right away. The clubs, you've gotta be hitting. In the independent scene you can tell an interesting story. People will be OK. They're not mad. Sometimes it's like they paid five dollars versus thirty dollars. It's a different . . .

But it was important to me to be able to do both. I remember one of the most inspiring things I've ever seen was watching Demetri Martin bomb at some show on Santa Monica . . . I remember just running home as fast as I could and emailing my friend to be like, "I just watched him bomb the same way we bomb. We can do this." That was the most inspiring thing ever, was watching someone fail who I thought the world of.

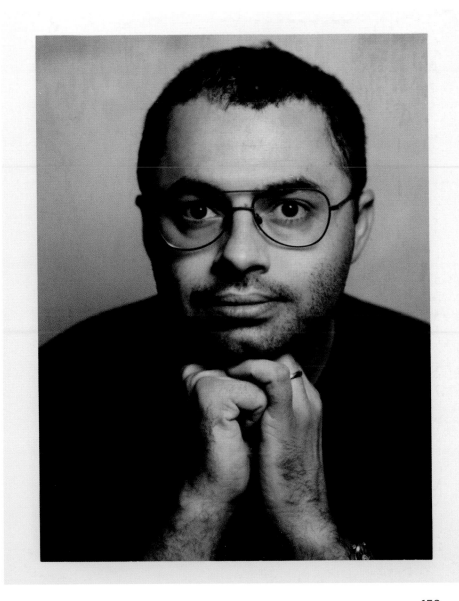

KAREN KILGARIFF: There are so few people that come at the producing game and come at comedy with the love of how magical it is as a thing by itself. Separate from how incredibly valued it is later. Comics are easy to trick. They're easy to string along. They're needy and desperate in ways that are astounding. And you have to be protective. Obviously, I think that's why you guys are successful: you understand the job of a producer around talent is to create the protective shell so that the show comes out of them. The show is made for the people. You guys are talent scouts in a way. When you put a show together, you're like, "Here's a voice that needs to be heard. Here are jokes you've never heard before." You guys know your shit. So you know what you can give people.

MJ: We always want to have a nice diverse lineup. That was the original goal. When we started *The Super Serious Show*, we liked being part of this community, so we just want to keep doing it. That was it . . .

Forever, and rightfully so, comics were so skeptical of me and Joel. They were like, "Why are you doing this?" I remember having a conversation with Greg Proops; he was like, "I don't understand why you do this." I was like, "It's fun." He was like, "But how much money do you make per show?" and I was like, "*Maybe* a hundred dollars after expenses?" And he was like . . . "But why?" and I was like, "Why not?"

KK: It's illogical for people who are short-termers. It's illogical for people who don't actually get it and who haven't seen straight-up fucking magic. What I think is so beautiful about the comedy explosion is that I would attribute it to that time after Largo. That was really the *Meltdown* time, your time, where it really got viral, digital. The people started finding the shows that were good for them, your guys' show, whatever, but it became this . . . It was foodies but for comedy. People really knew their shit as audience members. That was the shocking thing to me when I went back—is how smart and up-to-date everyone was. Greg Proops asking you that question, that's such a reflection of that era we're from, which is everyone's there to make money. There was very little art. A lot of people got treated like, "Get in line after whoever. You're one of many. Your shit isn't special."

I think the difference, it went from, if you just show up at a comedy club and you have a hundred dollars to spend, you might have a good time; you might find your dream comic that you'll follow to the ends of the earth. You also might hate it and watch someone that sucks. The audience was in turmoil and took it out on you if you even showed an ounce of weakness. Later on, because of the internet, people could find these independent shows. It was people sitting there getting exactly what they wanted. It was perfectly tailored to them.

RIGHT PAGE: "WEIRD AL" YANKOVIC

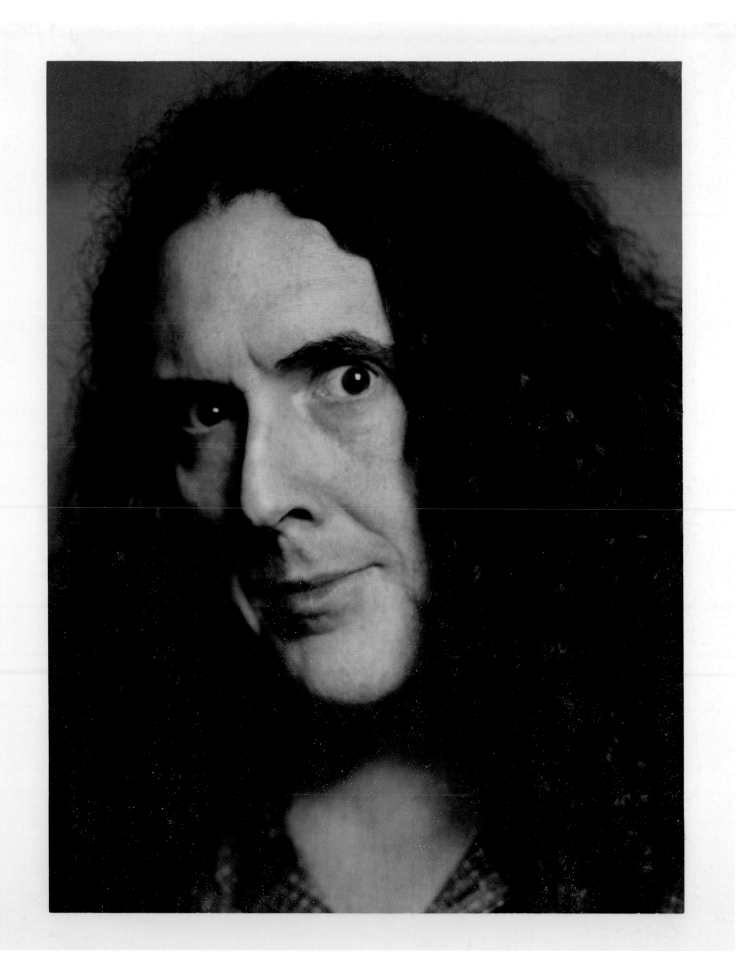

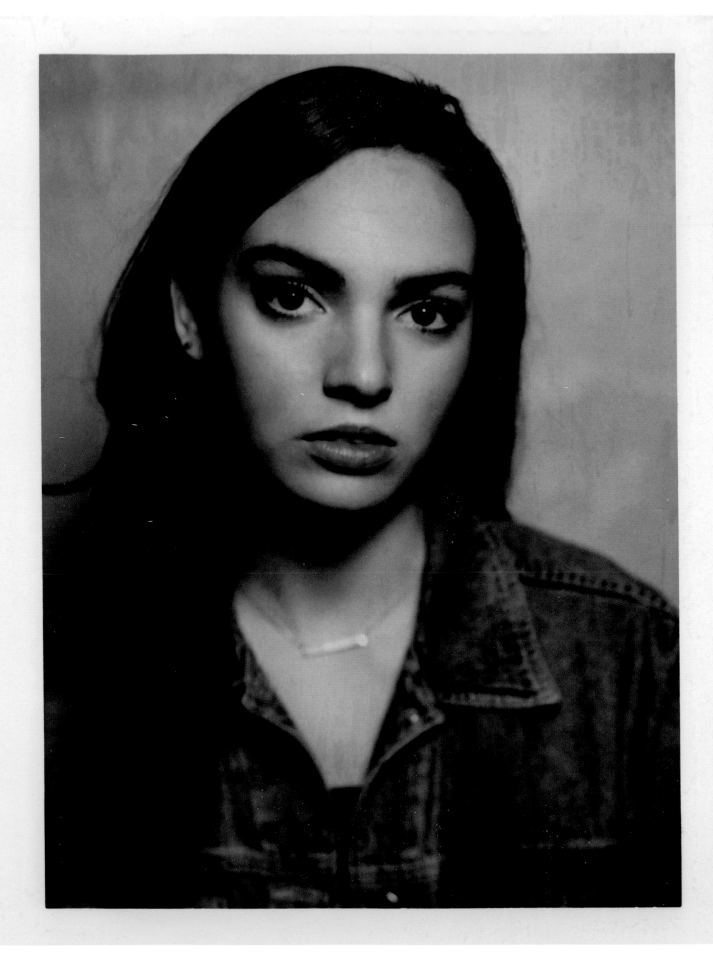

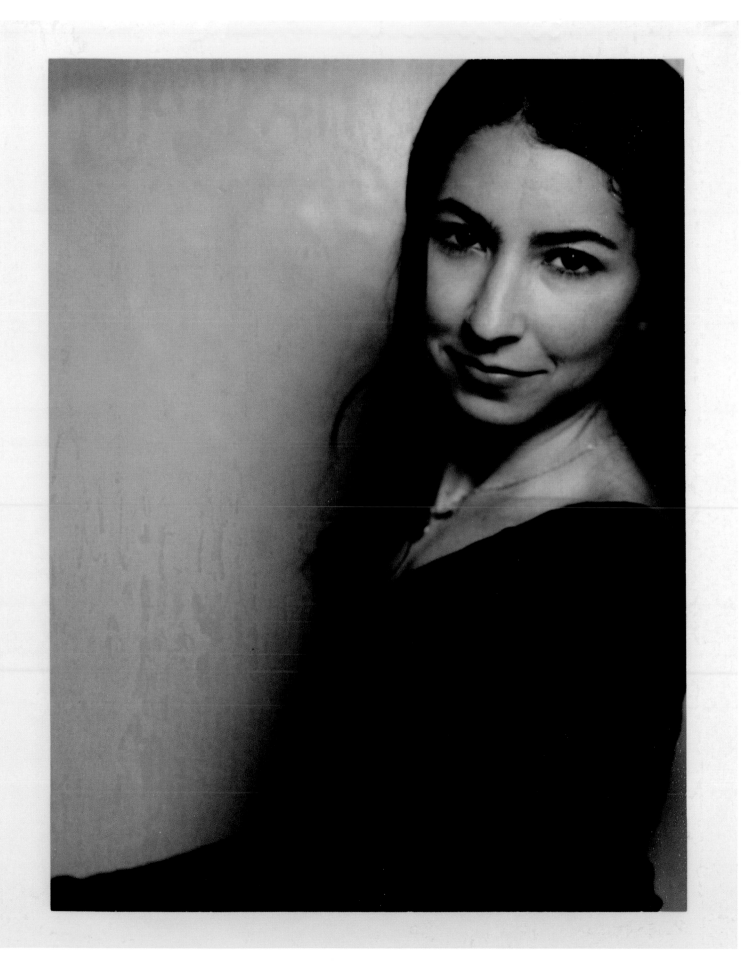

REGGIE WATTS: The term "alt comedy" came from Malcolm Hardee . . . British comedian, kind of the Godfather of, I guess . . . Some people consider him the Godfather of alt comedy. And the reason why they called it alt comedy is because he had a show at a place called the Time Tunnel or the Tunnel or something. He was the host. He would have to keep people at bay and keep people's attention, because when people came on to perform, the audience was super vicious. Almost like punk, like a punk comedy show . . . Someone's onstage and they're bombing, and then he would go behind them [and] he'd start peeing on the wall. The audience would be like, "Ahhh!" and the comedian thought they were doing well. So it was a pretty rough, crazy time.

MJ: When was that?

RW: This would have been the late seventies.

MJ: In London?

RW: London. He does postindustrial comedy, essentially. And somewhere between cabaret and stand-up comedy, but more cabaret comedy. And then there was some location that was the wrong location, and people were showing up for the show, but it was the wrong location. And the owner of that location put up a sign saying something to do with "alt comedy," as in the "alternative venue." It's, This isn't the venue; it's the other venue. I like the idea of thinking it came from a practical . . . not like someone was like, "Oh, it's alternative because it's the other choice beyond the mainstream choice," or whatever. That kind of pretentious way of thinking about it. "We're special because it's weird." But it just came from, "Oh, no, this is the wrong place. Alternative venue. Oh, OK, I'll go there."

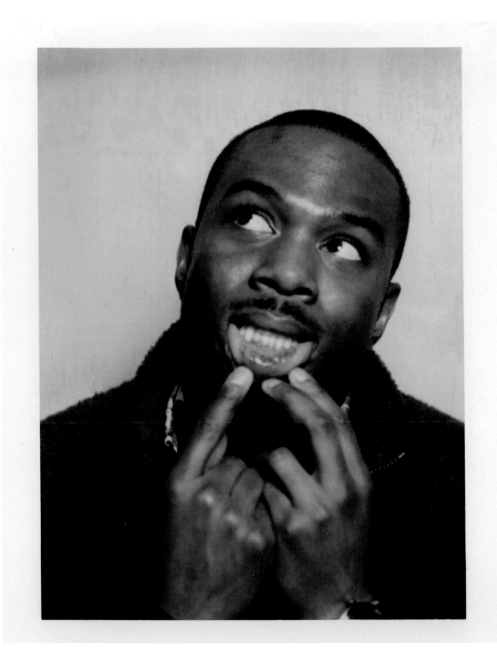

MJ: I love that; I love the reference with punk because I feel like a lot of the people I've talked to, Dave Ross especially, reference a lot of running independent comedy shows and building up a space in a very . . . It comes from a weird punk underground thing where you're like, "I want to do it my way. I want to have my thing. I don't want anyone to tell me what to do with it. I'm going to build my show. I'm going to put it in this weird place. I'll build the stage, I'll light it, I'll get the people here."

RW: It's super DIY. It started with Fugazi and Black Flag and all those guys. That whole DIY movement definitely carries over into comedy.

MJ: The reason *Super Serious Show* started at a photo studio is because no one else would have us. But then it informed so much of what the show was . . . It was built because we were like, *Oh, we're in this venue; we need to make this venue work . . .*

RW: The fact that you just did it. You just found a way to make it happen. You did it. That's fucking awesome.

MJ: That's the best part about independent comedy . . . If you get comedians there and you get an audience there, you have a show.

RW: Yeah, exactly. That's all it takes. It's pretty exciting that way. It's a good realization for an audience member or someone who's aspiring to get in on this. To see, *Oh, we just started a night*. Oh, that's what you did? *Yeah, we just started a night*. But there wasn't any . . . What's the protocol? There's no protocol. You just find a place to do it. Just let people know that you're doing a show. They'll show up . . .

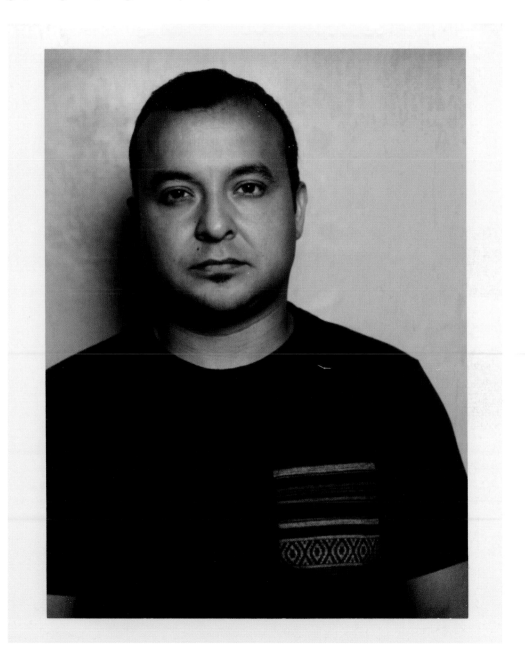

COMM

UNITY

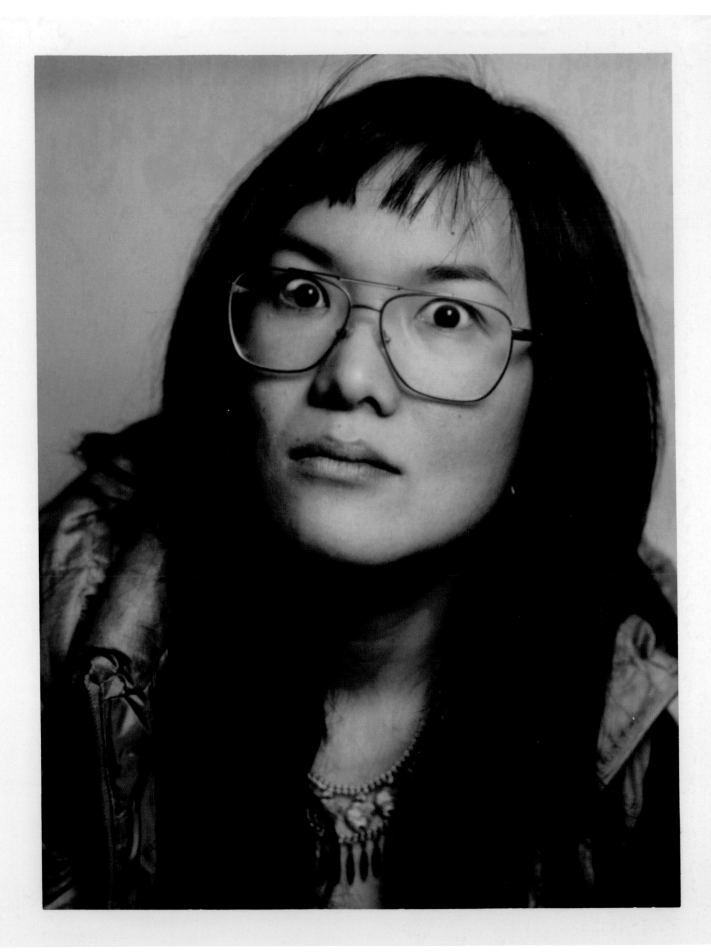

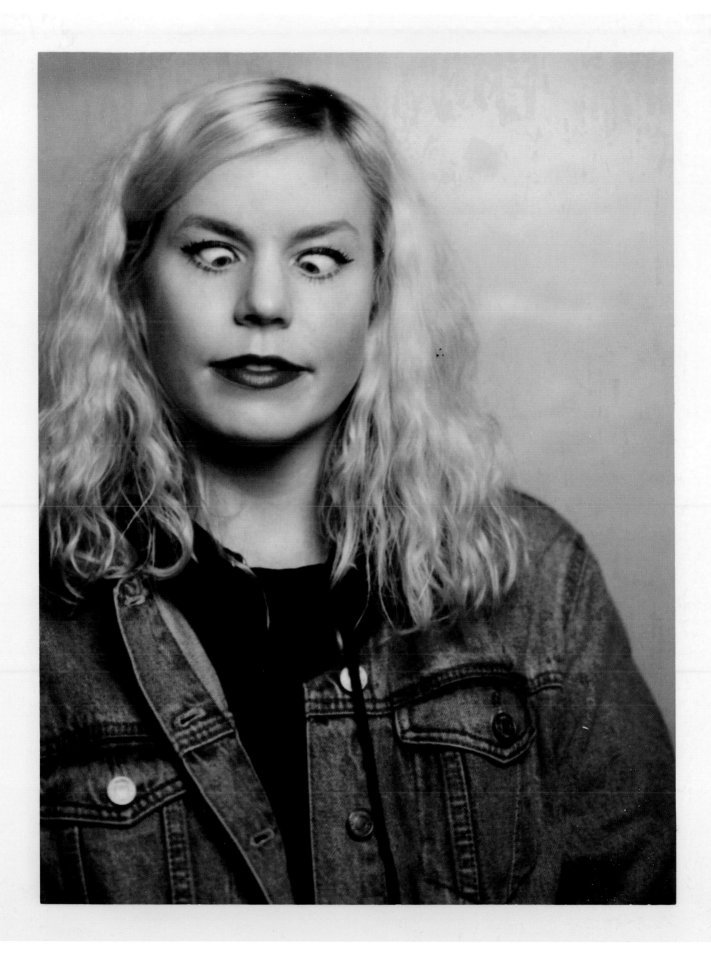

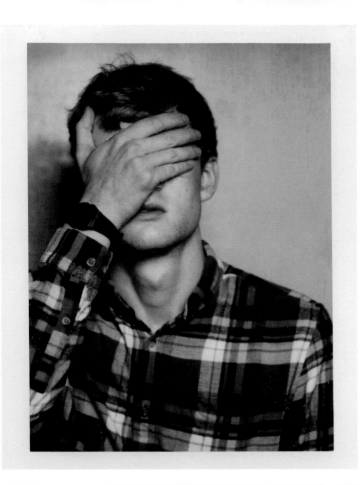

My love for Los Angeles isn't for the city; it's for the people. That's my family.

—Hasan Minhaj

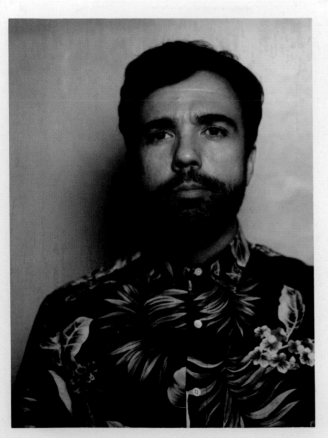

DANA GOULD: It's like skydiving. If you've never done it, you don't know what it's like. There's weird bonding. And even with comedians with whom I have nothing in common, you still have that. Very different schools of comedy and but you still have that "Well, I'm a plumber, and you're a plumber, so we're all plumbers." And it's specific to comedians more so than musicians . . . It's a beautiful mixture of arrogance and low self-esteem. Comedians think that they are the piece of shit that the sun revolves around, and we all kind of know that. You know there's just kind of a secret handshake. I get it.

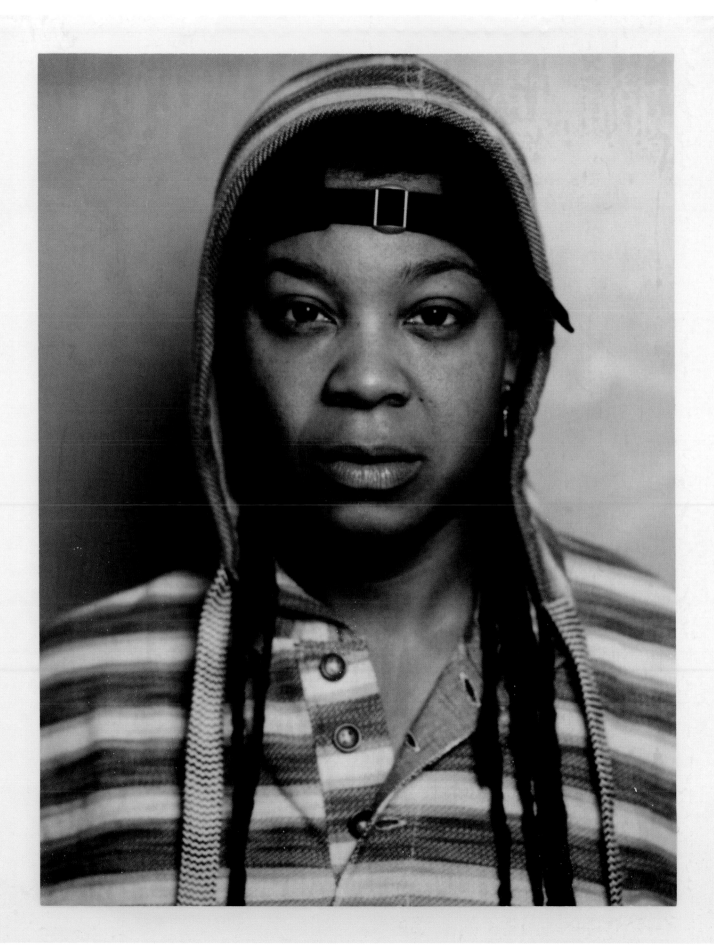

ALICE WETTERLUND: The best part about doing comedy is the community. The one thing I love almost as much as doing stand-up is talking about stand-up with my friends who do stand-up. That's what it's all about. Any industry, you see people, you see pipe fitters talking to other pipe fitters using their pipe fitter lingo; you get that. That's the kind of thing you get. It tickles that part of your brain to talk to people.

EDDIE PEPITONE: I think comics tend to gravitate toward other comics because they're just so insane. There aren't many people who, outside of comics—it's like being in a war. It's like being in war. The only people you can talk about war with are people who have been in war. So I think there's a natural organic thing between comics that they do support each other.

On the other hand, there is an intense competitive drive, an intense ambition, an intense resentment and envy that is part of trying to "make it." I have it too. I feel that's my dark side . . . And that's hard. You feel like you're being left behind. So that's also naturally built in, but I think people are very supportive out here.

The greatest thing about comedy is people are either going to laugh or not.
—Reggie Watts

REGGIE WATTS: It's like being the weirdo kid in the classroom. We call people like that . . . I call it "disenfranchised," because I don't like the terms "nerd" and "geek" [which] don't even mean anything to me anymore. But anybody who fancied themselves an observer outside of the system, whether by choice or whether with the perception that they should be, or that they don't fit in, the Land of Misfit Toys. That's the feeling. And also a bunch of—the hard thing to describe to non–comedy people— but basically a bunch of idiots. It's a bunch of knuckleheads and idiots and dumb-dumbs. They can't help but doing what they do. They can't help not saying what's on their mind or what they think is funny or about this thing or this new concept. The ideas won't shut up. So the only place to really vent that style is to a bunch of other weirdos, and you can laugh together and have a good time . . .

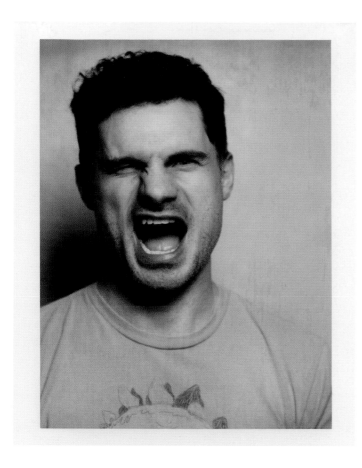
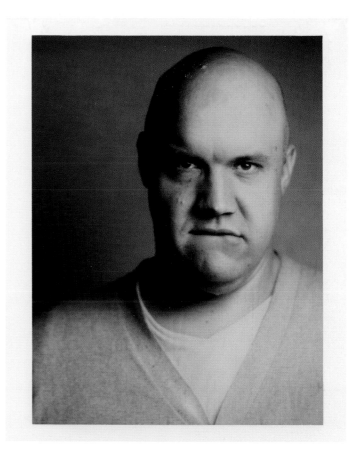
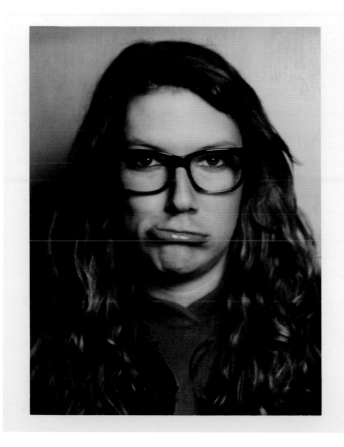
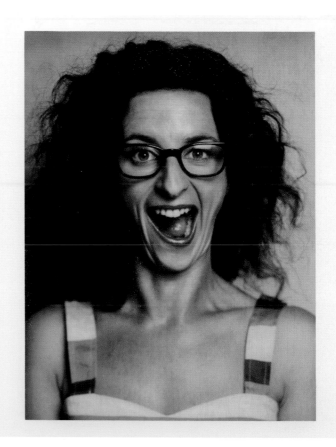

TOP: LEFT-FLULA BORG, **RIGHT-**GUY BRANUM, **BOTTOM: LEFT-**SARA SCHAEFER, **RIGHT-**FELICITY WARD

TOP: JAMES ADOMIAN, **BOTTOM:** JOHN EARLY

The greatest thing about comedy is people are either going to laugh or they're not. That's awesome. I love that. And to get the respect of your peers, especially the elders. I remember when Ken Marino came backstage one day. He had a show in Austin, and he was there, and I was totally shocked, because I was such a huge fan—am such a huge fan—of *Wet Hot American Summer* and all the stuff that he's been doing. He immediately got up and was super excited about meeting me, because he liked the stuff I did. I was very blown away. It was a huge emotional moment. "Whoa, that's crazy. He's paying attention to me." That's . . . that's who I thought of as the person that I was looking up to, in the sense of the way they were doing things and what they were putting out there.

MANDEE JOHNSON: Comedy is a weird level playing field like that. It's amazing when you watch young comics at *Hot Tub*. That's one of my favorite things, is that we all watch the show. Kurt and Kristen watch the whole show. We are part of the night.

RW: Yes. Exactly. It's great. It's awesome.

The community is so strong and I'm really thankful and I think that they really do know me.

—Beth Stelling

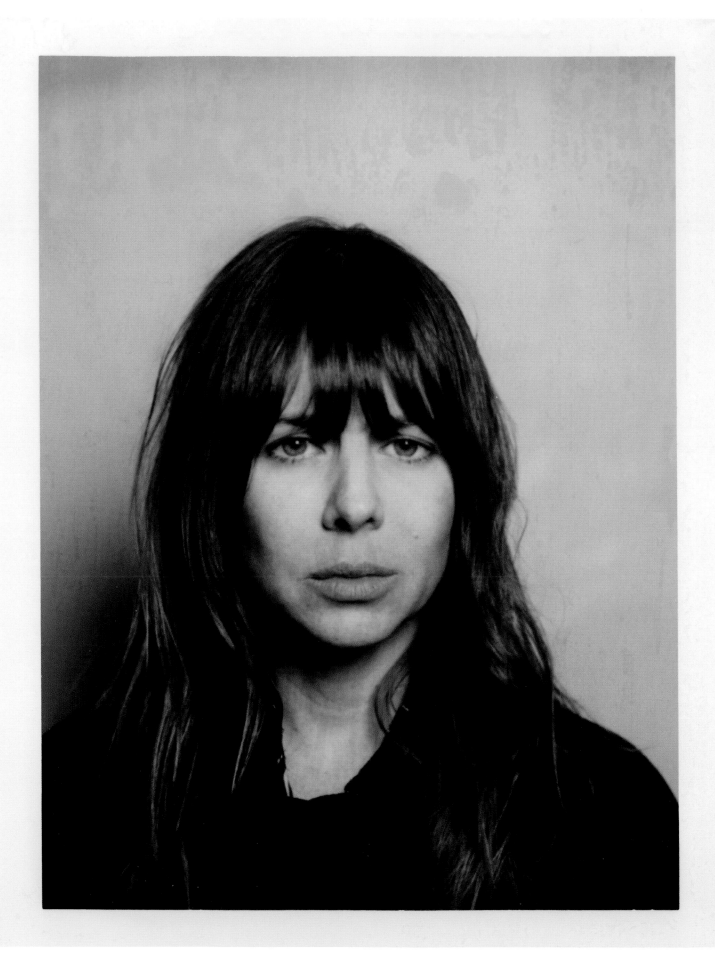

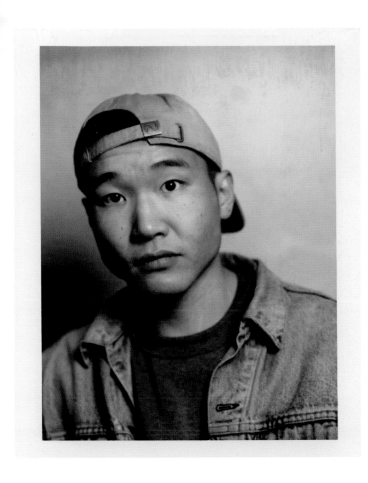

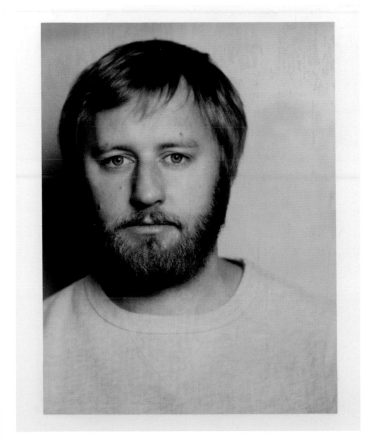

RORY SCOVEL: I've always kind of felt a great amount of support in the [comedy] community.
When I moved to New York City, the D.C. scene was so supportive. There are a lot of comics who came out of D.C. at a very specific time: Aparna [Nancherla], Andy Haynes, Hampton [Yount], and many more. When I moved to New York, there was a camaraderie that started, because now you were sort of in a class of people who all are like, "All right, I've clearly put all my chips on the table. I moved here, where I can't afford it, and I'm living with too many people."

There was a different kind of support system because you're with all of these other comics, and you all feel like, "Well, we all had the courage to go this far, so we're all in this together. We're all at the same shows wishing we could perform, but we can't." So you always find yourself hanging out at shows with a kind of a similar group of people, and that kind of becomes what feels like your class of comics that you're hanging around . . .

MJ: I think it's comedy as a whole. The struggle, the grind, all of it. It forges people and friendships and bonds in a very specific way.

RS: Yeah. It's also the only part of the job that makes it like a group. I'm just referencing y'all's shows, being upstairs and hanging out. That's kind of the only time that you're like, "Oh, this is the team; this is the group." That's the only time it's like group or a family or a band: hanging out before you go on or even just having a drink with people afterward.

It's kind of funny; you guys have probably noticed this, but I'm willing to say probably one hundred percent of the time that your shows, the greenroom probably feels like a miniature reunion because it's comics who are . . . Every time someone comes in, someone has gone, "I haven't seen you in so long!"

JOEL MANDELKORN: It's like co-workers that you don't work with.

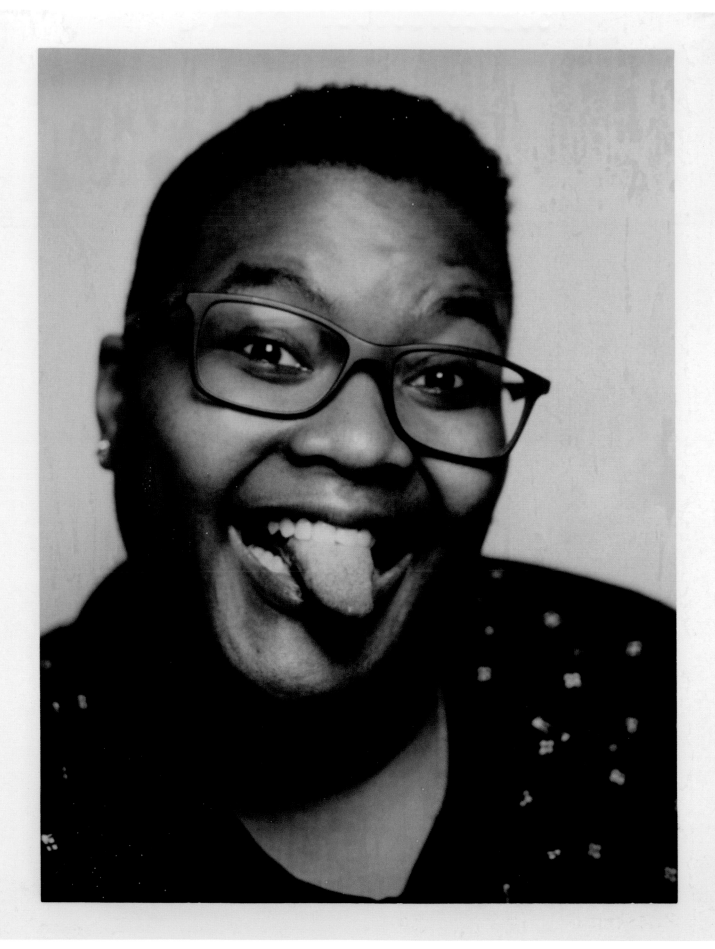

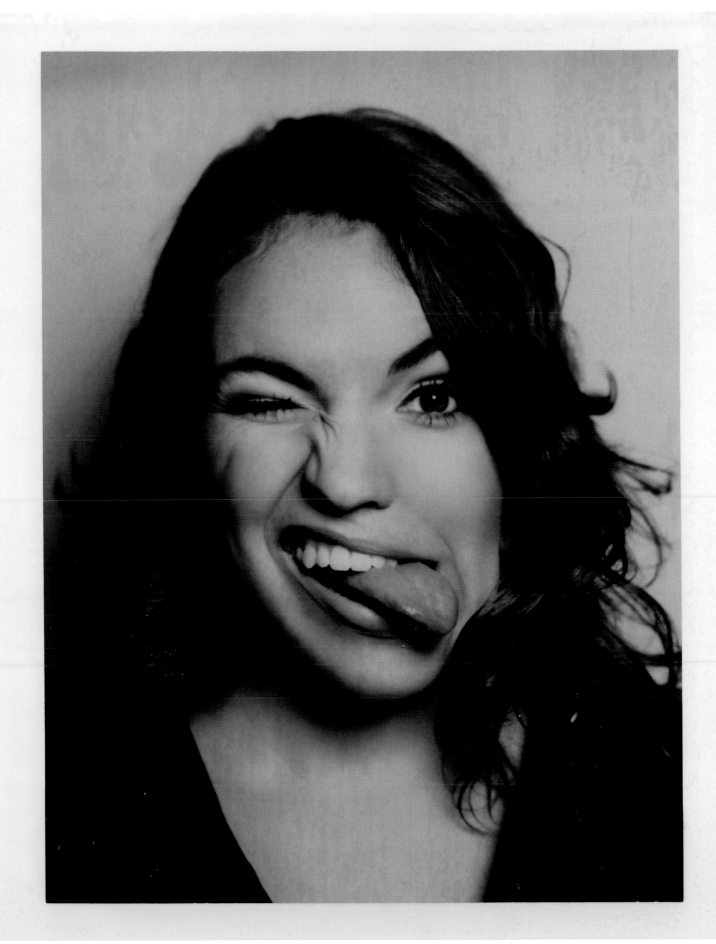

AARON KEE: We're all coworkers. It's a huge business that has no HR, no benefits, but we do have holiday and dance parties. It's different from other jobs because we're all like-minded people, at least as it pertains to comedy. We're all people who have chosen [the same] main thing in our life.

MO WELCH: It's interesting because in Chicago people would move, for the most part, when they hit a ceiling. "I'm becoming successful, and I need to leave Chicago." And then in L.A., they stay here, and then they become more successful . . . One minute you're at the Westside Theatre with me, trying to get on *Adam Devine's House Party*, and then the next second you have a Netflix show. It's wild. A lot of times you can't predict it, but I think that's what's fun. Because you can't predict people's success.

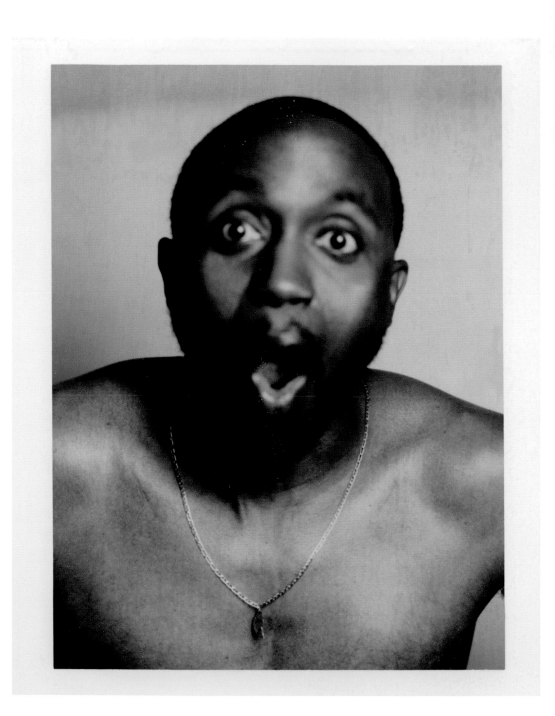

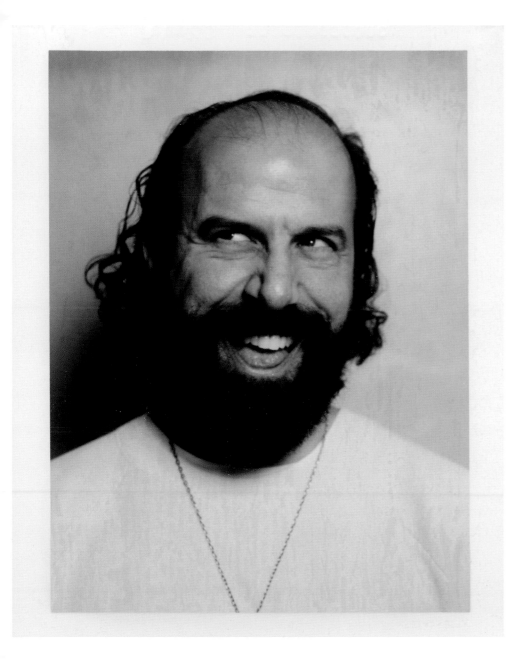

DAVE ANTHONY: The first time I was ever a paid emcee, I was sitting in front of the Holy City Zoo on a bench, obviously looking freaked out, and all of a sudden Robin Williams sits down next to me. And he goes, "First time?" And I was just like, "Yep! My first time doing a paid show." Then he just started talking to me like a guy, and that's just kinda how San Francisco was . . . I had seen him around, but I had never actually talked to him before, and he just saw I was totally freaked out and just started chatting with me and totally took me out of my head. That's just what the scene was like.

MATT INGEBRETSON: One thing I always knew to hang on to is to be kind and supportive and fight against feelings of jealousy. Everyone is going through hell trying this career. It's fucked up emotionally and physically. The people I look up to are kind and supportive. It's hard not to be bitter at times when you feel like you should be further along, at any point in your career, but it's foolish to not be entirely supportive and happy for your friends and colleagues that do well. If you don't hang on to that, I think it's easy to get lost.

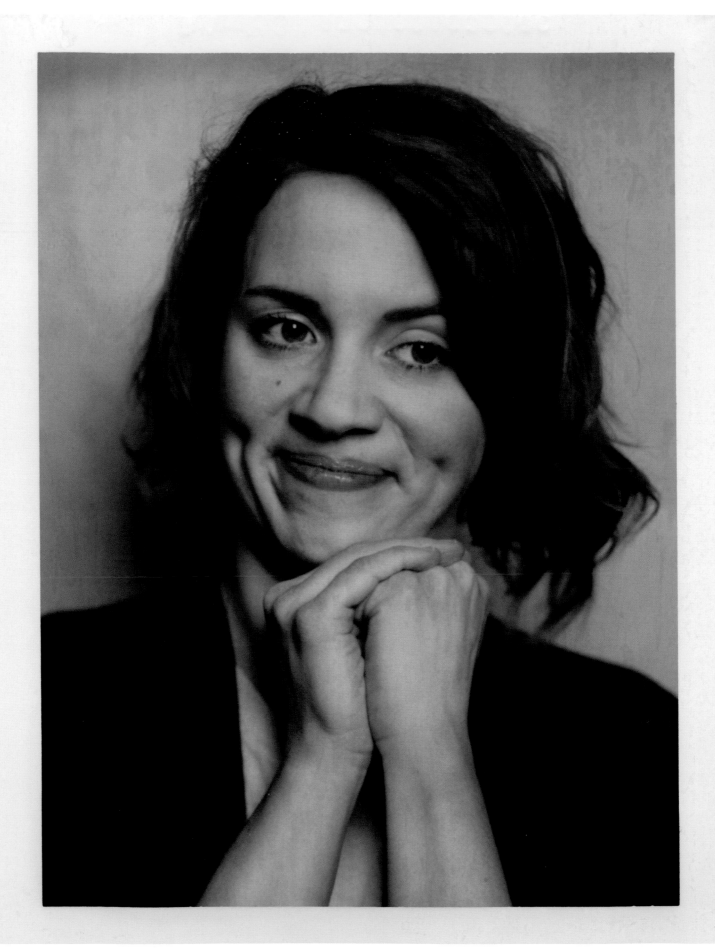

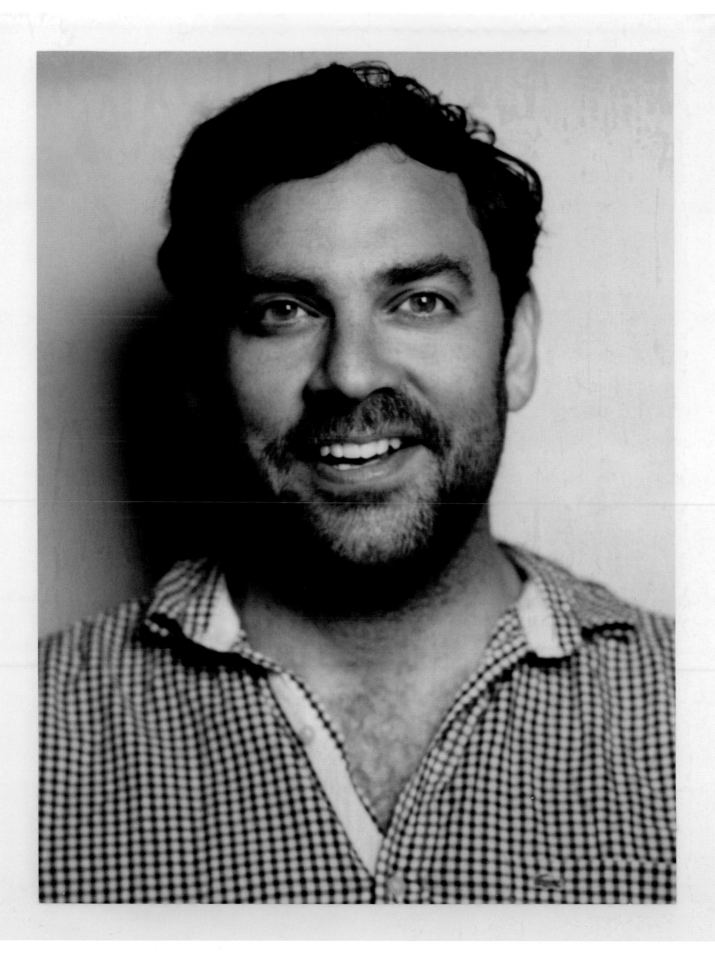

ABBEY LONDER (PRODUCER): The comedy community is like my second family. But we're also in a pretty competitive sport. When I first started out, I remember feeling the heat of that—always comparing myself to what others did (especially when they did it better), and I found myself not being supportive of others. Then I met this magical man who happens to now be my husband [Ahmed Bharoocha], and the biggest lesson he's taught me in this life—and in this community—is to support *everyone*. No matter what. Because at the end of the day, we're all just trying our best . . . Lift each other up and be nice, goddammit! It was a huge turning point for me, and ever since then I feel like this community really has been, in result, more supportive to me.

ANDY PETERS: I don't even know so much if comics are aware of how important they are individually to other comics. We all operate in this bubble. It's very organic. It's a scene based on community. I think we're all pursuing whatever a career means to us. Especially in today's comedy, there's no set description of what comedy is; there's no finish line. I originally had this thought of, "OK, you get famous, and you get successful, and then you're like: you did it." But I think those performers are still part of the community. They're still doing all the shows that we're all doing.

MJ: Do you feel supported within the community?

DRENNON DAVIS: Yes, more than ever before. Which is really cool because I've always felt when I first got here, I was supposed to be in the UCB community, but I don't feel fully embraced by that community. At all. But now I feel like because I started with you guys . . . there's a whole community that has been built that I'm realizing does completely accept me and has been with me from the beginning . . . it's cool.

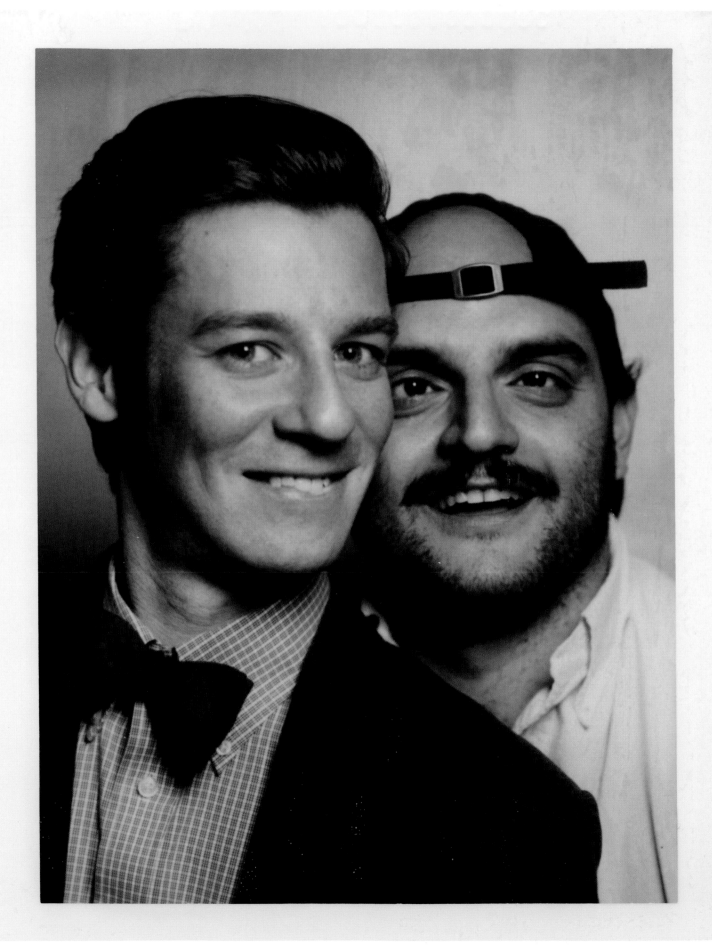

MJ: How do you feel about the support within the comedy community among comedians?

ANDY KINDLER: I think it's great. I really think it's great. There are cliques, but compared to New York in the nineties where there was a real . . . almost a misogynist vibe to the kind of comedy. It was very aggressive comedy. I feel like out here, everything is accepted. Maybe I have a Pollyannaish view of it. It's always going to be that way in Los Angeles. A vibrant thing.

MJ: The L.A. comedy community is the only comedy community I know, but I've always felt, even as a producer, so supported and welcome. A community of friends and family, almost, and I know it's competitive, but it's not always about being competitive and cutthroat.

AK: Comedy is not like . . . there's only five people going out for the *one* quarterback spot in football. There's no way that someone else's success is going to prevent your success. Comedy, there's always room. But you're also always struggling to make a living too, so it's—

MJ: It's not all rainbows.

Comedy, there's always room.

—Andy Kindler

CAMERON ESPOSITO: It is a loving place to work, but I also have found that at the end of the day, these are jobs, and these are your friends, but you're competing with your friends. And I think that it's important to keep both of those things in mind.

[Comedy] is a brutal industry. It just is. It's brutal on people. And so is the stand-up world. Stand-up world is brutal. I think that for me, L.A. and the comedy community out here has been . . . I have felt at times so welcomed and so part of things, and I have also felt at times so on the periphery, and I think all of that's fine. I guess I'm just saying that because I think there is this expectation that everyone in comedy is best friends with each other, and I feel like if you're a comic who's not experiencing that, it can feel really demoralizing. Why am I having this experience that no one else is having? But I think that we're maybe just a little less honest about the other sides of this.

Yeah, I absolutely want my friends to do well, and I want to be doing a little bit better than them . . . Every single person that I know that is a stand-up I think would agree with that statement. And it's not because I'm in this to crush other people. I'm a competitive artist. That's the whole weirdness that's built into this job. That's the contradiction of stand-up. You're making art, but you're doing it for money. That's never a good idea. You're making art, but you're doing it for acclaim? That's not how that's supposed to go. So it's like it's a machine that produces great results. And really close friendships, and people that will come to your wedding, and you'll also hate everybody sometimes.

188

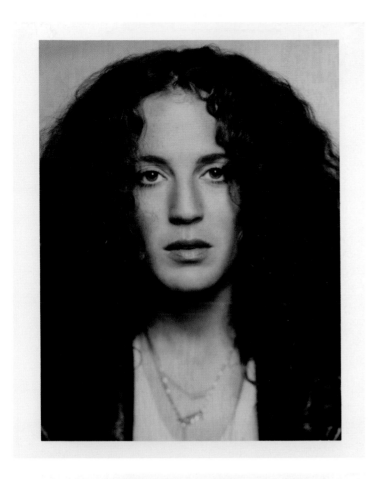

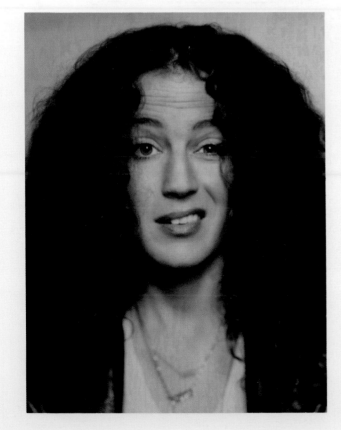

MJ: I think that's a very honest statement. I feel like comedians as a whole are sometimes the only people that I know that can hold both of those things simultaneously. They can be incredibly jealous of someone's opportunity that they got that maybe they were offered up for but also incredibly happy for their friend.

CE: Yeah, that's fair. I guess I just bring this all up because I think from ten feet or twenty feet or whatever, comics can seem like they're chill. We can seem like we're chill people. Because we're funny, or because there's alcohol at our job, whatever, you have to be such an intense person to be really serious about joking around. You have to be such an intense person to get up and repeat the same thing night after night and try to make [it] better. I think everybody that's involved in this field are generally people that are really hard on ourselves and have very high expectations and want to work really hard and really care a lot about things.

MJ: Do you also think all of the passion, all of the years, all of the heart, all the thinking about the small things—because they do matter, because they are important—and all of the struggle is what really forges the community together and what keeps it bonded even through jealousy and competitiveness?

CE: Well, right, it's a trade. It's a trade. Not actually just a job. By which I mean, it's one of those things you have to learn by doing, and it takes forever, and it requires mastery. There's no school that replaces being out onstage. I do think that that's exactly why it is so heartbreaking as a comic to not always have earned respect—to not always have respect unfurled like a carpet from other comics. I think that's something I just talk about because I would love for that to change for future generations. I would love that for other classes of comics.

MONIKA SCOTT (COMEDIAN + PRODUCER): I find the comedy community both supportive and challenging. It's not really one or the other. I do think it's *very* naive to believe it's only supportive.

Combined with social media there can be a dark side where we all feel, in a very tangible way, how we are all in direct competition with one another. We all tell each other "Comparison is the thief of joy," and we all know it's true, but it takes a superhuman amount of inner peace to not sometimes let someone else's success hurt your feelings. I think that just goes hand in hand with having a profession that *demands* constant self-reflection. Sometimes the bad stuff sneaks in there too! It's a hard industry, and there are a lot of very hard and painful parts of the experience of comedy.

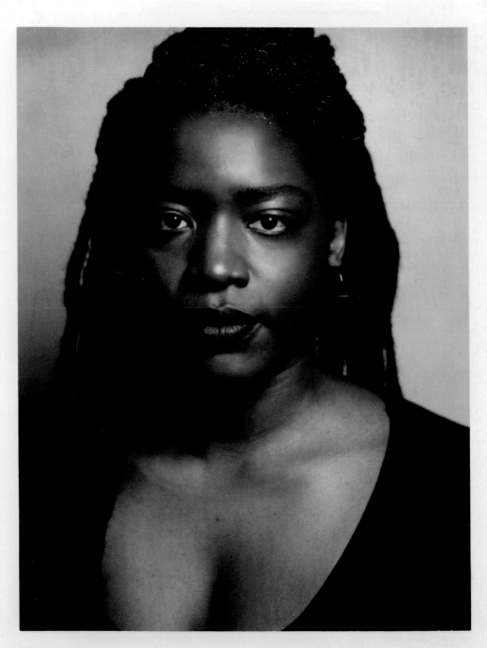

But that being said, if you can generally keep your eyes on you own paper and just enjoy laughing at how funny everyone is, it really is a joy. Working with people who are silly and creative is the best feeling in the world, and I think the one thing everyone in comedy can agree on is that once you find the comedy scene, you finally feel seen as a person. It opens this door to realizing you're not the only one who *thinks* the way you do. There's a community who "gets it," and I know for me that was everything. That's what keeps me in comedy now. I'm not alone, and I'm not insane for seeing how absurd things are.

There are very few shows that comedians feel cared about and appreciated at. *The Super Serious Show* is the only one I can think of where the experience

LEFT: CHARLA LAURISTON

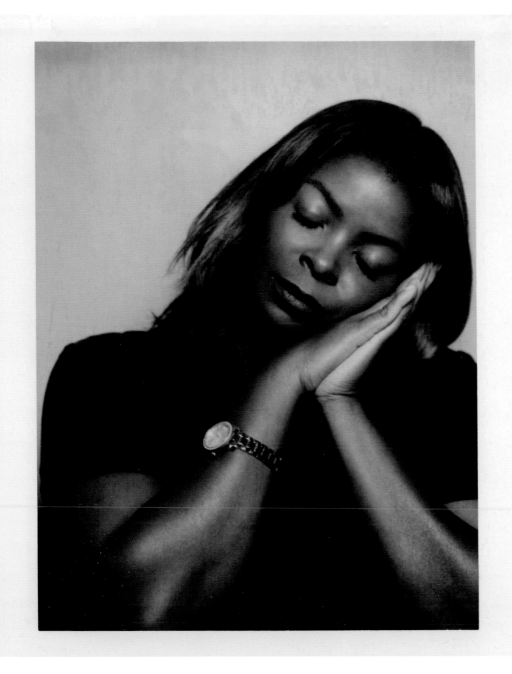

of the comedian is more important than the money being made on their backs. Paying the comics, making sure they have a comfortable greenroom space that is clean and nice, making sure they are taken care of from the time they arrive until the time they leave—that is *rare* in independent comedy. Most independent comedy I've experienced means well, but it's a special few that *do* well. *The Super Serious Show* does right by comedians and comedy fans alike, and that's something worth being a part of.

RON FUNCHES: Overall, I love it. It's like anything you would want: it is a supportive competition. Everyone knows that it's somewhat competitive, but what's for them is for them, and if someone gets something, then you're usually like, "Oh, I wouldn't have gotten that, so I'm happy for them," and it just kind of gives you a map of where you want to go.

I think the one thing everyone in comedy can agree on is that once you find the comedy scene, you finally feel seen as a person.

—Monika Scott

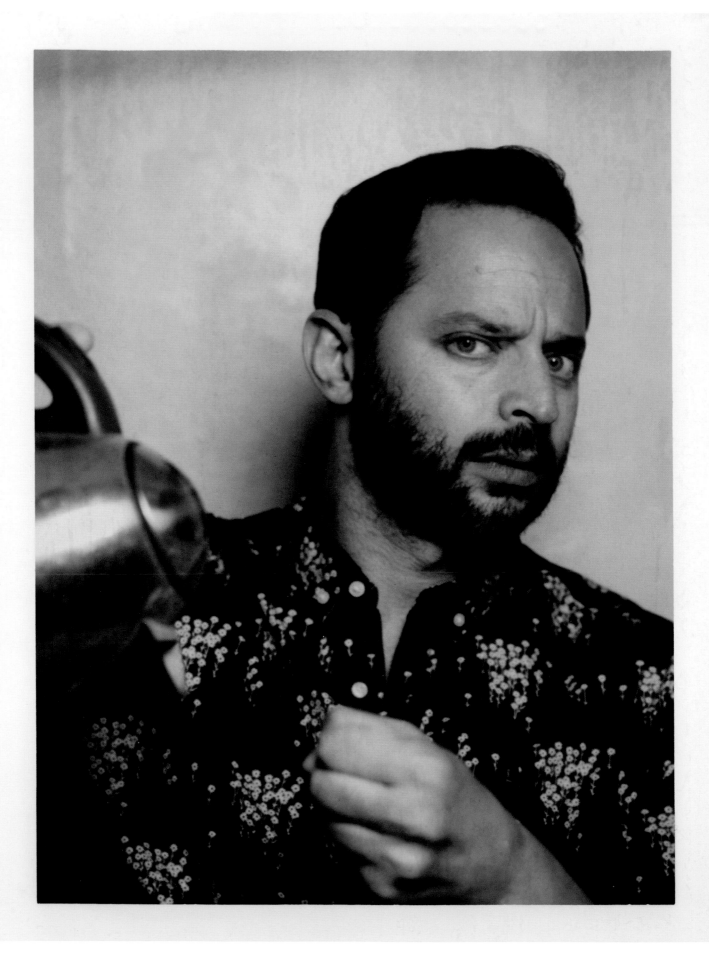

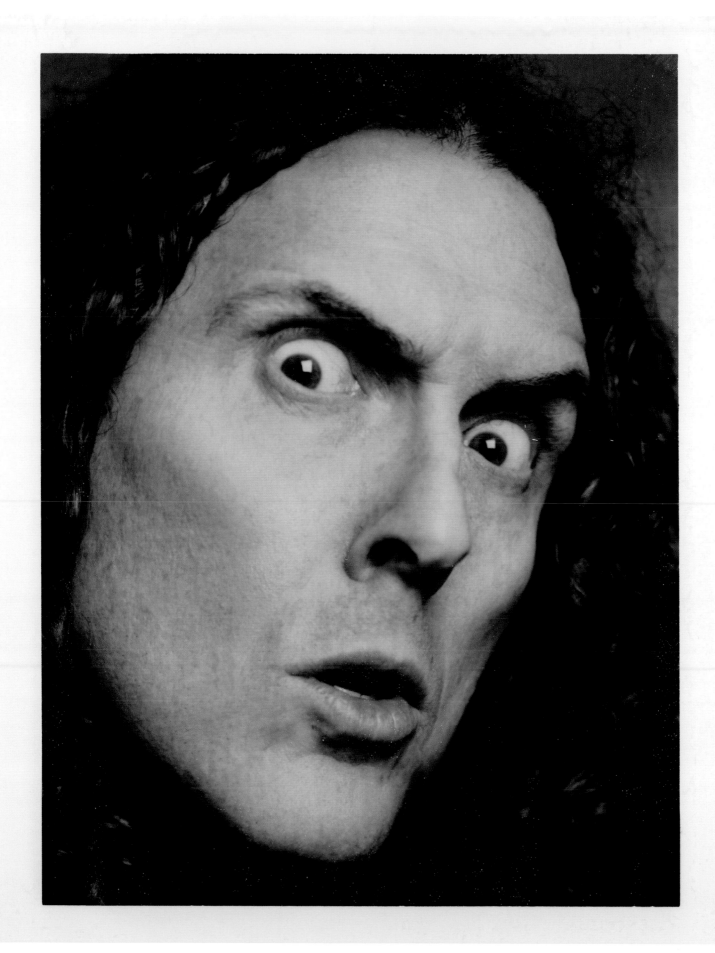

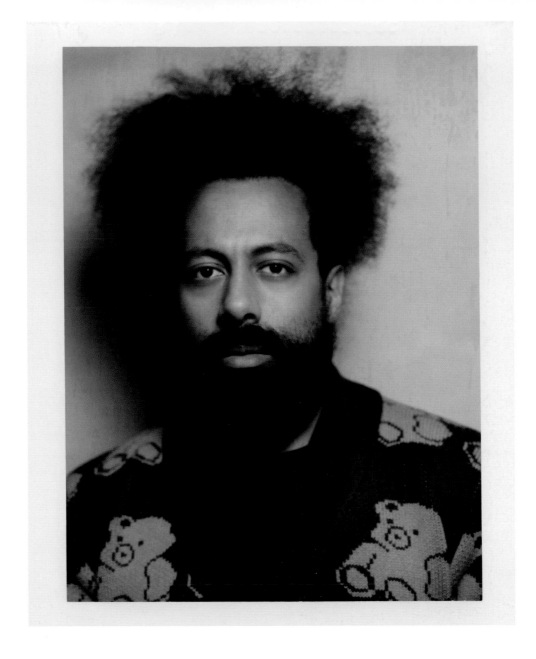

PAUL DANKE: I really think that independent comedy is still the future of the tapestry of comedy. More voices can and will come out of those places. I'm looking forward to seeing more people trying to bring circles together, to make a broader Venn diagram where many groups of people can fit together and relate together. I look forward to being a part of it, seeing it happen, meeting the new people that are coming into it, and encouraging the people that are twelve years into it who aren't sure they can still do it anymore. I think it's so wonderful.

MJ: It's the best part of comedy. More voices, the more diverse the community, the better the comedy. I think comedy is the best way to speak truth to not just to power but to life. Comedians have the power to share things, moments, thoughts with the audience, normalize things more than any other form of media.

PD: Yeah, and since laughter is a real response, it can grow very quickly. So often you see

someone deliver a line or an attitude, and you can see the audience, they need it, they were . . . thirsty for it, and they didn't know. They weren't able to articulate what they needed. But when you see it, it takes your breath away a little bit. I'm looking forward to all the future weirdos that come through.

MJ: Me too. It's fun.

PD: It's really fun. I hope that it continues to be important to support each other in a healthy life, a healthy community, and outing the monsters, encouraging mental health, and supporting each other as we all go through our drug addictions, sex addictions, gambling addictions, and recognize that a lot of people do fucked-up stuff, and, ultimately, it's not the story they want to share, and allow them to grow and tell it. I think that's what independent comedy allows for. That's the best part about it.

ASIF ALI: I think for me, it's truly like it's always the source of immense happiness for me. I love comedy so much. I love hanging out. Just shooting the shit with people, talking to people. It's like that's primarily my source of sanity and socializing. Especially now. People don't really hang out with anyone anymore. So, for me, I know, almost every night I socialize with human beings, both comics and people in the audience, for, like, two hours a day. People go to therapy for that shit. People spend a lot of money for the ability to just go talk to people. That's huge for me. It's a thing you don't realize initially. And then, you . . . It has bigger value to you later on. I get to laugh practically every night. In this day and age, that is a luxury.

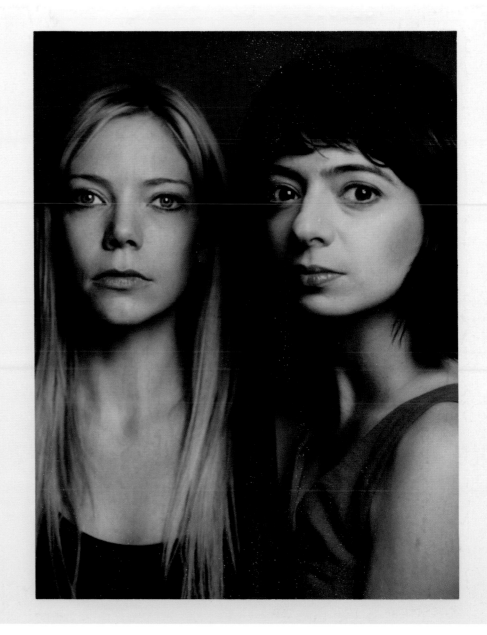

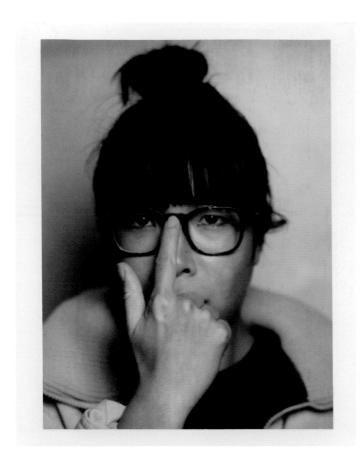
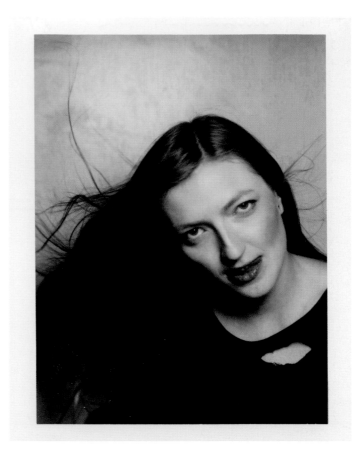
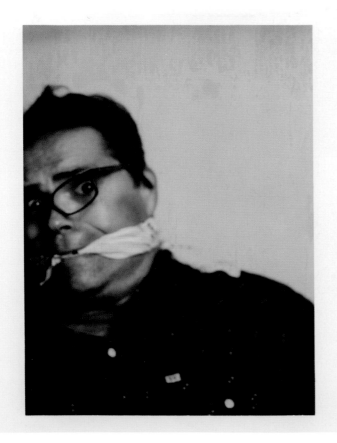
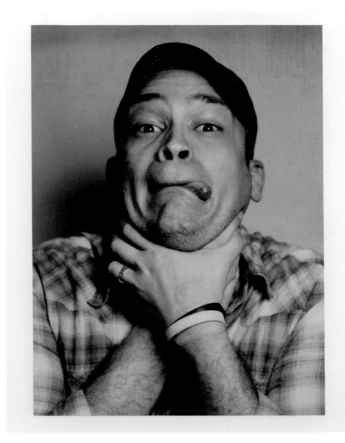

TOP: LEFT-KYLE MIZONO, **RIGHT**-ANNA SEREGINA, **BOTTOM: LEFT**-DANA GOULD, **RIGHT**-ANDY PETERS

SHENG WANG: A super important piece of the whole process and the whole experience is having other people to share it with, because outside of that, it's hard for other people to relate or to understand. So just from a mental health standpoint, it's very important. The community at large, you feel like as long as . . . We've all got to be crazy and delirious to some extent, but as long as they're comedians working on their craft, at large it just feels like we can connect. We can relate and understand each other. But then it's also important to have your tighter group of homies that you talk to more consistently, regularly or whatever, to help level you out, because it's always up and down. Then you have the people that you should really get inspired by, that you root for. It's a fun, crazy thing to be part of.

. . . you can see the audience, they need it, they were thirsty for it, and they didn't know.

—Paul Danke

EMILY MAYA MILLS: I think it's hyper important. Usually, I talk a little bit about the familiar aspect of it—it's intimate, there's something bold about sharing these vulnerable thoughts, and it's immediately bonding. I cry thinking about how well we all know each other. It's almost like having siblings or kids, or it's definitely more than a coworker bond that you share with the rest of your comedy community. The fact that you are an island sometimes, drifting around Los Angeles, knowing that, *OK, here we are; we all come together*, and there's a sense of home.

We also need to acknowledge that it sometimes can feel very lonely and difficult, and I want to recognize that so that we can remember as a community that we're all here for each other.

BLAIR SOCCI: Yeah, it's crazy. I mean, I'm sure everyone has said this, but you really are in the trenches together. It's a really, really specific life that no one else outside of it can understand, and you're bonded so closely through how gnarly it is. A lot of my girlfriends, the girls in comedy, have made me who I am now. Because I didn't really grow up around very many women, and I love my mom to death, but just Orange County in general, it's like women exist to be a lady. The men are the ones who make people laugh and have interesting jobs.

All the women, my friendships with my girlfriends in comedy, are just so deep. It's like we're truly family. All of them are so smart. So smart. They've all had wild, interesting lives. They're really good people, so loyal. It's crazy. I love them.

MJ: It's a nice thing that comedy gives you a family.

BS: Yeah, and I mean, I don't know if all people are like this, but whenever someone gets something that I love that I don't get, I'm still able at both times to be super happy for them and sad for myself.

MJ: That is quintessential of what I think a lot of the community is. Always very happy for people even if it means being bummed for themselves.

BS: It's never like, *Fuck that person*. This is the life that I wanted. I wanted it so bad. And now I'm around artists, all these incredible people every night; it is a dream come true. So when I

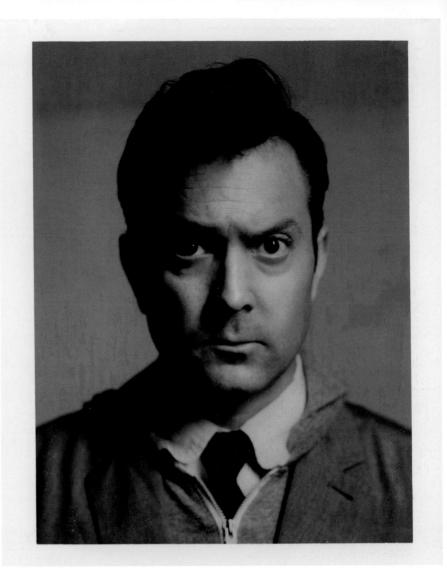

feel like, *Oh, why don't I have this job*, or *I'm behind*, I remind myself that it is happening. I don't know when, but whatever. I'm happy right now. I also need that life for other people. We have to keep each other up.

MJ: Comedy is really a journey. That's all the fun pieces. It's what bonds you to the community, it's what builds your career, it's what builds your family.

KYLE MIZONO: I love the community more the longer I'm in comedy just because the relationships become so long and so deep in this way where people who aren't necessarily my good friends but you just know people for so long. You know comics for like six, eight years, and that's crazy to me. I know that if I was stuck in a room with a comic who maybe I'm not good friends with but I've just known, it's like, I'll be OK; it'll be a good time. I have so much in common with that person. I think it gets better as you get older because you've known people for so long and you've seen them change, you've seen them grow personally. It's crazy.

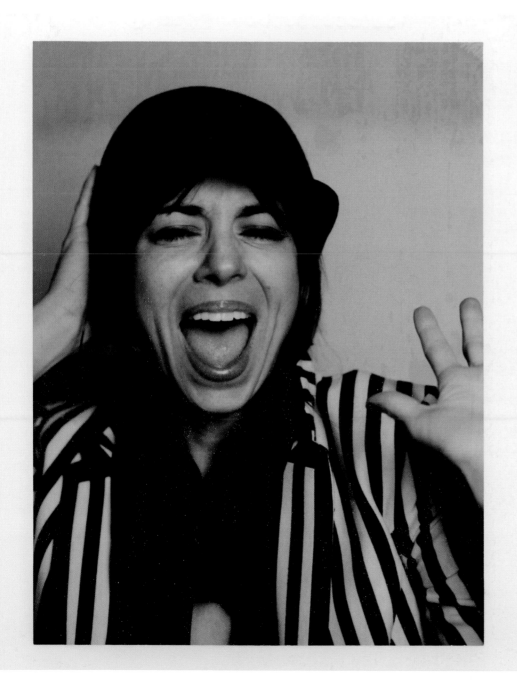

KARL HESS: When I started in comedy, I was twenty-three. I grew up and formed all of my adult relationships in comedy. All of my friends are comedians, for better or worse. When you're a young person and you're deciding that you want to pursue a creative venture, you throw your whole self into it. That becomes your life. So, yeah, all my best friends, all my relationships, are mostly grounded through comedy . . . There is something about going through deep trauma together that binds people. There's no deeper trauma than starting stand-up comedy.

RIGHT: NATASHA LEGGERO

KYLE KINANE: I don't ever make plans with friends. If I want to see my friends, I just look up what shows are playing. I've got five friends. They're going to be over here on this show; I'll just go over there. You think L.A.—it's going to be the shitty showbiz types and slimy creatures, and they're there, but you can smell them pretty quick. But the amount of good—spiritually and emotionally good—people that I get to meet, that's good.

Chris Garcia, this guy? He's the greatest guy in the world. That's nice. I'm glad these are the people that are in comedy. And then when you see them move forward, you're just happy for everybody for the most part. There's always that jealousy—so-and-so got this—but for the most part it's, "Hell yeah! Look at you skyrocket!" Jake and Matt getting *Corporate* on the air? Hell yeah! I did a table read with Lance Reddick for an animated thing.

I told him, "It's really cool that you're on my friends' show." He's like, "I am truly proud of that show." This guy! The dude from *The Wire!*

I think the community is great. I think it gives people a sense, because stand-up is a lot of outsiders and loners that, *Oh, you're a loner? You're a loner? We're all loners! Look at all us loners hanging out!* There's no hang-ups about this. We're all trying to do the same thing.

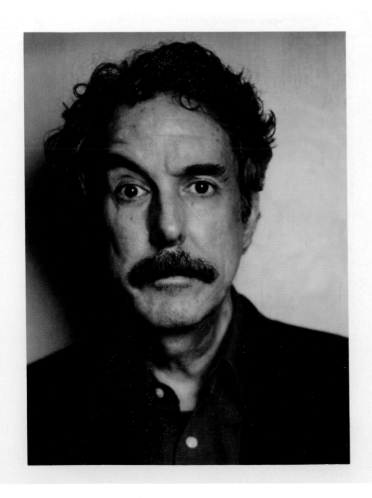

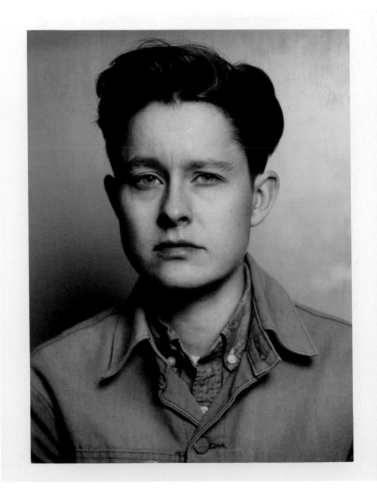

LEFT: RON LYNCH, **RIGHT:** RHEA BUTCHER

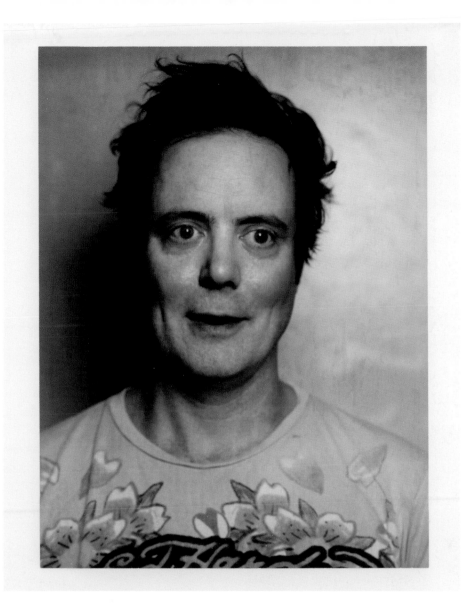

WHITMER THOMAS: My biggest problem with L.A. and living here was feeling like I had nowhere to belong. I couldn't connect with anybody . . . When I started doing comedy, you meet all these fucked-up people who are also willing to talk about things that are maybe a bit more personal. Which is what I like . . . When I met the comedy community, I immediately felt like I had friends for the first time in L.A. I couldn't believe it. Getting to go hang out at parties and talking about your set or whatever it was, just being really in awe of everybody. And then as we've gotten older, my group I guess is . . . We, no matter what, everybody feels like brothers and sisters, you know? You'll always have something to talk about. It's very rare that I meet somebody in the comedy scene and we can't think of anything to say to each other.

RIGHT: JON DALY

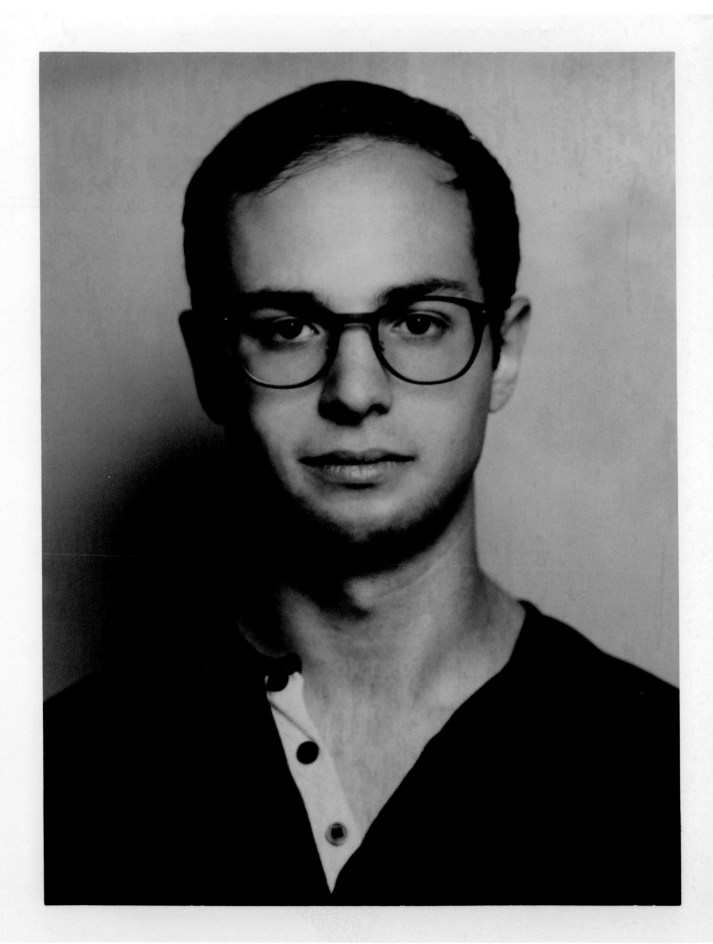

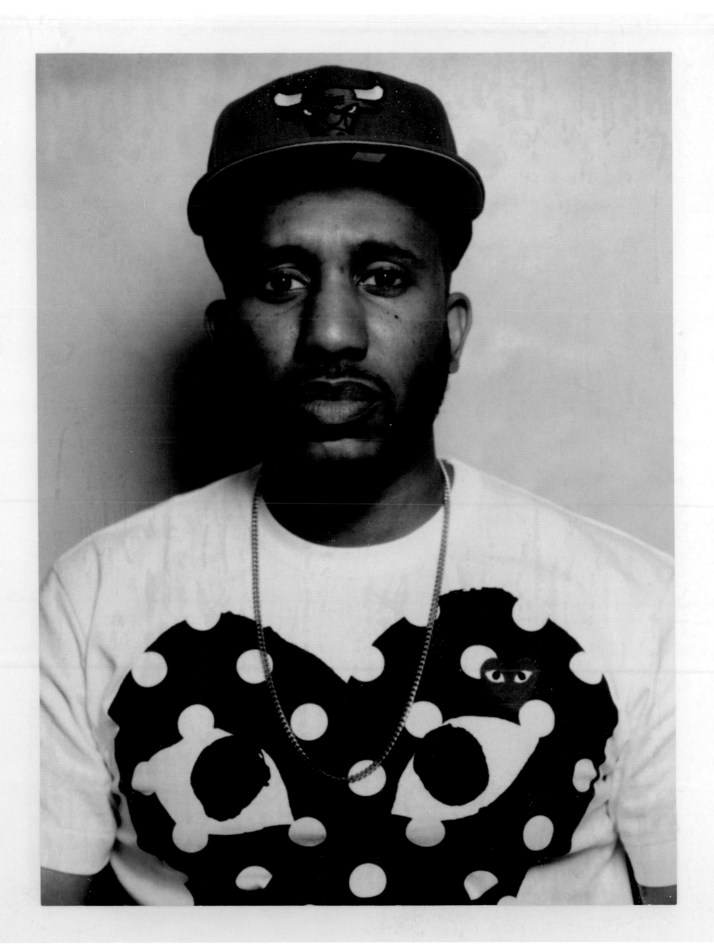

GREG BEHRENDT: Comedians in general are outliers anyway. So are comedy audiences. I think at least as long as I've been in it, people in the comedy community have always been super generous. And my experience, especially with podcasting and all that coming up, comedy fans can be incredibly generous and become really attached. You can get closer to a comedian than I think you can to a band.

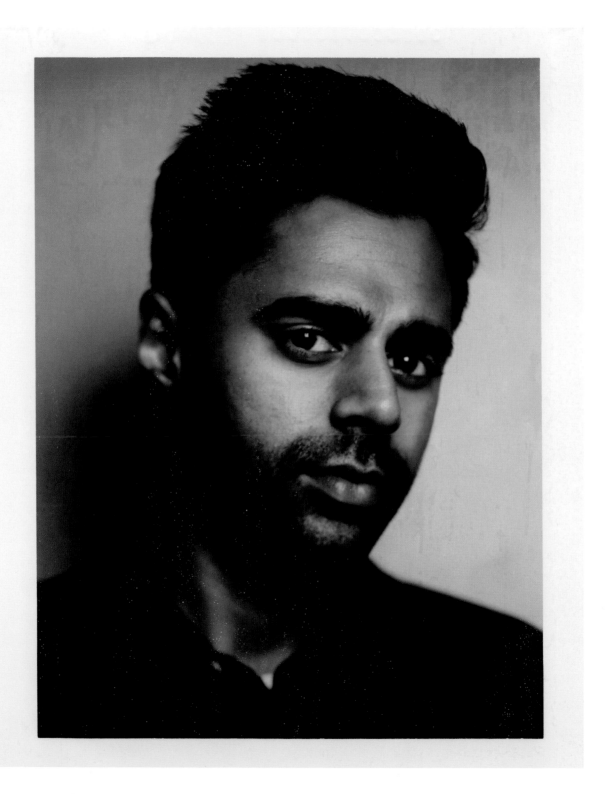

*PREVIOUS PAGE: **LEFT**-ZACH KORNFELD, **RIGHT**-CHRIS REDD* **LEFT:** HASAN MINHAJ

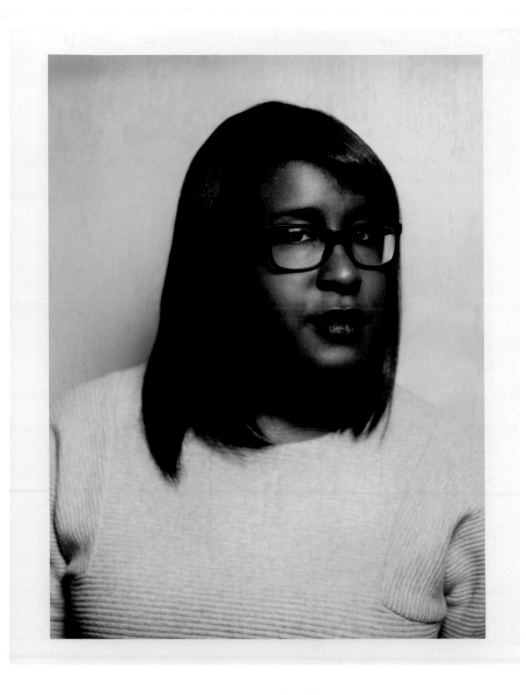

It's just awesome to do stand-up in Los Angeles because people, they want to be talked to, they want you to talk to them, and they want to share their experience.

—Jackie Kashian

MJ: It's interesting. Podcast fans come out to live shows, and they really feel a connection to the comedian that I think you don't necessarily feel with a musician.

GB: There's a little bit of a distance with music. And I think it's also . . . meant to be there. There's a bit of a wall

up with music. Whereas with comedy, it's such a raw—essentially live—art form. You can't help but have a personal attachment. It's conceivable to meet a comedian that you like. It's not like you finish comedy and then you're escorted off to a private room somewhere and then you get on a jet. You're in the parking lot.

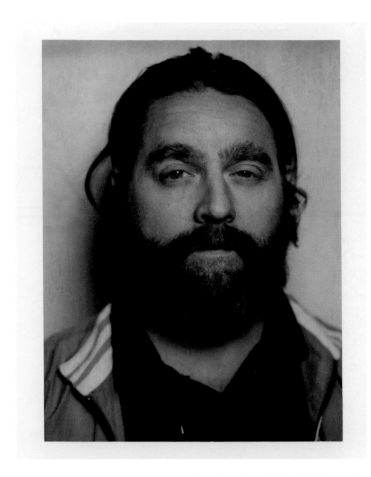

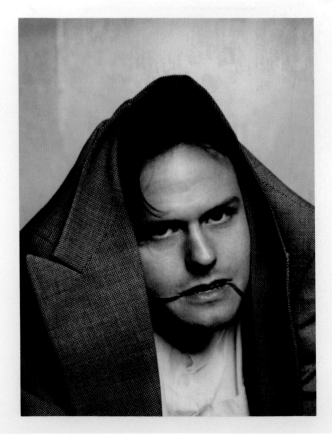

KAREN KILGARIFF: I think . . . the average stand-up comic type of personality is a very alienated person. It's a lonely person, and it's a person who's been called weird or whatever their whole life. So they figured out this way to verbally argue for themselves: here's how I'm valid, here's how you should listen to me, here's how I'm actually cool even though you would never think that. It feels to me—maybe that's just my personal experience—but you work that way for a long time, and then you find this tribe, and there is really something powerful when you get around people who you love what they talk about and they love what you talk about. It's like romance. They're the ones—people who can really appreciate you. All my life, it's like, *You're weird, you're obnoxious, you're whatever.* But I kind of couldn't help it.

MJ: It was who you were.

KK: It was how I dealt with my anxiety. Then to basically find this group of people who were just like, "You're the best." These things you're saying are great, and we can't believe it. You have these experiences, and it's not your career; it's not you trying to get a job or you trying to get ahead. You have these really important spiritual moments.

MJ: It's true. I think that the community and being backstage and coming up with people and all of it, the support and everything—that's the reason why I think we keep producing comedy is because we love the community so much. I love giving to it, I love creating a space for comics, I love knowing that I'm creating a good space for comics, and I can't imagine not doing it.

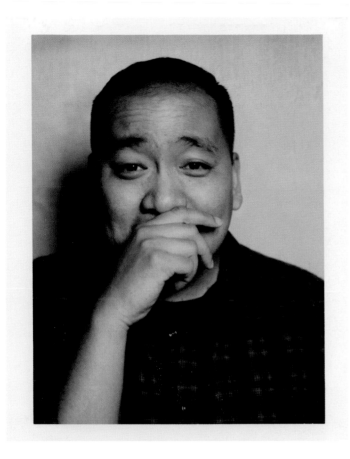

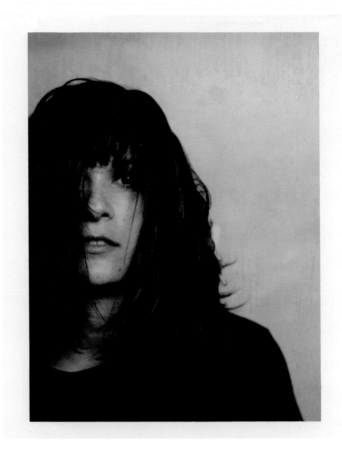

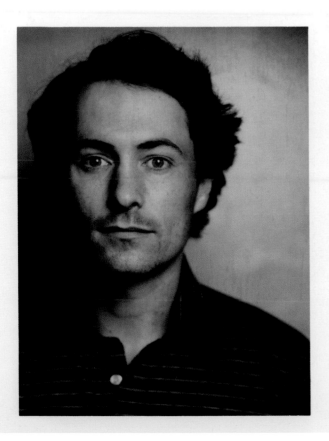

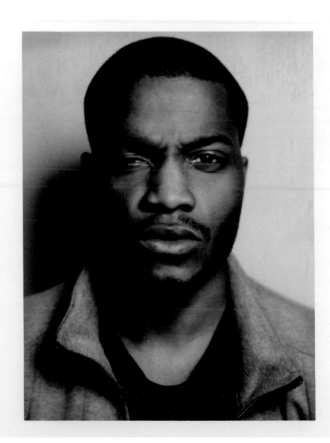

TOP: LEFT-KEVIN CAMIA, **RIGHT**-LISA BEST, **BOTTOM: LEFT**-DAVID HUNTSBERGER, **RIGHT**-JERMAINE FOWLER

207

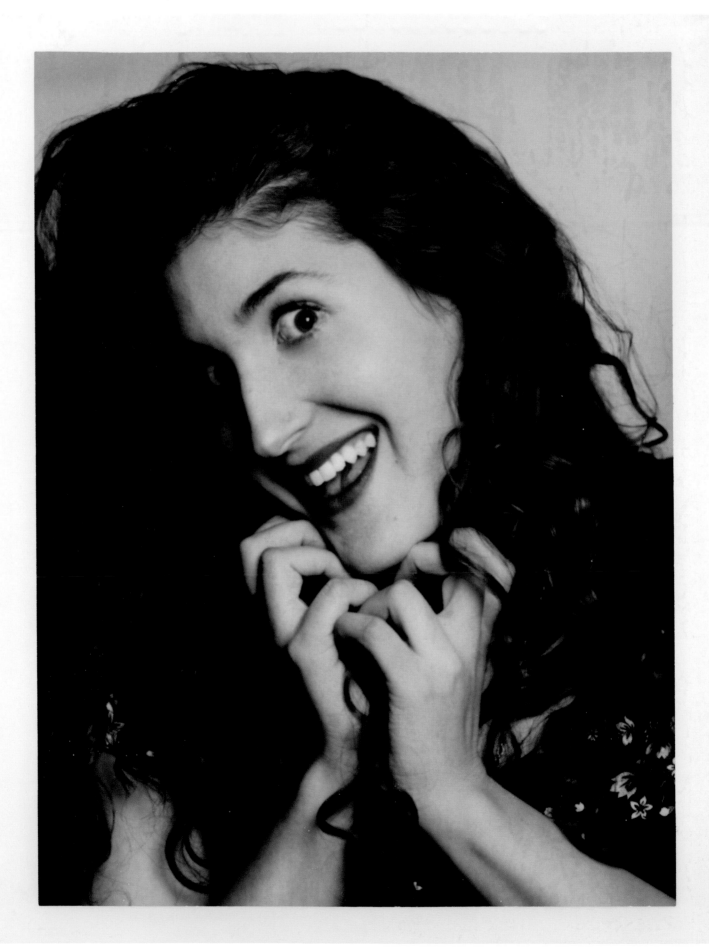

KK: Also because you guys have decided—this is what everybody in this area of business does—where you decide to be your own . . . you have to be your own apprentice. You have to teach yourself. Everybody is a self-starter in comedy. I think that's why musicians and comics and comedy people love each other so much, is because you have to go through a lot of bullshit and continue to say it to yourself, by yourself, "I should still be doing this," when you aren't making money and nobody gives a shit.

MJ: Nobody cares. You're definitely losing money, you're definitely not making money, nobody in your family understands exactly what you're doing.

KK: They think you're a fucking loser [or] they're scared for you, so they just want you to become an accountant so you have security and a future, and what you're doing is going, "No, I'm fucking rolling the big dice." And we are all here because we believe we can, we believe that luck is on our side. It's brave; it's rare. When I think of you producing shows for festivals, when I hear your name, I'm like, We're good to go. If people need to get paid, they'll get paid . . . There's going to be people there who are advocates for the talent and for the artist.

MJ: That's nice to hear . . . No one taught me and Joel; we didn't learn from anyone how to run shows. We just believed this is how it should happen. I know that there's a couple shows around L.A. that have told me that they pay performers because *Hot Tub* and *Super Serious Show* pay performers . . . I don't know why I'm so emotional!

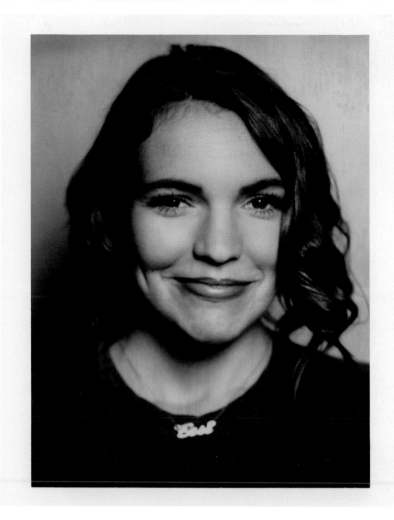

KK: You know why? *It fucking matters*. Look, I am too. This is where you shovel shit for years. We never talk about stuff like this. How many fucking times have we stood backstage at some big show, or cool thing, we look at each other and go, "Ooh, this is neat," but we treat it like it's a plain old day-to-day. And actually it's very special. It's very cool. It's very important. It matters.

KATHERINE LEON (PRODUCER): An important thing that has always mattered and still matters to me was to be able to surround myself with good people creating really cool shit. And I didn't really care what the cool shit was; I just wanted to be a part of it and support it. I remember waiting in line at shows thinking, "I'm here again. I always want to be here. I want to be around this forever, but I don't know how." The only performer bone in my body died with me in our production of *A Little Princess* in the fifth grade.

For me, the comedy community became a larger place that made me feel connected to Los Angeles in general. But because L.A. is so industry-heavy, being naive and thoughtful is what's eating me alive and also the only thing keeping me going, because I can trust my own taste. That's what makes it so special, to see what can stand out through the stuff that the industry doesn't really care about and make them care about it.

You and Joel met me when I knew absolutely nothing and believed in me ever since, and that really affected me. I would watch how you produced your shows, and it was so clear that you cared so much about not only running the show well and efficiently but making sure everyone on the show had fun and felt welcome. And you cared about the comics and the venue staff and the crew you brought on and the audience, and as someone that wanted to shoot photos and be a part of documenting what was happening, I looked for that quality in so many people. To make sure that I could work with people that understood that part was also important.

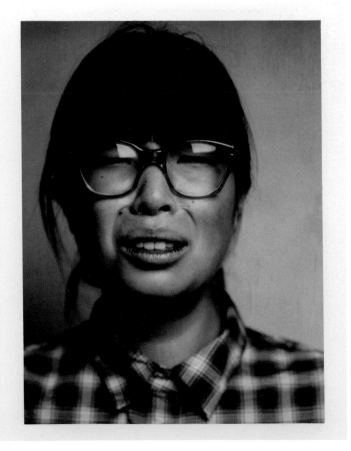 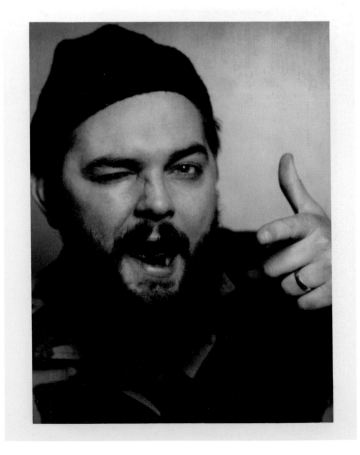

LEFT: KYLE MIZONO, **RIGHT:** NICK THUNE

ANNA SEREGINA: I love in independent comedy that there's a variety of shows that have a show to a prompt.

MJ: Homework shows.

AS: Yes, homework shows. I love to see because it's, on the one hand, it's a comedy nerd night, but it's where I feel most community. I'm always seeking that feeling of high school from doing theater where we're all in it together, we're rehearsing every night, we're a team. I love that sleepaway-camp feeling. Those are the moments where I love the independent comedy community the most. Seeing what they can do to a prompt, or different sides, or being excited together, being nervous together.

MJ: I think one of the main reasons that I've stayed producing comedy is because I like the community. They're in it with you . . .

AS: If friends are getting stuff, that just means it's closer to my world. And even selfishly, it's getting

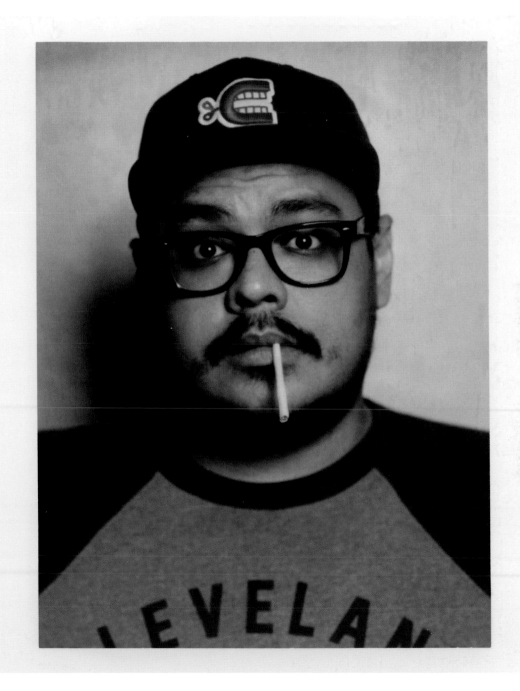

closer to me. Great! It's indicative of the fact that a path is opening. In general, I feel like people are happy for each other. It's exciting. You feel that community aspect of it pretty closely. That's not to say there's no pettiness—of course there is. But I do think, as opposed to other stuff, I think people are generally happier for each other.

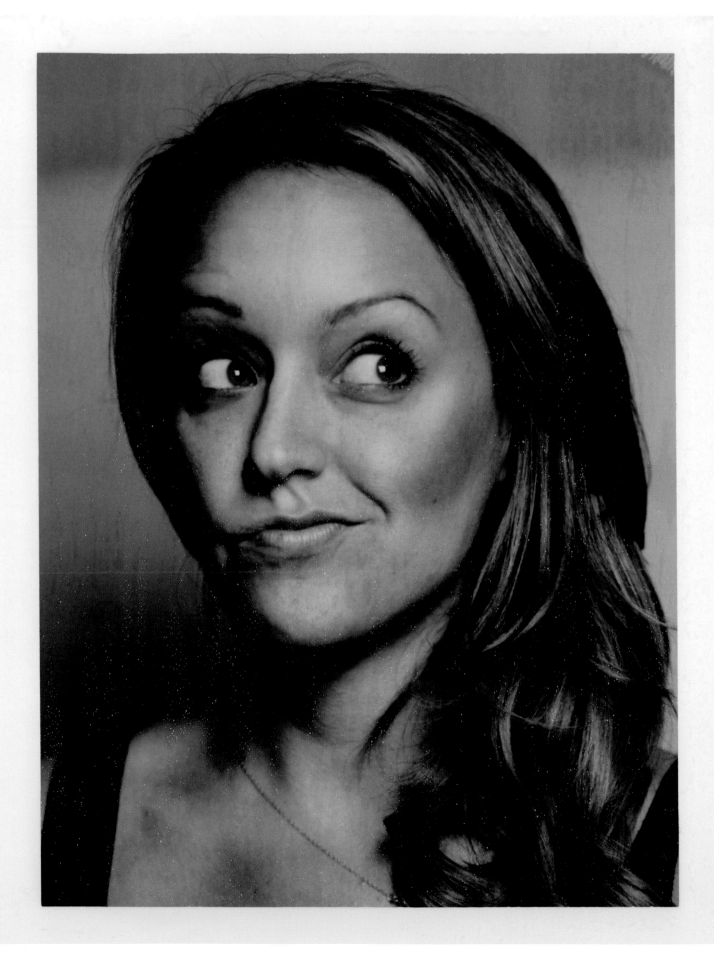

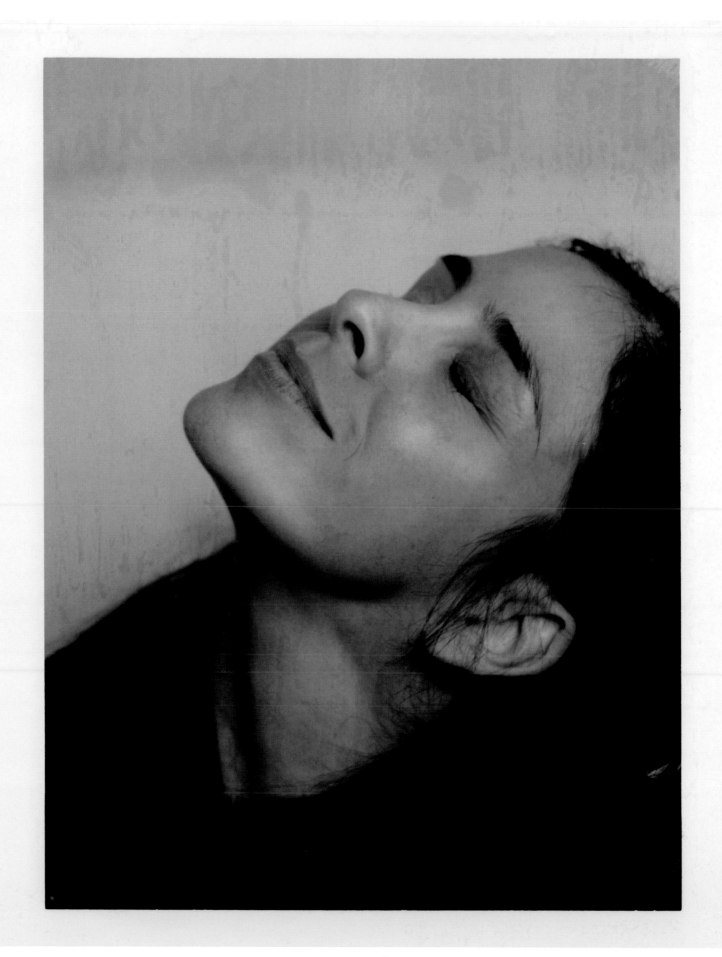

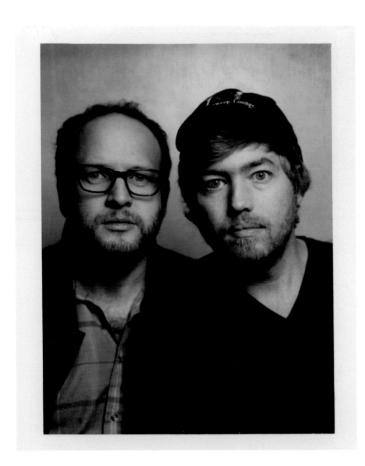 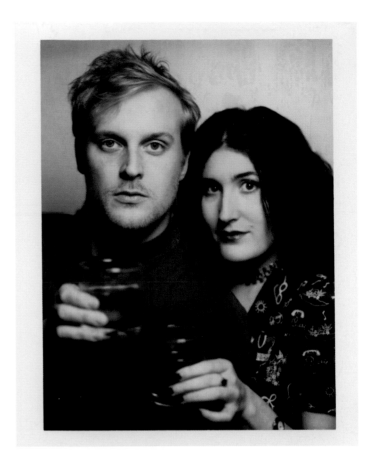

SARA SCHAEFER: It's such a community. On my talk show, *Sara Schaefer Is Obsessed with You,* I had writers, I had a producer, a sound guy. I mean, I looked back and was like, *Why did anyone do this?* We weren't making any money. All of those people have gone on to have very successful careers. I realized they were developing their career too. Just because I was the one onstage and getting name recognition doesn't mean they weren't getting value out of it.

That community of people—you know, we never knew where we would all end up, but we're the ones that stuck with it. We're still in it. It is fascinating that pretty much everybody, whoever they came up with, to a large degree, is a cemented friendship, a bond and a working relationship. That's your family in a way. Your other family, your work family.

In my crew, from my talk show, we've all gone on to bigger things. We're all working and doing really cool stuff with our careers. We've all had our highs and lows just like anybody else. After all this time, those people that were around when I first started are like my best friends. I had a fortieth birthday party, and I looked around. Most of the people in that room—I'm, like, getting choked up thinking about it—were there at the very beginning in New York.

BARON VAUGHN: I think it comes down to the independent stand-up comedy scene is a little bit more like the improv scene than it is the comedy club scene, in the sense of the level of support and that sort of kinship that people feel with each other. I feel like what happens at the clubs is, at a club, there's that stage. That specific room, that becomes the jewel, the trophy that you aspire to get. But literally anyone else that wants that becomes your competition. Whereas in the indie scene, it's sort of like, there's a rising tide that raises all ships, feeling a little bit more . . . There's enough to go around. The indie scene is an amoeba. It expands and contracts as it needs to . . . Producers start doing more shows in different places, or they move a show to a bigger venue, or they know each other, so they can recommend you. There's always this feeling of, I'm trying to help you out. I'm trying to do good by the people that I'm surrounded by . . . I like to be in a place where people are about helping each other out, helping each other become better.

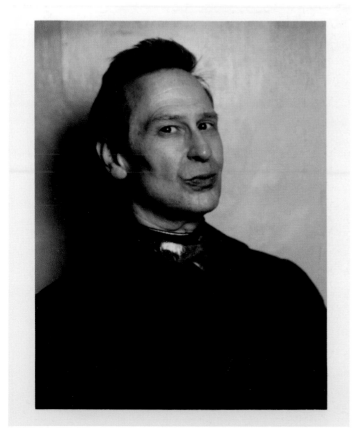 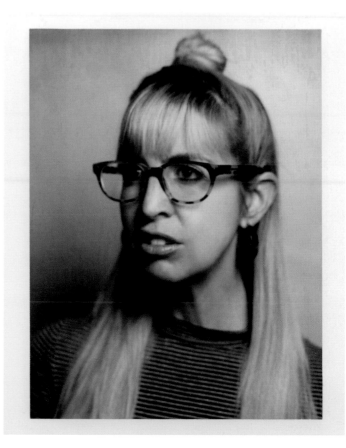

LEFT: SCOTT THOMPSON AS BUDDY COLE, **RIGHT:** LIZZY COOPERMAN

MJ: I think that is the exciting thing about comedy a lot of times. When you get a show, it's not just that that opens up doors for other shows, because it proves that a show like X, Y, or Z could work, but it also opens up actual jobs . . . You hired so many people that you met through the community. Your fantastic choreographer [on *Crazy Ex-Girlfriend*] is probably one of them that you met through—

RACHEL BLOOM: You're completely right. Kathryn Burns, I met from UCB. So when you're hiring for these shows, you suddenly go, "Why would I hire someone who's fifteen years older just because they have the clout when I could hire someone who knows what I'm doing and came up with me and knows exactly what I want?" That's why I push for hiring not even just people I know but people in the community. There's a shorthand there.

PETER ATENCIO (DIRECTOR): Comedy is far and away the most inclusive and supportive community I've ever been a part of. There's a kind of democracy to it: funny is funny, and you know funny when you see it. That leads to a lot of wonderful collaboration, because everyone typically has the same goal: to make the audience laugh. On *Key & Peele* we called it the "meritocracy of funny." The funniest idea always wins. Anyone in the room could pitch a joke, and that openness is the true spirit of the craft.

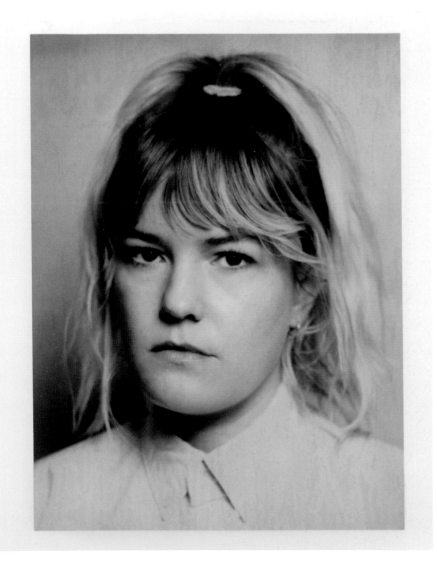

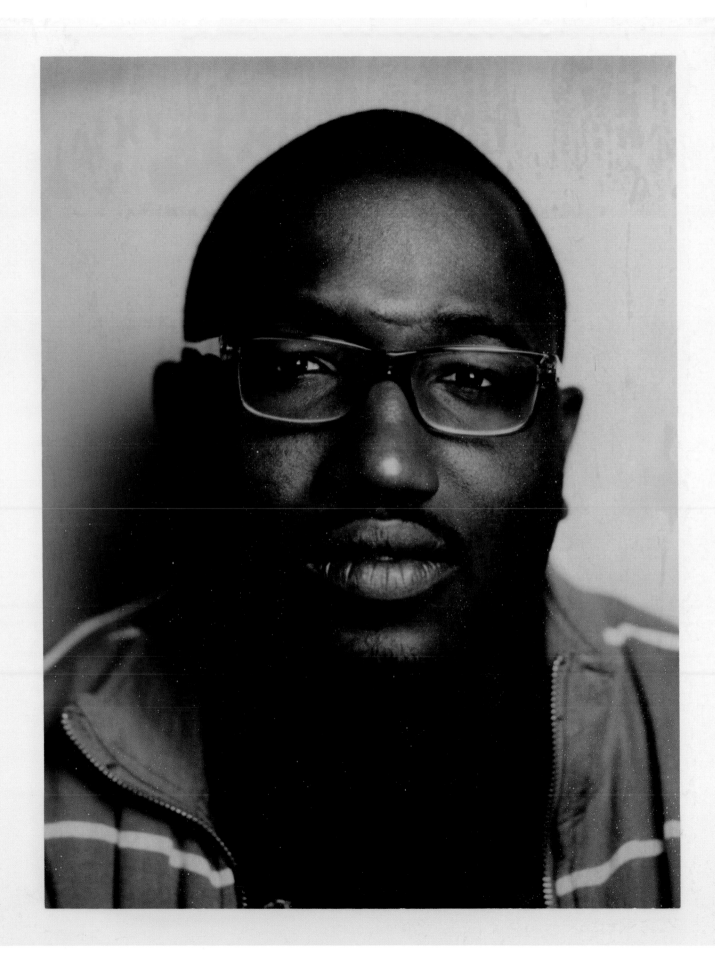

If you are funny and talented and willing to take risks and willing to fail, you can pretty much do anything. The advantage you have is not giving a fuck about failing. That's what comedians are. People who are willing to fail in public.

—Jake Weisman

KATE MICUCCI: There's also that great feeling of when you're doing a show, and you're standing in the back of the room, with other comedians, watching someone onstage, and you're having this shared experience with these other people who do the same thing you do. And you're rooting for that person onstage. It's just . . . or that extra laugh. *Come on, audience, let's do this*. It just feels so good.

RIKI LINDHOME: Comedians are the best laughers, too.

JUSTIN WILLMAN: I think it's so cool how open and enthusiastic you guys are for outside-of-the-box-type performers. And I feel, like, giving performers like that an opportunity to be within the fold of the comedy community and also be something that audiences aren't used to expecting is a treat. And I think it serves the show, and for the people like me, the weirdo acts, it really does help to have a home, so that you don't feel like an outsider. So don't stop.

MJ: Never.

JW: A rising tide does raise all ships, definitely for performers like me. I feel like whenever another magician or comedian does well, or I hear about someone who crushed it at the show, I feel like it just . . . It's not like there's a competitiveness where you feel like, Oh, there's one spot for an outside-the-box person, and I want to be that person . . . I feel like that's just not the case. I feel like the more, the merrier. The more really good acts, for getting up and being seen, the better.

MJ: It makes for better comedy.

JW: It makes for better comedy. We're lucky to live in this town where there's an appetite and an audience for our weirdness.

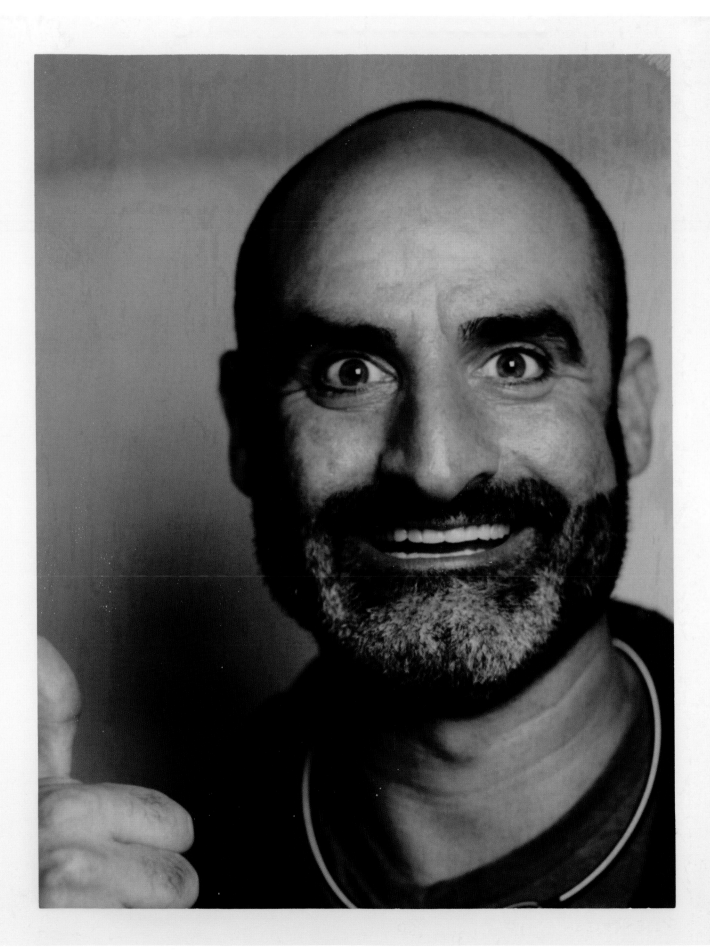

MATT BRAUNGER: I got this random gig where *Funny or Die* **sent me and Brody to do stand-up at this baseball retreat at this Florida resort, like a golf resort, that is . . . It was one of the most rich places I've ever been in my life.** My hotel suite was as big as my house, with a living room, three bathrooms, just for me. Wasted space. I don't know sports for shit, but the audience was like . . . Ken Griffey Jr., Dave Winfield, Mark McGwire, you name it. Anyone alive or dead that was a baseball superstar was in this giant hotel conference room that spilled out into the outside with a bar and just every kind of seafood, incredible opulence.

It's one of those ones, one of those situations where I'm like, Thank god I went first. I'm so happy I went first. I did fine, but then Brody gets up there, and it's one of those things—I wish I would have filmed it because Brody is the opposite of me in terms of sports. He knew what these guys stats were now, what their stats were last year; he knew where they went to college, where they went to

high school. So he just gets the mic and is like . . . We're all champions, positivity, and then he'd point at a guy and be like . . . Dave Smith! Not a bad RBI your junior year! Exactly this much! Now you're this much. Here to here. Everyone's like, What the shit. You can see their faces. It was like they were watching magic.

He would pick, pick, pick, and just ripping them to shreds, goes over to Ken Griffey Jr. and goes, I touched him. I touched him. I'm magic now. They were so happy. They were like, Yes! Then Kenny Lofton jumps up. He gets in Brody's face and just starts talking shit, but joking, and is like . . . "Man, you've got to watch out!" Brody goes, "Oh, Kenny Lofton getting in my face, wants to fight. Who the fuck am I now?" And then he names a player that everyone knows they hate each other, and people threw chairs. People were like . . . hands on heads. Literally, everyone's just like, What the fuck? How? How do you know this? I remember I'd never been happier to not be onstage and just be leaning against a tent post with a can

of beer. Just being like, Oh my god. It was like saying, Yep, I saw Hendrix. He rocked. I saw Brody do this thing that no one would ever see, but it was his element. He was a baseball pitcher, he loved the game, and he knew all the stuff.

After the show, we're all in the bar, we're all buddies now, and everyone is gathered around Brody. Every player. He became Ken Griffey Jr. Then Ken Griffey Jr., who's notoriously shy, just comes up to Brody and goes, I touched you! It was the cutest thing I've ever seen in my life. I got him back. Yeah! Good, Kenny. You did it.

MJ: Oh, that is so cute.

MB: Beginning to end. And it was, you know, it was one of those great stories I've always had, but I just . . . When I think of how he's gone, I'm so glad I have that.

MJ: It's a really great story. It's perfect. It's a really . . . I wish I could have seen that.

MB: I wish you could have too.

POSITIVE - ENERGY

I was in love with Brody, and he permeated everybody who loved him.

—Andy Kindler

WHITMER THOMAS: I had only met him that one time at *Power Violence*, the first year probably doing *Power Violence*, and then, one day, we were outside of *Tiger Lily*. I was walking up, and I realized that Brody and Joe Wagner were talking to Zach Galifianakis, who was standing on the sidewalk with them. My heart started beating because he was the most important comedian ever—he was just a huge deal. And Brody said, as I walked up, he was like, Whitmer Thomas, *Power Violence*, Zach Galifianakis; Whitmer, very funny comedian. I was like . . . such a cool introduction to Zach Galifianakis. Zach was like, Hey, man. But the truth is Brody had never seen me do comedy. There's absolutely no way. I was . . . If anything, he saw me intro him . . . He saw me go, Here comes Brody Stevens. That's all he ever saw. He was backstage at a show. There is absolutely no way. It's a great symbol of his character that he introduced a twenty-three-year-old kid to one of the most famous people in the world at the time as "Whitmer Thomas, very funny comedian," and gave him my credit, which was *Power Violence*.

JAMES ADOMIAN: I'm grateful that for how much pain he was in, he was still such a dedicated craftsman. He had theories and beliefs about comedy. He cared about it; he cared about making people laugh, more than anything. It was his life's work. It was his dream. He was great at it.

I'm very sorry, the way he went, and that we didn't get to say goodbye. I really would have loved to say goodbye to him. I really would have loved it.

Brody. He was like an icon of the L.A. comedy scene. He was a pillar. He was an early major influence. For a lot of people.

818 FOR LIFE

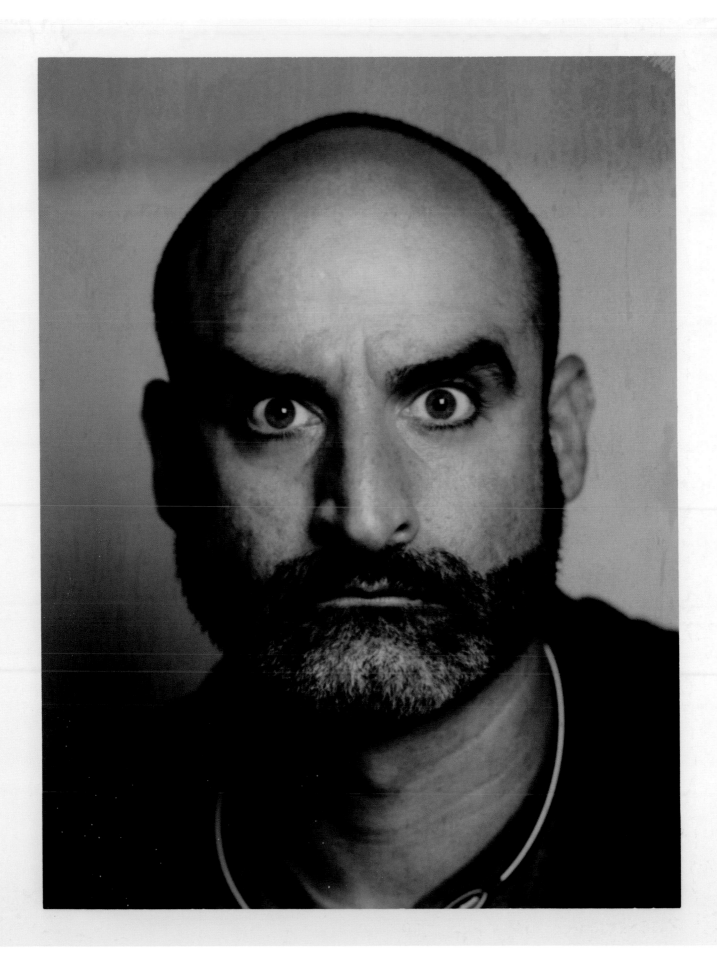

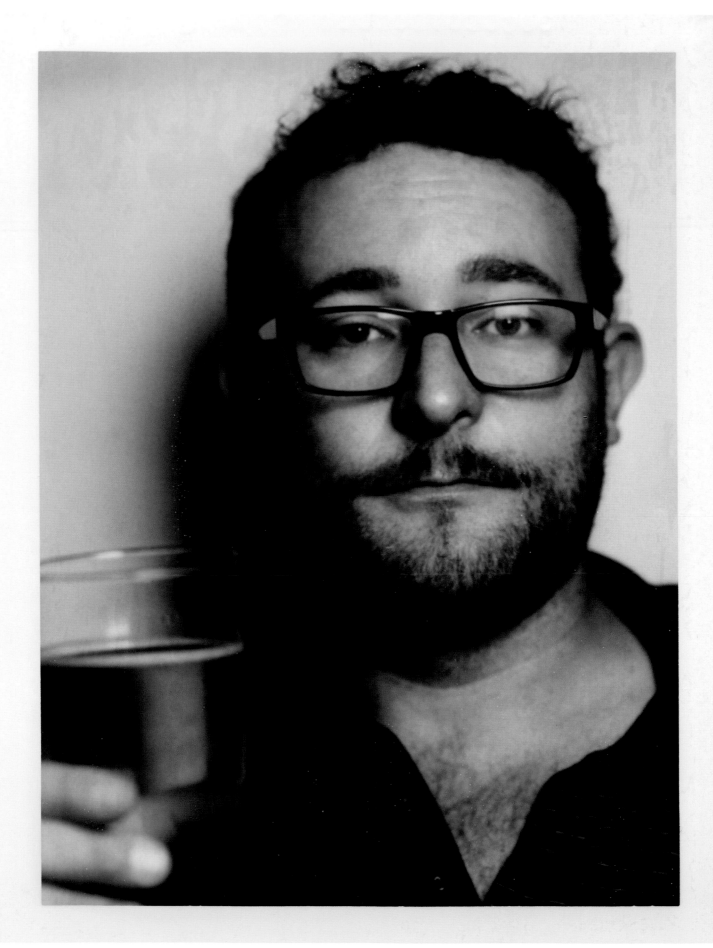

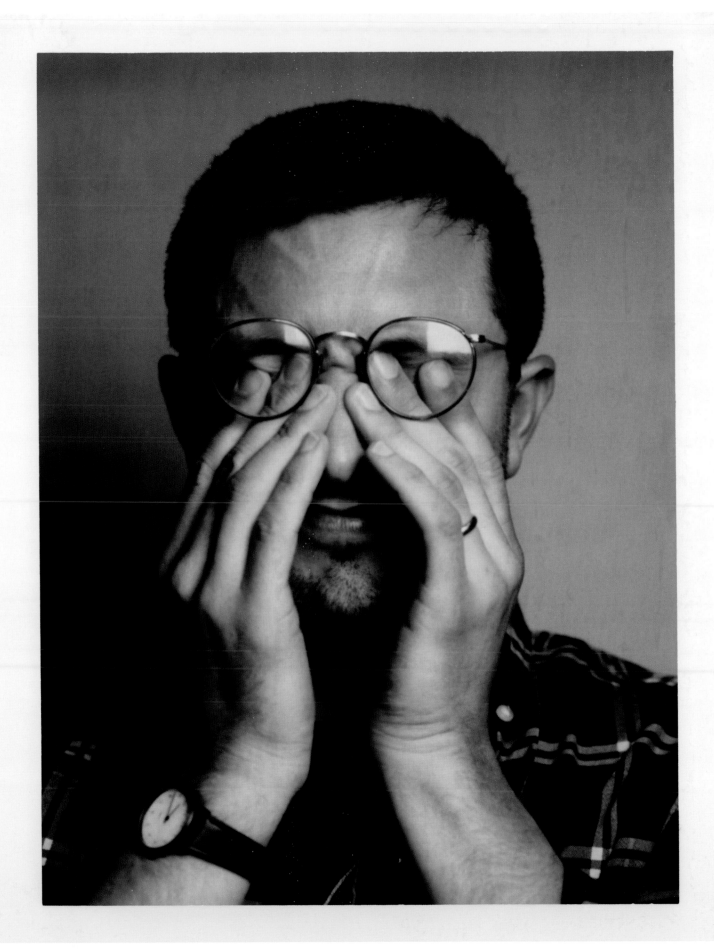

HY

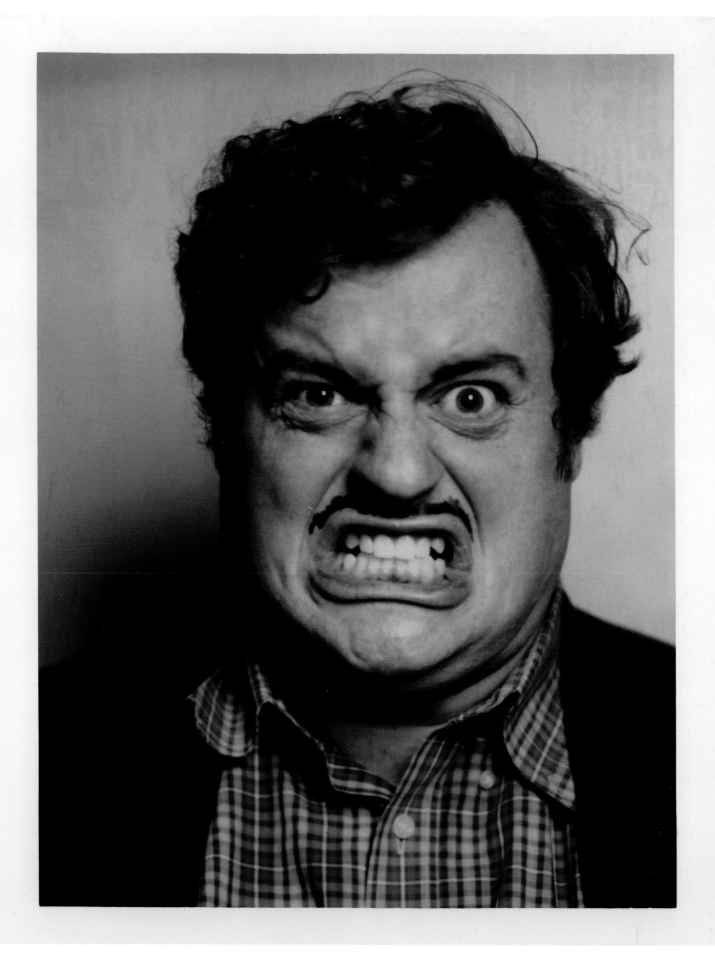

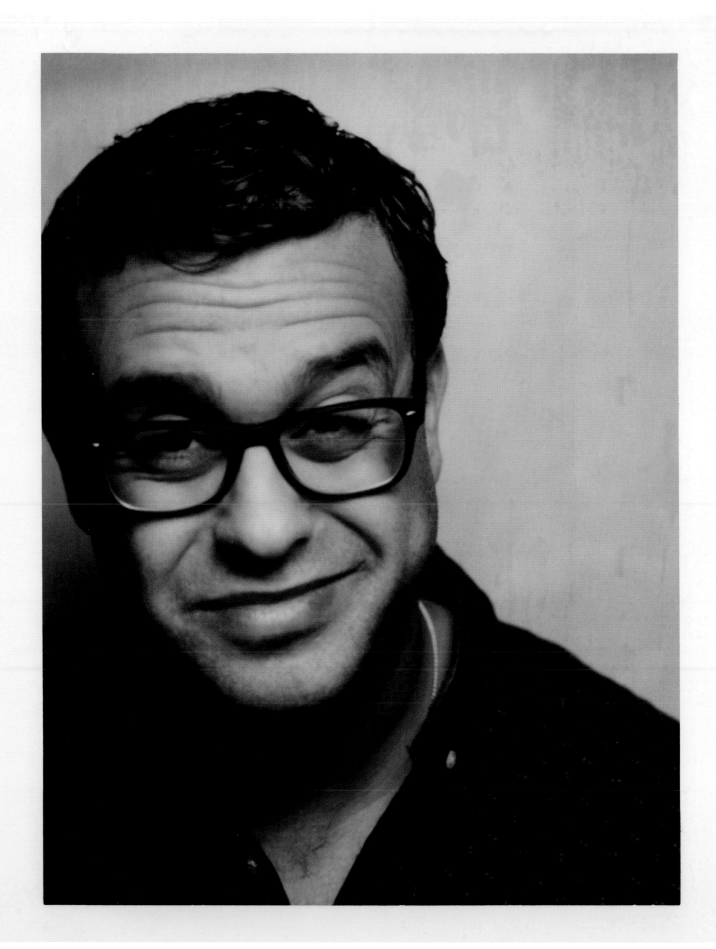

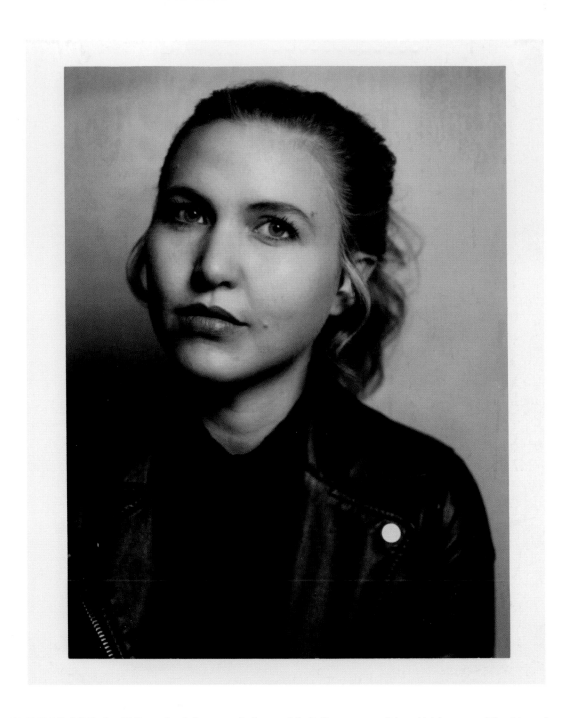

JIMMY PARDO: Why do I keep doing this? Because it's all I know. That's why.

MANDEE JOHNSON: Do you think that you'll ever stop doing stand-up?

JP: Yeah, as soon as tomorrow if I could.

MJ: You don't think you'd miss it?

JP: Obviously, I would miss it.

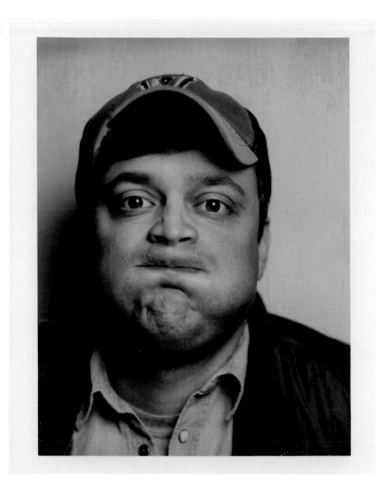

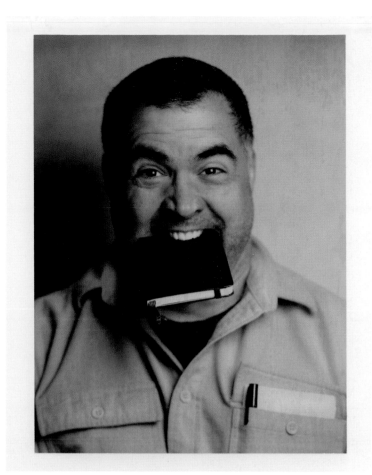

MJ: Do you guys think you'll ever stop performing live?

RIKI LINDHOME: I hope not. I mean, we're never going to break up. It's never going to happen.

MJ: You guys are very happy with each other, it seems, and very successfully long running.

KATE MICUCCI: We talk on the phone every day if we're not . . . If we're out of town, it's still, we're really good friends.

RL: We take breaks and come back. We perform more. It's been a wave.

KM: I don't know; it's a really important relationship in my life. It's one of those things where I always said, it's probably harder than a marriage, I think. There's so many things you have to figure out.

RL: I've had one of those really . . . Sometimes you have a bad year. Like, I have this year, and I've relied on Kate more than any other person. She knows me. She knows all the good and all the bad.

KM: We just get each other. Whatever we're working with, we have times where one of

us is busy, the other is busy; we just still make it work. We were just on a deadline for this writing thing, and I was in Vancouver and Chicago, so I was gone for ten days, and we talked on the phone every day. We worked over the phone for hours at a time. We just make it work somehow.

RL: We make it work.

KM: It's one of the luckiest things.

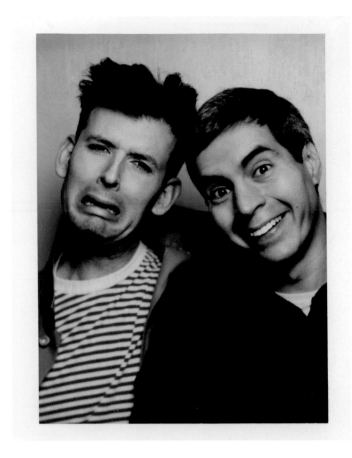
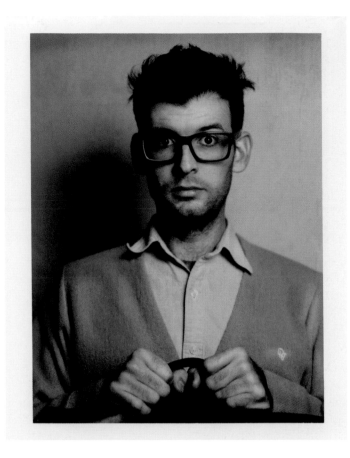
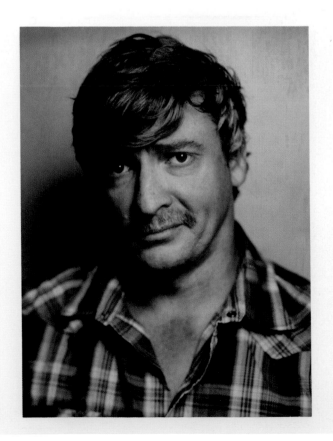
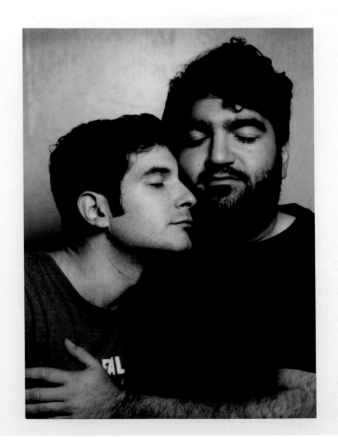

234

TOP: LEFT-SMUG SHIFT, **RIGHT**-MOSHE KASHER, **BOTTOM: LEFT**-RHYS DARBY, **RIGHT**-THE COOTIES

MJ: You mentioned it's the only thing you've ever wanted to do, but I think it's interesting that, as a whole, stand-up comedians predominantly don't get paid to do independent comedy.

EDDIE PEPITONE: It's so crazy.

MJ: So they don't make a living off of it locally, but they just keep showing up. Night after night they go onstage. They perform.

EP: The people who do that really want to be stand-ups. Because there's a lot of people who disappear. It gives people meaning. It gives their lives meaning. They're working some horrible nine-to-five job, and then at night they get to . . . I think comedy has always been a place where you can blow up the real world. You can blow it up. You can talk about the nine-to-five job, about what bullshit it is. What absurdity it is. I think, ultimately, there's a couple of factors, but one is it's a big safety valve where you let off a lot of steam that would drive you nuts if you didn't have

that place to do it. Two, it's got an addictive quality because once you start getting laughs, it's like, "I'm funny! They like me! They like me!"

MJ: A dopamine rush.

EP: Dopamine, yeah. That rush of "They like me. I'm not going to be a carpet salesman!"

MJ: What about you—do you think that you'll ever stop performing stand-up?

EP: I think I will stop when I physically can't. You know who I saw just doddering, but still going up, was Mort Sahl. He was eighty-two, and I looked at him and I was like, "I don't know if I want to be doing that at eighty-two." And then a part of me thinks I'll be being pushed out with an IV in my arm. And I'll still be . . . Maybe I won't be yelling because I won't have a vocal box anymore, but there will be a big computer screen that will digitally say: "Shouting at the top of his lungs!"

JONAH RAY: The one thing that Dana Gould always says about comedy . . .
He says it's so hard to walk away because it's the nuclear rod that's powered everything else that you really loved in your life. You have to make sure it's still working. You have to make sure it's still powering. To walk away from it entirely makes me feel like . . . I'm disrespecting comedy.

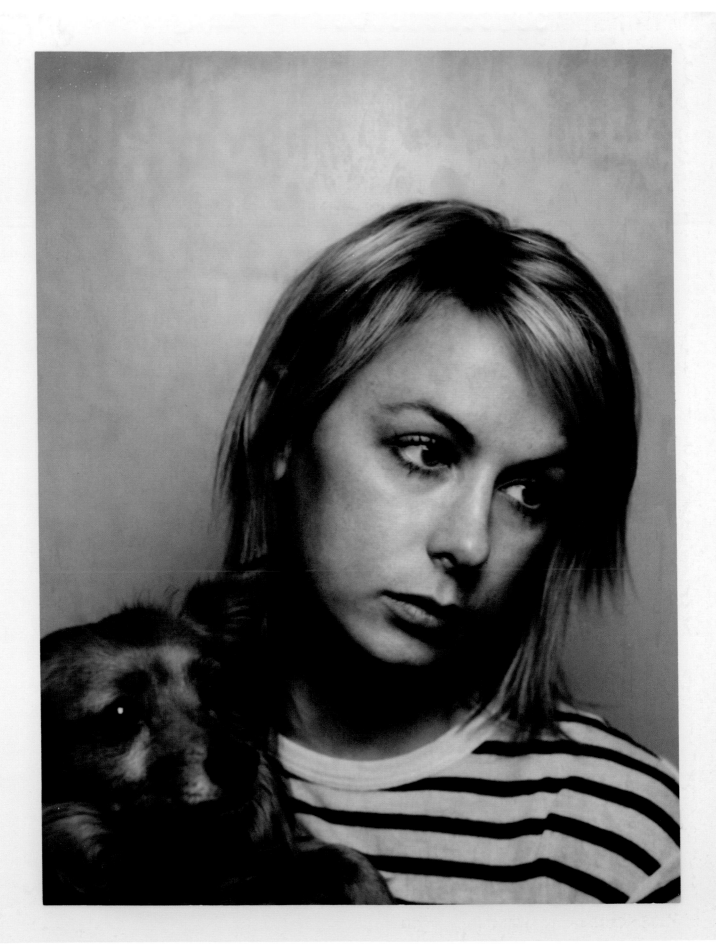

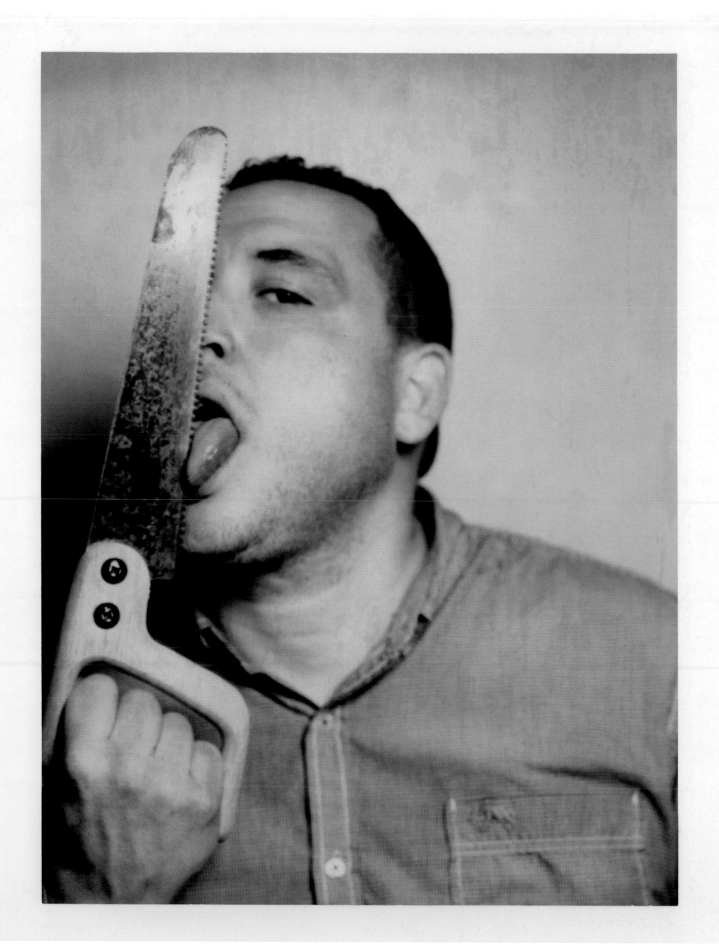

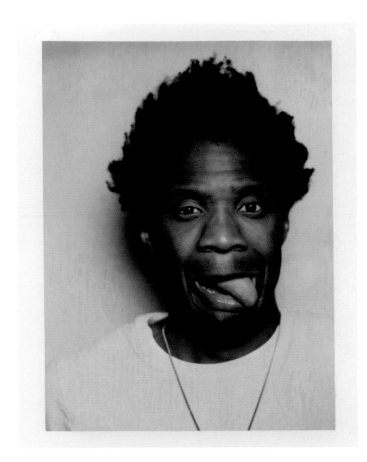
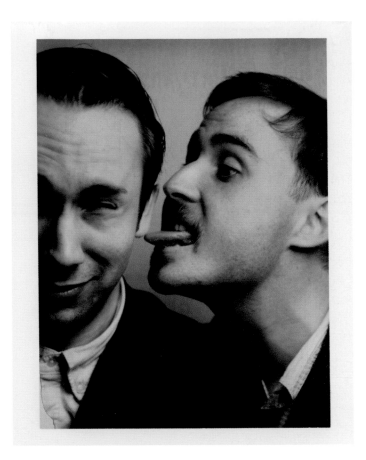

MJ: Do you think you'll ever stop doing stand-up?

PETE HOLMES: I understand the temptation to maybe just do this or just do one of the offshoots, but I really believe that stand-up is like your wife and everything you do apart from it is like your mistress. It's your side piece. And even a great show, six years, OK, if it's an incredible network show, maybe ten years, and then you . . . You're going to come back to your life partner. So treat them well. Check in with them. It keeps you from going . . . I think it keeps you from going insane, because if you have a lot of out-of-touch premises, if you're privileged, and your newly found success starts drifting you out further into orbit, you'll know by the fact that nobody understands your premises anymore. It's a nice way to kind of stay grounded . . .

I'm a big believer in *Don't just use stand-up*. If you spend ten years getting really, really good at this very, very difficult, very rewarding, very exciting thing, you're going to get a TV show and just stop doing that? That sort of breaks my heart. I almost look at stand-up like a person. You're just going to stop loving them?

MJ: There are some people who get success who stop performing live. Because they don't need to anymore; it's no longer important. Then there's some people who will never stop performing live because this is where they feel like they can breathe.

DANA GOULD: Oh yeah, I'm like that. I mean the longest I've ever gone without doing stand-up since I started: six weeks. When that was at the height of being a parent and kids were very little. But I would feel really awful for a long period of time if I didn't perform. I'm kind of glad I walked away and came back to it because—

MJ: Does it mean more now?

DG: Totally. It means more, and I really enjoy it for what it is. It's no longer a means to an end. I'm not using it to get a sitcom; I'm not using it to be known. I'm doing it because I've got this chunk of material based on how I view the world, and I want to communicate it to people, and that's it. And I enjoy it for that.

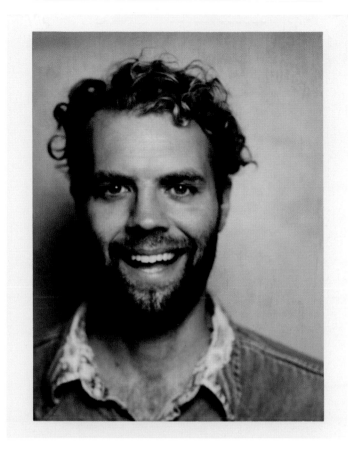

I get to go up and be as vulnerable as possible and talk about stuff and not worry about anyone that I know being upset. I jumped out of a plane before, and the rush wasn't as crazy as standing onstage and telling jokes.

—Byron Bowers

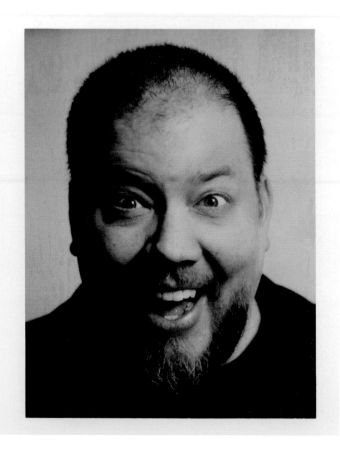

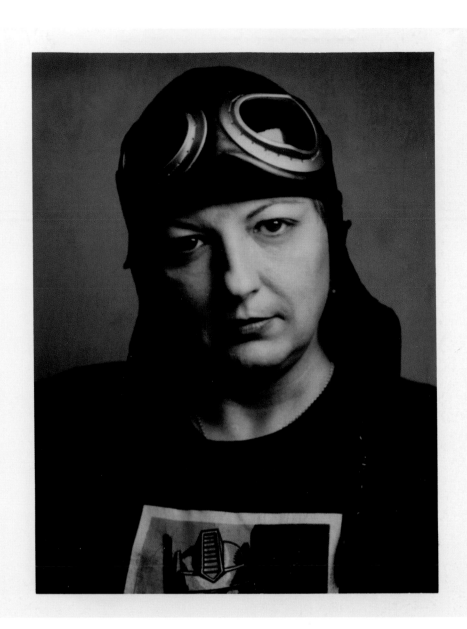

MJ: Why do you keep going back to the stage? What drives you to it?

BETH STELLING: I know, that's weird. I've always thought of myself as someone who would do it forever, even as an old lady.

MJ: I like old lady Beth doing stand-up.

BS: I don't know what keeps me coming back. If I had to guess in a therapy way, it would be for love, the feeling of love, instant gratification and attention. I've been told ever since I was a kid, "She's just doing it for attention," or "She wants attention," blah, blah, blah. It's like, Yeah, that's exactly why I did that thing. It was to get people to laugh. It felt really good making people laugh. I don't know how much of it is for them and how much of it is for me. It's a lot for me. I guess what keeps me coming back is the laughs and then the fear of the feeling of what would happen if I stopped and losing the gift if I stopped.

RACHEL BLOOM: It's what I love the most. It's the way I'm going to create new material. There's nothing . . . nothing can replace creating new material in front of an audience. And doing it for an audience. It inspires me, it gives me energy, it gives me honest or close-to-honest feedback in a way that I can't otherwise get. If I'm still interested in being an artist, which I am, the live component is essential to that.

MATT BRAUNGER: A big comedy event is . . . it's just a lot of fucking fun. It's great to laugh. It's great to make people laugh. It's great to have a good time. It's just . . . it's nothing you really understand if you don't love it.

REGGIE WATTS: I really dig performing for audiences.

I can imagine going a little bit more behind the curtain, providing experiences. No, I really dig it. It's really fun. I love using the platform to sneak in ideas. Being good humans and compassionate and not buying into binary bullshit whether left or right or whatever. I love that. I love having that platform and reminding people: *Life's really fun.* If anybody threatens to take that fun away, it's like, destroy them with absurdity.

ALICE WETTERLUND: It's the place where I feel the most myself and the most in control—in a good way. And I feel the most connected to an audience. You're telling your own story, and that's something that is irreplaceable . . .

Acting, I'm doing my best to communicate through this character the story that's happening, but when I'm doing stand-up, I'm doing me in front of an audience. I'm saying, "Hello, this is me, these are my ideas, this is my face, this is my body. You now are tasked with telling me whether or not this is funny. Go." Then they do or they don't. There's no separation between you and your audience. No time, no space, nothing. It's unlike anything else.

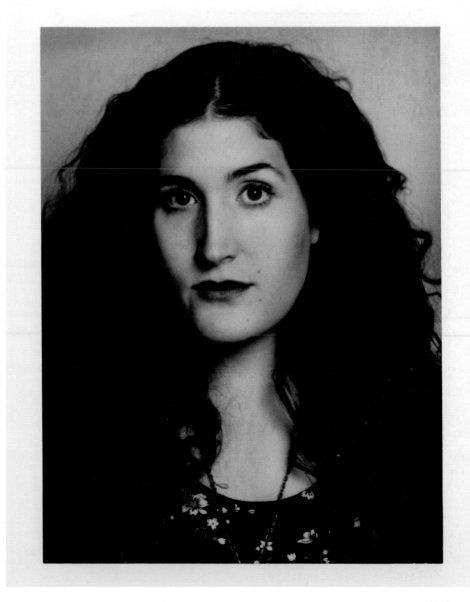

RORY SCOVEL: I think for me is it's the drug that I get from it. I mean, I can't say that I won't stop next year or I won't stop in ten years. I always get tired of it, and almost every year I'm like, "I think I'm done with this; I should focus on other stuff." But it's just not necessarily true because the high for me is the instant gratification that an audience gives you. It's the connecting with the live crowd. It's getting to say exactly what you think about something, and there's no possible filter in between you and that audience.

CHRIS GARCIA: The highs are so high. I feel like the high is . . . you wouldn't rather be anywhere else in the world. And then the low is like, I'd love to be anywhere but here. So it's that type of unpredictability that keeps you—stuck! It's like a casino! I'm going to walk out of here feeling like an emotional millionaire! Or you feel like a piece of shit . . . There's nothing like it . . . If you love it, nothing else could replace it.

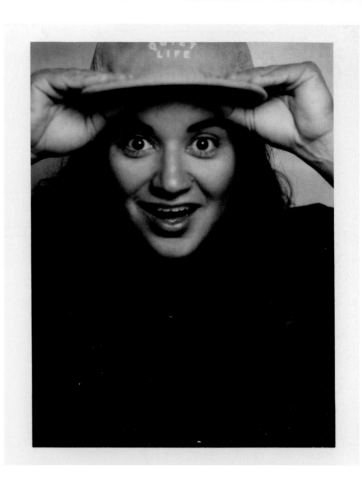

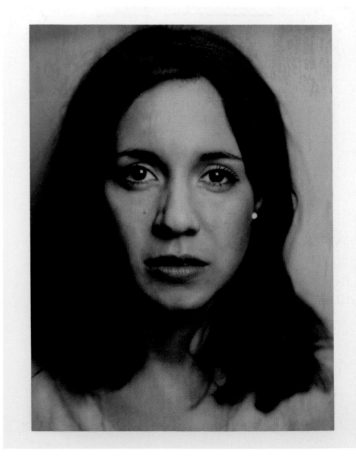

LEFT PAGE: TOP-SABRINA JALEES, BOTTOM-ALICE WETTERLUND, **RIGHT PAGE:** YVONNE ORJI

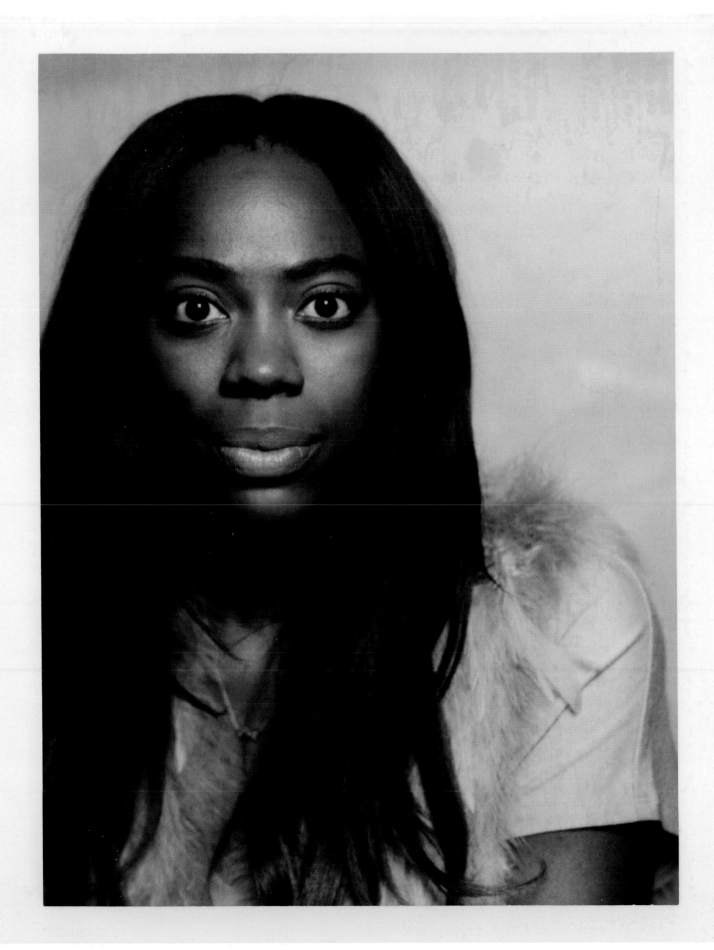

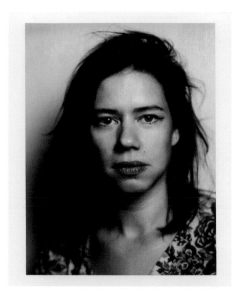
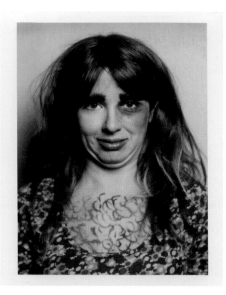

RYAN SICKLER: I really love the immediate fucking rush of reaction, good or bad . . . I realize that stand-up is perfect because as someone who likes to be in control, I've got control of that stage, I've got control of that room, and I won't ever need to get that close to you. All I need from you is laughter.

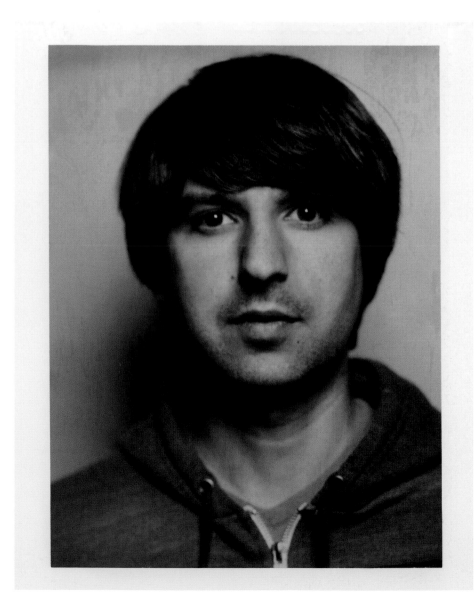

KARL HESS: Comedy's fucking rad. It's the most vital form of live performance there is. That's why even great comedy specials don't really convey what it's like to be in a room when a live comedy show is great. Something about comedy, you can't really capture it.

ANDY KINDER: I'm sixty-two now. I'm not stopping. Unless you try to pass legislation . . . If I didn't like it, I wouldn't do it, but the fact that I love it—and I don't love it every night—but the fact that I do love it means that, what would I be quitting? It would be quitting my life, basically.

TOP: **LEFT**-LOU SANDERS, **RIGHT**-NATALIE PALAMIDES, **BOTTOM:** DEMETRI MARTIN

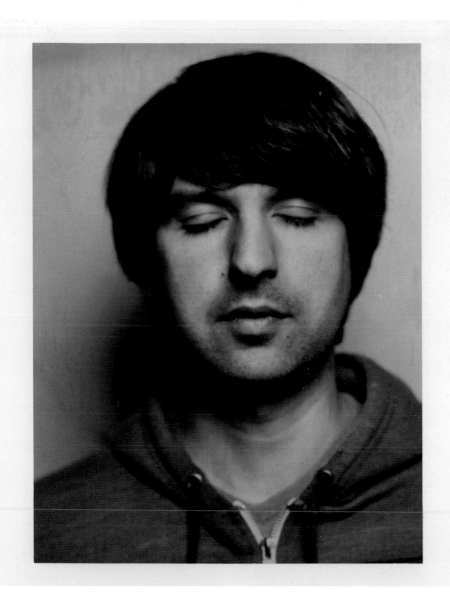

MJ: Do you think you'll ever stop doing stand-up?

ANTHONY JESELNIK: Yes. I see people when they're too old, frankly, to be doing stand-up. They've kind of let the muscle go, but the money is still there. That's the thing. You keep getting paid more, the more you do it. If I keep working at the same pace I've been working and putting the effort into it, then maybe—maybe—I die with my boots on. But I like the idea of retiring with my dignity. I never want to be bad. Just because you've been doing it a long time doesn't mean you can be lazy. As long as you put the work into it, great. People will buy a ticket to see you because they know your name, and it's easy to be bad. But I never want to get to that point.

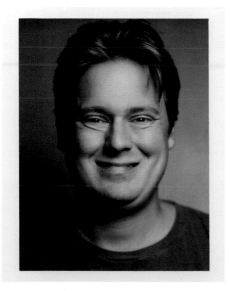

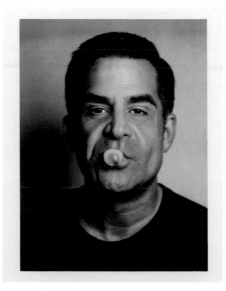

TOP: DEMETRI MARTIN, **BOTTOM: LEFT-**TIM HEIDECKER, **RIGHT-**TODD GLASS

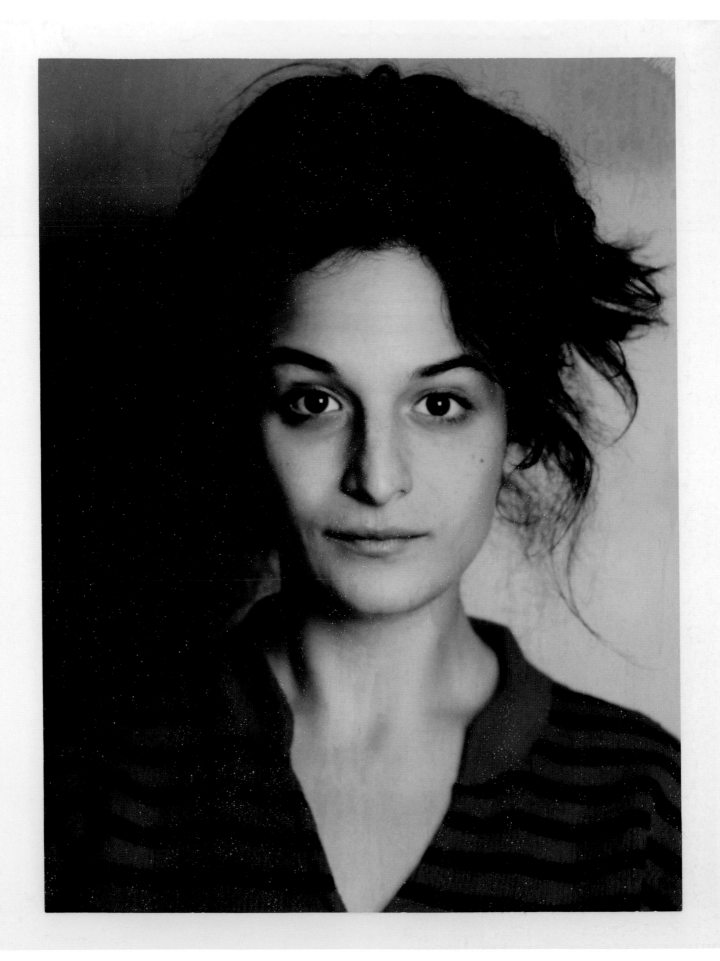

MJ: What do you think it is about comedy that draws you back even if you've tried to stay away?

BARRY ROTHBART: Validation, one hundred percent.

MJ: Just that? Just that simple?

BR: Yeah. Of course it is. It's the purest fucking cocaine of validation that you can get. If you're interested in being funny as an identity, it's like the purest form. The purest crack you can get. Because everything else about stand-up is the fucking worst, besides doing a good show. There's no replacement for that kind of fix . . .

To add to it, though, it's not just about the laughs. I would never want to do the hacky shit . . . It's really about knowing that you can still write a joke that you find funny and that other people find it funny . . . I think part of that validation is knowing that you're doing something that you can hold your head up high about.

MJ: You're sharing your perspective and thoughts with the world that you find funny, and then the audience is agreeing with you about it.

BR: Yeah. So it's not just the laughs . . . The best you'll ever feel as a comic, by far, is when you riff or improvise a new joke. You're just coming up with it on the spot. There's no better feeling. It's just killing, and you're like, "Oh my god, I just wrote a fucking new joke onstage." I can't wait to get backstage and put it in my notebook and be like, *I got a new one.* That's the absolute best feeling.

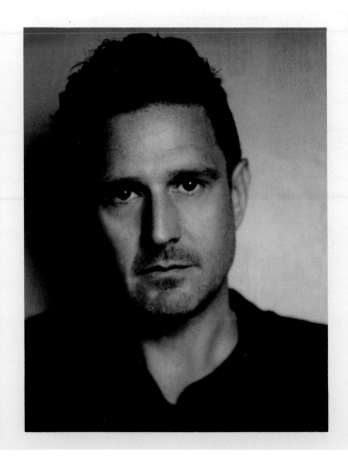

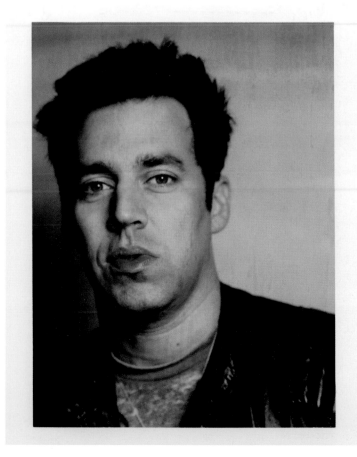

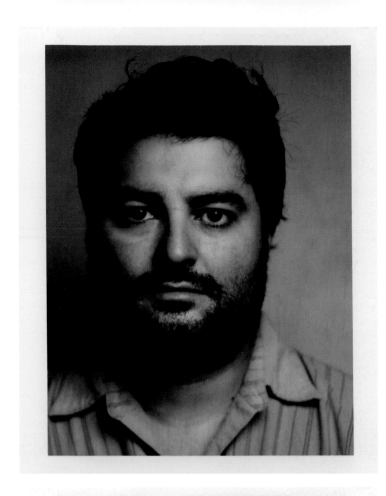

. . . it feels good to make people laugh.

—Sheng Wang

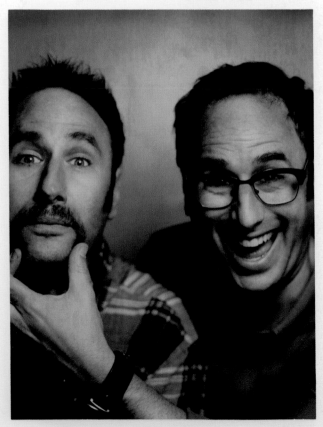

RON FUNCHES: I don't want to die on the road. But I don't see myself stopping performing live. It's fun; it's the source to me of joy. It's my home; it makes me happy. That was one of the . . . one of the weirdest chhanges and biggest blessings as I started doing other things like acting and stuff. I had less time to do stand-up, but then stand-up became less of a job. It was more of a treat again, and I was like, *I love it*; *this is the best*.

SHENG WANG: In general, connecting with a group of people or a small group of people, to an audience, that alone is very . . . It just feels, I don't know, it feels good. It feels good to make people laugh. Underneath . . . there's an understanding and a connection that makes a joke work, but also getting onstage is part of the writing process. Without doing that, you're not really finishing. You've got to bring it on to the stage, and you find out what needs to change or what worked. What changes you made are valid, are validated by this group of people . . . I think just being up there and having a group of people and an audience that connects with you is very thrilling and exciting, and it feels very . . . It makes you feel alive . . .

MJ: Do you think you'll always do stand-up?

SW: I think so. I don't know, what a weird show to see: an old Asian dude onstage. I don't know, that'd be funny, maybe.

MJ: I'm going to make sure I produce a show when I'm in my eighties with everyone I know who's also in their eighties who did comedy at this time period in my life.

SW: We better be healthy. Better eat healthy right now.

MJ: Me and Joel are healthy; we're good. We'll live long.

SW: I want to, eighties—we're going to be talking about what the young kids are doing . . .

MJ: They'll be flying on lion scooters by then.

SW: I'll probably be doing stand-up. I don't know. Who knows. I hope so.

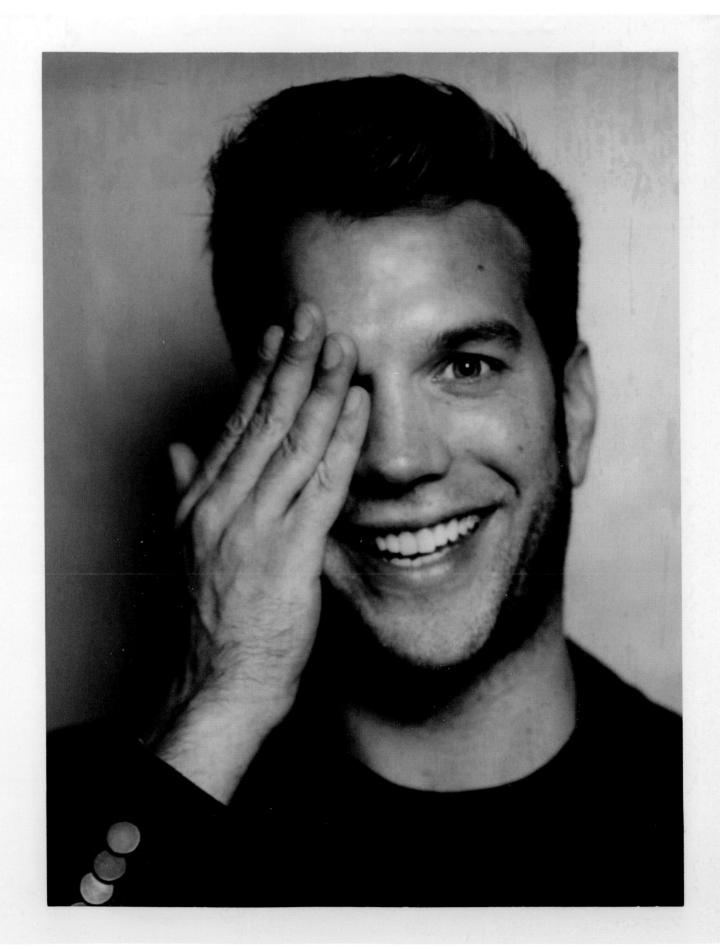

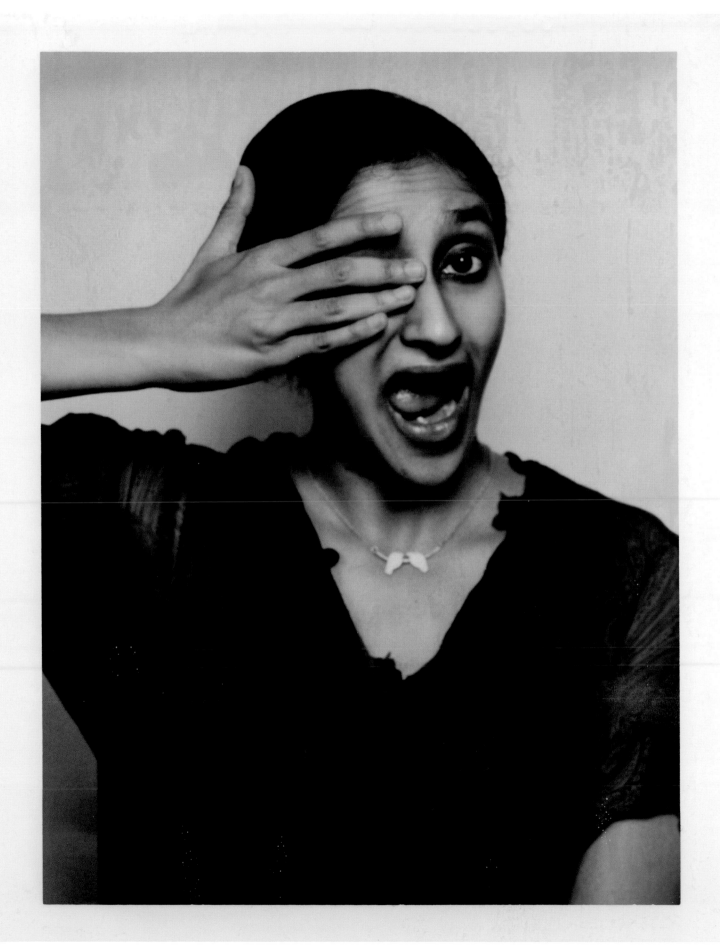

DEMETRI MARTIN: The number one thing I probably love about comedy is that there's a weird paradox in it for me: everybody's sense of humor is subjective. What each person finds funny is going to be unique and different, and it's a subjective thing. But when you perform in a room for people, and you tell your jokes to that group that's gathered, there are objective moments after each joke: they laughed, or they didn't. It's pretty binary. It's like, there's laughter, or there's silence. There are shades of it, but basically the joke did well, or it didn't; the story worked or not.

MJ: Laugh or don't laugh.

DM: And that's so objective. But it's made up of . . . It's an organism that's objective, made up of subjective parts. Then it just . . . from night to night, from hour to hour, from room to room. I love that you never really get a foothold. Because it's all ultimately subjective with seemingly objective moments along the way. I love live comedy for that experience alone. And that's the high that remains . . . Just getting the new stuff to work is . . . That's what does it.

When I finally didn't care what my parents, my grandparents, people from my church, whoever, thought about me, I was free to pursue a job in which I care about what strangers think about me every night.

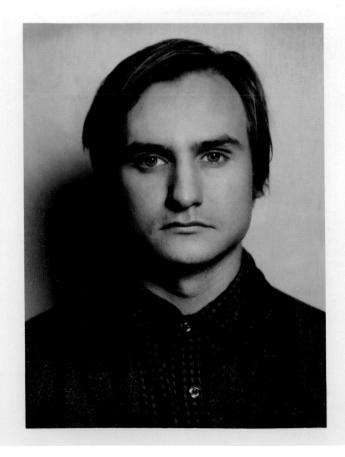 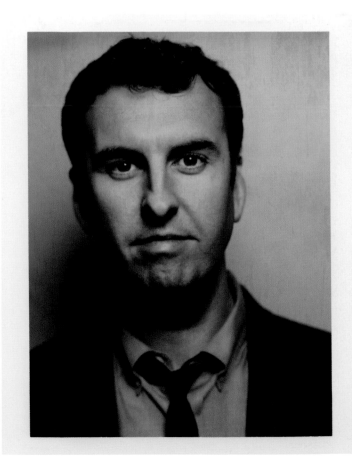

LEFT: MOSES STORM, **RIGHT:** MATT BRAUNGER

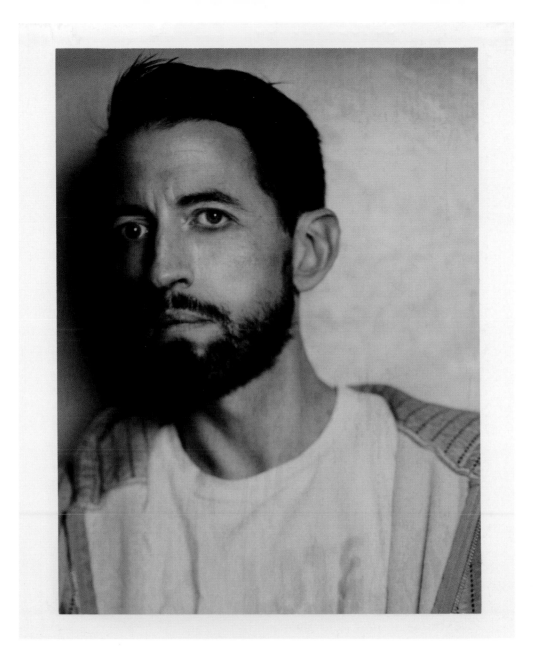

NICOLE BYER: L.A. lets me know what's funny. You can try shit on the road and have it work. Then you'll go back to L.A., and the audiences will be like, *MORE.* You can push the premise harder.

JUSTIN WILLMAN: I get pretty antsy after a few days off. For me, there's no better feeling than being onstage and no better thrill than doing something for the first time and having it work. The learning is so . . . What's fun is that every time there's a new bit or whatever, the process of honing, and trial and error, and what you learn is never the same lesson, from one bit to the next. That really does make it feel like you're a novice again every time. The nervousness, the butterflies . . . I think even though sometimes we wish they wouldn't happen, they are an exciting part of the process.

BLAIR SOCCI: I'll never quit stand-up. I love stand-up. You do think about why you do stand-up as you get older, because you're like, "Oh, I'm not drunk in my twenties. This is actually my life that I chose."

MJ: It's your life; it's your job.

BS: Yeah, and I still want to get married and have kids. Not for a bit, but that is something that's important to me. And as I get older, that puts the gravity of what you're doing . . . "Is this what I really want?" I'll always do stand-up. I do want to do movies and TV shows—I love acting—but stand-up, there's nothing like it, and I don't think that will ever go away.

Also, to have your own agency. I don't even know how people are regular actors, how you even become an actor. You have no agency over your own life. If you're a stand-up, you can always just go work and do stand-up.

MJ: So why do you think we all do it?

JAY LARSON: I think it's control, curation. The reason anyone jumps ahead of the status quo to do anything is because they just want to do it their way. Every time I walk in Bar Lubitsch, I'm like, "I want to do a show here." I love that room. It's such a cool room. There's something about the idea of doing it on your own. I've always loved doing things on my own. You get to design the poster or how it's going to be seen by people. The same reason people want to have you over to their house: they want you to see how they do their house. Why we wear clothes. What we're into. I think it's just that you . . . it's the control to put out how you want comedy to be seen.

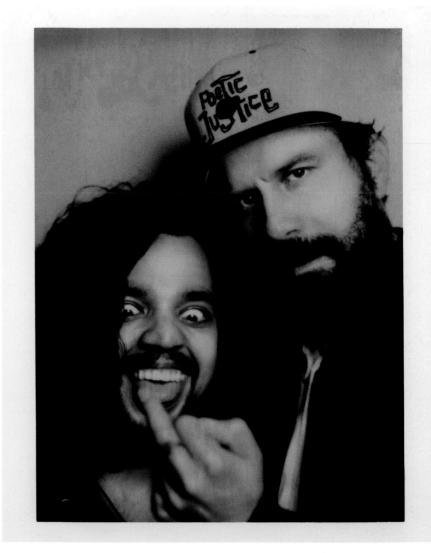

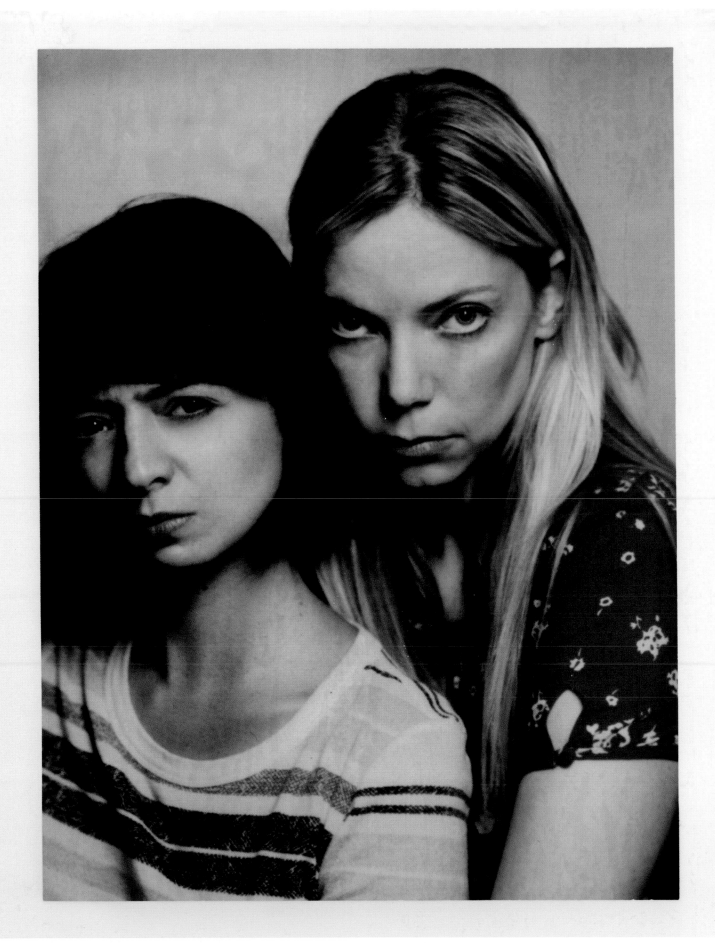

MJ: Directors and comedians have very different experiences with audiences. Comedians get immediate feedback while they're onstage, while directors create [short films] that may or may not be screened in front of a live audience. What's your experience watching your shorts live in front of an independent-comedy audience?

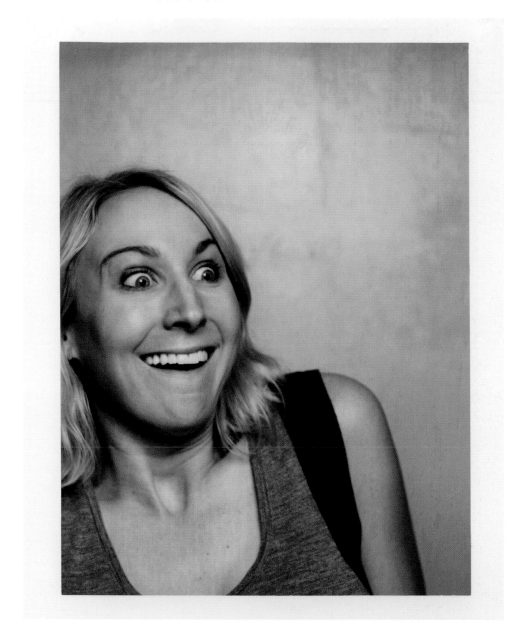

PETER ATENCIO (DIRECTOR): There's nothing like it. I can see why people get addicted to it, because it's intoxicating. It's also very instructive. It teaches you the necessity of proper comedic heightening, of hitting the right beats to build the comedic tension, and when to hit that crescendo and bring the house down. Showing shorts to a live audience has probably taught me more about editing than any film school ever could, because it really teaches you about human nature and the organic experience of watching something with a group, particularly comedy. And there's been countless times where showing work to an audience has led to me opening up the edit and making tweaks in order to strengthen the timing.

I can see why people get addicted to it, because it's intoxicating.

—Peter Atencio

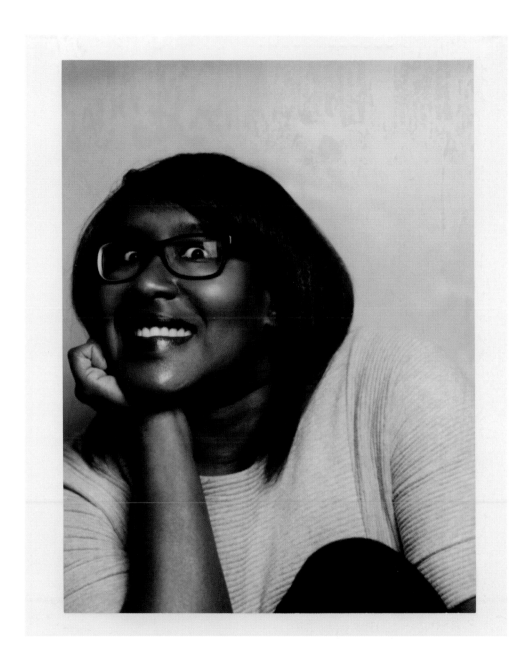

MONIKA SCOTT (COMEDIAN + PRODUCER): Stand-up will always be an art form I care about more than anything in the world. I care less and less about the "industry" of it, but if you develop the skill of turning life into jokes, there's no turning that part of your brain off. As long as life continues to be silly, I'll always do stand-up.

MJ: Do you think you'll ever stop producing live comedy?

MS: No, never. I think that my true gift is being able to pull together a show that is silly and fun, because when you are in the room watching some kind of comedy being performed, and it's KILLING and the whole room is laughing . . . that feeling is like being inside a shaken-up bottle of soda. It's infectious and uplifting, and it can keep your spirits up for a long, long time.

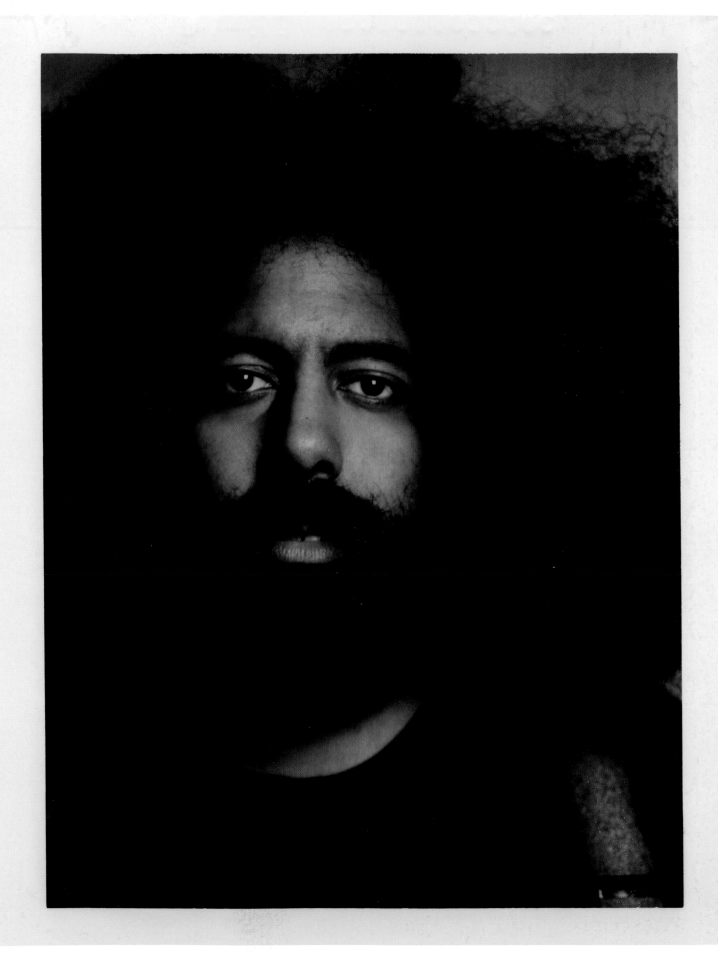

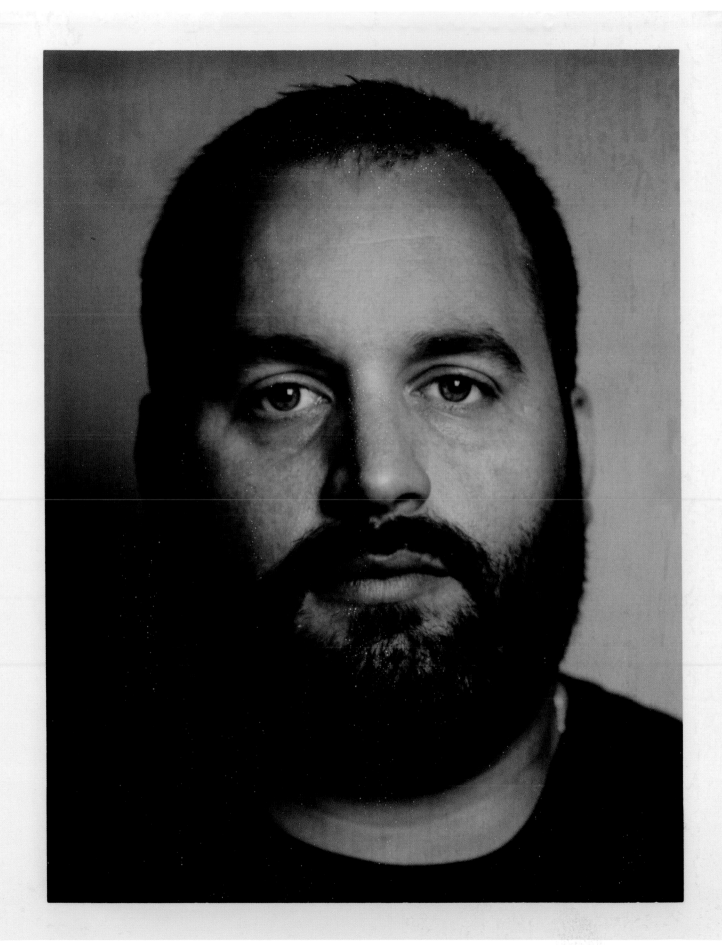

I can't stop performing live. I don't think I ever will.

—Natalie Palamides

SEAN PATTON: I'll never stop doing it. It's too much a part of who I am. Because we've all had those nights where it's a full house, the audience is hot, everyone's going up and just having these amazing sets . . . and everyone, be it the comedians, the producers, the audience, the fucking people serving drinks . . . we've all had those nights where everything happens just right and it's too good to not do again. You feel like you're part of something, you feel like you've provided something. I hate to sound fucking cheesy, but who's to stay those nights don't change someone's life for the better and they're better because of it, and you don't know those nights could be the the idea of what God is. I know it sounds fucking crazy, but you know what I mean . . . And, yeah, you're right: no one gets really paid, some shows slip you an envelope with a twenty-dollar bill in it, but I never think about money in those moments.

I just feel like that's why we still do it, because when we have those nights, it just reminds you of that same feeling of why you started in the first place. And it feels good. It's a different type of success, one you can never buy.

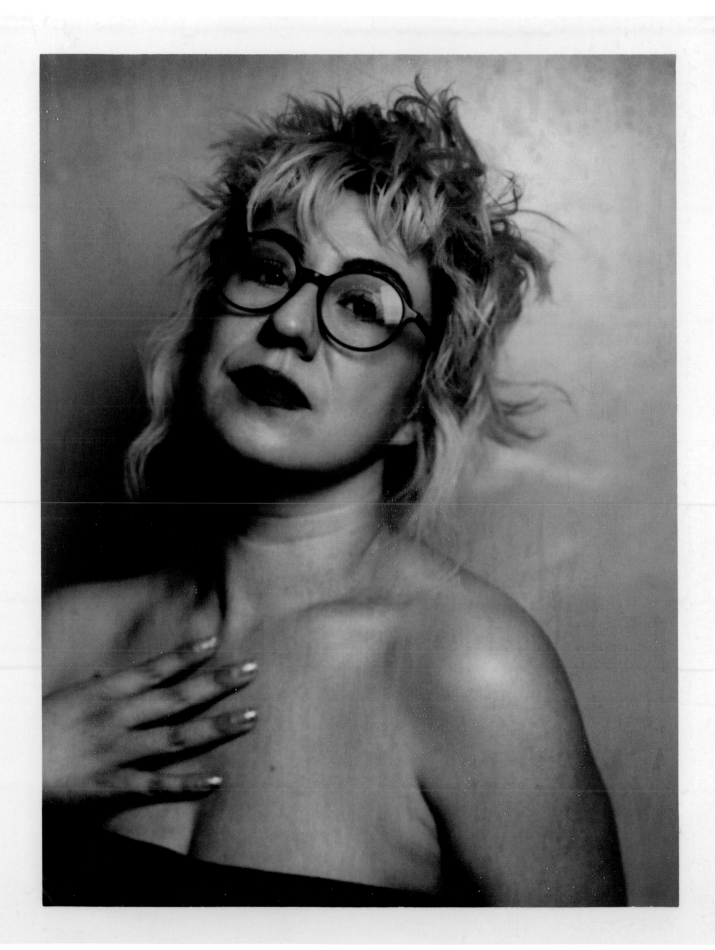

FINAL

ACT

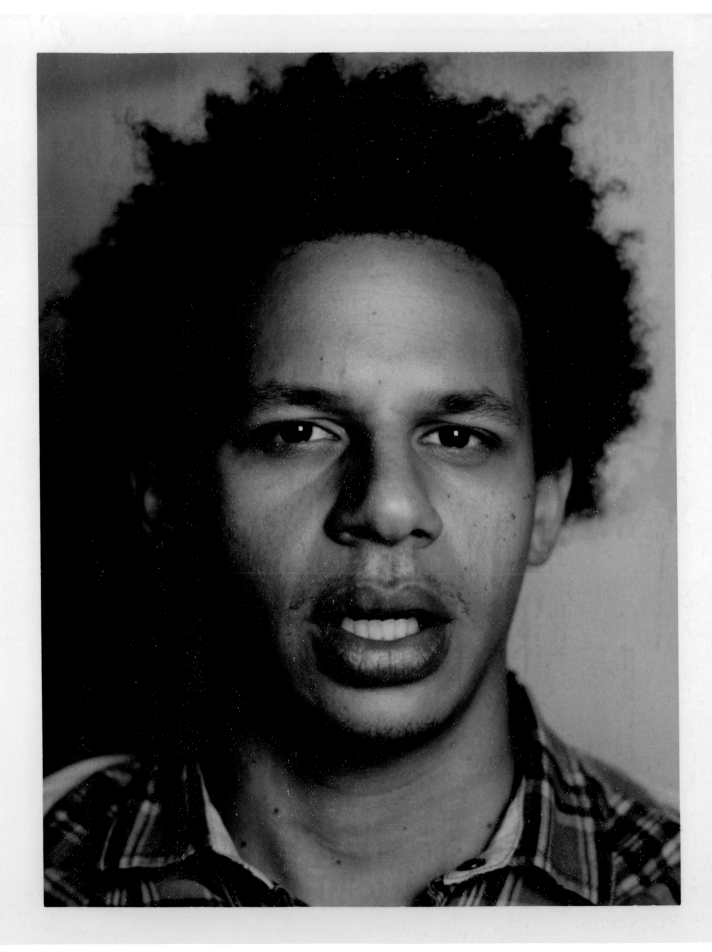

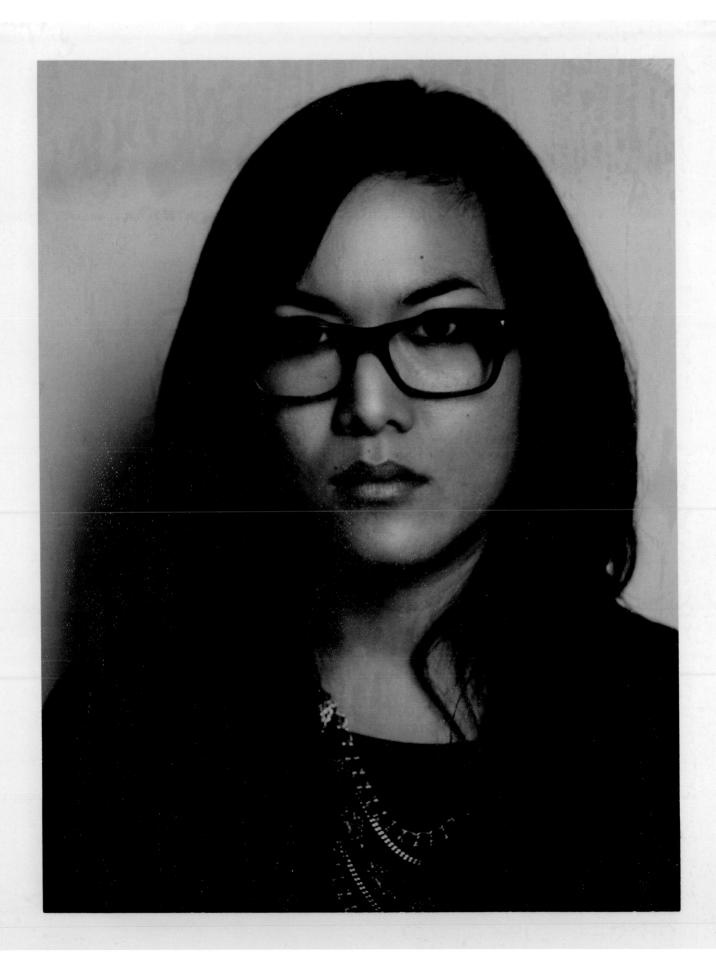

Stand-up taught me a lot, not just about comedy and stand-up itself, but about how you define success: what kind, how it relates to time, how long do you give yourself before you say I have succeeded or failed, or do you learn to not even assess yourself that way, and say, "Hey, I'm in this for the long haul, so I'll do my best."

—Demetri Martin

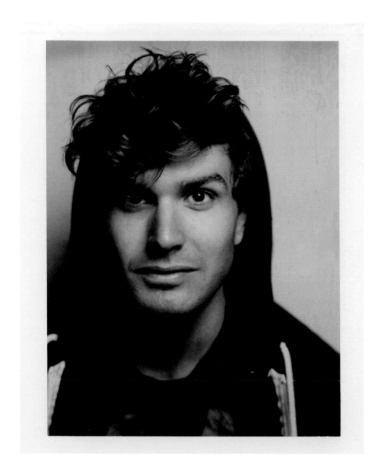

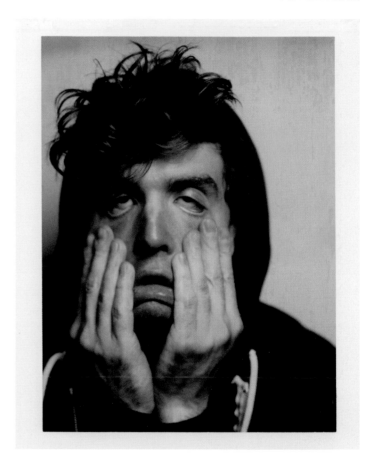

JAKE WEISMAN: If you are funny and talented and willing to take risks and willing to fail, you can pretty much do anything. The advantage you have is not giving a fuck about failing. That's what comedians are. People who are willing to fail in public.

CAMERON ESPOSITO: I'm incredibly grateful that I've gotten to do stand-up in the time I've gotten to do it. It's been sometimes so rewarding, so demoralizing, but huge swings, and I've felt important. I've felt like I'm actually part of this big change for LGBT folks and for women in this field. It's one of the true American arts. It's incredible.

ANTHONY JESELNIK: Independent comedy was just cool. It was important to me, if I was going to be a comedian, I wanted to be a cool comedian. The clubs weren't cool. The clubs are crowd-pleasers. Independent comedy was more for the performer. It was on the audience to get it. The onus is really on the crowd to . . . you're entering into this; you better be cool enough to get it. One of my lines early on, my saves, if you will, if a joke didn't work, I'd go, "Oh, I'm sorry; I thought you guys were cool." That would kill on the independent scene because it really is like when you go to see an independent comedy show, you're trying to prove yourself as an audience. We'd better be cool. You can see the people who fucked up and thought they were going to a club show. If it wasn't for the independent scene, I wouldn't be a comic. If I had to just do clubs, it wouldn't have interested me. Being on the independent scene of a Largo or a Virgil was really what made me what I am.

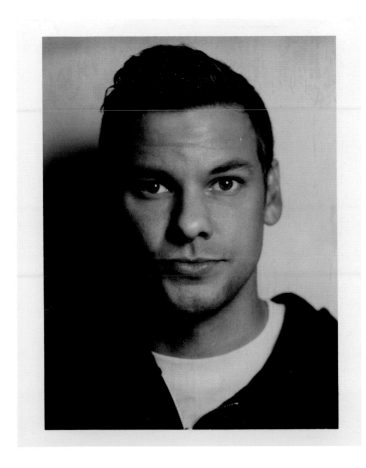 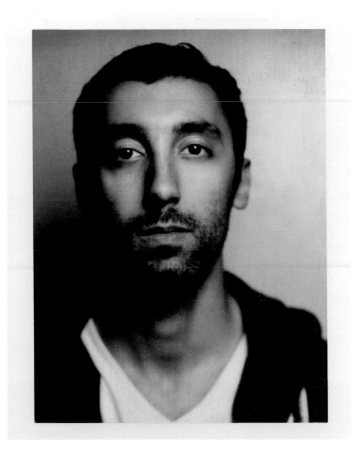

LEFT: THEO VON, RIGHT: MORGAN JAY

GREG BEHRENDT: I wouldn't have a career without it. I wouldn't have a career. I got discovered, such a corny word, but it is sort of true, at the *UnCabaret* by the executive producer of Second City who gave me my first job. That job turned into the book that I wrote and ended up getting on *Oprah*. I wouldn't have been as good as I was if I hadn't been encouraged to go up and do the kind of comedy that I wanted to do. And so, without independent comedy, I don't know what I would have done.

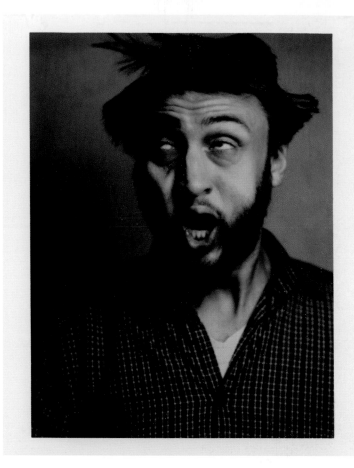

BARON VAUGHN: You know, independent comedy is the reason that I have never been so obsessed with clubs, being at a club or getting passed at a club. Because clubs come and go. The level of popularity of a club comes and goes. But since independent comedy is always there, I can always start a show. Knowing that that opportunity is there and that there's a space for it, that I've seen people do it for years. Knowing that it's always there feels like, if anything else, I can go to my family . . . is the way I look at independent comedy.

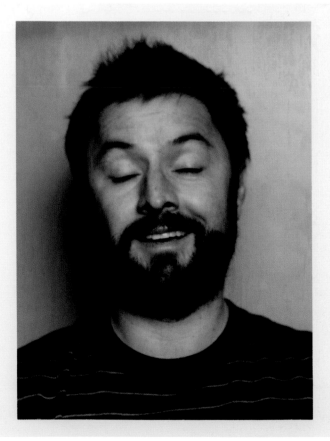

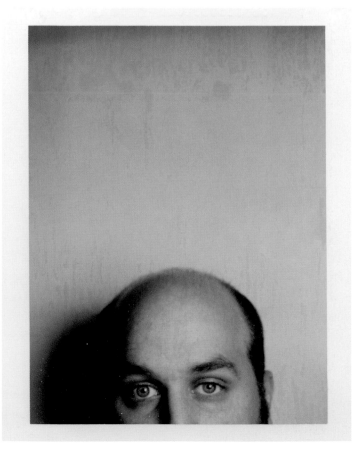

TOP: LEFT-ANDY HAYNES, **RIGHT-**SHENG WANG, **BOTTOM: LEFT-**ADAM CAYTON HOLLAND, **RIGHT-**RON BABCOCK

MATT BRAUNGER: I just think independent comedy is always going to be around because comedy will always be kind of the misfit child of the entertainment family that everyone kind of secretly loves the most. It's universal, and it's never going to go away. I just think the independents will always exist in every art form, but it will always exist maybe the most in comedy because comedy in its own way is eternally and universally the most independent of the arts. Because it's the lowest. Because we are rats in the sewer—that's why.

NIGEL LAWRENCE: I feel like independent comedy is alive and well. It's better. It's noticeably different. I think it's sort of like anything independent: if you go to McDonald's, you're going to get McDonald's. It's that sort of formula. But I think if you go to your local coffee shop, you're going to get somebody that maybe cares a lot more about your coffee than McDonald's does. It's more of a machine versus anything independent; whether it's comedy or coffee shop, they're putting their lifeblood into it, and it's different—you can totally tell. It's all those little things that if you take them away, you get diminishing returns, but if you put them in, you get a much higher return.

WHITMER THOMAS: One thing I'll say is approaching comedy in the independent scene feels like everybody is on the same page. There is no hierarchy, and there is no waiting and hanging out to prove that you're loyal or whatever. If you feel alone and you feel like you don't have anywhere to go, go to the independent comedy scene.

RANDY SKLAR: I love independent comedy so much. It has been . . . it's this heartbeat for us . . . I feel so connected to it; I feel connected to anytime there is a—

JASON SKLAR: It's like a litmus test or a reality check for us, a gut check. The second we come into those rooms and don't do well because we're maybe too polished into the clubby zone or doing stuff—

RS: Really what it's saying is, You're not connecting enough. You're not connected enough with what you're doing, and get to the truth of what you're saying—does that have relevance with these people? So I love it. I love it, and also it's taught us to have, as we get older, confidence in what we are doing. Believe in it. Anytime you're worried about a show, just believe in yourself. We will . . . You'll have good shows, and you'll have bad shows, but—

JS: But the independent scene is so valuable in terms of creating material, in terms of being connected to talented, young, upcoming, interesting people. The clubs—certainly the Comedy Store now because it's just so big— there's not a lot of room for new faces to pop into the lineup. There's only so many spots, and they give them to these giant people. It's like a murderer's row of headliners.

RS: I love the club—don't get me wrong; I love it—but there's a thing about independent comedy where you're a band of people friends, ostensibly artists—

JS: For the sake of art—

RS: And the audience is lucky to be there to watch whatever's unfolding unfold.

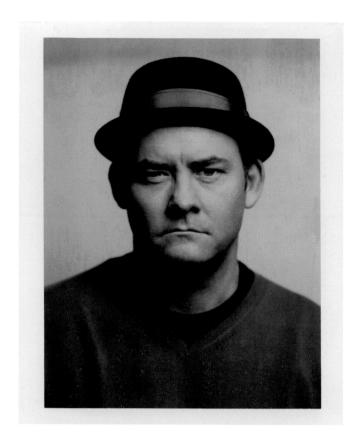

I obviously think independent comedy is really important, but I'm not really worried about it in any way.

—Reggie Watts

272

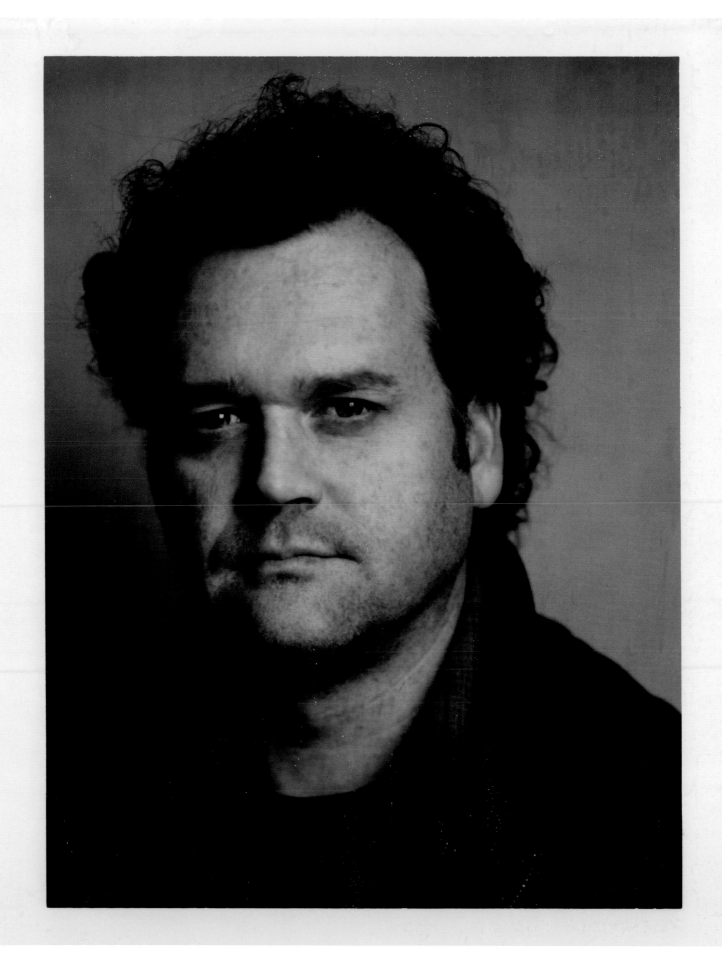

KAREN KILGARIFF: I think it's a huge sign that we are evolving, that people are coming to comedy so strongly. In my opinion, it's a very high-level means of communication. It's talking about things in an entertaining way to people you don't know. When you think about it, it's very important. It's important to process the horror show that we live in, in the world right now and the government that we have right now. It's almost like setting up a support system so that you can go to a comedy show and see another intelligent human being go, "This is fucked." And be like, "Oh, thank god." It's a truth-telling thing. People bum out at the popularity or the boom or the fact that every single person in the world thinks they can take one improv class and that means they're a stand-up comedian. But that's OK. There are plenty of shows. The good people, the cream rises to the top. We should all be afraid we're not good enough. And we should work harder for it. And then the shitty people will disappear because it's too hard. It's really fucking hard.

MANDEE JOHNSON: You have to really, really want it.

KK: You have to want it, and you have to understand the value of it. There's nothing that I cared about more than stand-up comedy when I wasn't doing it. To not be labeled as a comedian and to [not] be in the mix is one of the worst things that has ever happened to me. And my mother died of Alzheimer's. And I have seizures. It's a very difficult mental game, and you guys make it so that the right kind of people are playing it and their voices are being heard.

BARRY ROTHBART: It didn't matter who was hosting [a show], and where it was, as much as it relied on who was producing it, to make it have an independent vision. I think that is really the indie scene. It's the spirit of the show. I know from doing a Mandee and Joel show I can get away with doing certain things that I couldn't do when it's just a booked show. It comes from the vision of the producers and who's running it. It's more than just a taste; it's a spirit.

MJ: I like to think that independent comedy at its best is a strong producer giving a shit, booking comics that they think are funny. Those are the only rules. Give a shit and make it a good show.

BR: But it is your vision—it really is. I think that works with independent film too. If you have a singular vision of the thing and it's not influenced by corporate people who are trying to make money off of it, it really will always come off with a more independent spirit. I think that's a testament to who's producing it.

KATE MICUCCI: Did you get everything you need from us?

MJ: Yeah, did you guys have anything else?

KM: I don't think so. Do you have anything?

RIKI LINDHOME: Do you?

KM: Thanks for always having us on your shows.

MJ: Thanks for always doing it. We're equally grateful.

KM: And thanks for making us Weird Al's house band.

MJ: Oh my god, anytime.

Hi. It's Reggie Watts,

here to present the afterword. I've never heard of an afterword. I didn't know *The Super Serious Show* was ending. So, there are some things I admittedly don't know. But after reading and admiring the entirety of this excellent book, I have learned a couple things, which I will now share.

I think sometimes that you take shows for granted, that you just assume they'll always be around. *The Super Serious Show* sticks out in my mind because Joel and Mandee ran it with an invisible hand.

It was important because it wasn't self-important.

From a just-starting comedian to a very well-established one, the experience of doing the show was the same. Everything was practical and doable. And because of that approach, comedians would respond in kind. No one would ask for much, you didn't have to think about it, it was all—and I'm gonna use a newer, more zeitgeist word here—rad. I think people, the comedians specifically, will miss that.

Good art that's still around is around because someone was diligent enough to keep a good, consistent record of it. The photo portrait was part of every single show. You got used to it, it was casual, super-fast, fun, you'd barely even notice it was happening. But then, after years of that, there's this amazing book. Maybe Mandee didn't know what she was going to do with the photos, but at a certain point a light went off. Now, we have this time-traveling element, this book with photographs, and when you look at the photographs, it brings you closer to the moment that was. You can be present in those past times.

As a comedian, *The Super Serious Show* was a stealth happening; it just happened. And time went by quickly and while I wasn't specifically focused on it, the show was part of the fabric of my reality. You think that it's always gonna be there and then suddenly someone is asking you to write an afterword and you're like, *oh crazy, it's not gonna be there anymore*. But there's a record! So now, it doesn't just go away. This is how an event like this should end. With a surprise conclusiveness, not dramatic, but with a record of everything that happened. It's a night that was born of artists, for artists, for people to come see these artists. It's great that it ends in an artful way.

When I was at the show, I would try and watch as much of the show as possible. You can bullshit backstage with the comedians a long time and that's fine, but I mainly wanted to see what my friends were doing, what material they were using, how the audience was reacting. It's also just fun to hide between the curtain and the door, super dark and cozy back there, and you can't make any noise. That's my zone. My favorite thing to do when a performer finishes a set and is coming off stage, just about to reach out for the curtain to exit, is to pull the curtain back for them from my hiding place—*whoosh*—and then they just walk through, out through the door and up the stairs. They're off: clean, smooth, never knowing I was there. I close the door, then close the curtain, making sure there's no gap, and go back to my hiding spot. I love a good standard like that,

the helping but unobtrusive shift of energy, and that's what *The Super Serious Show* brought every time.

So. In that spirit, now that you've experienced everything this book has to offer, you can finally go to sleep knowing that everything is gonna be okay. Good job, everybody, we made it. There were a lot of pictures, I know it wasn't easy, but you guys held your ground. Some of you took your time, some of you just devoured the whole thing at once, but whatever your absorption style, congratulations, you did it, you finished it. Now, just have a chamomile tea and settle down for the night cause there's nothing left in life to learn.

Close the door, shut the curtain, go to sleep.

Love,
Reggie

THANK YOU

To every comedian: Thank you for taking a chance, for trusting us, and for making the drive. Thank you for giving the world laughter, making us think, and lightening our load. Thank you for being our community.

To every audience member who's ever come to anything we've produced or to any live comedy show: There isn't a show without you. Your time is valuable, and independent comedy won't exist without you.

To our crew: You are our family, and we couldn't do any of this without you. We love you from the bottom of our hearts.

To the unstoppable Betsy Koch, who joined us as producer a handful of months into the show: Thank you for understanding our vision for the show, for loving comedy and us. Thank you for always being a good friend.

To my sister, Jessica Johnson: For slinging sweets, laughing with us, helping us carry too many bins, and listening to us only talk comedy and production for too many years.

To Michael Sagol at Caviar, Jasper Thomlinson and Cathleen Kisich (in the early years): You supported the show early on, and you really believed in the type of show and community we were trying to build. Your constant support and deep affection for comedy are the reason why we were able to pay comedians, and your undying support will forever mean the world.

To our first home, Smashbox Studios: Thank you for letting us raid your EQ room and barely pay for stages for eighteen months. A specific thank you to Rebecca Cabage, Dee deLara, and Donato Sepulveda for taking a chance on a comedy show. Your generosity shaped the show into what it is today. Your spirit lives on in Andrea Streiber, a true lover of comedy who continues to work to provide us a home when needed for any silly comedy venture we can dream up. To Dimo, Chad Schollmeyer, Jack Rigollet, Mark Luebbers, and everyone who worked in the grip room at Smashbox: You came to our show, helped us tear down, and rarely charged us for overtime. Your kindness will never be forgotten.

To Eric Macklin: Who helped us rig our first show, and for encouraging me to take the first set of portraits. Also, thank you for introducing us to Vern Breitenbucher, who was very kind to complete strangers because of you.

To our current home, the Virgil and its owner, Louie Ryan: It's rare to find a home to produce independent comedy where everyone *really loves* comedy. We're incredibly grateful to Novena Carmel and the amazing staff. Your enthusiasm for our shows makes them feel special. You all mean so much to us. Thank you for being there with us through every show.

To my dear buddy, Natalie DeRosa, for your undying love and support: Thank you for always believing in us and having our backs no matter what came our way.

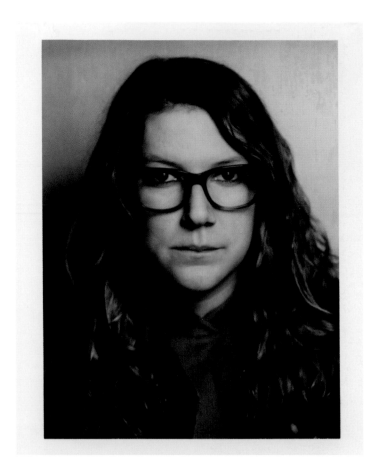

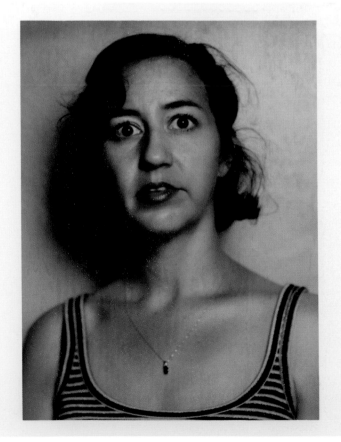

To Timothy Wilkinson, an integral part of the show for many years: You are our dear friend. Thank you for letting us trick you into rigging those early shows, gifting us 12–15-hour days for free. Our gratitude and love for you are undefinable.

To my fellow photographers, Rebecca Adler Rotenberg, Callie Biggerstaff, and Wei Shi: you captured the energy, heart, and humor of the show. Thank you for being incredibly talented photographers, kind humans who are deeply generous with your time, and our dear friends.

To Monika Scott, Steven Long, Abbey Londer, and Katherine Leon, for your Los Angeles support and also for letting us drag you all over the United States for the sake of comedy: Thank you for stamping pizza boxes, hanging fake hot dogs, jumping into dumpsters, long days with little sleep, good meals, laughs, and all the memories, moments, and friendship. We're lucky to share everything with you.

To Harris Mayersohn, for being a spectacular friend and our counterpart on the East Coast and for your emotional check-ins: Thank you for always being down, always being there, and always giving a damn.

To Allie Zisfein, for being a wonderful human who is incredibly giving and talented: Thank you for bringing an incredible amount of joy into our lives and helping make our crew a family.

To Lee Sacks, for being our calm in every live show storm. Also, your attendance record to everything we've produced is impressive and should be noted for history. Consider this the official record.

To Regan Bond: We're not exactly sure how we tricked you into being our DJ for the past ten years, but we wouldn't want it any other way. Thank you for always showing up, playing the

TOP: SARA SCHAEFER, **BOTTOM:** KRISTEN SCHAAL

perfect music, and creating the vibe that is *The Super Serious Show*.

Thank you to our regularly scheduled comedy partners Kurt Braunohler and Kristen Schaal: for trusting us for all these years to be your producers. Thank you for being the best partners and great friends. Producing *Hot Tub* is always a highlight every week.

To Antonia Loverso and Patrick Starzan: for being tremendous partners over the years and trusting us to lead the charge: We're lucky to call you dear friends, and we love you both.

To Kyle Mizono: for being a dependable, neurotic, loving, and vibrant friend: Thank you for everything and all the amazing memories.

To Aaron Kee: for growing up with us and with the show and for always being on our team. We love you. Yes, even Joel.

To Rachael Sheridan: for showing up every month with cases of wine to give to our audiences and comedians for free. Your friendship over the years truly is the best.

To Jeremy Raub, Ting Su, and Steven Raub of Eagle Rock Brewery: Thank you for the amazing beer over the years and your support.

To Tenniel Chu: for allowing two strangers to convince you to help run sound at a comedy show. Regan would've quit if you didn't come on board.

To Tina Brockman: Thank you for bringing the best energy and excitement to our front of house. You set a high bar for everyone who's followed.

To David Kloc, Barry Blankenship, Garett Ross, and Jenny Fine: for the fantastic poster art that made our show cooler than it ever really was.

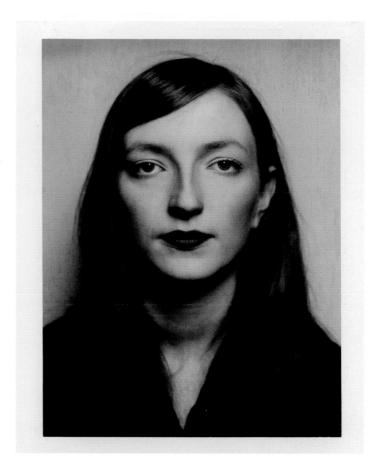

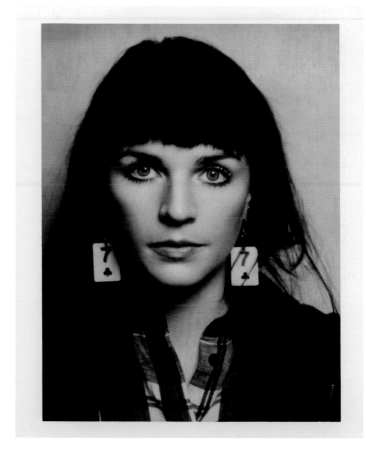

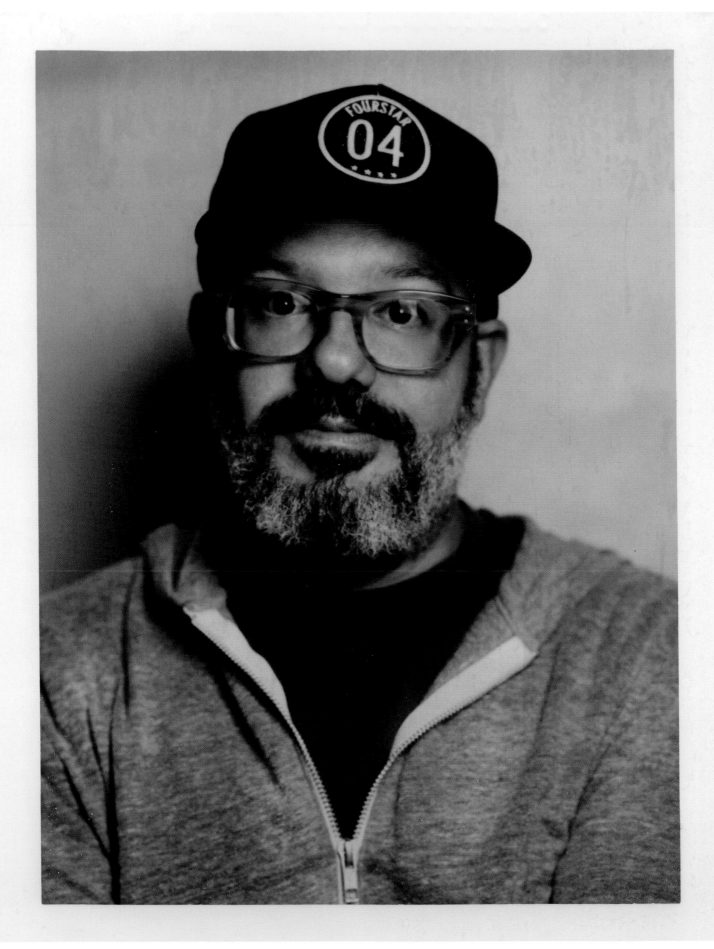

To Chris Salazar: for the perfect logo right out of the gate.

To Erica Backberg: for following us to Scotland for a long month of shows at a festival we knew nothing about for a plane ticket and a bed.

To Sohail Najafi and Josh Cuellar: for making every stage and show look beautiful. Thank you for following us anywhere, answering late-night texts, bringing your amazing team, and often working on little sleep. Mostly, thank you for being incredibly talented, creative, and our friends.

To Nigel Lawrence: for being a good friend, a wonderful comedian, and for your free labor to build the DIY lighting dimmers for the show.

To Jake Kroeger: thank you for being one of our earliest cheerleaders and always getting it.

To Nick Applebaum: for your unwavering support to help us figure out filming, always supporting the show, and so many tripod loans.

To Molly Perez: for holding my photo backgrounds when needed and for introducing me to my amazing book agent.

To Monika Woods and Allison Adler: for believing in the vision of this book.

Thank you to the rest of my family for always loving and believing in us: my sister, Kamala Nyamathi and my brother, Chris Gates, who've been by my side since I was sixteen; my sister and brother-in-law, Berit and Lars Kristoffersen, and my wonderful nieces, Asta and Ida, and my nephew, Villads. We may not be blood, but we are family, and I treasure you all deeply.

I'm grateful that comedy continues to bring so many amazing women into my life. You've all shaped me beyond measure.

We're very grateful to all of our beautiful friends who come to our shows, continue to put up with a lot of comedy shop talk, and always root for us.

Finally, thank you to my parents, John and Eileen Johnson. You helped provide the space we needed to create this show and build our company. We are forever grateful and love you both.

—Mandee and Joel

GLOS

SARY

AVAILS

Short for "available dates." These are the dates a comedian has open to perform. Often comedians will send in their avails to producers or bookers, hoping to get stage time.

BARKING

The act of standing outside of a comedy venue before a show begins and encouraging passersby to attend said show. Barking is usually done by producers and hosts right before a show if they are worried the show they're about to put on will have low attendance. Clubs also often hire young comedians to bark for their shows, paying them minimum wage and the possibility of stage time.

BOOKER

The producer who sends out offers and determines which comedians will perform on a show.

BRINGER SHOW

A comedy show, typically held at a comedy club, where the performers must bring a predetermined number of paying audience members to the comedy club. If the performer does not bring enough audience members, they are often not allowed to perform.

BURNING THE LIGHT

When a comedian performs beyond the end of their allotted stage time, which is indicated by a light at the back of the room that tells them when their time is up. Burning the light is generally considered to be very disrespectful to other comedians on the same show and to producers.

COMING UP

A shorthand phrase used to reference the early years of a stand-up's career. For example: "I came up in Denver before moving to Los Angeles."

GETTING PASSED

When a performer is hired to perform regularly on a comedy club's roster of nightly shows. The process of "getting passed" differs at every club but usually involves some combination of the venue's booker watching your act in person and hanging around the club when not performing.

HOMEWORK SHOW

A premise-based comedy show that falls outside the typical parameters of a stand-up comedy show. These shows require performers to write a set, piece, or bit specific to the night's premise instead of performing their usual material.

INDEPENDENT SHOW

A comedy show that isn't held at a comedy club or produced by a corporate comedy company. Most shows held at bars, restaurants, and various other nontraditional spaces are independent shows.

SET

A comedian's actual performance of jokes and bits. Variety stand-up shows tend to consist of anywhere from five to seven sets on a show.

SETUP PUNCH

The traditional structure of a stand-up comedy joke. The setup is the premise of the joke, where the comedian sets the audience up to expect one thing. The punch, short for "punch line," is the laugh line of the joke, where the established expectation of the setup is upended, hopefully, to humorous effect.

THE LIGHT

A literal light held up by a show's producer from the back of the room to inform a comedian onstage how much time they have left onstage, indicating that the comedian should start wrapping up their set.

TWO-MINUTE LIGHT

Two minutes is the standard amount of time left in a comedian's set when they are given the light. Usually confirmed with the comedian before the show begins.

WORKOUT SPACE

Workout spaces are cheaper shows where comedians can work on new and developing material while allowing smaller audiences a glimpse into their process. Typically, workout spaces are in larger markets, such as Los Angeles and New York, where most comedians live while not touring.

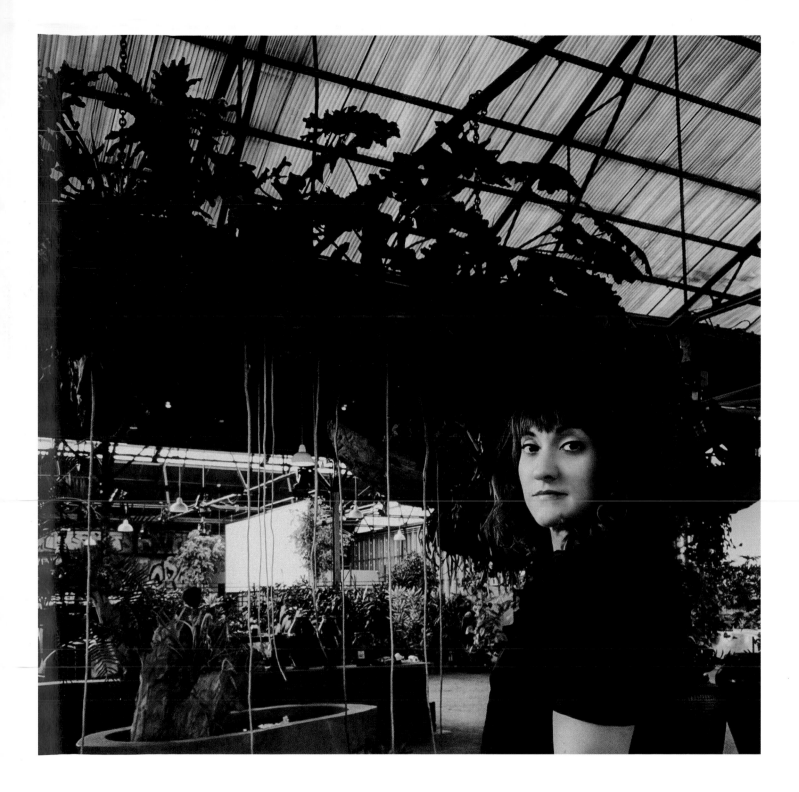

Mandee Johnson

is a photographer and producer. She is, with Joel Mandelkorn, the co-founder of CleftClips, the comedy-oriented production company behind *The Super Serious Show* and *Hot Tub with Kurt & Kristen*. She lives in Los Angeles.